FREDERIC REMINGTON

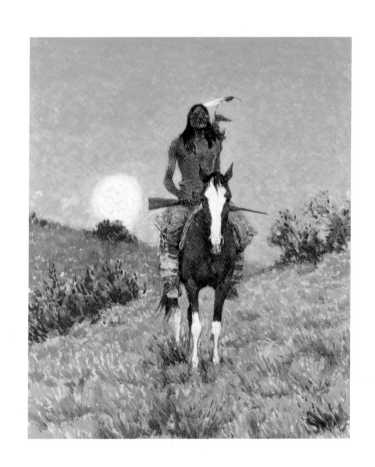

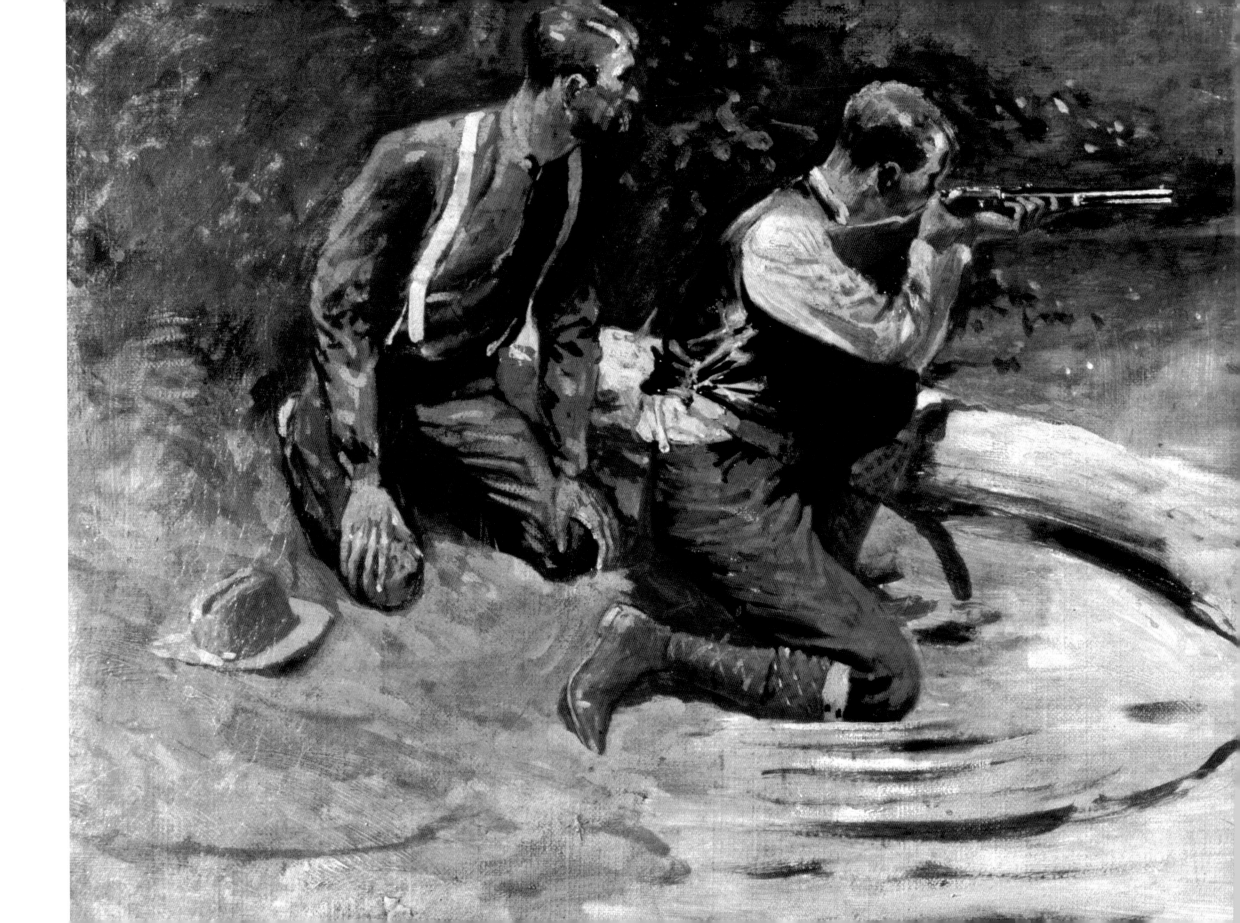

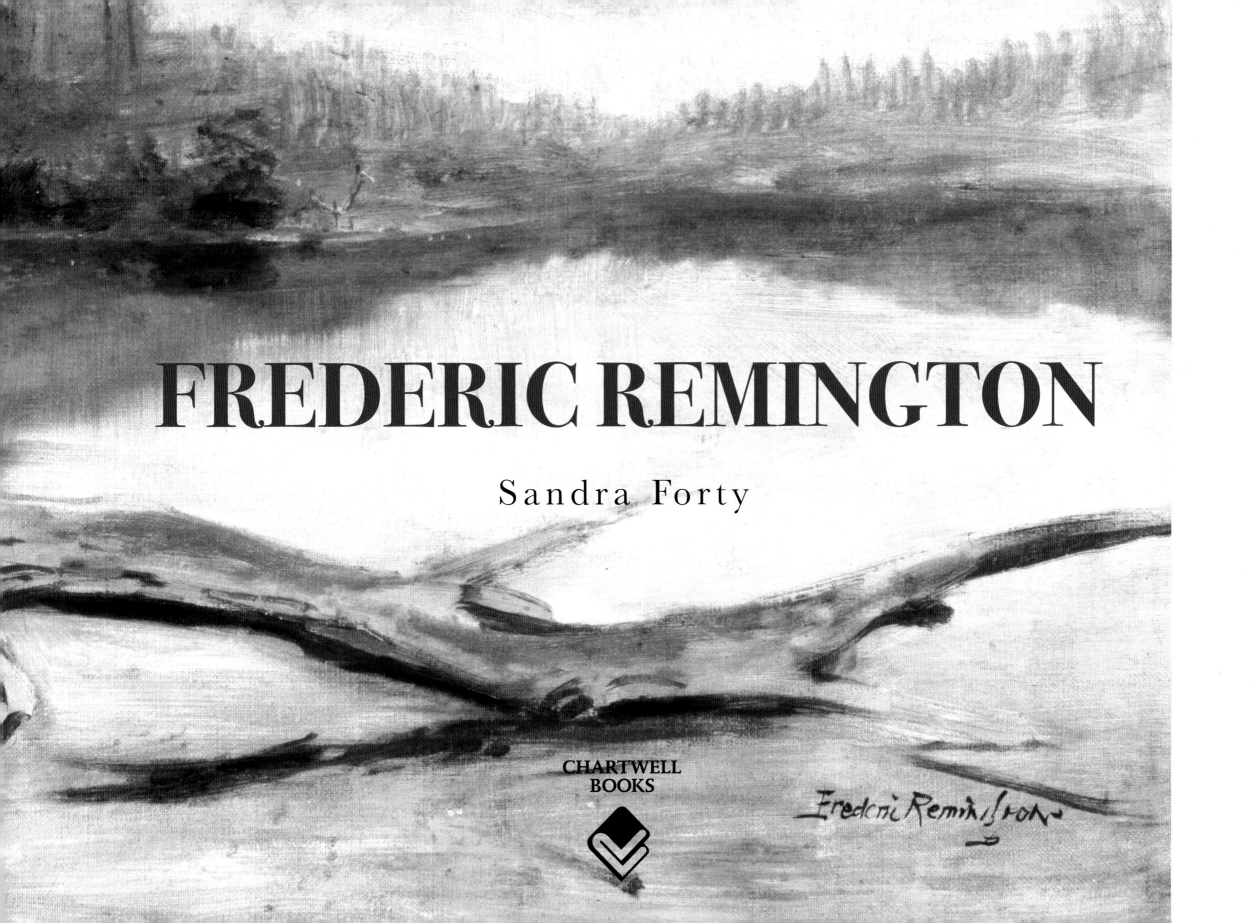

FREDERIC REMINGTON

Sandra Forty

CHARTWELL
BOOKS

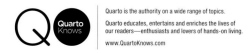

Quarto is the authority on a wide range of topics.
Quarto educates, entertains and enriches the lives of
our readers—enthusiasts and lovers of hands-on living.
www.QuartoKnows.com

This edition published in 2016 by

Chartwell Books
an imprint of Book Sales
a division of Quarto Publishing Group USA Inc.
142 West 36th Street, 4th Floor
New York, New York 10018
USA

ISBN: 978-0-7858-3464-9

Printed and bound in China

10 9 8 7 6 5 4 3 2 1

Design: Danny Gillespie

Acknowledgements
All images are credited with their captions. Thanks to Caroline Haywood at the
Art Archive and Ed Whitley at Bridgeman New York for their help with images.

PAGE ONE: *The Outlier*. Oil on canvas, 1909. *Brooklyn Museum of Art, New York, USA,
Bequest of Miss Charlotte R. Stillman/The Bridgeman Art Library*

PREVIOUS PAGES: *The Winchester*. © *Private Collection/Photo © Christie's Images/The
Bridgeman Art Library*

RIGHT: *Aiding a Comrade*. Oil on canvas c.1890. *Museum of Fine Arts, Houston, Texas,
USA/Hogg Brothers Collection, Gift of Miss Ima Hogg/The Bridgeman Art Library*

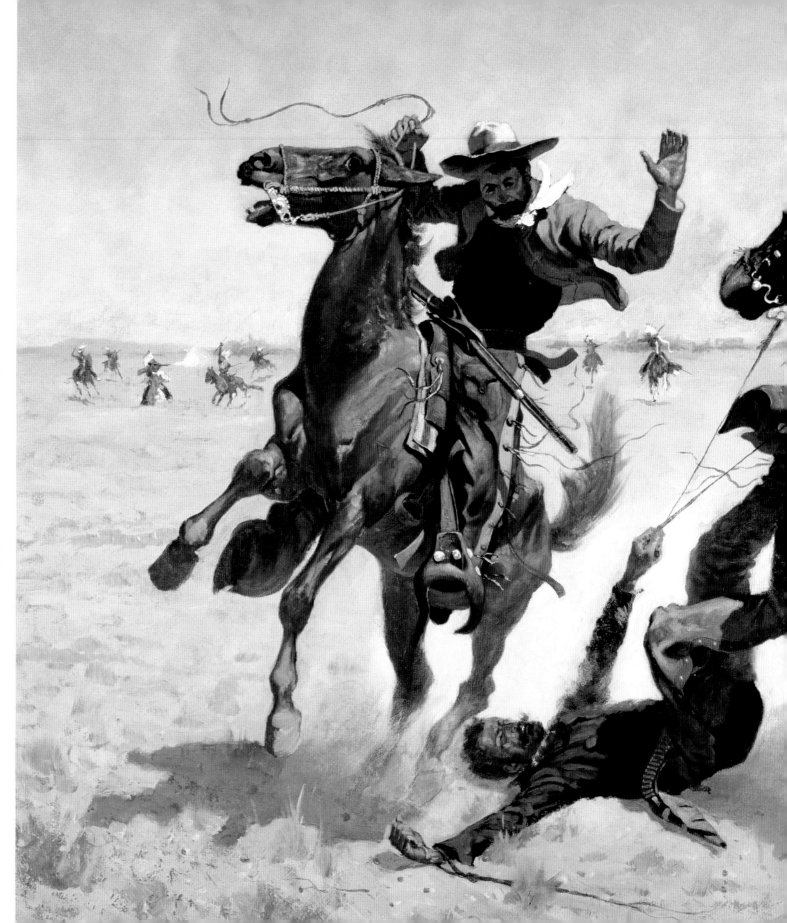

Contents

Introduction

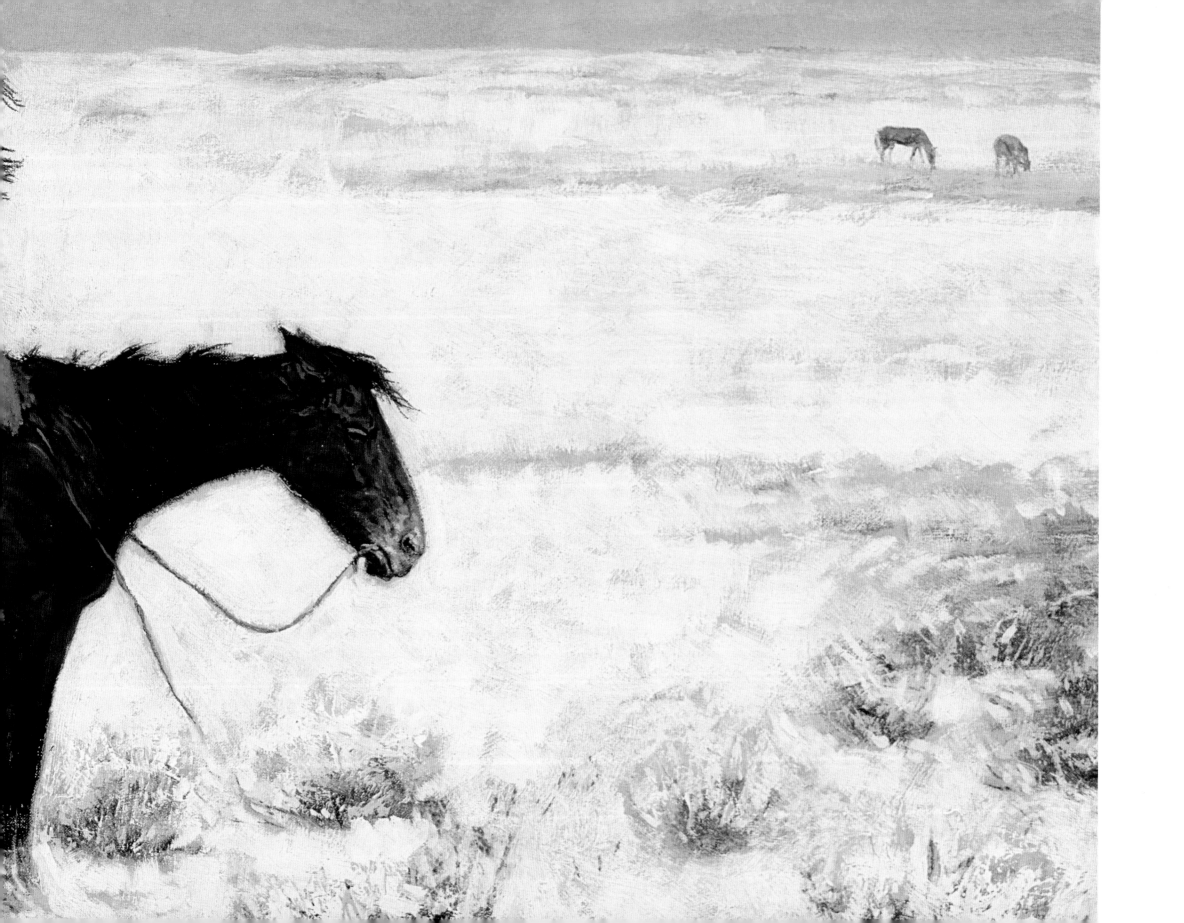

Introduction

One of the strangest stories in the history of American art is how a born and bred easterner became the defining artist of the American West, so much so that even today his interpretation of the West is recognizably reflected in popular novels, television, and movies. Without his eyewitness reports and illustrations, an accurate historic record of how the West was won and the reality of the appearance of people and places would be distinctly sparse. Another surprising fact about Remington is the huge body of work he left—not just some three thousand or so paintings and drawings, but also twenty-two bronzes, eight books, plus numerous short stories and magazine articles—all this is a working career that lasted for around twenty-three years until his life was tragically cut short at the early age of forty-eight.

Expansion into the American West had started seriously in the 1840s: Texas was annexed in 1845; the Mexican War ended in 1848 with California and much of the southwest joining the union; and then gold was found in California in 1848. Gold diggers headed west in their thousands and their followers, suppliers, and families followed soon after. At the same time the United States expanded by over a million square miles. This expansion westward was reaching its peak by the time Remington became its principal observer and recorder; the momentum and influx of people was so rapid that the heyday of the pioneer and frontiersman was quickly numbered. All his life Remington was fascinated by horses and soldiers and the stories of how the west was conquered, and it is his profound love and understanding of that way of life that gives his artworks such vitality and veracity. As luck would have it, Remington's skills and interests coincided with the relatively short period of expansion of America's westward frontier and he was one of the very few people recording and documenting the changes in both words and pictures.

Well before the end of his life, Remington was illustrating the process from memory back in his home studio, as the west was already more or less settled. Although his work romanticized the notion of the "Wild West" with its cowboys and indians, soldiers, frontiersmen, and pioneers, he was unflinching in depicting the brutal realities of such lives, and thanks to his newspaper background, his work always contains a compelling narrative from which entire scenarios can be constructed. This narrative brilliance, however, was the cause of one of Remington's greatest grievances: he wanted to be considered a real artist, not just a commercial painter as many of his contemporaries lazily labeled him. It was only toward the end of his life, in 1908, that he achieved the artistic status that he craved, and the following year the National Museum bought *Fired On* for its own collection.

Frederic Remington created literally thousands of illustrations, often *en grisaille* (in black and white oil on canvas), in gouache or ink wash. These were subsequently produced in color, particularly when as cheap color printing became possible. Many of his paintings were produced in this medium in the popular press. Indeed, some of Remington's published paintings no longer exist except in print form. He is known to have burned many paintings with which he was dissatisfied: for instance, his diary entry for February 8, 1907, relates that he burnt seventy-five paintings, and this was by no means an isolated incident. Because of his involvement with printed media, for the majority of his career Remington was regarded as no more than an illustrator and it was only toward the end of his life that he became recognized as an artist in the true sense. In 1907, no less a personage than President Theodore Roosevelt endorsed Remington's work by saying, "He is of course, one of the most typical artists we have ever had, and he has portrayed a most characteristic and yet vanished type of American life. The soldier, the cowboy and rancher, the Indian, the horses and the cattle of the plains, will live in his pictures and bronzes, I verily believe, for all time." Such a glowing tribute is by no means diminished by the fact that the two men were long-standing friends.

Early Years

Frederic Sackrider Remington was born in Canton, in rural northern New York State on October 4, 1861, into a prosperous newspaper family. He was the only child of Clara Bascomb Sackrider Remington and Seth Pierre Remington, the proprietor and founder (in 1856) of the *St. Lawrence Plaindealer*, a successful Republican newspaper. The Civil War had just started and politics and peoples were in turmoil, although the Remington family was well away from the action. His family life as quiet and settled as could be expected in the circumstances, although only two months after his birth, his father left for New York to become one of President Lincoln's 500,000 Congress-authorized three-year volunteers. He was initially given the task of recruiting local men in St. Lawrence County for Scott's 900 of the 11th New York Cavalry. In March 1862 he was promoted to captain and then made major in the 11th New York Cavalry with whom he served in battle. The unit performed creditably and was involved in slowing General Jeb Stuart's attempt to support General Lee's troops at Gettysburg.

After his distinguished service, the then Colonel Remington was able to return to his family and resume the reins of his newspaper. Remington junior's early life was near idyllic as the adored only child of indulgent parents: he held their complete attention and they provided a secure and loving home life for him. His tall, slim, and handsome father was every inch the dashing war hero while his doting, shorter, plump, and stubborn mother passed on her physique to her son. He never grew as tall as he would have liked, and in later life was prone to carrying excess weight. His father enjoyed telling dashing stories of soldiering escapades to his excitable and impressionable young son, who by all accounts took them as inspiration for mild trouble-making at school. But even at this young age he was sketching and drawing imaginative stories featuring horses and soldiers.

In 1870 the colonel was rewarded for his political support of Lincoln and the Republican party, and was given the prestigious position of U.S. Collector of Customs for the Port of Ogdensburg, New York. The new appointment required that the family move to Ogdensburg, which is in New York state but up near the Canadian border. In 1873 he sold the *Plaindealer* and the family settled permanently in Ogdensburg. Throughout this happy childhood Remington heard numerous stories of the far frontier: of how the buffalo roamed in uncountable numbers as far as the eye could see; and of how the "red man" fought for his lands against the civilizing army and pioneers. By the time he was fourteen Remington had made up his mind to go and experience the west for himself just as soon as he could.

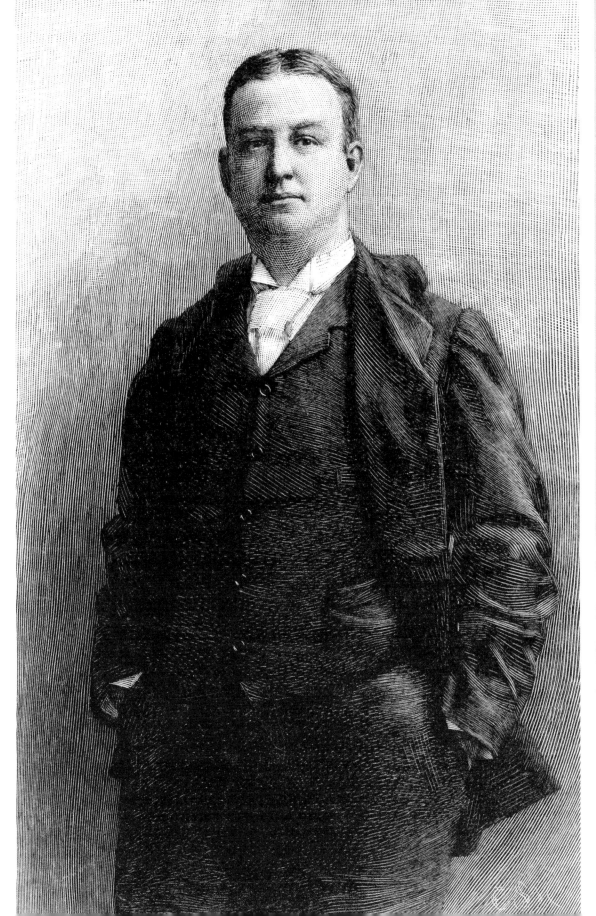

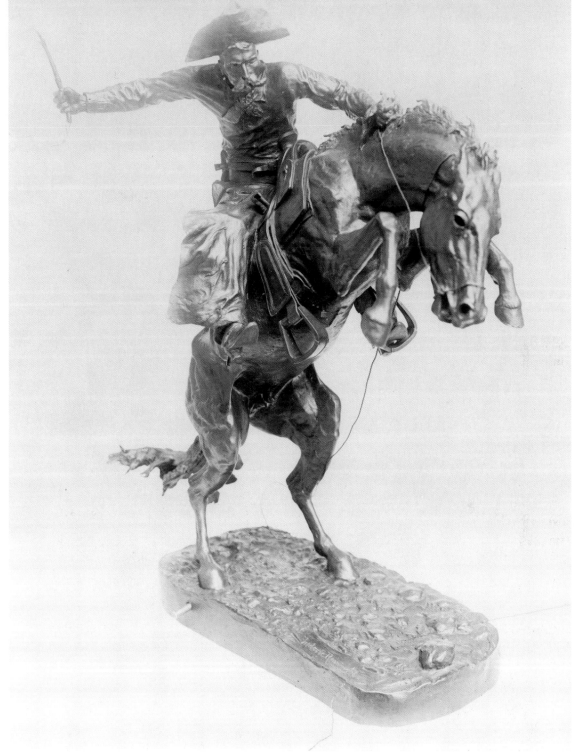

LEFT: Portrait of Frederic Sackrider Remington as illustrated in *Harper's Weekly*, 1893. *The Art Archive/Culver Pictures*

PREVIOUS PAGES: *The Herd Boy*. Oil on canvas, c.1905. © *Museum of Fine Arts, Houston, Texas, USA/Hogg Brothers Collection, Gift of Miss Ima Hogg/The Bridgeman Art Library*

ABOVE: *The Bronco Buster*, c. 1895. Remington's first and easily most commercially successful bronze. Theodore Roosevelt—a long-time enthusiast of Remington's work—had one. It was presented to him on September 15, 1898, on the occasion when his Rough Riders mustered out at Camp Wikoff on Long Island. *Library of Congress, Prints & Photographs Division, LC-USZ62-55874*

9

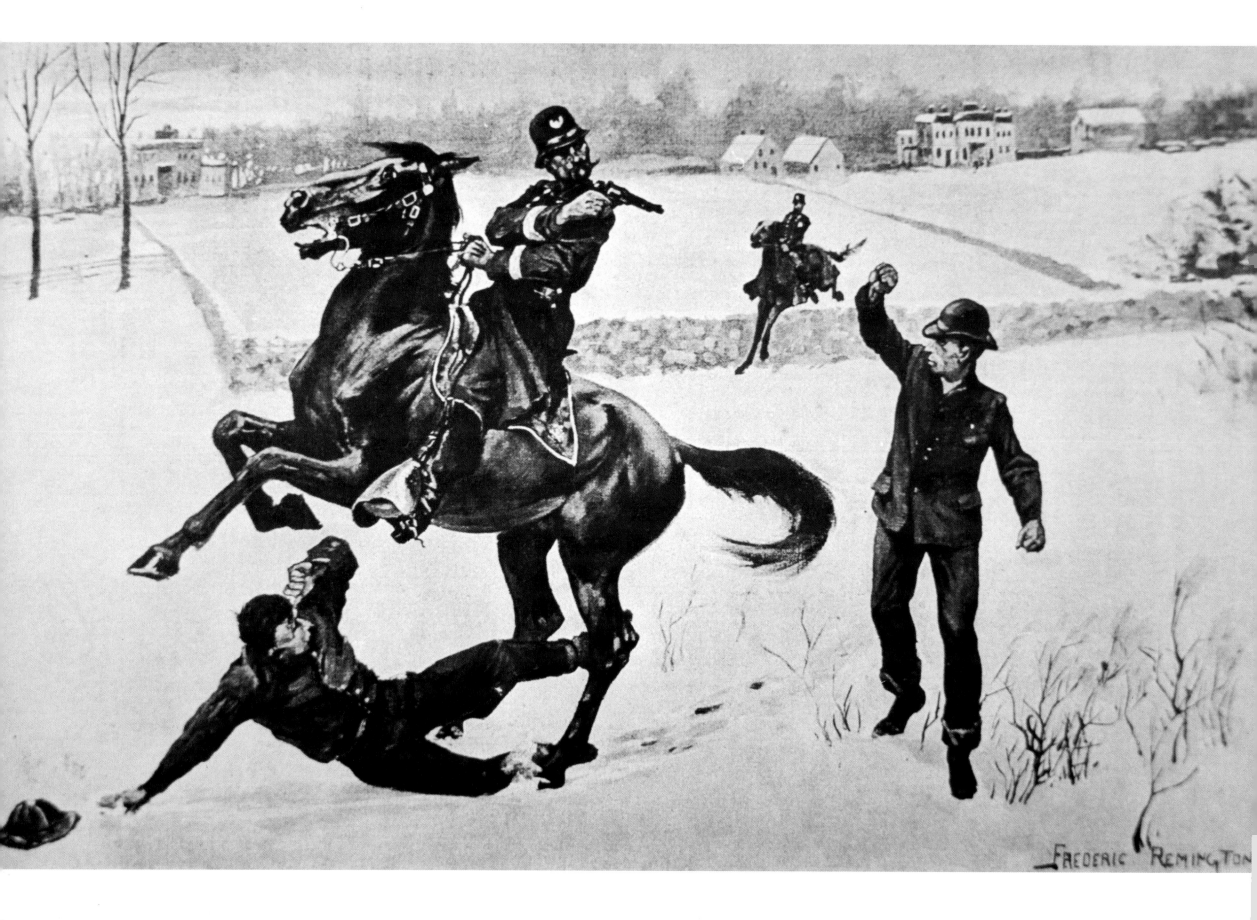

HARPER'S WEEKLY.

JOURNAL OF CIVILIZATION.

Vol. XXXIII.—No. 1686.
Copyright, 1889, by HARPER & BROTHERS.
All Rights Reserved.

NEW YORK, SATURDAY, APRIL 13, 1889.

TEN CENTS A COPY.
WITH A SUPPLEMENT.

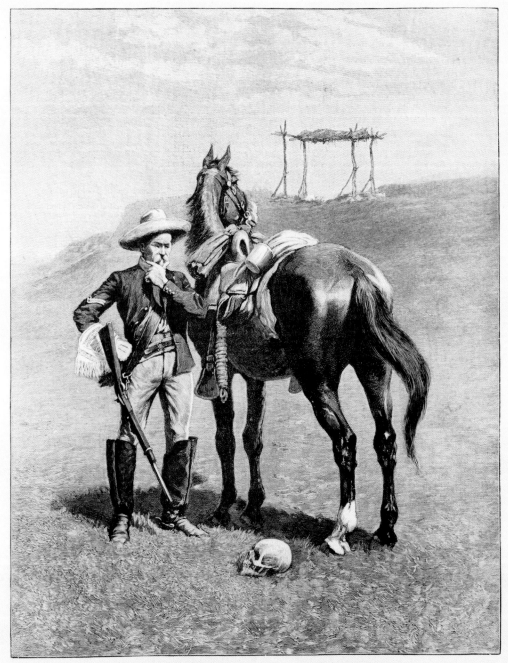

THE FRONTIER TROOPER'S THANATOPSIS.—FROM THE PAINTING BY FREDERIC REMINGTON.—[SEE PAGE 282.]

Raised on heroic stories of Civil War derring do from his father, his uncles, and his father's army friends, it was perhaps inevitable that the lively and adventurous young Remington became a skilled horse-rider, a huntsman and an enthusiastic fisherman. His father's love of horses was so great that he started a small business buying and training them, an enterprise that his son enthusiastically followed. In the fall of 1875 Remington's father enrolled him at the Vermont Episcopal Institute in Burlington, Vermont, a prestigious but austere military school, where he hoped his son would learn a love for the military that would lead to a distinguished army career. In reality military life proved too harsh and the academic studies too hard, while the cadets' rations proved too sparse for young Remington, although he still sketched his fellow cadets and surroundings. He soon moved to the less disciplinarian Highland Military Academy in Worcester, Massachusetts but continued with his sketches (many of them along the margins of his school books) and copious correspondence home.

One of the seminal events of American history happened in 1876 and had an equally important effect on the imagination of fifteen-year-old Frederic Remington: the Battle of Little Bighorn and its aftermath. The annihilation of General Custer's troops and the subsequent bloody reprisals against the Indians was major news across the land, and Remington made one of his earliest surviving sketches of the encounter while at the Academy. During his two-year stay he only reached the rank of acting corporal and it was obvious that his talents lay elsewhere, most notably with his sketching which was showed real promise. Remington was torn between choosing a career in journalism—like his father—and following his talent as an artist. After much agonizing he chose the latter and enrolled as one of the first pupils at the Yale College School of Art in New Haven for the academic year 1878–79.

Art school proved a bore as he had to make life drawings from static plaster casts and was not allowed to explore movement and action as he wanted. College football was much more exciting and in his second year Remington was picked as a varsity rusher for one of the Yale teams. While there he made several paintings of the football, one of which *Foot-Ball—A Collision at the Ropes* still hangs in the Athletic Director's office. During his time at Yale his father had fallen ill with tuberculosis and his condition became terminal over the Christmas 1880 vacation. Remington dropped out of school and was home when his father died on February 18, 1880. His mother's brothers, uncles Horace and Robert, and his father's brother Lamartine (Uncle Mart) now took a hand in his upbringing.

The young Remington needed to earn a living, so his paternal uncle—who was also in the newspaper business—found him work record keeping for the State of Albany. The work was tedious, meticulous, and repetitive, and Remington hated it, but during his time off he met and fell in love with Eva Caten, the young woman who was to become his wife five years later. At the time Eva, who was from Gloversville, New York, was lodging in Caton before attending the St. Lawrence University there. The pair almost certainly met in early fall 1879 at the St. Lawrence County Fair when one of Seth Remington's horses was racing. They fell in love and in August 1880 he asked her father for

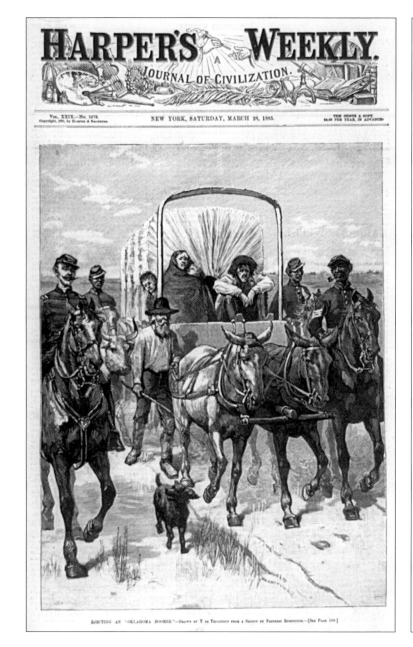

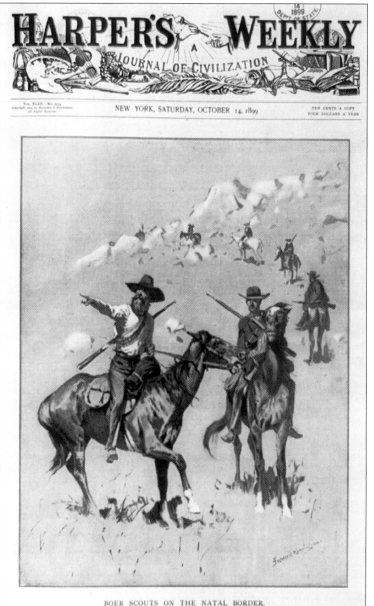

ABOVE: *Harper's Weekly* March 28, 1885. *Ejecting an "Oklahoma boomer."* Drawn by T. de Thulstrup from a sketch by Remington. *Library of Congress, Prints & Photographs Division, LC-USZ62-97956*

ABOVE RIGHT: *Harper's Weekly*, October 14, 1899. *Boer scouts on the Natal border.* Remington was a regular contributor to *Harper's Weekly* from the mid-1880s until they stopped using him in 1900 when massive cutbacks on costs were forced on the magazine after it ran into financial trouble. *Library of Congress, Prints & Photographs Division, LC-USZ62-98519*

her hand in marriage, but he refused because Remington had no obvious means of providing a comfortable life for his daughter. Perhaps inevitably, this made Remington even more disenchanted with his lot and strengthened his desire to travel westward. His work suffered and his family worried.

Finally, his uncles agreed to his plea to travel and in summer 1881 allowed him to discover what the Wild West and ranch life was really like, in the vain hope that the harsh reality of frontier life would knock some sense into him. Accordingly he was sent to Wyoming and Montana Territory at the tender age of 19 to investigate and live his dreams of the wild west to the full. Coincidentally this was one of the great periods of change in Montana. It was still wild country—Montana did not join the Union until 1889—buffalo still roamed the land in their thousands, although they were being systematically wiped out by ruthless hunters; the local Native Americans were hostile and untamed; and the age of the vast cattle ranch was only just beginning. This was everything and more than Remington expected and wanted—he even visited the Little Bighorn battlefield—and this was the only period in his life when he actually lived in the west. He could see how rapidly things were changing across the land and how fast "civilization" was settling across the landscape, and he credited an old wagon freighter with whom he chatted around a campfire one night, for inspiring him with the notion of recording the fast disappearing west before it had disappeared altogether.

In October 1882 Remington, at the age of twenty-one years, inherited a substantial inheritance—a little over $9,000—from his father and the following year after, only a few months ranching, bought himself a 160-acre sheep ranch near Peabody, Kansas, next to the ranch of an old Yale friend, Robert Camp. There he became a "holiday sheepman," meaning he left most of the running and the heavy work to hired hands while he journeyed out and about sketching to his heart's content. Cowboys were among his favorite subjects and Remington was able to closely observe their working methods and came to a real understanding of their ways, especially during the "long drives" when the cattle were driven to the northern railheads from their ranches in far away Texas.

In his free time he sketched the people and animals he saw and from Wyoming he sent *Harper's Weekly* a small sketch drawn on wrapping paper. They accepted it and after being redrawn by A. W. Rogers it was published as *Cow-boys of Arizona: Roused by a Scout*, in the February 25, 1882, issue. This was his first paid artistic work.

Unlike his rangy cowboys and elegant soldiers and indians, Frederic Remington presented a less heroic figure: stocky (he only reached 5 foot 9 inches in his stockinged feet), sandy-haired, and on the plump side—but on the positive side he was a more than competent horseman. It soon became obvious even to him that ranching was not his metier, and besides, wool prices were not good. After some ten months he sold the ranch in late spring 1884, and in the process was lucky to recoup most of his investment as ranch and stock prices crashed soon after. Free now to travel as he wished, he went to the southwest where he journeyed into Indian Territory and saw Comanches and Cheyennes, then he moved on to see the Apaches in Arizona Territory. Before

returning east he journeyed south to Mexico where he started his (later very extensive) collection of Native American material culture with beaded bags and jewelry, buckskins, moccasins, and silver horse decorations.

The adventure over, Remington moved back to Canton—but life back east soon palled, and by February 1884 he had returned west, this time to Kansas City, Missouri where he tried his hand, rather unsuccessfully, at being an iron broker: he soon gave that up that profession. Remington invested what remained of his inheritance in a silent partnership in a Kansas City business, the Bishop and Christie Saloon, and, in August that same year, hearing that Eva Caten was still unmarried, he determined to try his luck again. This time he was accepted and they married in Gloversville on October 1, 1884, and immediately left for Kansas City: he neglected to tell her about his interests in the saloon. All this time Remington was compulsively sketching and painting the people and animals he saw around him, mostly in graphic black and white drawings. His local art supplier, Mr Finlay, asked (or maybe was asked) if he could try selling some of Remington's works: they started to sell. At much the same time Remington himself managed to sell a second illustration to *Harper's Weekly*. Redrawn by Thure de Thulstrup, it was titled *Ejecting an Oklahoma Boomer* and appeared in the March 28, 1885, issue—a "boomer" was the local term for a settler who tried to take unestablished land.

When, by chance, Eva found out about his involvement in the saloon she was not pleased; she did not like Kansas City anyway so she returned home to her parents in Gloversville. The problem was solved when Remington lost his investment in the saloon altogether. Money, or more precisely lack of money, became such a problem, that in August 1885 Remington had to ride out of town altogether. He headed southwest to Arizona Territory specifically looking for Apaches and their heroic leader Geronimo. Sketching all the way he went to the San Carlos Reservation, which had been allocated for the Apaches, and then on through to Texas where he joined up with a Texas cowboy and together they moved on up into Indian Territory and Comanche country. At summer's end Remington returned to Kansas City, totally broke but with a portfolio bulging with sketches that he was hoping to sell in New York. Over this relatively brief time he had laid the foundations for his artistic career. He had confirmed to himself and to his family that his future lay in his art. He had studied, understood, and loved the people and lifestyles of the western frontier, and he had as well as his portfolio collections of artifacts which he could use to add further authenticity to his work. Professionally he was ready to take on the art world, and personally he wanted a reconciliation with Eva, which was quickly achieved once he was back in the city in the fall of 1884.

On borrowed money Remington hired a shared apartment at 165 Ross Street, Brooklyn from where he could hawk his drawings round the local publishing houses. Luck was on his side as popular interest in the west had never been greater as the general public avidly followed stories of the frontiersmen and the attempts of the army to control, corral, and "civilize" the Native American tribes into defined areas and reservations. Stories of the numerous clashes between the Indians and the U.S. Cavalry filled the papers

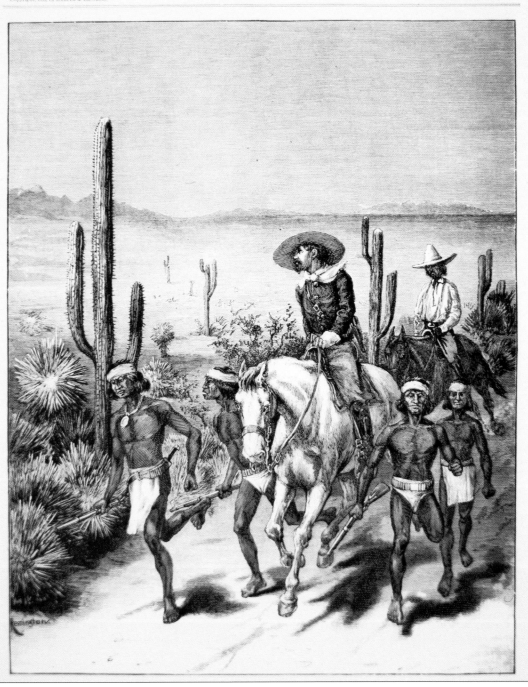

LEFT: *Apache Scouts lead army patrol on pursuit of Geronimo* from *Harper's Weekly* January 9, 1886. The previous year Remington had ridden out to look for the Apache leader but without success. However, the sketches he subsequently sold led his many fans to believe that he had actually met the great man: he never even saw him. © *Private Collection/ Peter Newark Western Americana/The Bridgeman Art Library*

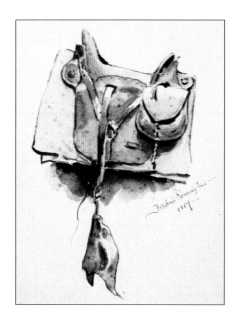

and especially the dramatic wild goose chase that Geronimo was leading the soldiers, who tried to capture him and his Chiricahua Apaches. The Apache were trying to protect their tribal lands from the encroachment of the United States in the area that subsequently became New Mexico.

The latter years of the nineteenth century were great times for newspapers and magazines. In the days before radio and television, they were not just the main source of news and comment, but also the main forum for politics—it was a time of bitter rivalry between Republicans and Democrats with plenty of quarrels and scandals to keep the public entertained and enthralled. The periodicals were desperate for informative and entertaining copy and pictures with which to fill their pages and to capture new readers. New advertising techniques were filling the pages and as circulation increased, so the price of the papers dropped and the competition increased. Alongside political intrigue, the hottest stories were of those about the west.

J. Henry Harper of *Harper's Weekly* immediately recognized Remington's commercial value with his realistic and informed work and bought two illustrations, *The Apache War: Indian Scouts on Geronimo's Trail* (published full page on the cover, January 9, 1886), and *The Apaches are Coming* (published January 30, 1886). That spring *Harper's* published a few more of his sketches: at last he was earning a little money, but work was erratic and irregular so to fill the time he enrolled himself for the spring term at the Art Students League of New York, starting March 1 that year. He finished in May but while there made a number of friends that he kept for life. He left because *Harper's Weekly* urgently needed a reporter to describe the Indian wars to their readers, and in particular, the exciting encounters in Arizona between General Nelson A. Miles (1839–1935) and Geronimo (1829–1909).

In June 1886 Remington was commissioned as a professional illustrator to journey to the southwest desert where the army was hunting Geronimo and to go to Arizona to illustrate the lives and times of the soldiers themselves. While there he took many photographs (a relatively new technology) of the people, animals, and landscapes from which to work up his illustrations when back in the studio. The first of many of his new commissions, *Signalling the Main Command* was published on July 17. In fact, much to his disappointment, Remington never encountered the great Geronimo, but he did come across many other Native Americans and was able to sketch them. Instead he made friends with General Nelson Miles, and also with Lt. Powhatan H. Clarke from whom he learned a considerable amount about how the army went about its business. For the next few years until the lieutenant's tragic death in a drowning accident Clarke sent back east copious notes and photographs and first-hand information about the Indian fighting: he was Remington's primary source for the period. In return Remington offered his advice and claimed to put in a good word for him with General Miles and with newspaper editors back in New York—Clarke was an aspiring writer.

This was the open-air, exciting life Remington craved, and he returned to New York with numerous pictures that he was determined to sell. He worked hard at his illustrations, putting in long hours at his studio every day, making use of his sketches, numerous collected artifacts, and photographs to add detailed authenticity to his work. Additionally he possessed a remarkable memory for detail and an almost photographic visual memory which served him well throughout his life.

By fall he was taking his work around the various publishers and was pleased to find it well received. For the November issue of *St. Nicholas* magazine he sold illustrations for an article by Frances Baylor; and his old Yale friend Poultney Bigelow, now editor of *Outing Magazine*, commissioned him to do some sketches to illustrate a series of five articles about Geronimo, starting with the first published in December 1886. At the same time *Harper's Weekly* was regularly using his work as well. All this meant that Frederic Remington could now consider himself a well-established commercial illustrator and at last he was earning good money: in this his first year as a professional illustrator he earned around $1,200—an extremely good sum in those days.

In these early days as an illustrator Remington was inspired and influenced by the French military illustrators whose work he greatly admired and tried to emulate. By illustrating the west in graphic black and white drawings Remington took the atmosphere and excitement of the farthest reaches of America into the homes of easterners via the pages of *Harper's Weekly*. Remington's particular skills lay in sharp observation, attention to detail, and almost uniquely for his era, a real feel for motion and speed, as well as a consummate command of his medium. This was particularly evident with his depiction of horses and the way they moved. He was able to make them completely realistic in the way they flexed their muscles and moved their limbs; before Remington, horses invariably looked stilted and unconvincing. Remington was so enthralled by life in the west that he filled his illustrations with copious details and imagery. He realized that many, if not most, of his audience would fail to understand these references, so in 1885 he started to provide explanatory notes with his illustrations to explain to the staffers back at *Harper's* exactly what was happening in his pictures. These notes proved so helpful that they were rewritten and fleshed out for publication until the editors, suspecting that he had the gift for writing as well, asked him to write proper commentaries to accompany his illustrations. Initially unsure about this, but perhaps thanks to his newspaper background, Remington surprised himself and found that not only was he a natural writer, but he also enjoyed the work as well, delivering clear, direct prose that interested and excited the readers of *Harper's Weekly*.

The following year for the first time Remington attempted to break out of his role as a mere illustrator by showing his paintings in major art exhibitions; he showed a small watercolor at the 20th Annual Exhibition of the American Water-Color Society and another at the 62nd Annual Exhibition of the National Academy of Design. Neither won prizes, but at least they were accepted for exhibition, a distinct first step in the right direction. Between 1887 and 1899 he went on to show thirteen paintings in the academy exhibitions.

In April 1887 Remington accepted a tempting commission from *Harper's Weekly* to sketch the Canadian northwest. Once there he made his usual copious quantities of illustrations, this time mainly of Canadian Mounties and the Native Americans—mainly Blackfoot and Crow. The pictures from this

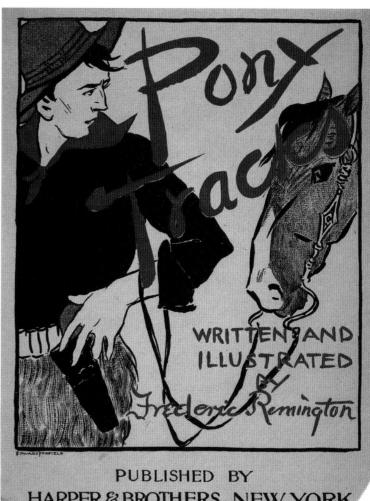

trip appeared in the paper through most of the year and on into the beginning of 1888. This was only the first of many regular trips out to the wilder lands of the west for Remington. Once there he invariably sketched to his heart's content all the various peoples and animals he found, but his favorite subjects remained the same—soldiers, Native Americans, and especially, horses. The trips could be quite physically demanding, with plenty of time in the saddle and camping out in the open air, something Remington loved. He had always been a good horseman and remained so despite his increasing bulk and girth. But Eva rarely accompanied him, preferring to stay in the comfort of New York. She suffered from a number of medical complaints, in particular ovaritis, a painful inflammation of the ovaries that kept her from joining him.

Frederic Remington was one of the first artists to use the new medium of photography as an aid for his illustrations. He regularly took photographs of people and places to use as references when back home in his studio, and some commentators also speculate that he even posed some scenes for later painting. Additionally he would buy photographs from soldiers to supplement his own collections of photos, sketches, and memories. His personal collection included hundreds of books on a wide range of western subjects, plus maps and government surveys and reports to Congress, as well as numerous military books. Alongside these he possessed many Indian artifacts including pottery, blankets, beaded objects, and knives. He also had a similar assembly of cowboy artifacts such as guns, hats, and spurs; he even had a set of buckskins that had once belonged to Calamity Jane. Most of his books and photographs are now in the Frederic Remington Art Museum in Ogdensburg, New York, while most of the artifacts are in the Whitney Gallery of Western Art at the Buffalo Bill Historical Center in Cody, Wyoming.

Initially unknown to him Remington had an admirer in Theodore Roosevelt: in fact the pair were born only three years apart and shared many similarities. Remington attended Yale while Roosevelt—a New Yorker—went to Harvard, before both journeyed west to see the far frontier for themselves, a seminal experience for both men. Both of them loved the lifestyle so much that they attempted to live it: Roosevelt bought and ran a cattle ranch and Remington bought (although failed to run very well) a sheep ranch. In time they became lifelong friends, corresponding regularly up until Remington's death. Theodore Roosevelt had seen and admired Remington's illustrations in *Harper's* and *Outing Magazine* and wanted him to illustrate a series of articles entitled *Ranch Life and the Hunting Trail* that was to be serialized in *The Century Illustrated Monthly Magazine* in six articles appearing between February and October 1888, before being published as a book. Roosevelt's writings cover the period 1884 to 1886 and describe ranch life on the Little Missouri in the Badlands of Dakota and all the peoples and excitements of everyday events there. At the time Roosevelt was starting his return to politics after a period spent on his ranch, where he withdrew while he mourned the loss of his first wife. Remington was commissioned in fall 1887 for the work. The book was a best seller and Roosevelt was acclaimed as the ultimate commentator on, and Remington as the supreme illustrator of, western life. Together they produced a book that immediately became the benchmark for life in the West.

Remington was now a nationally recognized artist and in 1887 his income doubled—he made the most of this by moving to a smart new apartment in Manhattan from where he could ride in Central Park whenever he wanted, or visit one of his many haunts such as the Players Club where he would meet up with his friends, most of them fellow writers and artists or people involved in show business and the media in general. From about this time onwards Remington made at least one extended visit a year to the west— occasionally Canada or Mexico—returning with armfuls of sketches and ideas. Most of these trips were now financed by the various magazines he worked for and he would arrive with special letters of introduction which would get him straight to the heart of the action. Back home his latest illustrations were eagerly awaited by his ever-growing public, whose hunger for his first-hand comments and observations helped to inform and picture the mysteries of the far western lands. Habitually, he would make numerous sketches of both landscapes and figures and then work on the composition and complete the picture once he was back home in his studio.

Remington entered his large oil painting *Return of a Blackfoot War Party* into the 63rd Annual Exhibition of the National Academy and won both the prestigious Hallgarten and Clarke Prizes. The exhibition was open to contemporary artists who had completed their work within the previous five years. It was an important step in Remington's progress towards a career in fine art, but the vast bulk of his work was still illustrating and he was fretting to get himself noticed as an artist—the recognition he most craved. However demand for his illustrations was constant and he was no longer struggling to sell them; instead, he was in the pleasant position of having offers of work coming to him. One particularly attractive offer in April 1888 was to journey to Indian Territory for *Century* magazine to sketch the "Wild Tribes" who lived there and to write an accompanying commentary. The writing appealed to him less and he was initially unsure of his ability with words but he proved more than adequate for the task. Remington's particular interest in the commission was that it gave him access to the "Black Buffaloes," a group of black cavalrymen in Arizona Territory whose name was given to them by Native Americans who likened their curly black hair to that of the buffalo. As part of the expedition Remington was taken on a two-week scouting trip by a white lieutenant who tried to tire him out and make him give up by taking him on an exhausting ride. He misjudged his man: Remington absolutely loved the experience despite being overweight and not having ridden hard for over a year. The following tour of the "Wild Tribes" was not nearly so exciting for him. The articles themselves appeared in January, April, July, and August 1889.

Once back in New York Remington had more work than he could easily cope with—not just illustrations, but also prints, a few paintings, and his new outlet, writing, as well as a studio bursting with western treasures. His work was appearing regularly in *Harper's Weekly*, *Outing*, *Century*, and *Youth's Companion* and other occasional commissions came from *St. Nicholas Magazine*, *Harper's Bazaar*, *Harper's Young People*, and even in the *London Graphic*. His work was in great demand and he had made himself a wealthy man. With his new prosperity Remington and Eva moved home from Brooklyn to a new apartment in

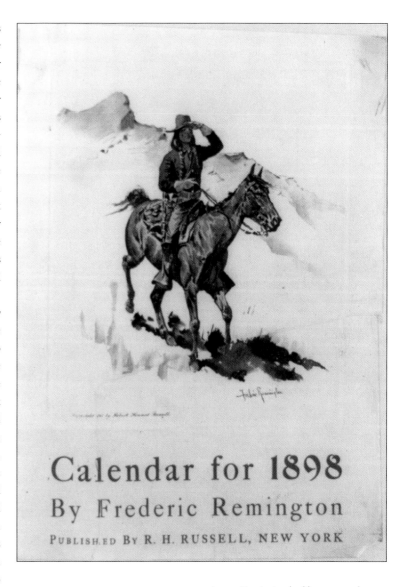

Calendar for 1898
By Frederic Remington
PUBLISHED BY R. H. RUSSELL, NEW YORK

ABOVE: Remington had become such a popular and sought after illustrator that the New York publisher R. H. Russell produced a calendar of his works for the year 1898. *Library of Congress, Prints & Photographs Division, LC-USZ62-98458*

BELOW: *Miss Summerhayes*, September 22, pen, ink, and watercolor on paper. Martha and Major Jack Summerhayes were friends and correspondents of Remington's. Frederic advised Martha on her diary writing which was published as *Vanished Arizona: Recollections of My Army Life*, 1908. The Art Archive/Gift of Fred A. Rosenstock/Buffalo Bill Historical Center, Cody, Wyoming/50.83

RIGHT: *Buffalo Bill in the limelight*, c. 1899, an illustration for *Last of the Great Scouts*, a biography written by Helen Cody Wetmore (Cody's sister). As a friend of Cody's, Remington often visited his exhibitions to sketch western subjects and even saw Cody while he was in London touring Buffalo Bill Cody's Wild West Show. *The Art Archive/Gift of the Coe Foundation, H.P. Skoglund, Ernest Goppert Sr and John S. Bugas/Buffalo Bill Historical Center, Cody, Wyoming/23.71*

Manhattan in the Marlborough House at 360 West 58th Street. However they did not stay long and by the end of 1888 had relocated again, this time to a house with a studio on Mott Avenue in upper New York City, next door to his old friend from the Art Student's League of New York, Edward Kemble.

As part of his ongoing campaign to become an accepted "artist" Remington, early in the year submitted a large oil painting entitled *Last Lull in the Fight* to the American jury section at the 1889 Paris International Exhibition. That July he was informed that it had won second prize. While waiting to hear from France he took a commission from *Harper's Weekly* to go to Mexico to illustrate a series of articles by Thomas Allibone Janvier, an American travel writer, storyteller, and historian. Their collaboration, *Aztec Treasure-House, a romance of contemporaneous antiquity*, subsequently appeared between December 1889 and April 1890. Remington, however, was not interested in the Aztec ruins he was contracted to sketch, and instead wrote and illustrated a piece on the Mexican Army. For this he paid individual soldiers to pose while he sketched them. The pair worked together again for an article on *The Mexican Army* for the November 1889 edition of *Harper's Monthly*. On his return from Mexico, Remington and Eva returned to Canton for a time to relax and catch up with family and friends. Between socializing Remington started working on a particularly large commission for the educational publishers Houghton Mifflin, that of providing the pictures for the first illustrated edition of Henry Longfellow's hugely popular epic poem, *Song of Hiawatha*, originally published in 1855. This was a huge undertaking: he had to produce 379 black and white pen and ink sketches to sit in the margins and 22 color paintings each to fit a full page. For suitable inspiration he went to Cranberry Lake where he did the entire project while ostensibly vacationing through summer 1889.

Cranberry Lake sits on the western slopes of the Adirondacks at the edge of Adirondack Park and was one of his favorite spots . He returned each summer for years (until he bought his island summer retreat). He and Eva would journey there by train from New York via Caton, where they would visit friends and family before traveling on for sixteen hours by wagon to get to Cranberry Lake at the southern tip of St Lawrence County. Once there he would set his easel up at the shore side, sketch from the stern of a skiff, or take photographs of the surroundings. In between working, he enjoyed fishing and hunting as well as the social side of the vacation that included eating, drinking, and talking with his many and various friends, many of whom he would persuade to pose for him. Sometimes the Adirondacks provided material for his writing as well: one such event was a canoe trip he made with a companion up the Oswegatchie River from Cranberry Lake to the mouth of the St. Lawrence River in July and August 1892 . The story was called *Black Water and Shallows* and appeared in *Harper's Monthly* for August 1893.

Remington's second important painting of 1889 was *A Dash for Timber*, commissioned by Edmund Cogswell Converse (1849–1921), a wealthy inventor, industrialist, and philanthropist. This important work confirmed Remington's now impregnable status as a painter of worth and talent and from then on he was able to earn a very substantial income—so much so that he was

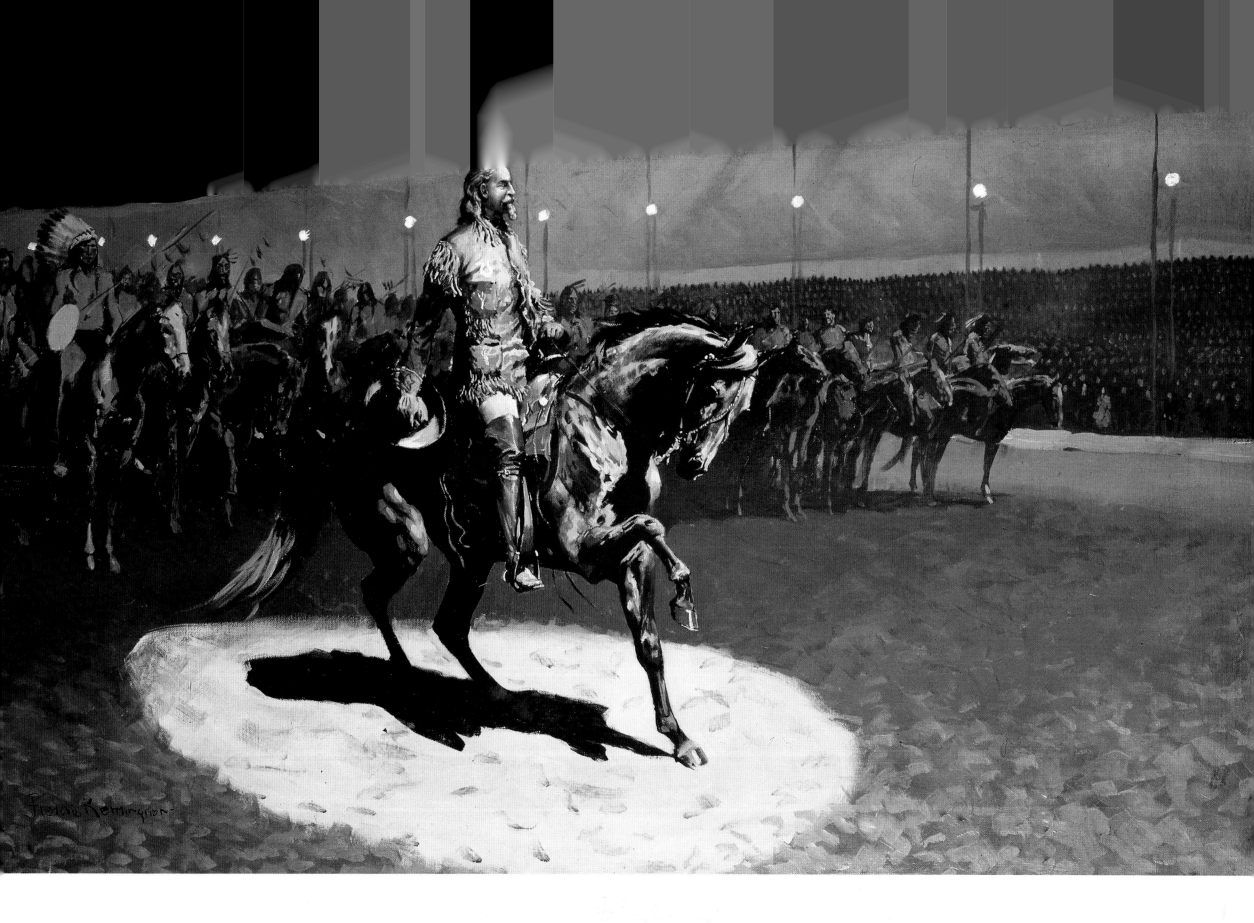

able to afford to commission "Coseyo" a large house on a three-acre lot in New Rochelle, Westchester County, New York into which he and Eva moved that year; they later renamed the house "Endion," meaning "the place where I live" in one of the Native American languages. Remington would brag that he could get to Times Square with two horses in just 3o minutes. In December 1889 he was commissioned along with his long-time friend and popular travel writer, Julian Ralph, to journey to Canada for *Harper's Monthly*; their work appeared in October the following year entitled *Antoine's Moose Yard*.

Frederic Remington was now known simply as "the Western artist" famous nation-wide for his realistic pictures of cowboys, soldiers, horses, buffalo, and Native Americans. His work had all the authenticity of someone who had actually been there, spoken to the people, and done that, it resonated with the life and energy of the still largely unknown (to the general public) Western lands of America. Nevertheless when an irresistible invitation was offered to him in January 1890 by General Nelson A. Miles (who he had met out West in 1886), he had to accept. This was the chance to tour California as a guest of the Army, and for once, Eva came along as well. *Harper's Monthly* also seized the opportunity to extend this trip by sending him and Julian Ralph up to British Columbia to do a series of illustrated articles on western Canada, these appeared throughout 1891 and 1892 and then combined in to a single book (along with some other Ralph-penned Canadian essays) published as *On Canada's Frontier*. In some of these articles Ralph also wrote about his illustrious companion, all of which added to Remington's fame.

In 1890 Remington wrote the definitive reports on the Sioux outbreak at Wounded Knee. By now he had provided Americans with their picture of what the Wild West looked like and how people lived there; his work still provides the definitive backdrop for everyone's idea of what frontier country looked like. A critic declared, "Eastern people have formed their conceptions of what Far Western life is like more from what they have seen in Mr. Remington's pictures than from any other source." The latest Indian troubles had started in 1890 with unrest in the reservations in South Dakota between the Indians and the government agents. The trouble centered on the Pine Ridge Indian Reservation—became known as the Ghost Dance movement and proved to be the last uprising of the Sioux, led by Sitting Bull (c.1831–1890). By now Remington's friend General Miles had been promoted to major general in command of the Division of the Missouri which included the Pine Ridge Reservation and the former hunting grounds of the Sioux. The general wanted to see for himself the Indian situation and to help publicize the government's position, invited Remington to accompany him when he journeyed there in October. Remington produced two illuminating articles from the excursion, both of which appeared in December issues of *Harper's Weekly* in 1890: *Chasing a Major General* and *Indians as Irregular Cavalry*. Remarkably, Remington's character sketches of individual soldiers were so closely observed that an onlooker would have been able to recognize them if they were to meet.

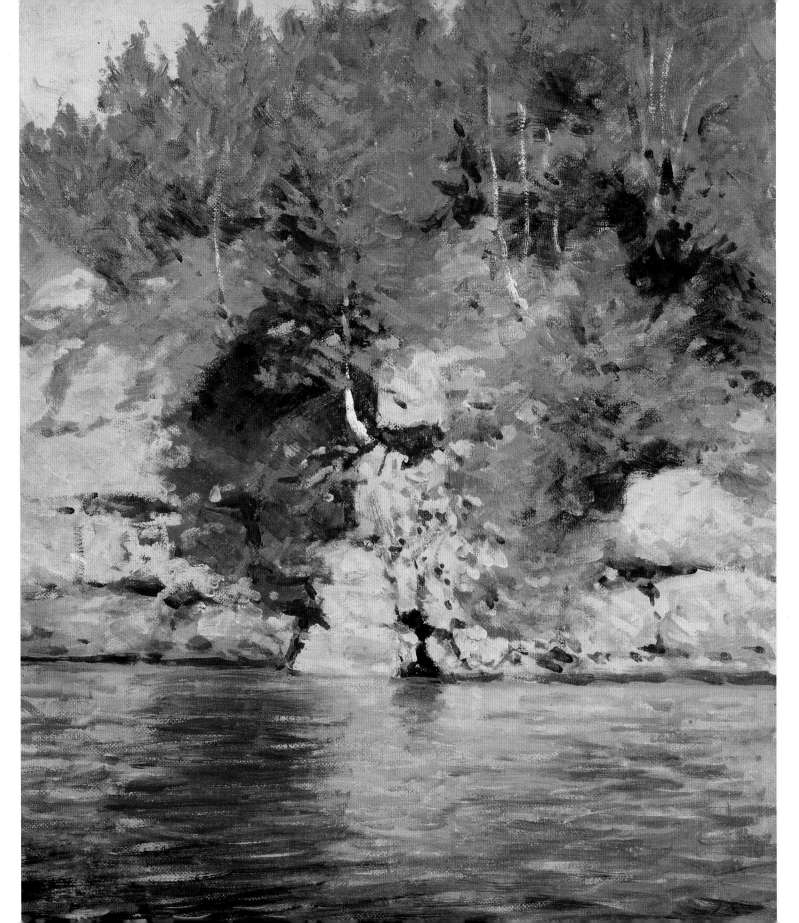

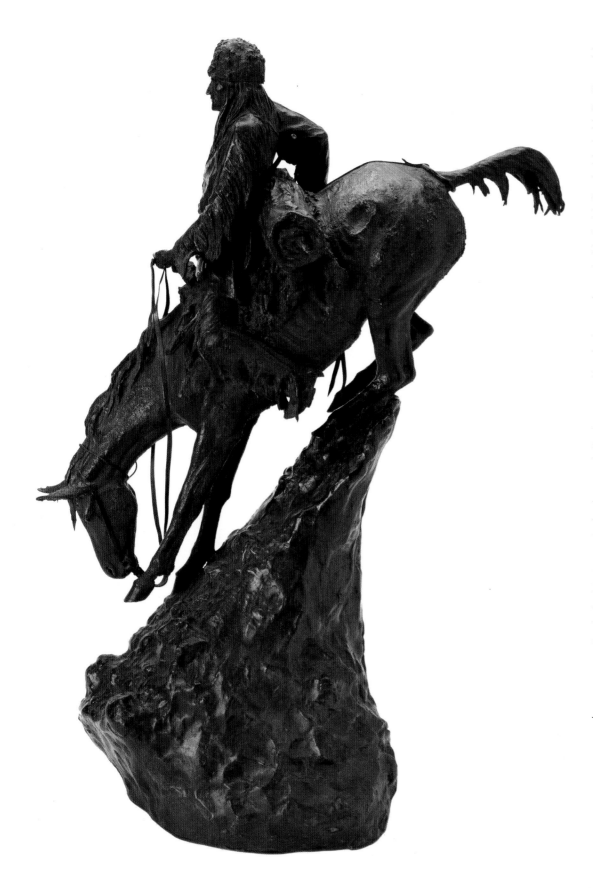

Despite President Harrison's instruction to avoid hostilities with the Indians, the situation did not calm down but rather escalated on December 15, 1890, when a police detail sent to arrest the Sioux leader Sitting Bull at the Standing Rock Agency in South Dakota managed to get involved in a fire fight and shot him in the side of the head and killed him instead. The ensuing Indian uprising became instant news and Remington immediately got *Harper's* to assign him to cover the breaking story. He rapidly moved up to South Dakota where he joined Lieutenant W.E. Casey and his Cheyenne scouts as they went out on mission; however they found no action, so Remington attached himself to an interpreter called H.C.Thompson who was going to the Pine Ridge Agency along with some Indian scouts that included Red Bear. At one point the latter even saved Remington's life when they encountered some hostile Sioux, once back in safe lands Remington sent Red Bear a rifle to say thank-you.

Although he was in the area Remington missed the massacre at Wounded Knee (December 29, 1890), when the Seventh Cavalry slaughtered 146 men, women, and children at a camp of Lakota Sioux. Then, while on his train journey home on January 5, Remington heard that Lieutenant Casey had been shot dead by the Sioux. Remington's articles about the uprising appeared in *Harper's Weekly* as *The Sioux Outbreak in South Dakota*, *Lt. Casey's Last Scout*, and *The Sioux War: Final Review of Gen. Miles's Army at Pine Ridge*.

For a long time now the complete master of Western ways, Remington decided that he should extend his remit to wider horizons and, accordingly, in spring 1891 with Eva beside him they journeyed to Mexico where they had been invited by General Miles. While there they even met Porfirio Diaz (1830-1915), the president of Mexico. The result of this trip were three articles for *Harper's Weekly*; *General Miles's Review of the Mexican Army*, *Coolies Loading a Ward Liner*, written and illustrated by Remington, and *El Cinco de Mayo* in collaboration with the writer Maurice Kingsley.

Later that year, in June, he was at long last recognized by his peers and elected an Associate of the National Academy of Design, the second highest honor possible: he never did achieve his real ambition of becoming an Academician. Still chafing at the bit Remington was in an artistic dilemma, he was earning a very comfortable living making his Western paintings and illustrations but he was frustrated. He wanted to develop as an artist, he admired the Impressionists and wanted to go to Europe to see their work and also to study European soldiers and men of war. His mind was made up by an offer to accompany inveterate traveller, Poultney Bigelow (1855-1954), the journalist and author, and old friend from Yale, across the Atlantic in May 1892. Together they travelled to Germany and Berlin, then to Russia and back to Germany. They had intended to canoe up the River Volga and had bought and prepared all the necessary equipment but Russian officials took them to be spies and threw them out of Russia. Unable to sketch while there for fear that their constant watchers would incarcerate them, it was only after they left Russian soil that Remington could get out his sketchbook, but thanks to his remarkable memory for detail nothing seems to have been lost by the inconvenience, especially his studies of the Cossack horseman and their

FAR LEFT: Landscape, rocky cliff with pine trees above lake. This was painted near Ingleneuk, the small island on the St. Lawrence River which Remington bought in 1900 as a summer home and studio. *The Art Archive/Gift of the Coe Foundation/Buffalo Bill Historical Center, Cody, Wyoming/91.67*

LEFT: Mountain Man, 1903 (bronze). Somewhere between fifteen and thirty castings were made of this dramatic bronze in Remington's lifetime showing a vanished breed of frontiersman. The statuette depicts a French Canadian fur trapper and his horse carefully picking their way down a steep and dangerous mountain slope. When not trapping, such men guided travelers across the treacherous Rocky Mountains. *Mountain Man* is one of four bronzes in the Metropolitan Museum of Art, New York that were purchased at cost price direct from the artist, this one was an anonymous gift to the Phoenix Art Museum. *Phoenix Art Museum, Arizona, USA/The Bridgeman Art Library*

remarkable skill with their mounts.

Remington and Bigelow's exact itinerary is uncertain, and at this stage it is probable that they returned to Germany and Trakehnen, where Kaiser Wilhelm II kept the royal stud —Bigelow was an old friend of the Kaiser's which got them unprecedented access to the Prussian military, a subject which fascinated Remington, before visiting Algeria in North Africa, where he delighted in the hugely skilled Arab horsemanship, before journeying back through Paris. Three principal works for *Harper's Monthly* came from the adventure: *Why We Left Russia*, *In the Barracks of the Czar*, and *Sidelights on the German Soldier*. For his part Bigelow published a book entitled *Borderland of Czar and Kaiser*. When the friends parted company Remington decided to stop off in London where he went to see Buffalo Bill Cody's Wild West Show—and produced ten illustrations called *Buffalo Bill's Wild West Show in London*—and then went to the British Army headquarters just outside London at Aldershot for eight studies entitled *An Athletic Tournament of the British Army at Aldershot*. Various other illustrations came out of the trip including some drawings for Bigelow's article *Emperor William's Stud Farm and Hunting Forest*.

In 1893 Remington decided to give the Annual National Academy of Design exhibition a miss and instead held a one man exhibition and sale at the American Art Galleries in New York. This took him a long time to prepare but the endeavor proved a great success and was well received in the national press, and, more importantly, brought him over $7,000 in sales of his works. He and Eva need a change and a rest so they left New York for Chihuahua, Mexico where they stayed at Jack Follansbee's ranch at Bavicora. The stay proved remarkably productive and Remington made sufficient sketches to keep him going with material for the next three years or so. The last of which was his own illustrated article called *Coaching in Chihuahua* for the April 1895 edition of *Harper's Weekly*. This same year saw the publication of *Pony Tracks*, the first of Remington's collected anthologies (the others were *Crooked Trails*, 1898; *Sundown LeFlare*, 1899; *Men with the Bark On*, 1900). His other books were *A Rogers Ranger in the French and Indian War* (a reprint of an article published in *Harper's Monthly* in 1897; *Stories of Peace and War*, (reprint of three articles from *Harper's Monthly* in 1899); and two novels, *John Ermine of the Yellowstone* (1902), which was turned into a play, and *The Way of an Indian*, 1906.

In the late 1880s the publishing world changed as the old reliable titles like *Harper's* were challenged by a different type of magazine. New titles such as *Cosmopolitan*, *The Outlook*, *Literary Digest*, and *The Saturday Evening Post* appeared. These were livelier, more sensational, and cheaper than the established press but still wanted good, strong stories and attention grabbing illustrations that told a good story—exactly Remington's style. He however continued to be gainfully employed by the *Harper's* stable of weekly and monthly magazines, as well as the old faithfuls *Outing Magazine* and *The Century Illustrated Monthly Magazine*, but he also picked up work from the new titles which were anxious to publish such a popular and high profile illustrator. By the turn of the century many of these new publications could add colored artwork to their pages after five-color photomechanical printing was developed: this was a great bonus for a painter such as Remington who made

RIGHT: *Radisson and Groseilliers*, 1905. Number four in a series of nine oil paintings and the sole survivor from *The Great Explorers*, commissioned by *Collier's Magazine* and published on January 13, 1906. In 1659-60 Radisson and Groseilliers were the first white men to explore Minnesota, the former was the leader of the expedition and is shown standing in a birch-bark canoe with the latter sitting down beside him. *The Art Archive/Gift of Mrs. Karl Frank/Buffalo Bill Historical Center, Cody, Wyoming/14.86*

OVER PAGE LEFT: Another *Collier's Magazine* painting, *Lewis and Clark at the mouth of the Columbia River*, 1805, from *Collier's Magazine*, May 12, 1906 (from an engraving after Remington). *Library of Congress, Washington D.C., USA/The Bridgeman Art Library*

OVER PAGE RIGHT: *The Stampede*. Bronze, cast posthumously in 1910. Although virtually finished before he died, Roman Bronze Works engaged sculptor Sally Farnham, Remington's one-time student and later friend, to finish the piece and oversee the casting. *Library of Congress, Prints & Photographs Division, LC-USZ62-106852*

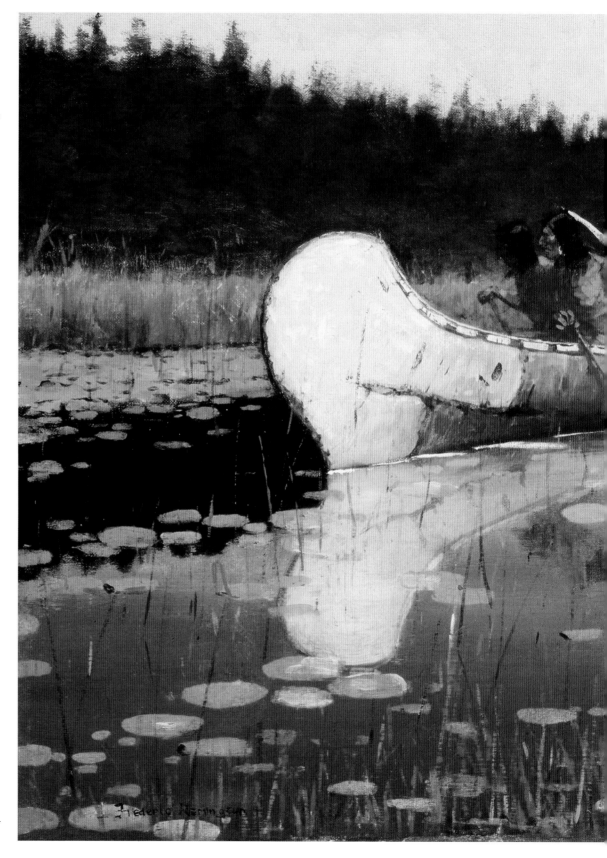

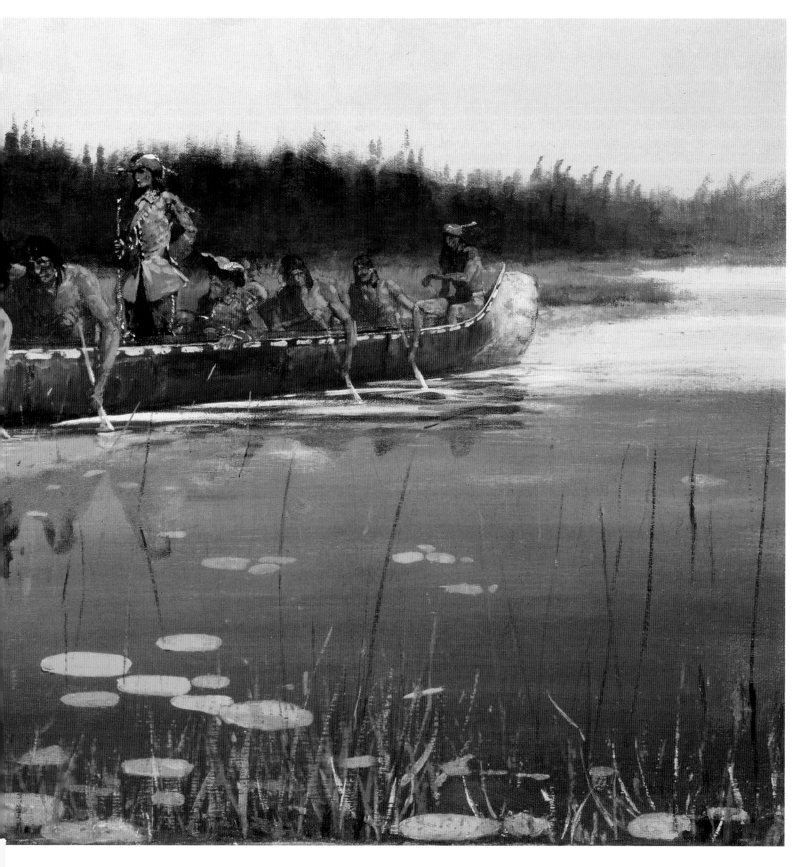

the most of this latest technological advance. On the other hand another technical advance rather reduced his career opportunities, that of the development of photographic illustrations which lessened the necessity of having an illustration created and soon proved to be much cheaper and faster than an artist, as well as giving a far more realistic image.

Early in 1895 Remington tried his hand at sculpting after being encouraged by a couple of his friends including his near neighbor the sculptor Frederic W Ruckstull (1853-1942). For a long time he had been frustrated by the limitations of matching his illustrations to the printed text and the constantly looming deadlines. He used clay or plasticine to form his model and worked hard to infuse his characteristic movement and vibrancy into the model—perhaps to his surprise he found he was rather good at it and found the challenge very satisfying. In August he took his clay model to the best sand casting foundry in New York, the Henry-Bonnard Bronze Co. The model proved too big (it was about 24 inches high in common with most of his bronzes) and complicated for a single sand casting and the recast plaster model was cut into a number of separate sections for casting, and later refitted with pins after casting. Titled *The Bronco Buster* its quality was evident immediately and it was copyrighted on October 1, 1895. He quickly proved himself to have remarkable sculpting skills which made him into an acknowledged artist. *The Bronco Buster* proved his most popular figure and became the art sensation of the year and with some of the proceeds Remington bought Eva a Steinway grand piano for their apartment. Remington subsequently presented one of the bronzes (casting number 23) to President Roosevelt and it has ever since had pride of place in the Oval Office at the White House.

Thrilled with his work Remington immediately set about sculpting another model, *The Wounded Bunkie* of a wounded cavalry officer being supported by a colleague as their horses gallop along. Amazingly, the entire sculpture is supported by just two of the horses' legs, it is a masterpiece of balance and movement; it was copyrighted in July 1896. His next bronzes were *The Wicked Pony* which shows a fallen cowboy scrabbling for the ears of his bucking bronco in a futile attempt to pull him down (based on a true life incident witnessed by Remington in which the cowboy was fatally injured), and *The Scalp* (originally titled *The Triumph*) it shows a stylized Sioux warrior in triumphant pose brandishing a scalp from the back of his horse, both copyrighted in 1898. These were well reviewed but did not sell in sufficient numbers to please Remington. In time he completed 22 bronzes of cowboys or indians and their horses and in the process turned himself into one of the most sought after and successful contemporary artists and established his significance as a major talent. The bronzes were very popular with the public and often occupied a prominent position in Tiffany's store window on Union Square in New York City. The bronzes were cast according to demand, and some proved more popular than others, although none were as successful as *The Bronco Buster*. Many more were cast after his death and only those cast in his lifetime by the Henry-Bonnard Bronze Co. or Roman Bronze Works, those by Eva's authority and those authorized by the estate are considered to be authentic casts. In all between 1900 and 1907 he

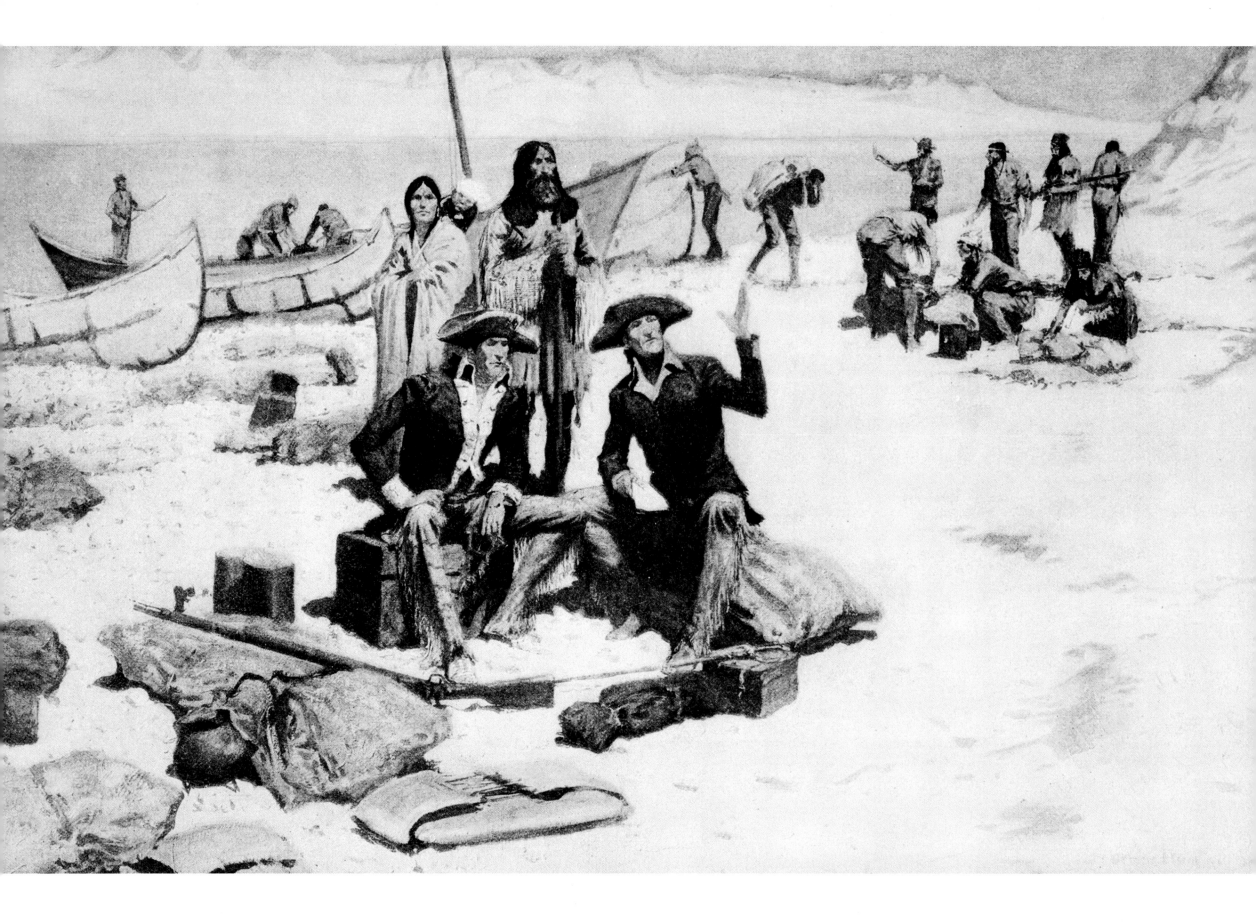

completed 13 bronzes.

All in all he was a successful and busy man, writing, painting, and sculpting and even inventing—he devised a military munitions carrier, patented it, and sold half shares in the patent to his friend Joel Burdick—all fitted around a busy social life; for exercise he took up the new fad for bicycling. In 1898 the Henry-Bonnard Foundry was destroyed by fire (including the original plaster mold of *The Wicked Pony* of which only ten were made, the original mold for *The Scalp* was probably also lost). This gave Remington the opportunity to use the lost wax process of casting in which he could retouch or alter each piece before casting if he wished (as he almost always did). For this he chose to work with the Roman Bronze Works in Greenpoint, Brooklyn where he met and got to know as a friend and colleague Riccardo Bertelli, the president of the works.

Remington was offered a new challenge in December 1896: from William Randolph Hearst [1863-1951] who wanted Remington to report on the Cuban revolt against Spain for the *New York Journal*. Remington accepted and journeyed to Cuba from where he famously cabled back to Hearst, "There will be no war. I wish to return," to which Hearst even more famously (and egotistically) retorted, "Please remain. You furnish the pictures and I'll furnish the war." Remington wasn't convinced and returned home to draw pro-Cuban propaganda. Two years later when war was officially declared on April 25, 1898, Remington returned to Cuba as war correspondent for *Harper's Weekly*, *Harper's Monthly*, the *Chicago Tribune*, and the *Journal*, as well as working for the R.H. Russell publishing house. But far from the glorious magnificence of cavalry charges and battle he expected, Remington found himself sickened and horrified by the reality of warfare with all its bloodiness and horror. As soon as he could following the Battle of San Juan Hill he left Cuba. Nevertheless, Remington's pictures and commentaries on the war were some of the most powerful to come out of Cuba. After a lifetime love affair with all things military Remington saw real blood and guts battle for the first time and was utterly repelled by the suffering he saw. From this time on he lost his interest in the military.

In between visits to Cuba Remington journeyed to the scene of the Spanish-American War where he worked as a correspondent chronicling his much admired cavalry with their wonderful horses and exciting exploits. The result was *With the Fifth Corps*, a piece that showed the grind and horror of battle rather than the more usual bluster and glory stuff. On the positive side Yale University presented him with an honorary fine arts degree, in return he gave them the gift of a painting and a bronze. Also in 1897 he started writing with a new angle by doing short stories of western fiction in frontier dialect, these were called the *Sundown Leflare* stories and they proved very popular with his fans. This was part of getting himself into training for writing a full length novel which he started in 1900 with his typical ambition of becoming the best author of Western fiction.

Meanwhile other artists were invading his field and while he admired the Impressionists and would have liked to emulate them, he could not use their hazy techniques for his Western images. Furthermore despite being the

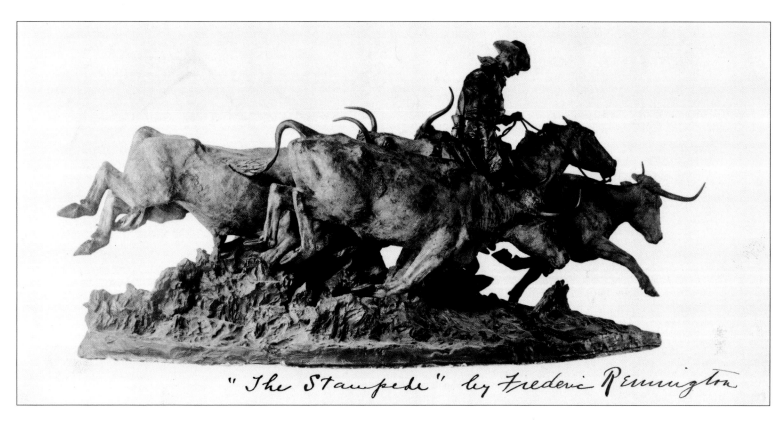

"The Stampede" by Frederic Remington

undisputed premier artist of the Western scene Remington was still not accepted as a "proper" artist and to his immense frustration he was still not included on the roster of true artists by the art establishment. Above all he longed to be elected as an academician of the National Academy, the highest pinnacle of the art establishment. His writing was bringing him a good income, with his short pieces being collected together into anthologies, but despite all his efforts his later bronzes lacked the spontaneity and popular appeal of his very first one, *The Bronco Buster*.

By 1900 Frederic Remington was 38 years old and packed 295 pounds in his 5 foot 9 inch frame. By then a successful and well known magazine artist and writer he had authored (and illustrated for himself) over 100 articles, mostly about the Army and life on the western frontier. But that same year his long-time employer *Harper's Monthly* and *Weekly* (since 1850 and 1857 respectively) found themselves in financial trouble and suddenly stopped using Remington as an illustrator. Luckily *Collier's Weekly* was simultaneously increasing its scope and readership and had plenty of work for Remington (although not for his writing) and his western speciality. Other periodicals were using him regularly as well, principally *Scribner's*, *Cosmopolitan*, and occasionally, *Outing Magazine*.

Through all this hard work Remington had earned sufficient money to buy an estate in the exclusive New York suburb of New Rochelle and also the funds to buy himself Ingleneuk—one of the St. Lawrence River's Thousand Islands—a five acre island in Chippewa Bay, not far from his favorite Cranberry Lake and his childhood home in Ogdensburg and somewhere he

could enjoy privacy, now a rare commodity for him. The island held a huge house with its own boathouse (where he kept a motorboat and a couple of canoes) and dock, and other luxuries. The only things it lacked were a clay tennis court, and a studio—Remington built them both, the latter beside the rocky shore where he could overlook the shipping channel and catch the northern light. Many of the surrounding islands had similar holiday homes and the summers would pass in a very sociable and agreeable way. He liked to start his mornings with a swim in the chilly waters, then take his canoe for a paddle around the island for a time before getting down to work. Nevertheless, despite all his gregarious socializing Remington still had a prodigious work rate and would work most days until mid-afternoon and sometimes by night as well when he wanted to capture the moonlight on his canvas.

Friends from New York would come and stay, tennis parties, and competitions arranged and a generally good time had by all; by all accounts he was often its gregarious heart and soul. Ogdensburg was only a short steamer trip away—the *Island Belle*—so civilization was near at hand when required. Here he passed the hot summer months every year until 1908. He was by now well overweight and out of shape which limited his expeditions somewhat, much to his frustration. That same year he sold Ingleneuk—much to the disappointment of his many friends and neighbors—to raise funds to build a new home at Lorul Place in Ridgefield, Connecticut. They moved in on May 17, 1909.

By now Remington was easily the best paid and best known illustrator in America with unceasing demand for his black and white illustrations of

western scenes. Having at long last achieved the financial security he wanted and the acclaim for his work that he craved he was nevertheless frustrated: he wanted to be thought of as much more than a commercial illustrator and appreciated for his serious painting. By now he could see how the railroad was opening up the West and bringing "civilization" to the distant lands that once were beyond most mens' reach. Times had changed fast for the West and now Remington was more than ever illustrating a vanished era. The millions of buffalo had been systematically wiped out and the Native American corralled into reservations where their ancient ways of life were eroded.

But his enthusiastic public were curious about the man himself and a number of articles about Remington appeared in the popular press: *Artist Remington at Home and Afield* appeared in July 1896 issue of *Metropolitan Magazine*; *Remington and his Work* in the May 1899 issue of *Success Magazine*; and *Frederic Remington: The Man* for the March 1903 issue of *Outing*. Then in March 1905 *Collier's* devoted an entire issue to him, the *Remington Number* with five new paintings and pictures of bronzes, contributions from a number of influential people and a centerfold of *Evening on a Canadian Lake* (the prints were available for separate purchase from Noe Galleries and the bronzes from Tiffany's and Knoedler's Gallery), Remington contributed a piece about his life entitled, *A Few Words From Mr Remington*.

Intrigued by a new challenge he spent his time writing his first novel, *The Way of an Indian*, a story written as if from the mouth of a "wild" Native American whose tribe was ruthlessly subdued and pacified by the Army. Part of his plan was to beat his friend and rival author, Owen Wister (a law graduate from Harvard) to publish a novel about the wild west and in the process establish himself as the premier authority in print (as well as illustration) on the subject. They had first met by accident in Yellowstone Park in 1893 and discovered a shared interest in all things Western, as well as a somewhat morbid political philosophy that everyone was out for himself at the expense of the land. Both worked intermittently for *Harper's* and even collaborated for the January 1894 issue of *Harper's Monthly* on an article written by Wister entitled *Balaam and Pedro* (about Mexico) for Remington to illustrate. This was the first of a long series of collaborations commissioned by *Harper's* whose editors thought that the pair complimented each other's work. Their philosophies varied though when it came to an appreciation of the cowboy: Remington saw him as a bit of a rough and ready rogue while Wister saw him as an altogether more noble figure and they enjoyed a long argument (often through correspondence) as to what exactly constituted an authentic cowboy. Their work together started to slow down and by 1902 they no-longer collaborated. Remington's mistake , though, was to choose Randolph Hearst as his publisher and for one reason or another the book did not appear until 1905. Unfortunately for Remington, Wister meanwhile published his seminal novel *The Virginian* (also called *The Virginian, a horseman of the plains*) published in 1902 and swept the literary field with his achievement. The following year Remington published *John Ermine of the Yellowstone*, an illustrated love story set among the Crow Indians, it was very well received, but Wister had collected the prize as premier western author. This was an ambition he had had for a long time and was part of his desire to be the complete authority on the

RIGHT: *Dark Island Castle, St Lawrence River,* c. 1907. On one of the Thousand Islands in the St. Lawrence Seaway and close to the Canadian border, "The Towers" was originally built to look like a Scottish castle. *The Art Archive/Gift of the Coe Foundation/Buffalo Bill Historical Center, Cody, Wyoming/105.67*

FAR RIGHT: *The Rattlesnake,* 1905. This bronze shows a cowboy on a bronco which is shying away from a rattlesnake that is rearing up ready to strike. This work became his third best-selling bronze and certainly one of the ones he most enjoyed modeling. © *Private Collection/Peter Newark Western Americana/The Bridgeman Art Library*

Western way of life. Nevertheless, when it did appear, his old friend Theodore Roosevelt complimented him on his efforts at understanding the mind of an Indian. Meanwhile Remington started another novel, John Ermine, which was adapted for a stage production the following year. Remington and Wister were jointly named by *The Bookman* as the main authors of popular Southwestern stories, even though the latter was the vastly more popular author. By 1905 Remington had accepted this reality and gave up writing novels to concentrate on his painting and sculpture where he had no rivals—either with popularity, skill, or financial.

By 1902 Remington was not only a household name and an accepted artist, his work was eagerly sought out and bought by a seemingly insatiable public. So much so that *Collier's Magazine* gave him a contract to provide one color painting—of any subject he chose—a month for the princely sum of $1,000 each. These were usually printed as a two-page centerfold in color halftone; this was a great technological leap forward, using four colors plus black screens, giving a total of five dot-pattern prints. Most of the paintings Remington made for this were oil on canvas, approximately 27 x 40 inches. Additionally, *Collier's* offered reproductions of the prints to readers by mail order for around a dollar each. He was also allowed to take his paintings back and sell them on privately. With this freedom to paint anything he chose Remington was able to experiment with new styles, new materials, and brighter colors. Remington was still making the occasional large expedition, in 1900 he went to Colorado, in 1904 to both Mexico and Cuba, and in 1905 to South Dakota.

However, writing did not provide the level of income that he had become used to and he returned to serious painting and sculpture, even abandoning his illustrating. His first exhibition as a serious artist was held at Clausen's Gallery in New York in December 1901. There he showed 15 paintings and ten pastels. This same year his old friend and long time correspondent, Theodore Roosevelt became President of the United States following the assassination of President William McKinley. The two continued to write regularly to each other despite Roosevelt's busy term in office. From 1903 Noe Galleries on Fifth Avenue in New York started to give regular exhibitions of Remington's works. His bronzes were now fetching impressive prices and while his paintings were gaining in value, any member of the public could buy one of his prints from *Collier's Magazine* at very reasonable cost. On January 16 1905 an exhibition of nine Remington bronzes opened at the prestigious Knoedler's Gallery in New York and each following December the gallery put on an annual exhibition of Remington paintings; ten new paintings in 1906, 12 in 1907, 19 in 1908, and 23 in 1909.

At long last his small bronzes were starting to garner serious art recognition and to prove his true ability, then in May 1905 Remington was approached to consider a project offered by the Fairmount Park Association to sculpt a 12 foot statue of a mounted cowboy for Fairmount Park in Philadelphia. He was excited by the challenge and eagerly accepted the commission. The project went exactly as planned, Remington was intimately involved in all its aspects, including its exact siting. Feeling that it was vital for

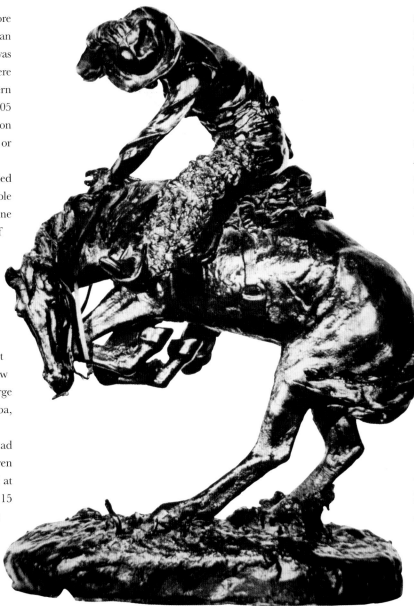

the project that he work outdoors on the sculpture, he had an elaborate track system installed so he could easily move the statue in and out of his studio. *The Cowboy* was unveiled in a lively ceremony which included real cowboys and Indians on June 20, 1908 to a large Philadelphia crowd, but Remington did not attend the ceremony, he had already moved to Ingleneuk for the summer. Excited by the prospect of making larger bronzes Remington remodeled both *The Bronco Buster* and *The Rattlesnake* half as big again. Additionally he modeled *The Savage* (1908), *The Trooper of the Plains—1868* (1909), and *The Stampede* (cast posthumously in 1910). After his death the bronzes were cast only on Eva's orders until she died (in 1919) at which point the molds were to be broken.

To make things even better the New York Metropolitan Museum of Art bought four of his bronzes and the Corcoran Gallery in Washington bought

another one. He called this triumph "A brevet before death." He now had friends in the higher art echelons including among The Ten American Impressionists and was using their help and inspiration to adapt Impressionism into his western paintings to use light and shade to convey movement and the impression of mood, and was a regular correspondent with the artist Childe Hassam (who all too soon was to attend his funeral).

In October 1907 *Pearson's Monthly* featured *The Bronco Buster* on the cover and inside ran an article entitled *Frederic Remington: Most Typical of American Artists*, but it was the open letter from President Roosevelt called *An Appreciation of the Art of Frederic Remington*, which really grabbed the public's attention. Towards the end of 1908 a large exhibition of his work at last brought Remington the unequivocal acclaim that he so craved. At long last the art establishment was at his feet and the critics were lauding his work—the colors, composition, and even his authenticity—the old bugbear of just being a scene painter was long past. Money was plentiful and he sold his estate in New Rochelle and moved to a new mansion he had had built in Ridgefield, Connecticut. His friends had grand plans for him: at a dinner for Buffalo Bill Cody it was proposed that he sculpt a statue of a Native American indian to stand in New York harbor where it would dwarf the Statue of Liberty. At last he was being lauded by his compatriots; he was even allocated a retrospective article about his work for the January 1910 issue of *Scribner's*. He was working enthusiastically and successfully and had just completed two maquettes for a pair of statues and at long last one of his paintings, *Fired On*, was bought by The National Museum, the first join a museum collection.

At the end of 1909 a Remington exhibition of his paintings opened on the 11th and was very well received by the critics and public alike. Additionally he was negotiating a commission to paint a mural featuring Seneca Indians in Albany. But after living at Ridgefield for only eight months Remington contracted peritonitis just before Christmas, on December 18. He had been shelling corn for his chickens when he pulled a muscle in his stomach; two days later the stomach pains suddenly became really intense making him to think he was suffering from either dreadful constipation or really bad muscle strain. Suspecting the former he took a really strong laxative to alleviate the problem. Unknown to anyone at that time he actually had appendicitis, and the laxative caused peritonitis, emergency surgery for a burst appendix failed to save his life and by December 26 Frederic Remington was dead. The funeral services were held in Ridgefield and despite the heavy snow a number of his closest friends were able to attend. He was laid to rest in Evergreen Cemetery, Canton, New York, the headstone simply says, Remington. In total he had spent only about three years of his life in his beloved West, but this was still more than sufficient to make him the premier recorder and illustrator of a by then already lost way of life.

For several years afterwards Eva traveled before settling in Ogdensburg with her sister Emma.

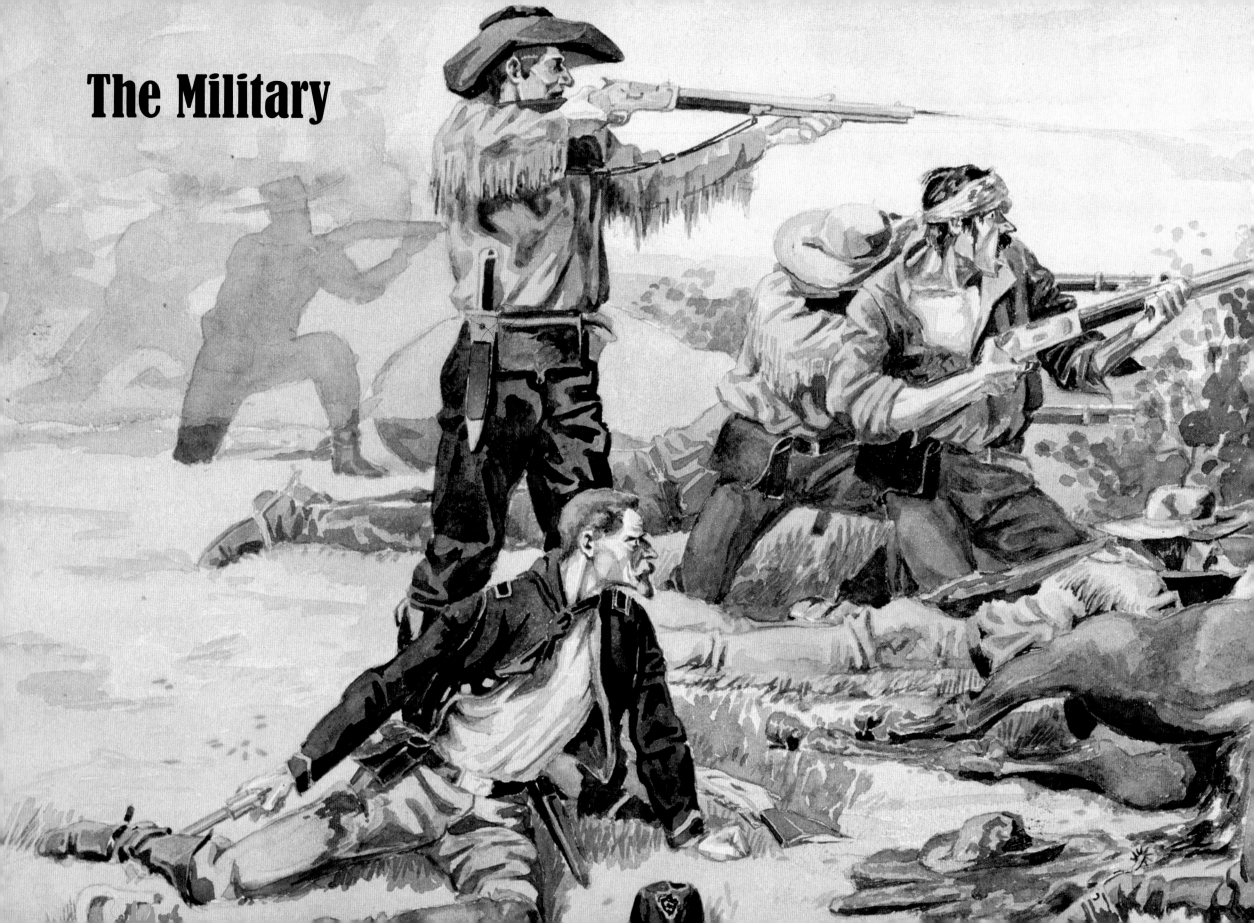

The Military

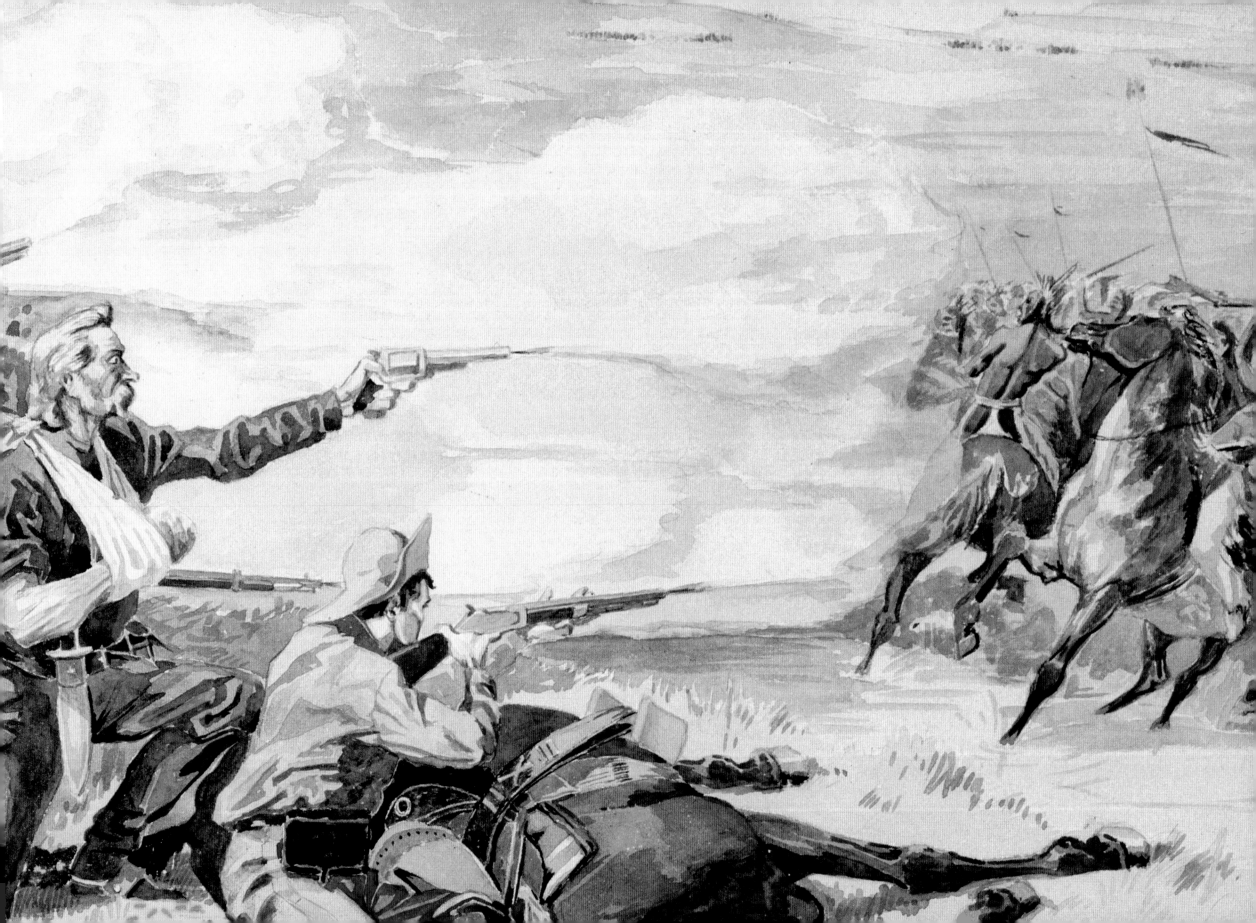

The Military

Thanks to the tales of his dashing Civil War hero father it is only to be expected that Remington from earliest childhood was irresistably drawn to soldiers and all things military. Raised on heroic stories of bravery and selflessness it is hardly surprising that as an impressionable child he became infatuated with the Army and everything to do with it, especially the soldiers themselves and their mounts. Accordingly he was sent to the prestigeous military academy, the Vermont Episcopal Institute in Burlington, Vermont, but he hated the discipline, the austerity, and lack of sustaining food and it rapidly became clear that he was not cut out for a military career in the footsteps of his father. He was soon moved to a more sympathetic environment at the Highland Military Academy in Worcester, Massachusetts, but even this more benin regime proved too harsh for the young Remington. Abandoning thoughts of a career in the military he took up his brushes and sketch pad and instead sketched military life from the standpoint of a very well informed observor. Remington's love of the military continued unabated until he experienced the true horror of war for himself in Cuba in 1898, after that he lost interest in the military altogether.

PREVIOUS PAGES: *Battle of Beecher Island, 1868*. Watercolor on paper, c.1885. Also called the Battle of Arikaree Fork, this was a three-day engagement between Plains Indians and the U.S. Army in present day Colorado. *Museum of Fine Arts, Houston, Texas, USA/Hogg Brothers Collection, Gift of Miss Ima Hogg/The Bridgeman Art Library*

RIGHT: *The Defeat of Crazy Horse* (also called *The Defeat of Crazy Horse by Colonel Miles, January 1877*, or *Winter Attack on an Indian Village*). Oil on canvas, c.1901. Crazy Horse was the leader of the Lakota tribe who led his people to defend their ancestral lands against the settlers and the U.S.Army. The first time Remington and Colonel Nelson A. Miles met was in 1886 in Arizona, they soon became good friends. © *Museum of Fine Arts, Houston, Texas, USA/Hogg Brothers Collection, Gift of Miss Ima Hogg/The Bridgeman Art Library*

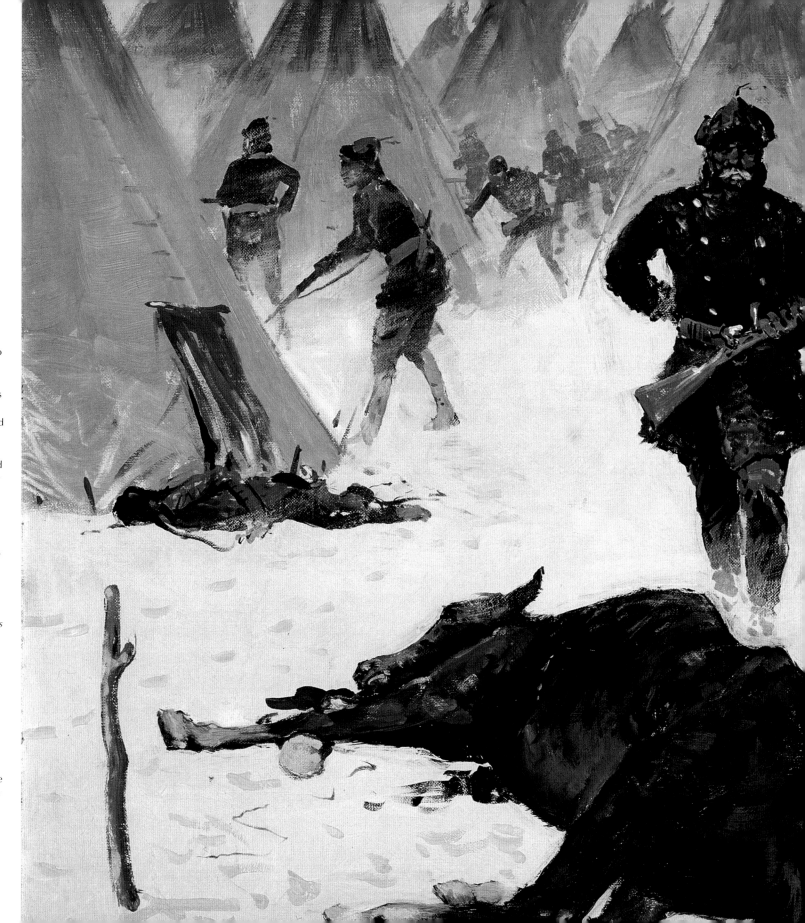

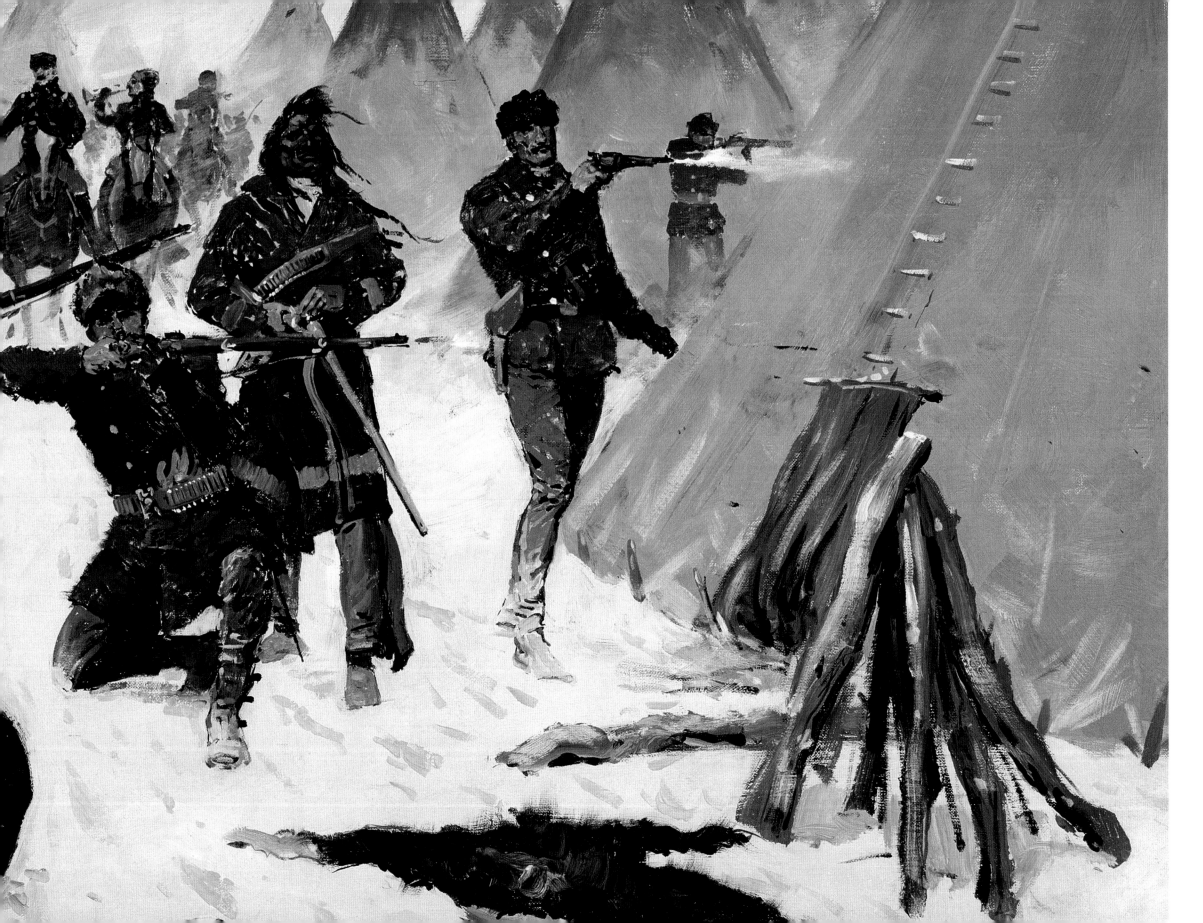

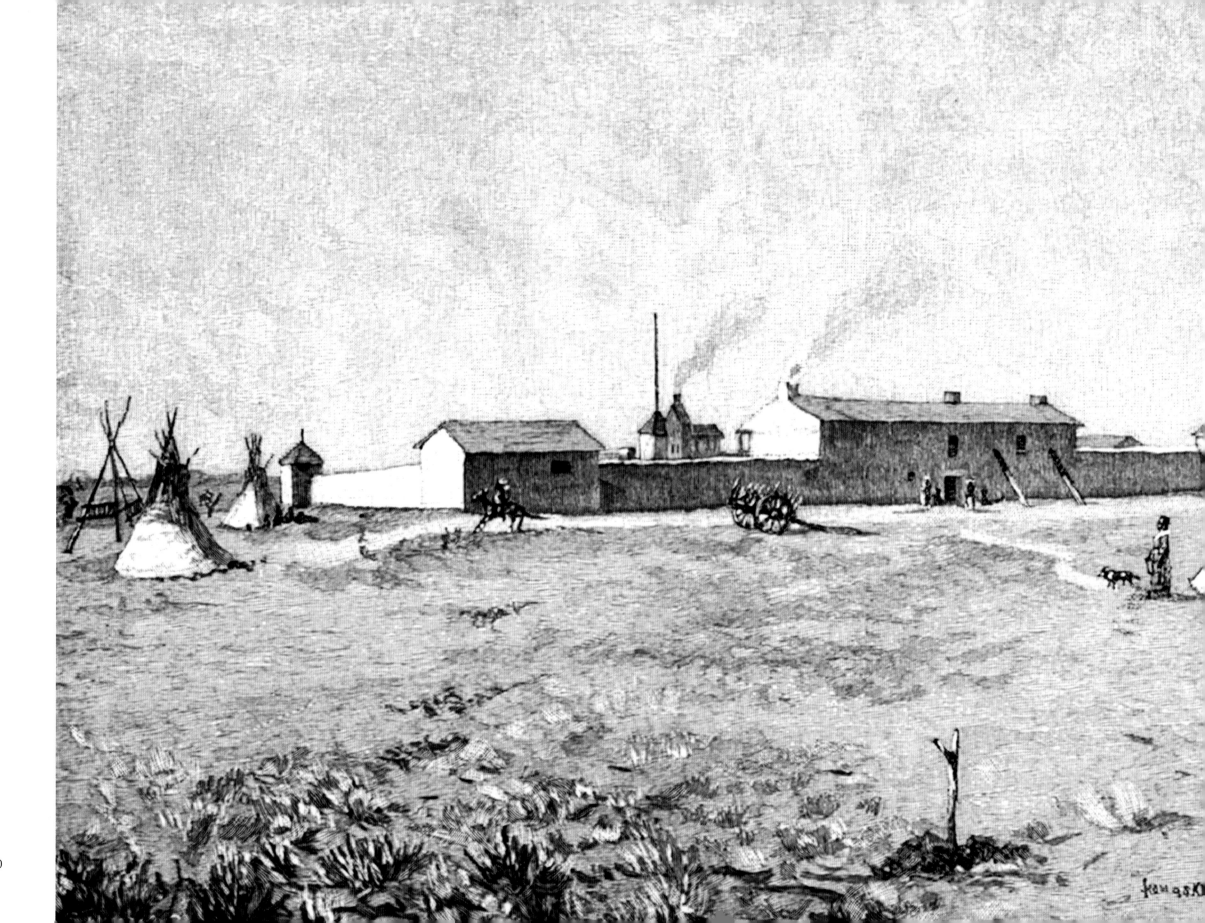

LEFT: Old Fort Laramie, Wyoming Territory, 1849. The military post was founded in 1849 as the first military outpost on the Oregon Trail in Plains Indian territory. At this period it was garrisoned by Mounted Riflemen. *The Art Archive/Bill Manns*

RIGHT: The Rescue of Corporal Scott during the Geronimo campaign of 1886 (colored engraving after Frederic Remington). The fourth time Remington journeyed West it was in futile pursuit of Geronimo, this however, did not stop him from making numerous topical illustrations and paintings. © *Private Collection/Peter Newark American Pictures/The Bridgeman Art Library*

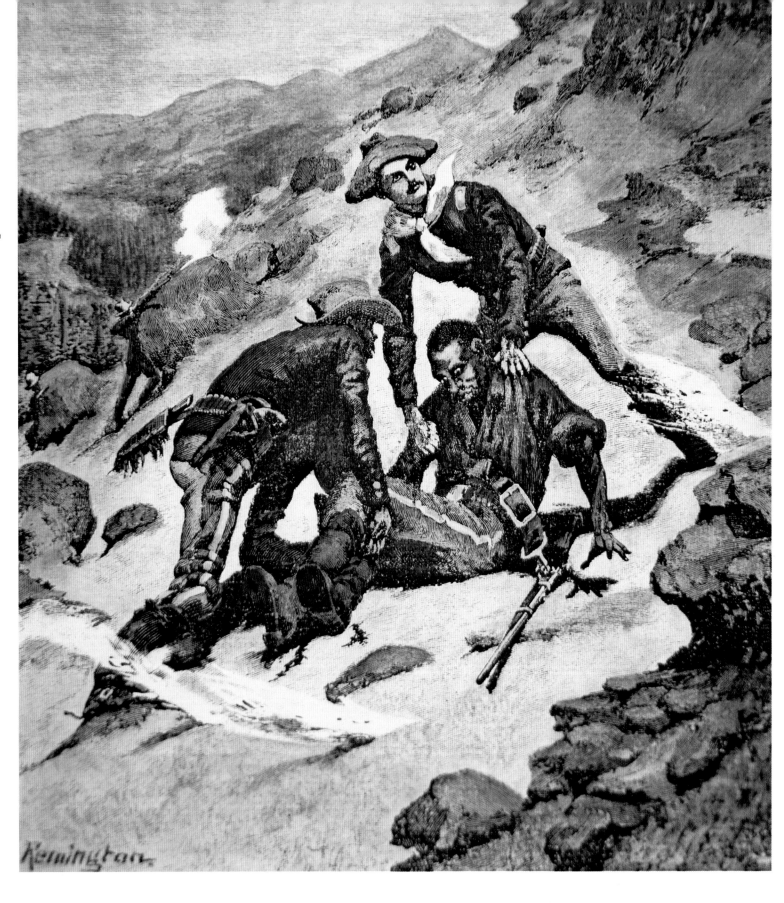

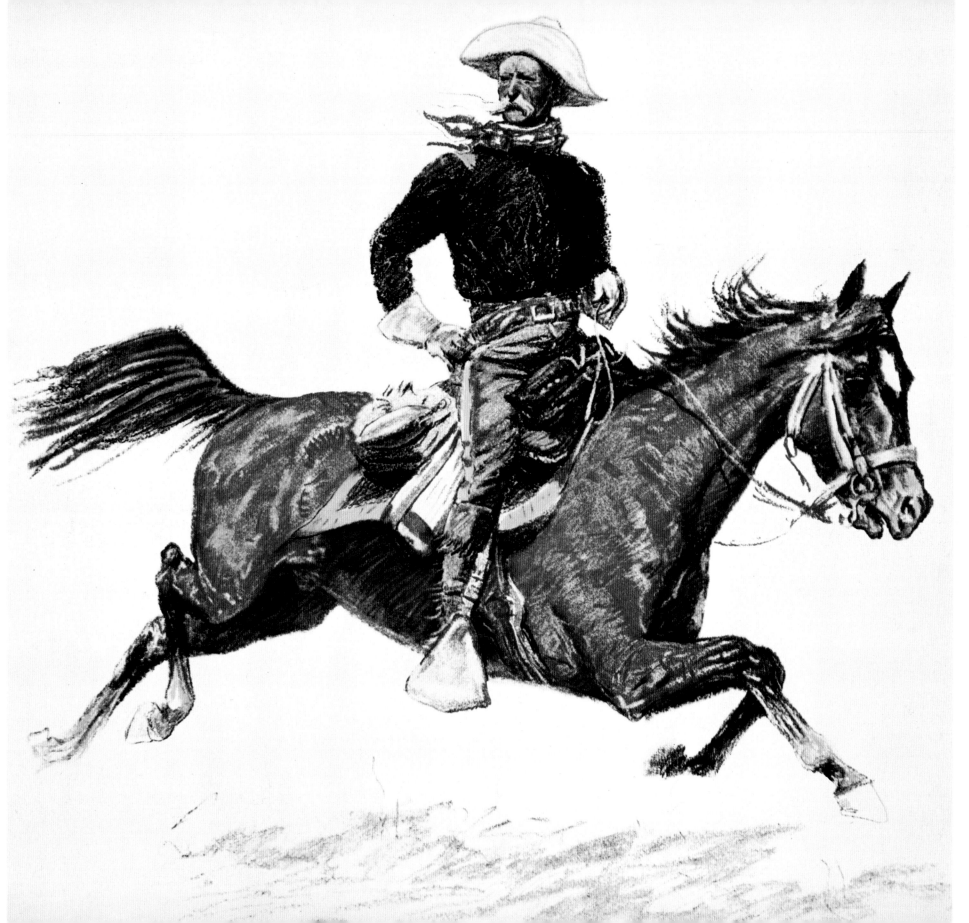

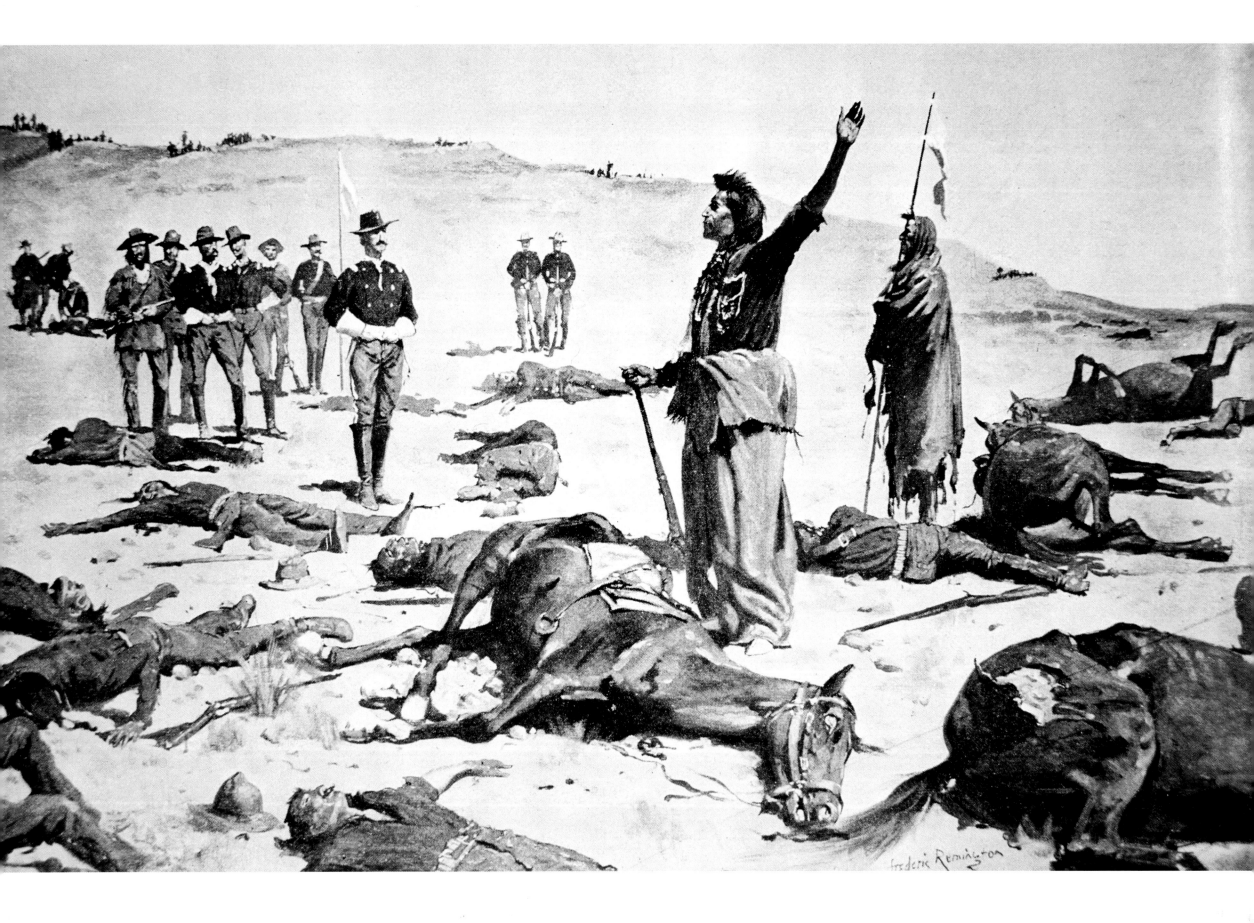

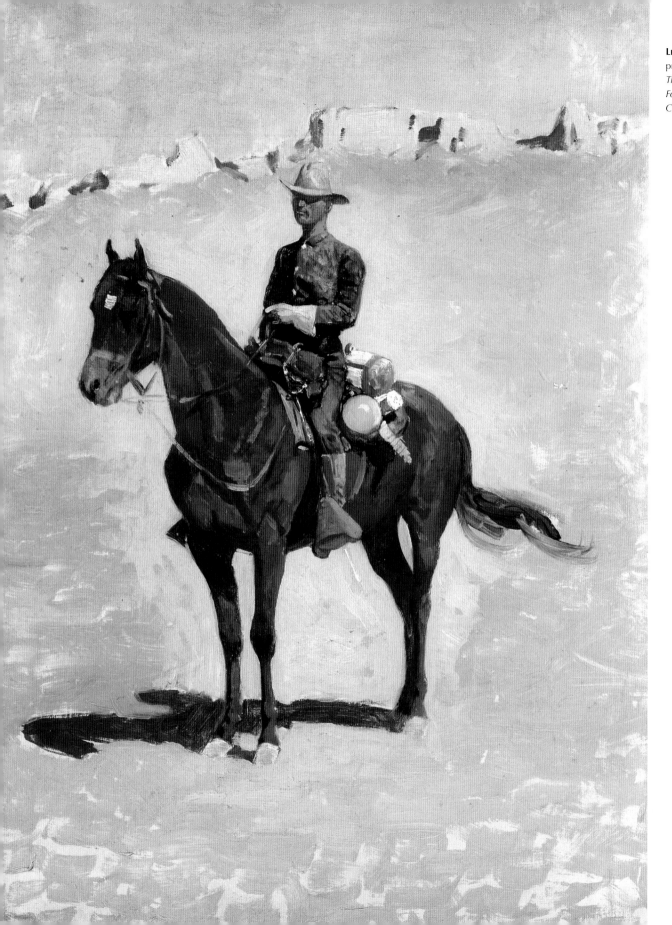

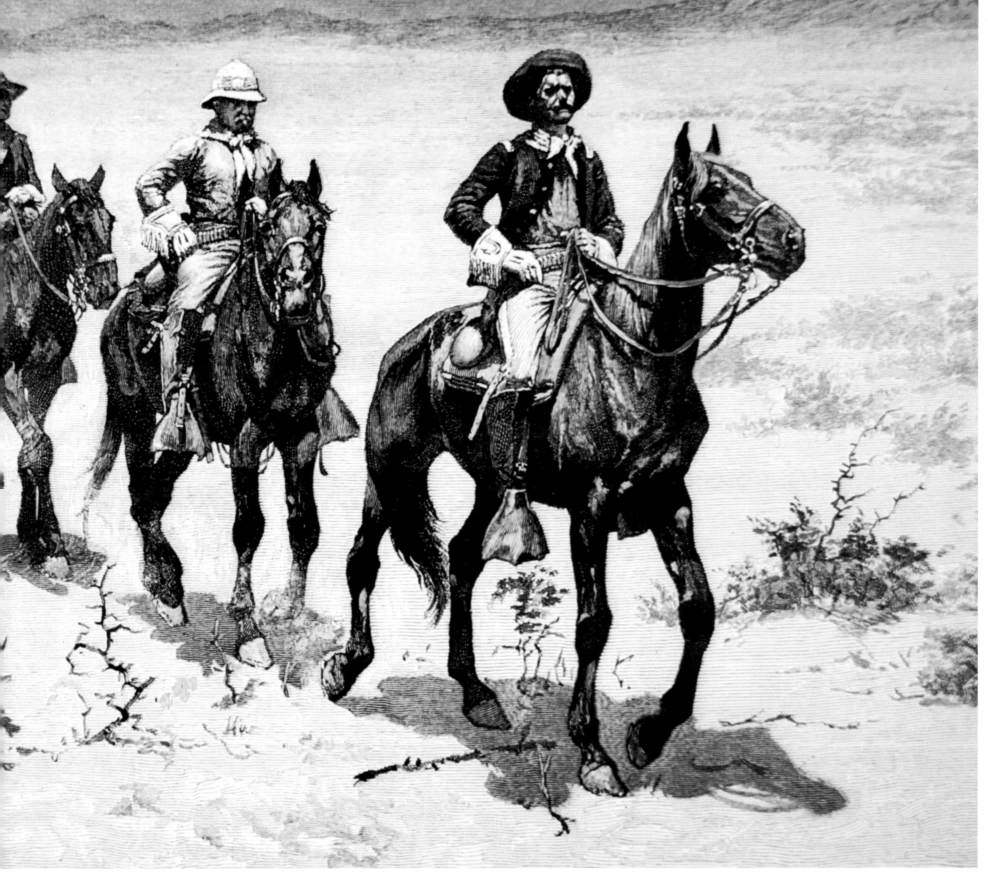

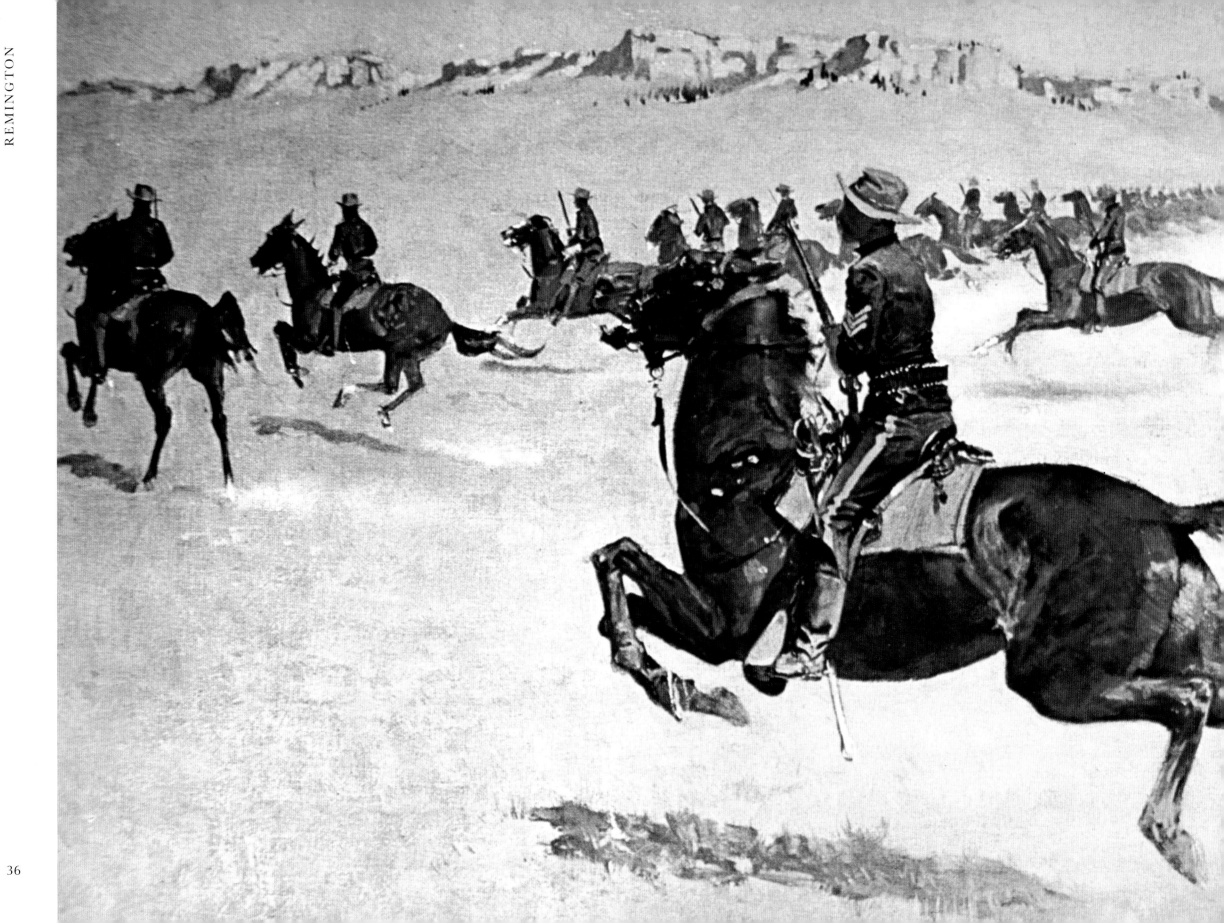

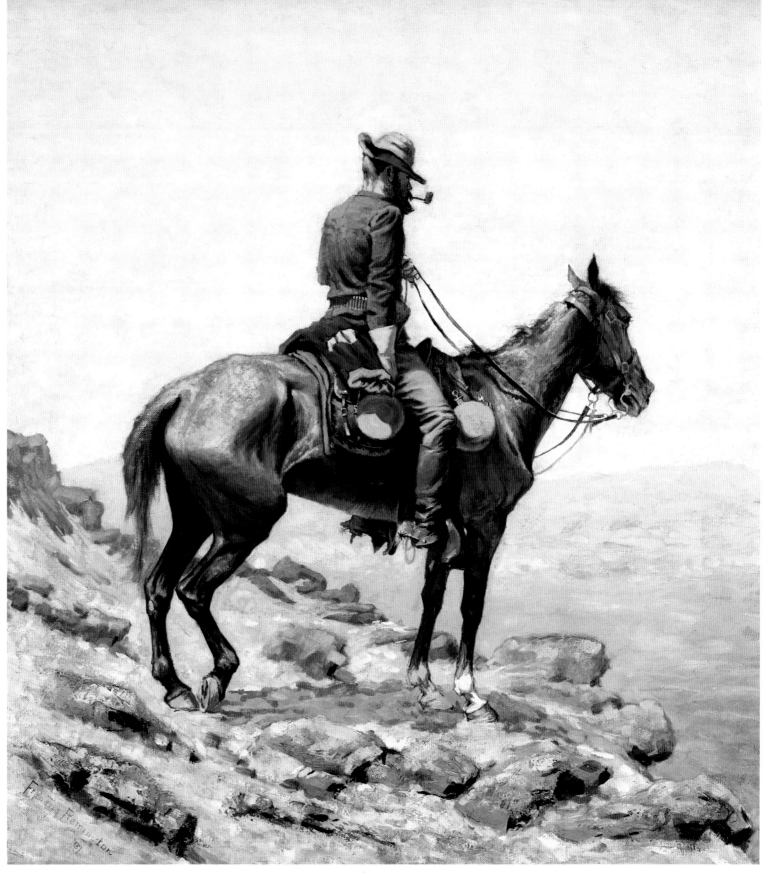

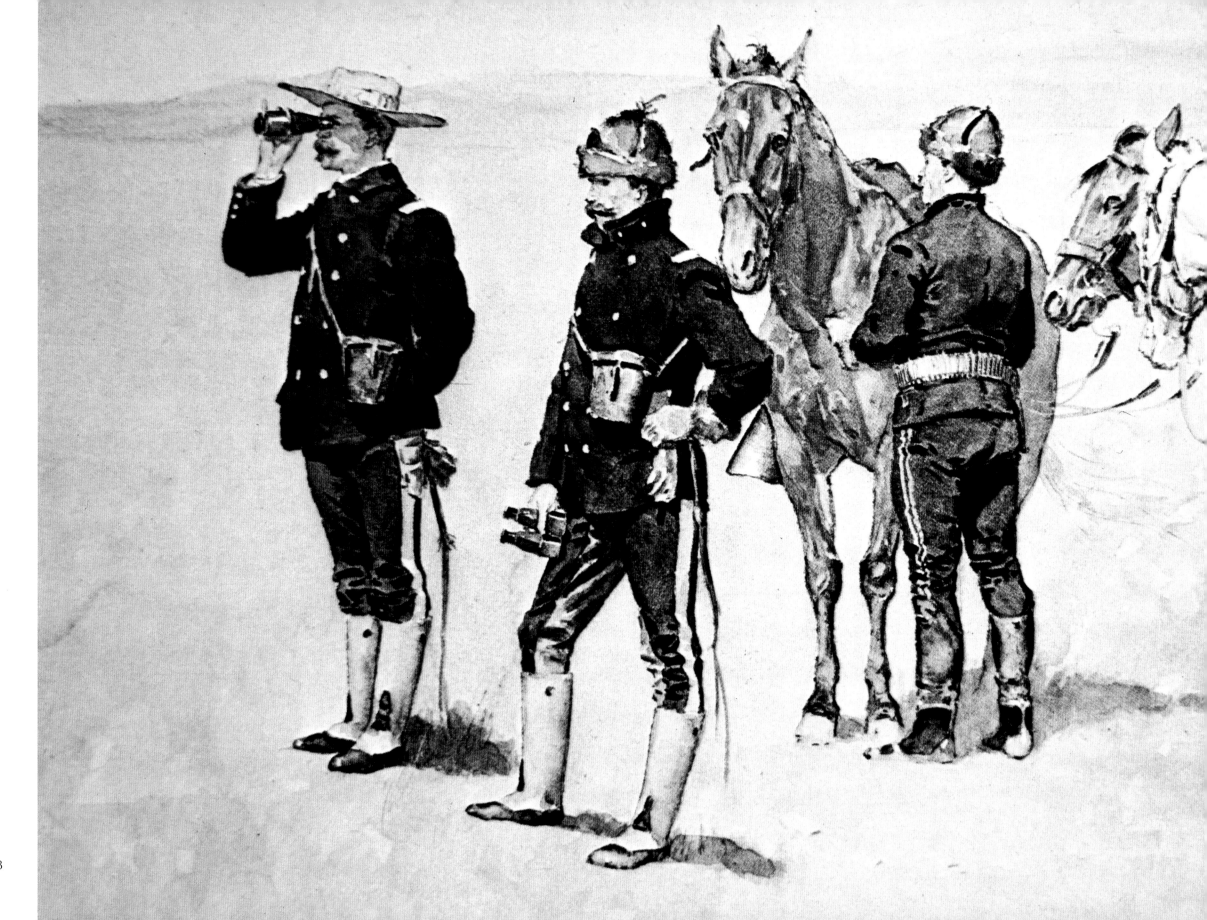

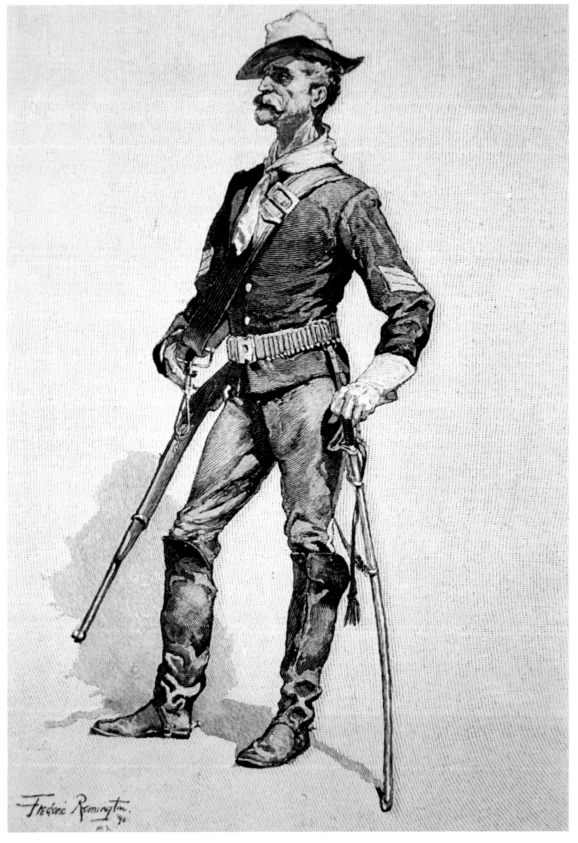

PREVIOUS PAGE LEFT: *Cavalry Scouts,* c.1890, color litho after Remington. The Scouts were among Remington's favorite troops because they were the real adventurers who were brave enough to venture into unknown territory where they would frequently encounter the indigenous and sometimes dangerous, peoples. *Private Collection/Peter Newark Western Americana/The Bridgeman Art Library*

PREVIOUS PAGE RIGHT: *A Sergeant of U.S. Cavalry,* an engraving after a drawing of 1890 by Remington. *Private Collection/Peter Newark Western Americana/The Bridgeman Art Library*

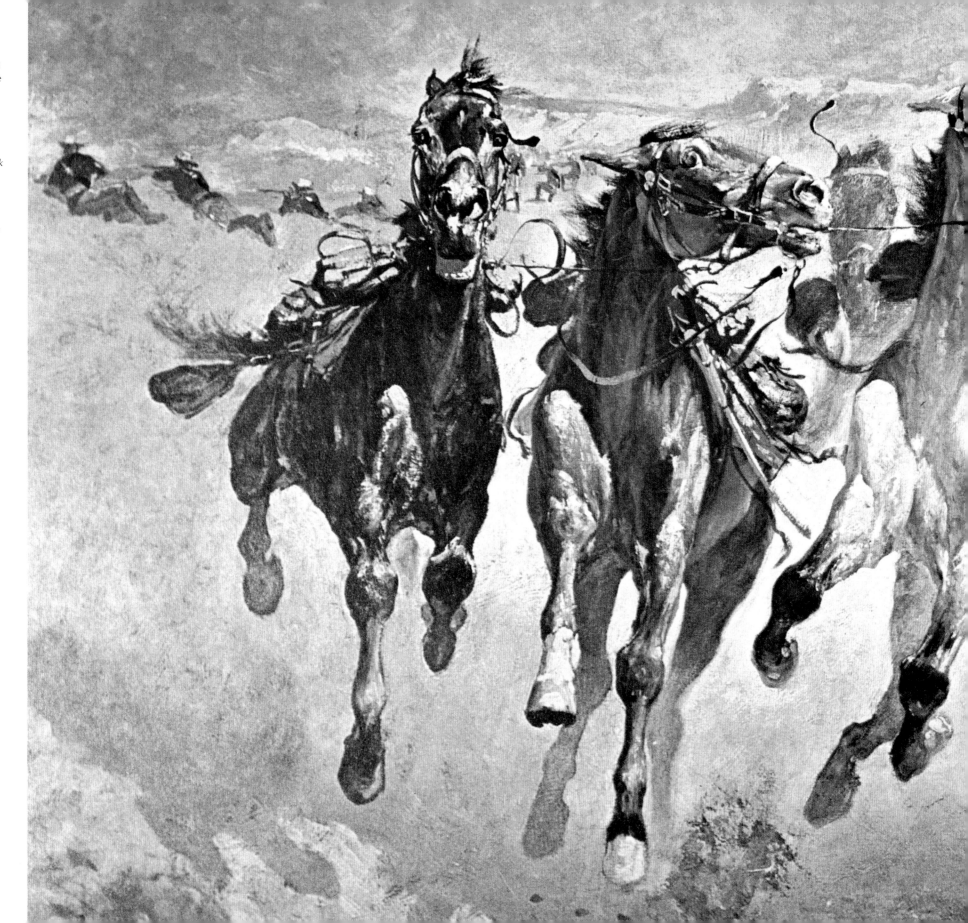

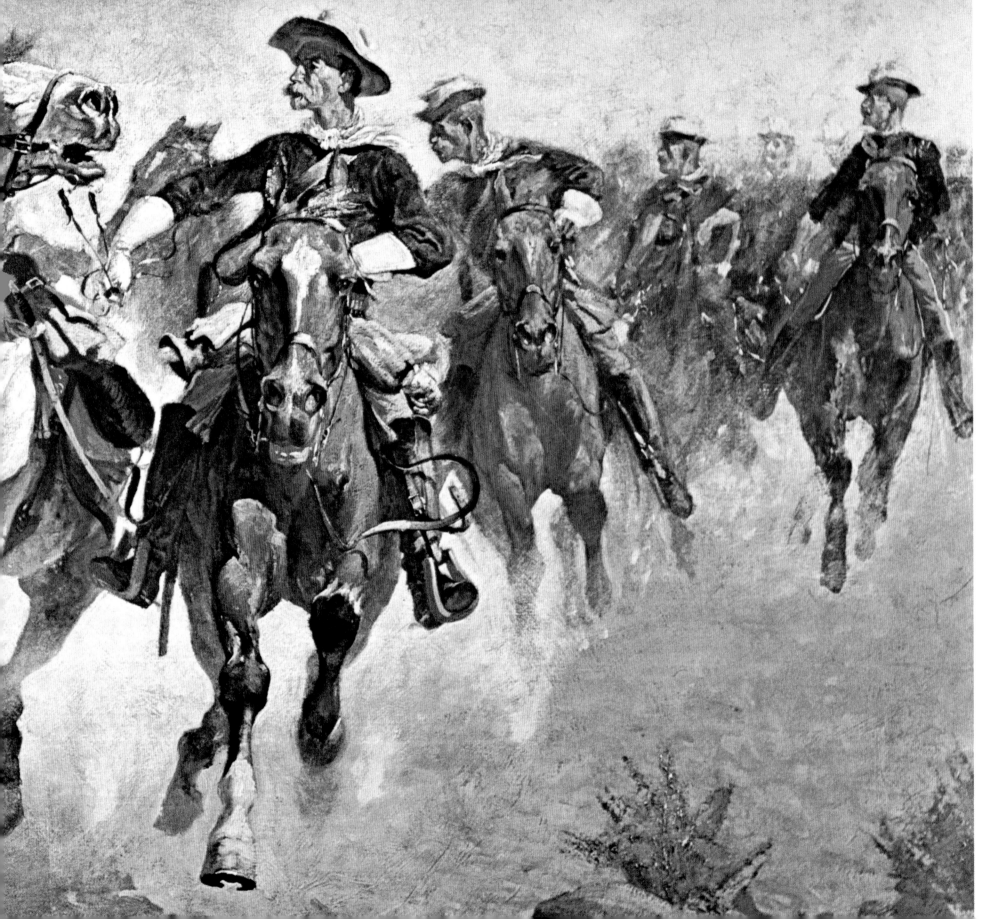

LEFT: *Dismounted: the 4th Troopers Moving*, originally painted 1890, color lithograph after Remington. *Private Collection, Peter Newark American Pictures/The Bridgeman Art Library*

41

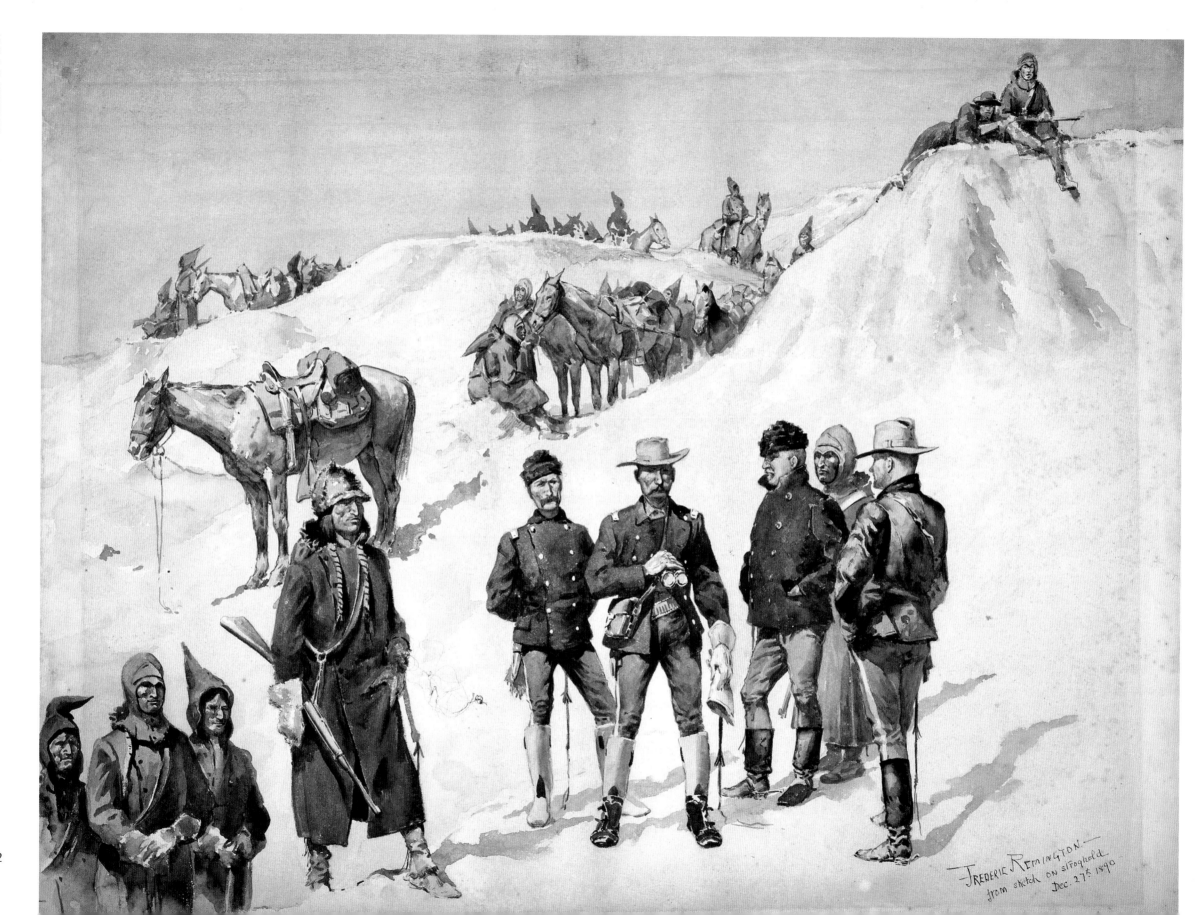

FREDERIC REMINGTON—
from sketch on stronghold
Dec. 27th 1890

LEFT: *Watching the Hostilities from the Bluffs of the Stronghold, Lieutenants Casey, Getty and Struthers, Cheyenne scouts, Wolf Voice, F. Remington, in South Dakota.* Grisaille, December 27th, 1890. Published in *Harper's Weekly*, January 31, 1891. *The Art Archive/Buffalo Bill Historical Center, Cody, Wyoming/10.76*

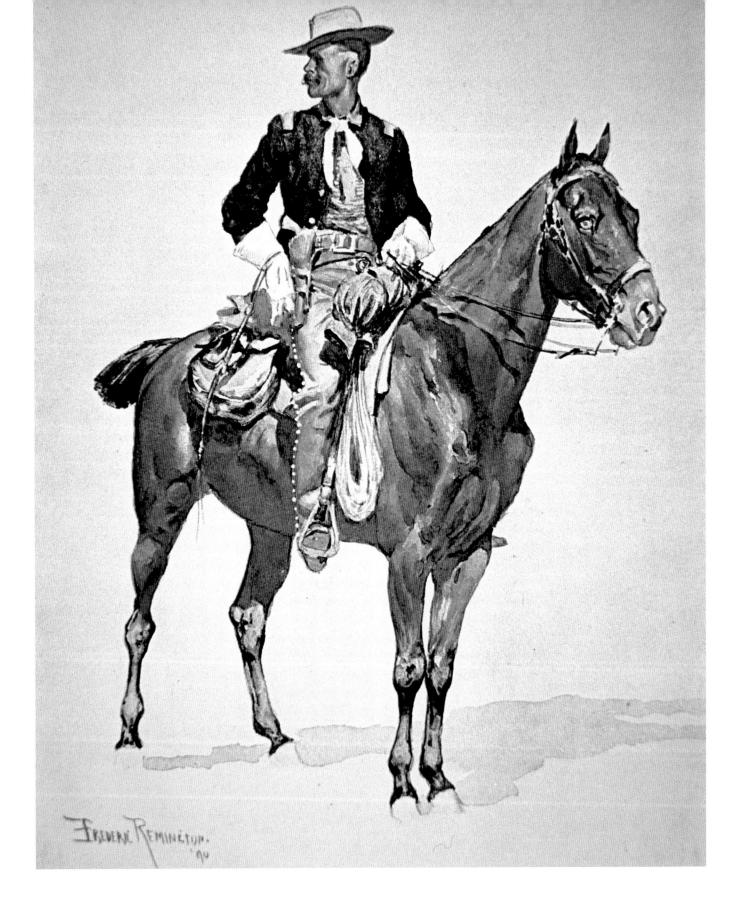

LEFT: *Lieutenant S.C. Robertson, Chief of the Crow Scouts,* color lithograph after a watercolor of 1890. Lt. Robertson wears a blue military jacket with gold epaulettes, a white kerchief, leather chaps, and a broad brimmed hat and is absolutely in command of his chestnut horse. *Private Collection/Peter Newark American Pictures/The Bridgeman Art Library*

RIGHT: *A Cavalryman's Breakfast on the Plains*, color lithograph from an oil painting c.1890. *Private Collection, Peter Newark American Pictures/The Bridgeman Art Library*

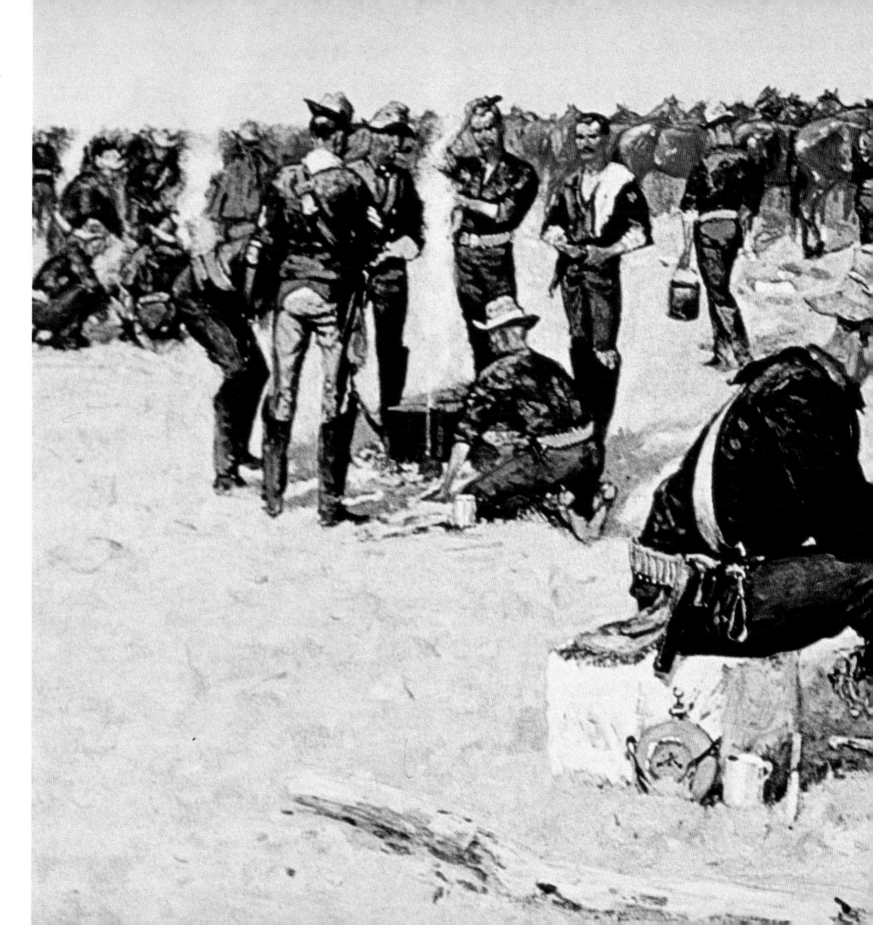

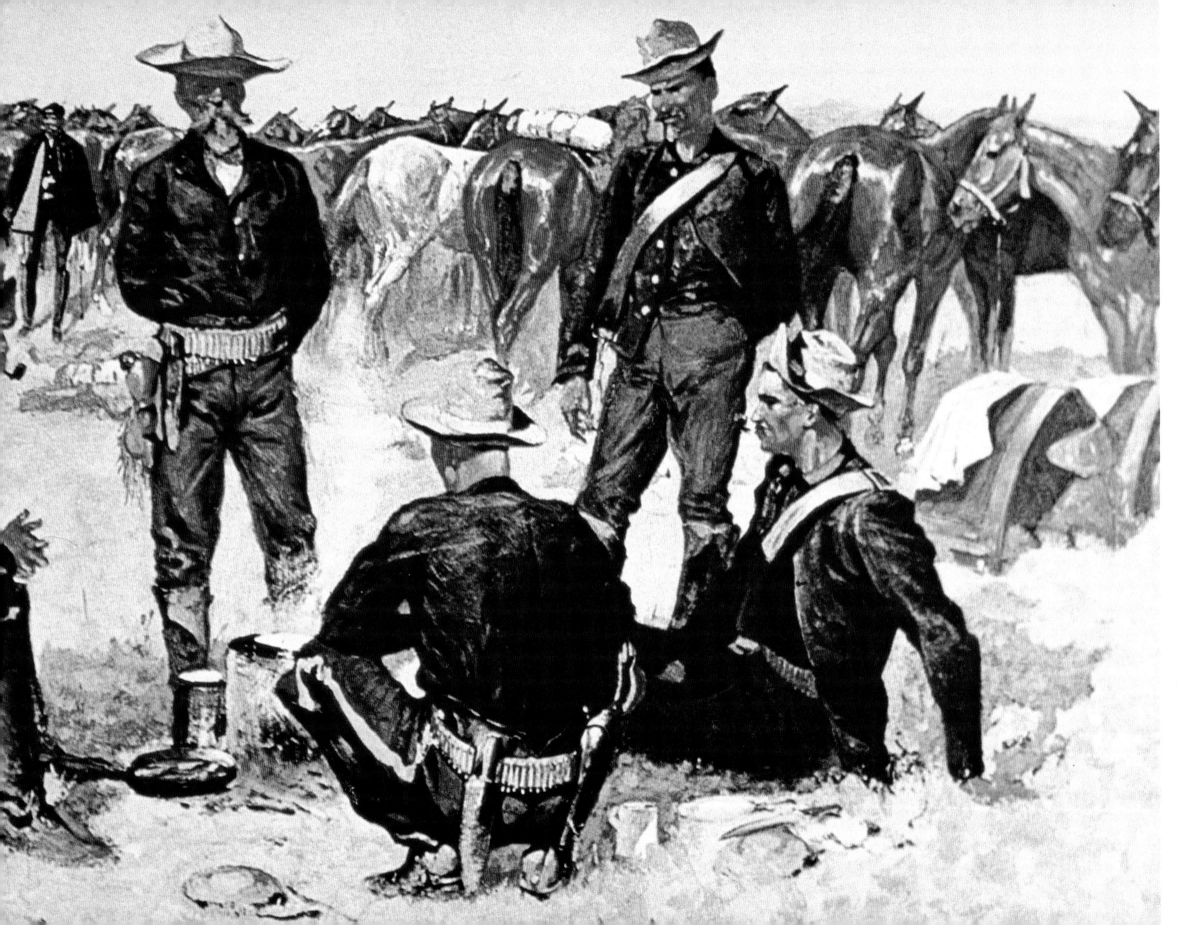

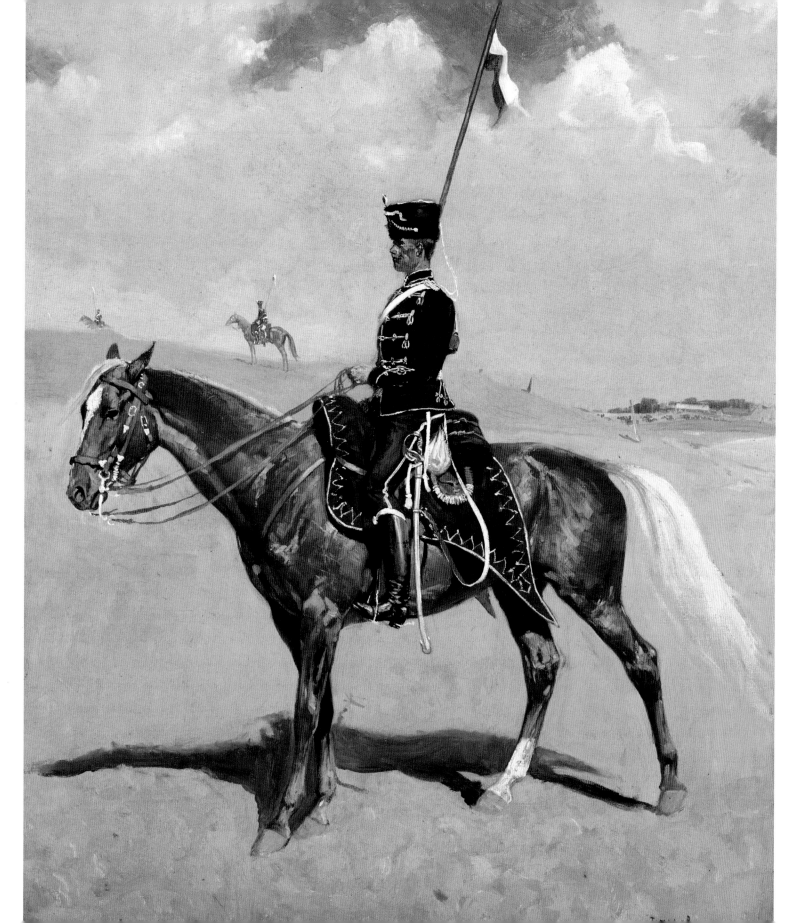

LEFT: *The Hussar* (or *Private of the Hussars: A German Hussar*), oil on canvas, 1892–93. Remington visited Germany and Russia with his old Yale friend Poultney Bigelow, who was also an old friend of Kaiser Wilhelm II, and through whom he got himself and Remington unprecedented access to the German military. *Museum of Fine Arts, Houston, Texas, USA/Hogg Brothers Collection, Gift of Miss Ima Hogg/The Bridgeman Art Library*

RIGHT: *An Amoor Cossack* (or *Cossack of the Amoors*), watercolor, pen, and ink on paper, 1892–94. Remington was unable to make any sketches or notes in Russia for fear of being arrested as a spy—both he and Bigelow were constantly watched. Instead, Remington relied on his remarkable memory and worked on his sketches after he left the country. *Museum of Fine Arts, Houston, Texas, USA, Hogg Brothers Collection, Gift of Miss Ima Hogg/The Bridgeman Art Library*

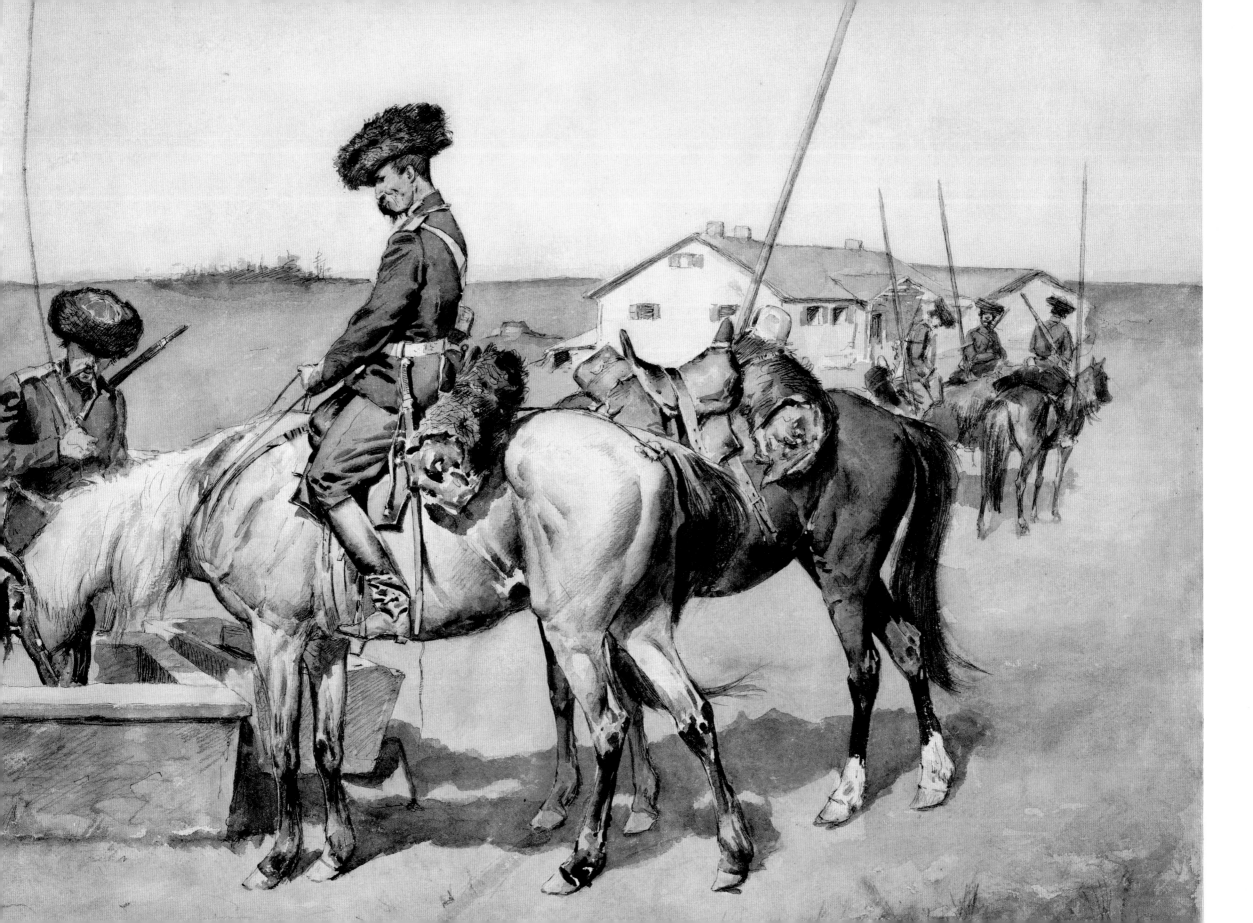

RIGHT: *Scouts Climbing a Mountain.* Oil on canvas, 1891. *Museum of Fine Arts, Houston, Texas, USA/The Bayou Bend Collection, gift of Miss Ima Hogg/The Bridgeman Art Library*

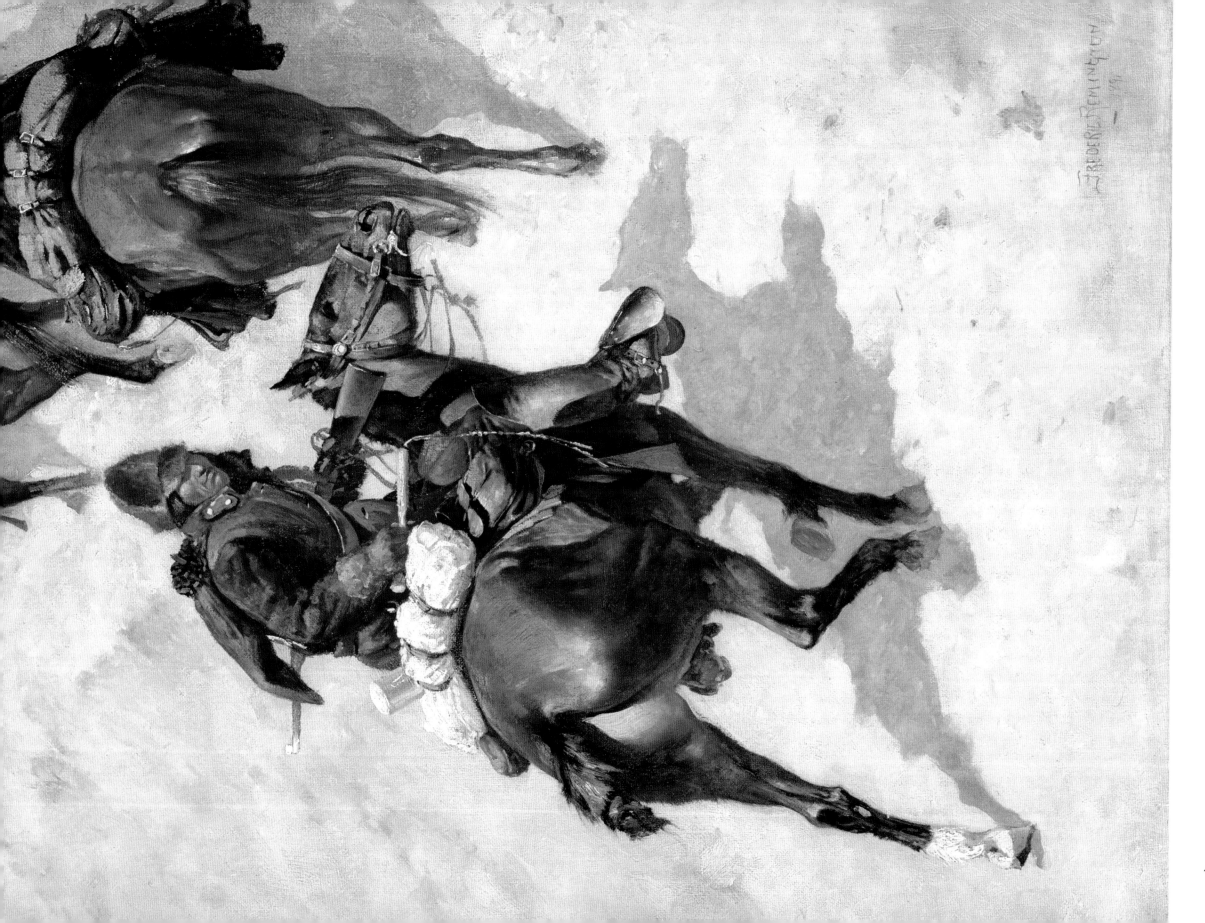

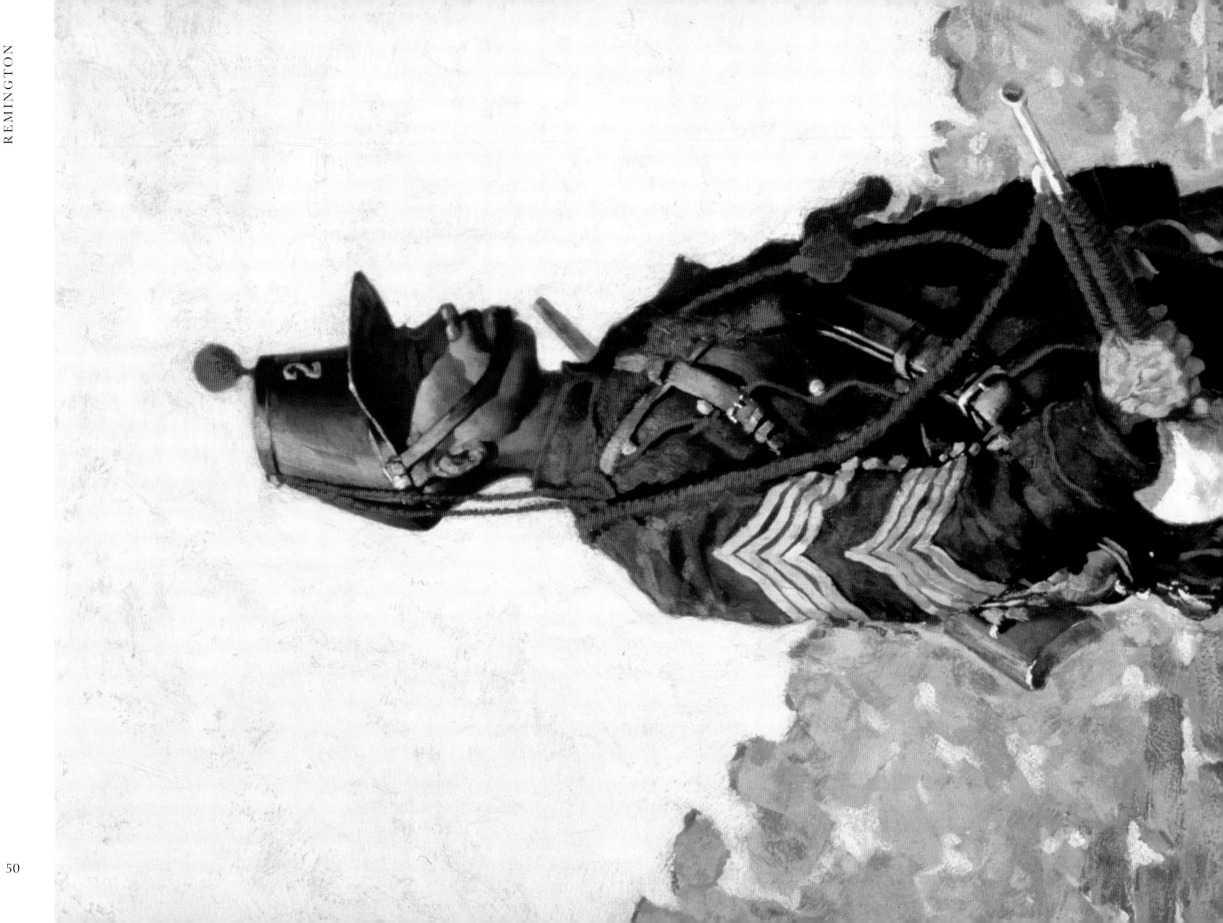

LEFT: *Bugler of the Cavalry.* Private Collection/ Photo © Christie's Images/The Bridgeman Art Library

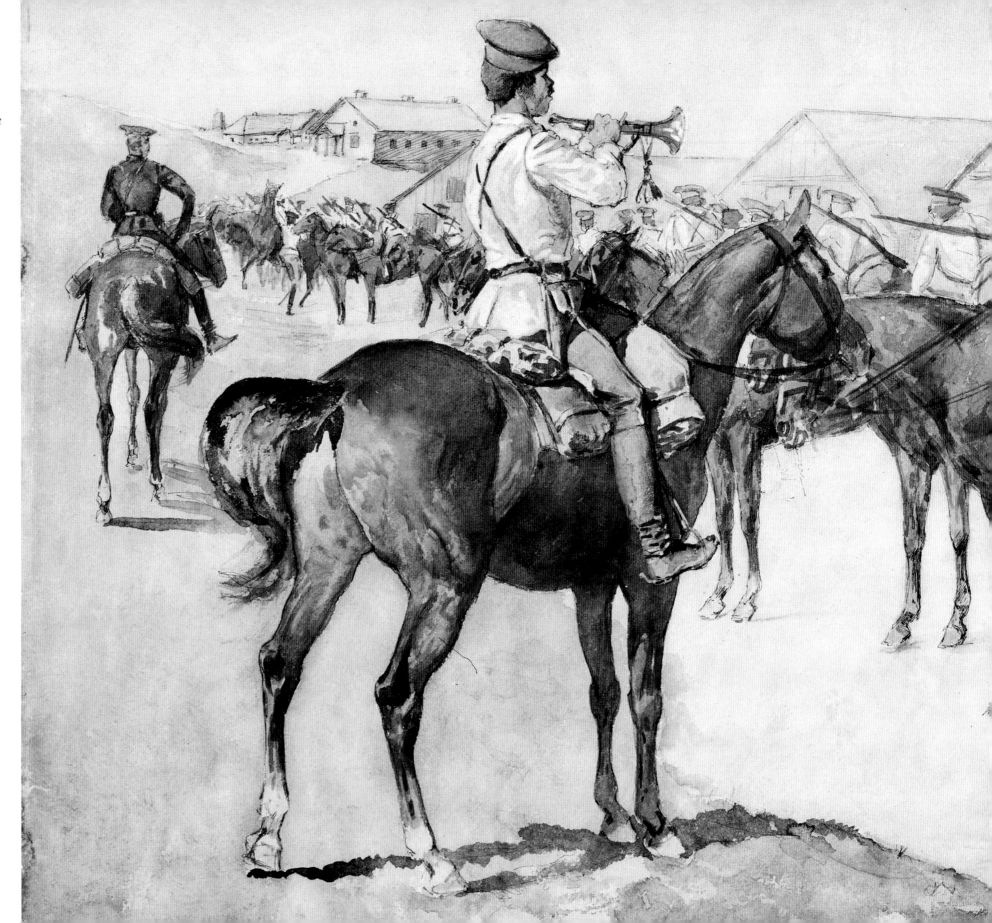

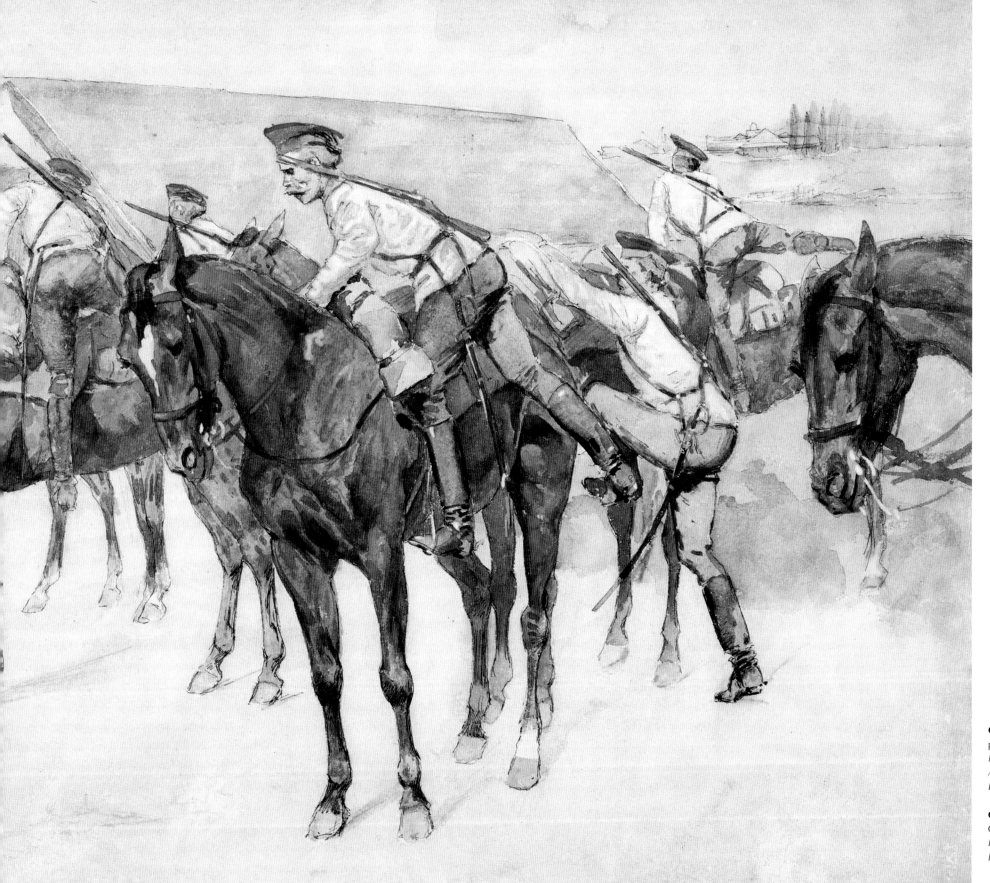

Over page left: *Texas Rangers.* Lithograph, published in *Harper's Monthly*, 1896. *Private Collection/ Peter Newark American Pictures/The Bridgeman Art Library*

Over page right: *Trooper of the Plains.* Oil on panel. *David David Gallery, Philadelphia, PA, USA/The Bridgeman Art Library*

53

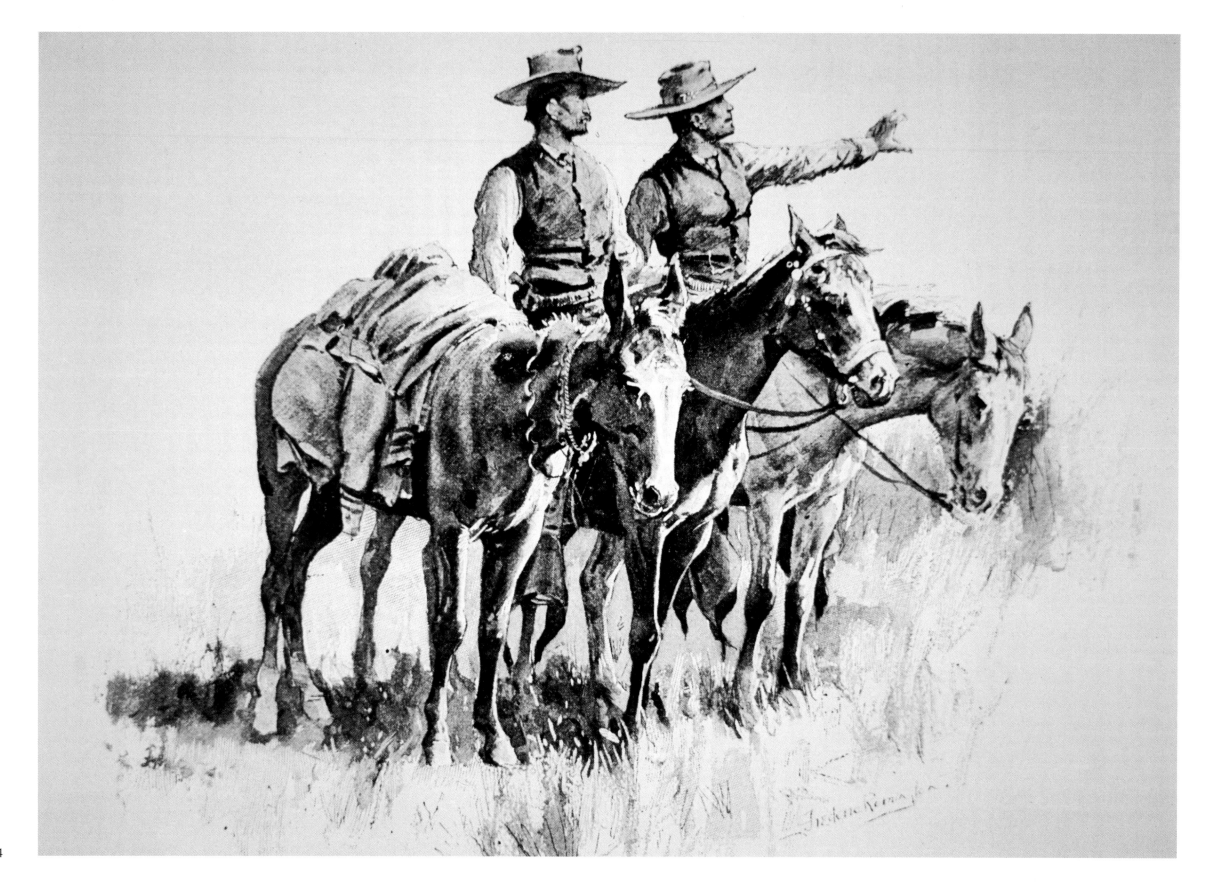

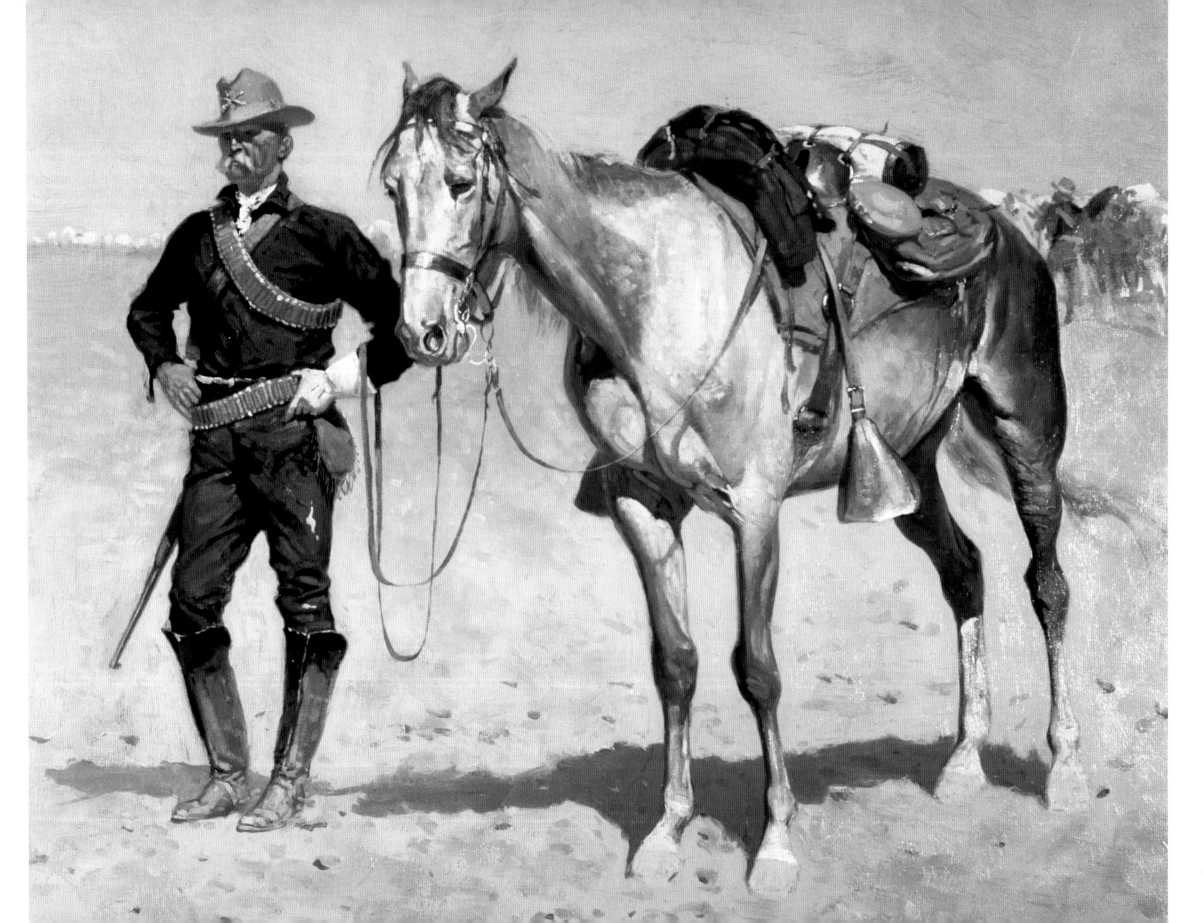

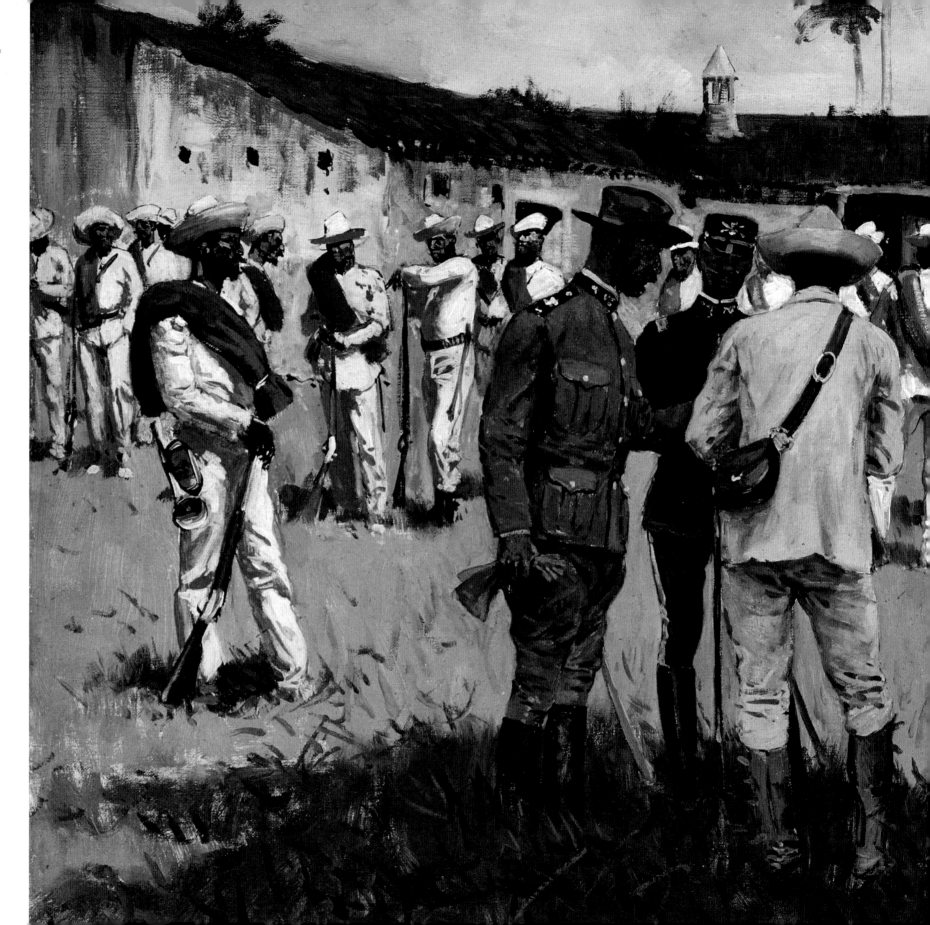

RIGHT: *Disbanding Gomez' Army*. Oil on canvas, 1899. Maximo Gomez y Baez was the leader of the guerillas during Cuba's Independence War. *Museum of Fine Arts, Houston, Texas, USA/Hogg Brothers Collection, Gift of Miss Ima Hogg/The Bridgeman Art Library*

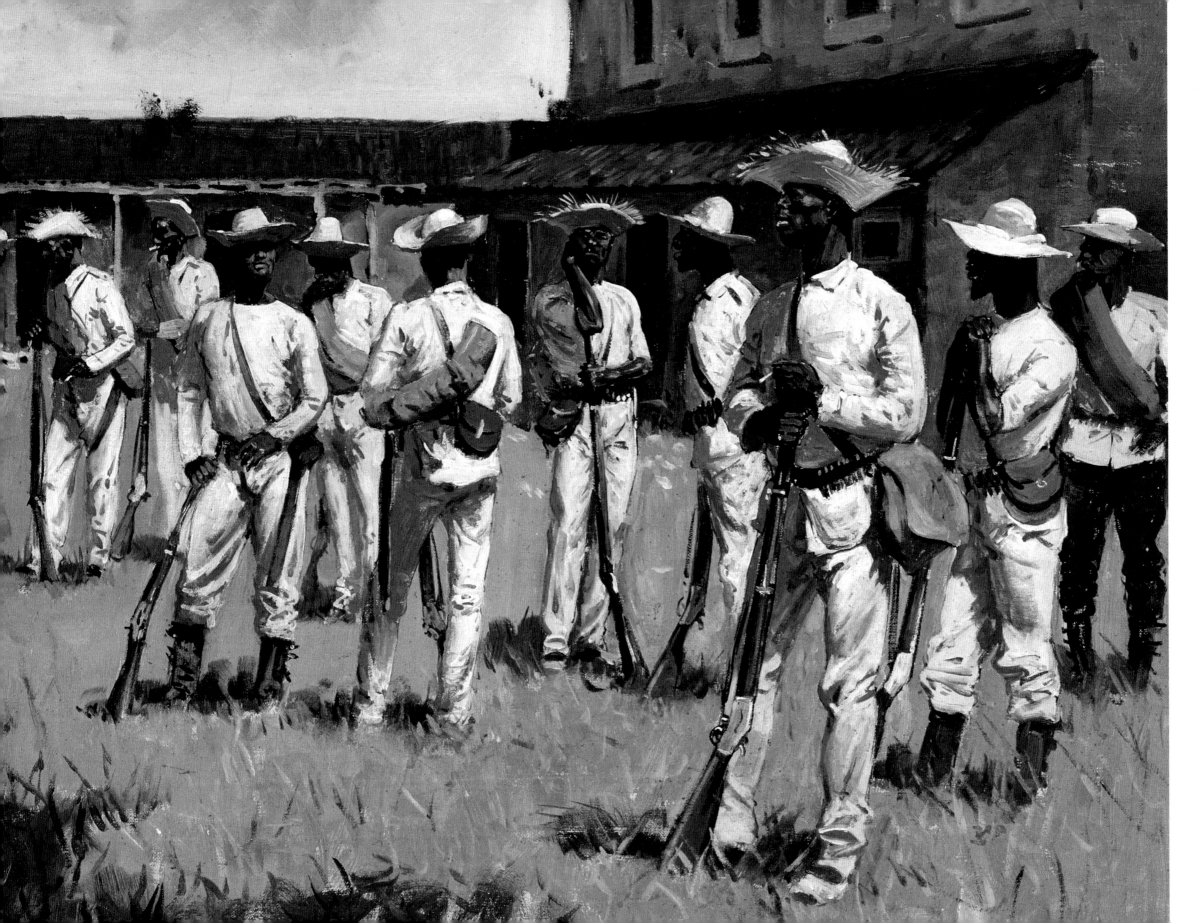

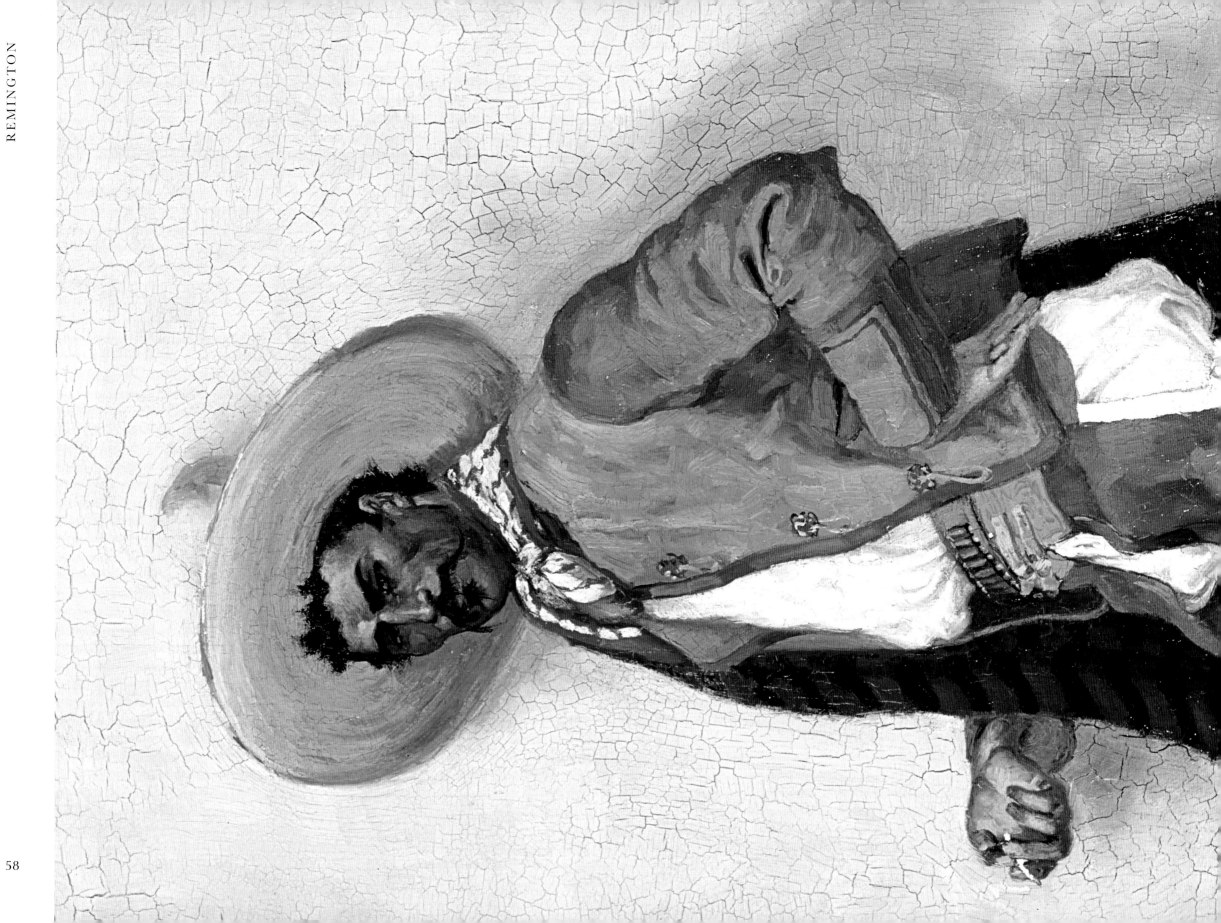

LEFT: *A Vaquero*. Oil on panel.
© *Private Collection/Photo*
© *Christie's Images/The Bridgeman Art Library*

59

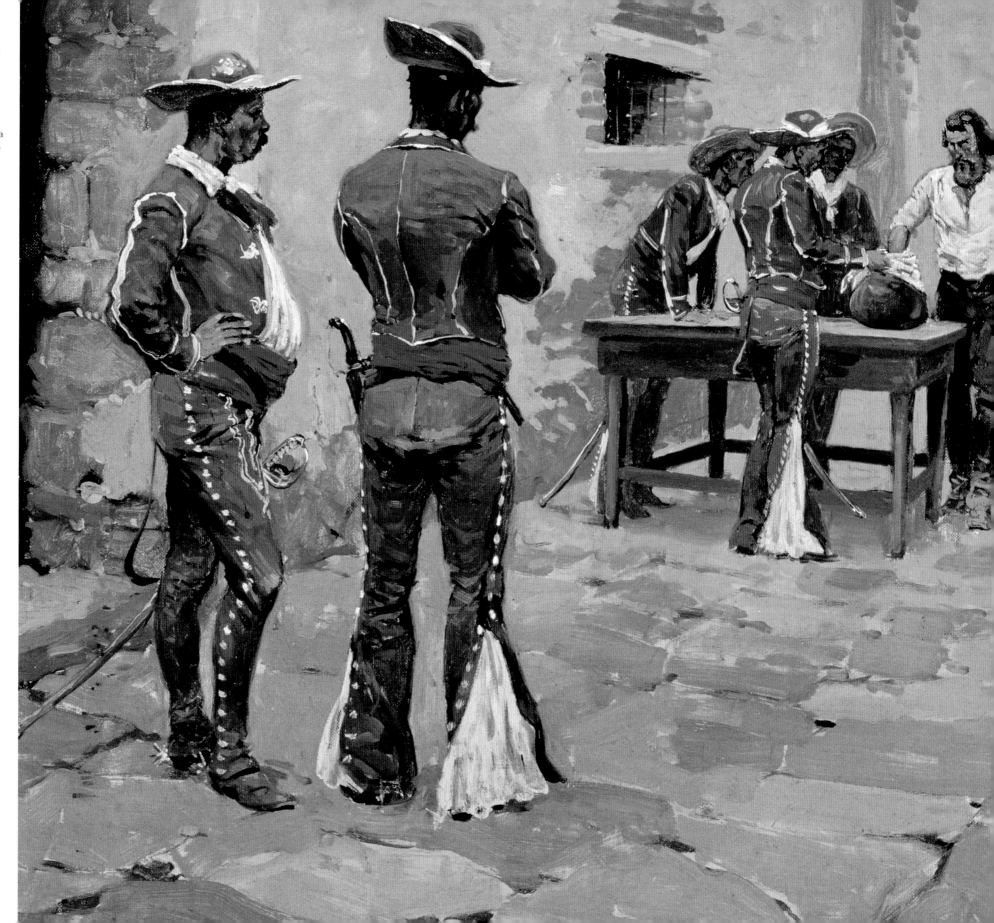

RIGHT: *The Mier Expedition: The Drawing of the Black Bean* (or *Prisoners Drawing their Beans*). Oil on canvas, 1869. The notorious Mier Expedition in December 1842 was a failed raid by a group of Texan militia on the Mexican border town of Cuidad Mier. The captured militia men had to draw beans from a pot to see who would die: 17 black (death) beans, and 159 white beans. *Museum of Fine Arts, Houston, Texas, USA/ Hogg Brothers Collection, Gift of Miss Ima Hogg/The Bridgeman Art Library*

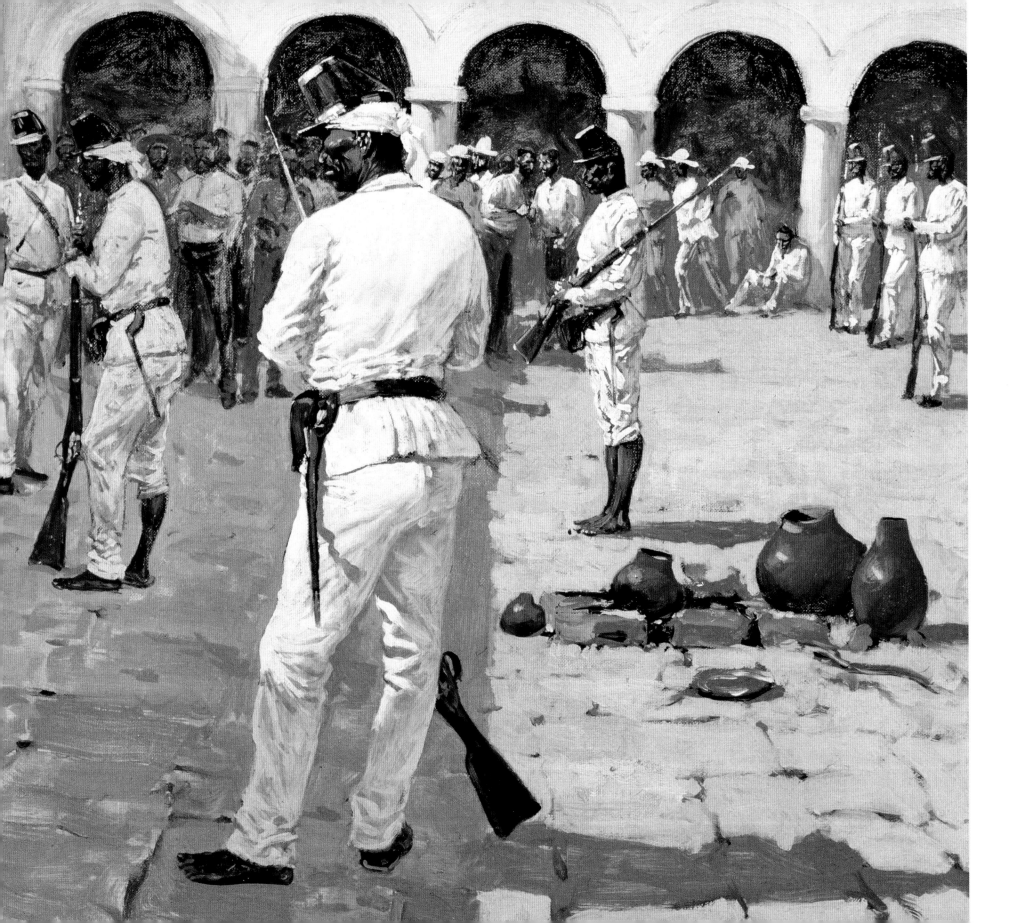

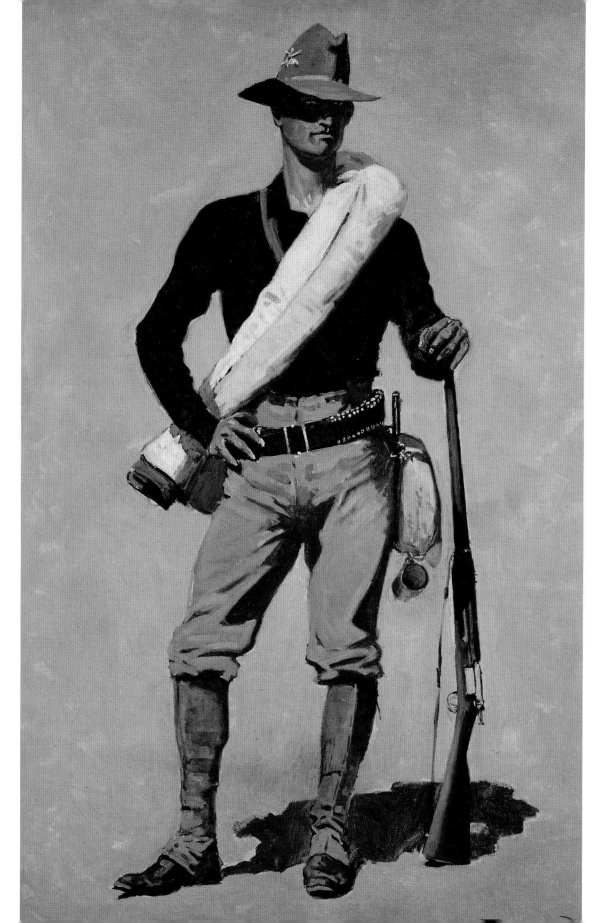

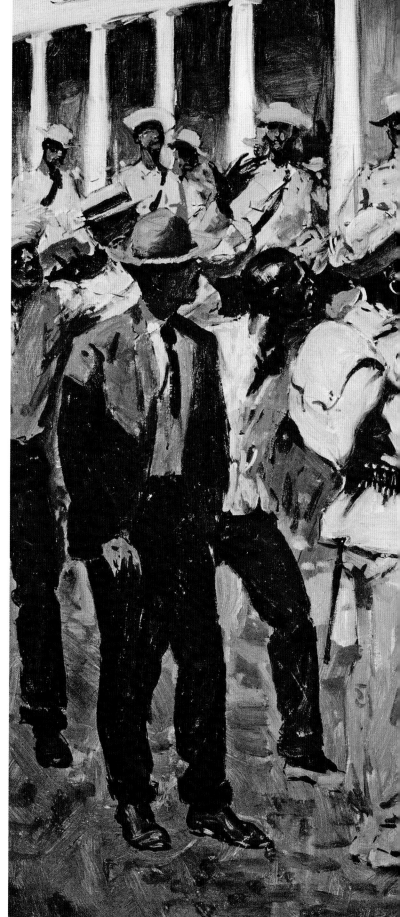

LEFT: *U.S. Soldier, Spanish-American War* (or *A First-Class Fighting Man*). Oil on canvas, 1899. Remington worked as a correspondent throughout the war with particular attention to his beloved cavalry. The resulting work was an illustrated piece entitled *With the Fifth Corps* for *Harper's Monthly*. © *Museum of Fine Arts, Houston, Texas, USA/Hogg Brothers Collection, Gift of Miss Ima Hogg/The Bridgeman Art Library*

RIGHT: *The Return of Gomez to Havana*. Oil on canvas, 1899. In 1898 the U.S. united with Gomez and the Cuban guerillas in their battle to rid Cuba of Spanish occupation. The Spanish quickly collapsed and the war ended with the Treaty of Paris, signed on December 10, 1898. *Museum of Fine Arts, Houston, Texas, USA, Hogg Brothers Collection, Gift of Miss Ima Hogg/The Bridgeman Art Library*

OVER PAGE LEFT: *How Order No. 6 Went Through*, (or *The Vision*). Oil on canvas, c.1898. The painting shows an exhausted courier banishing a hallucination of a Native American spirit and originally accompanied an article of the same name "As told by Sun-Down LeFlare" and published in *Harper's Monthly*, May 1898. In the article the illustration was captioned, "She was keep off jus' front of my pony". © *Private Collection, New York, USA/The Bridgeman Art Library*

OVER PAGE RIGHT: *Apache Scouts Listening*. Oil on canvas, 1908. Such scouts were famous for their tracking skills and their physical fitness and ability to melt into the landscape and survive in the wilderness. *Private Collection/David Findlay Jr Fine Art, NYC, USA/The Bridgeman Art Library*

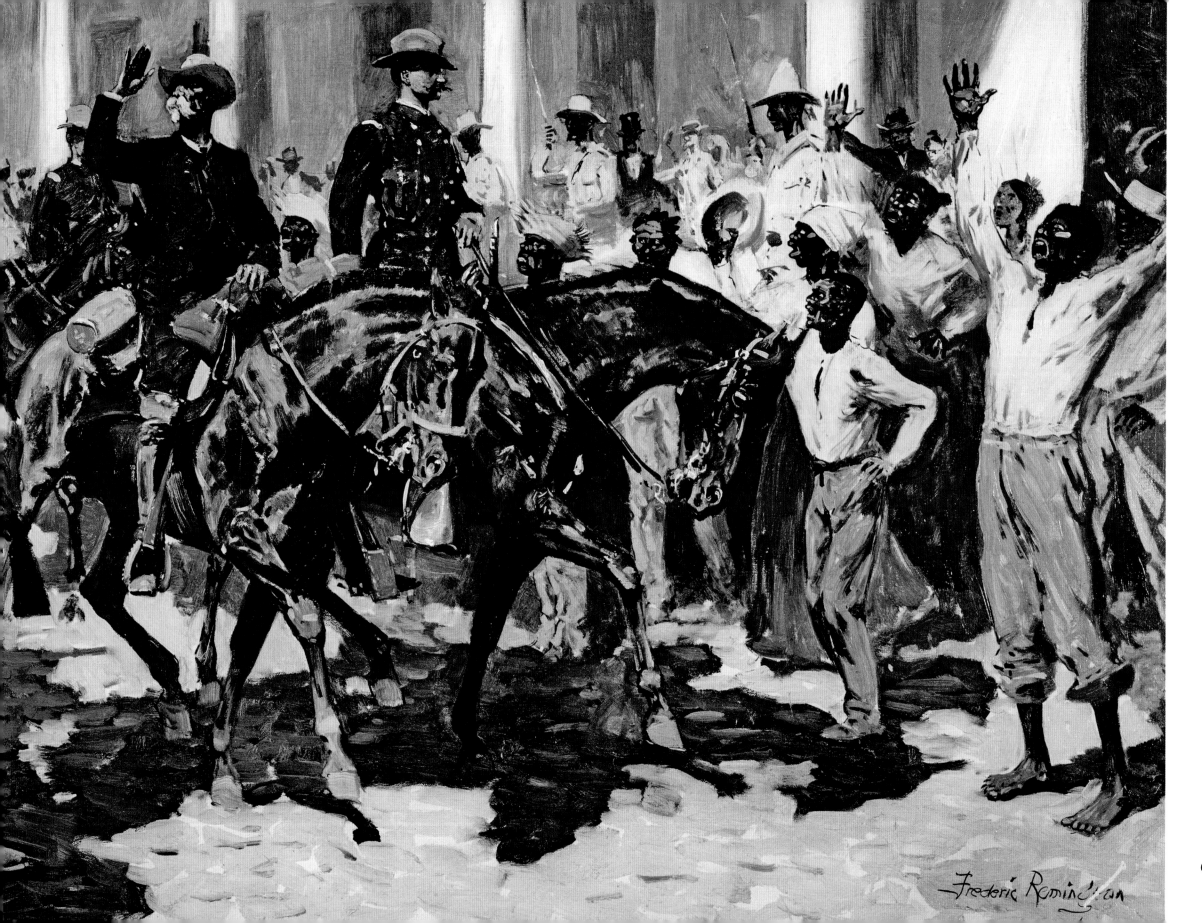

Frederic Remington

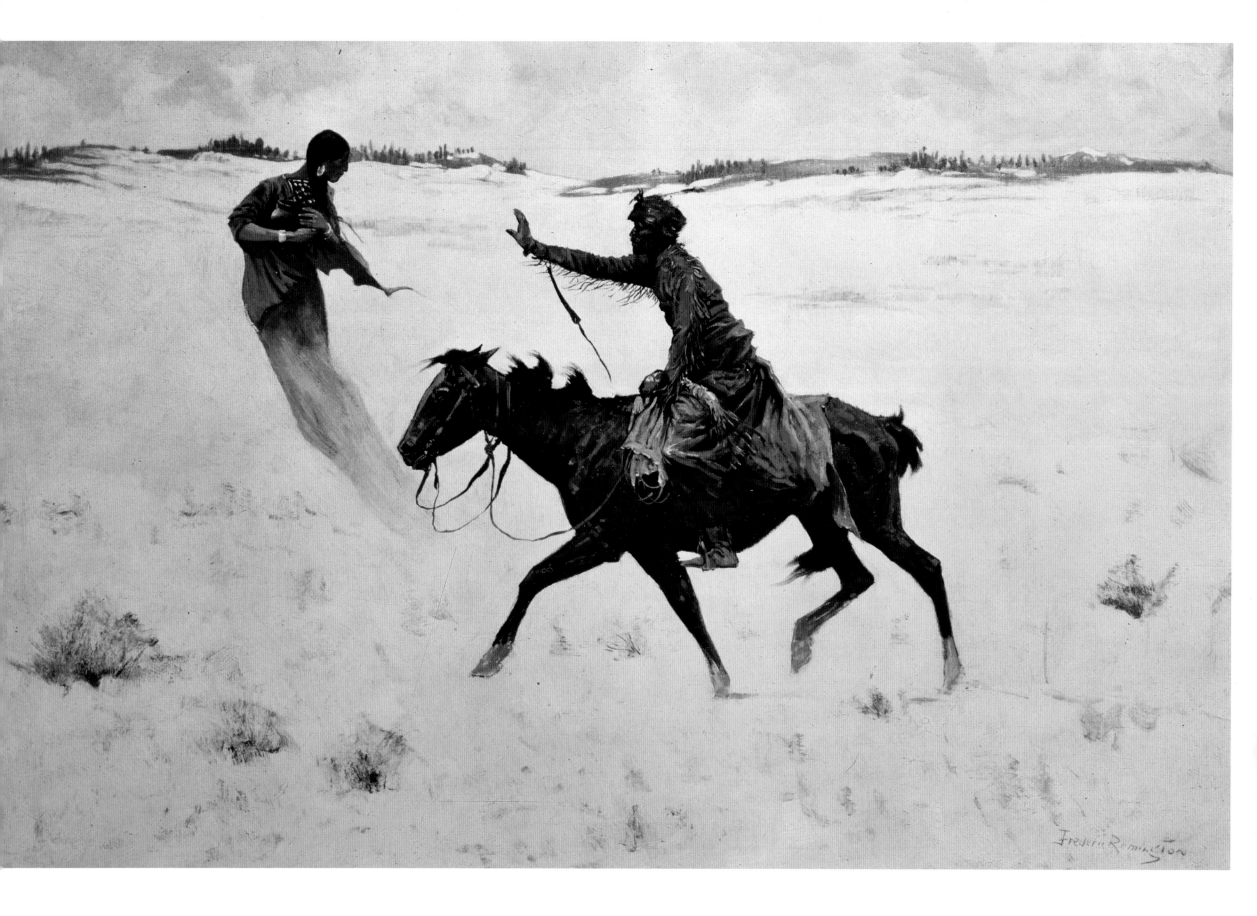

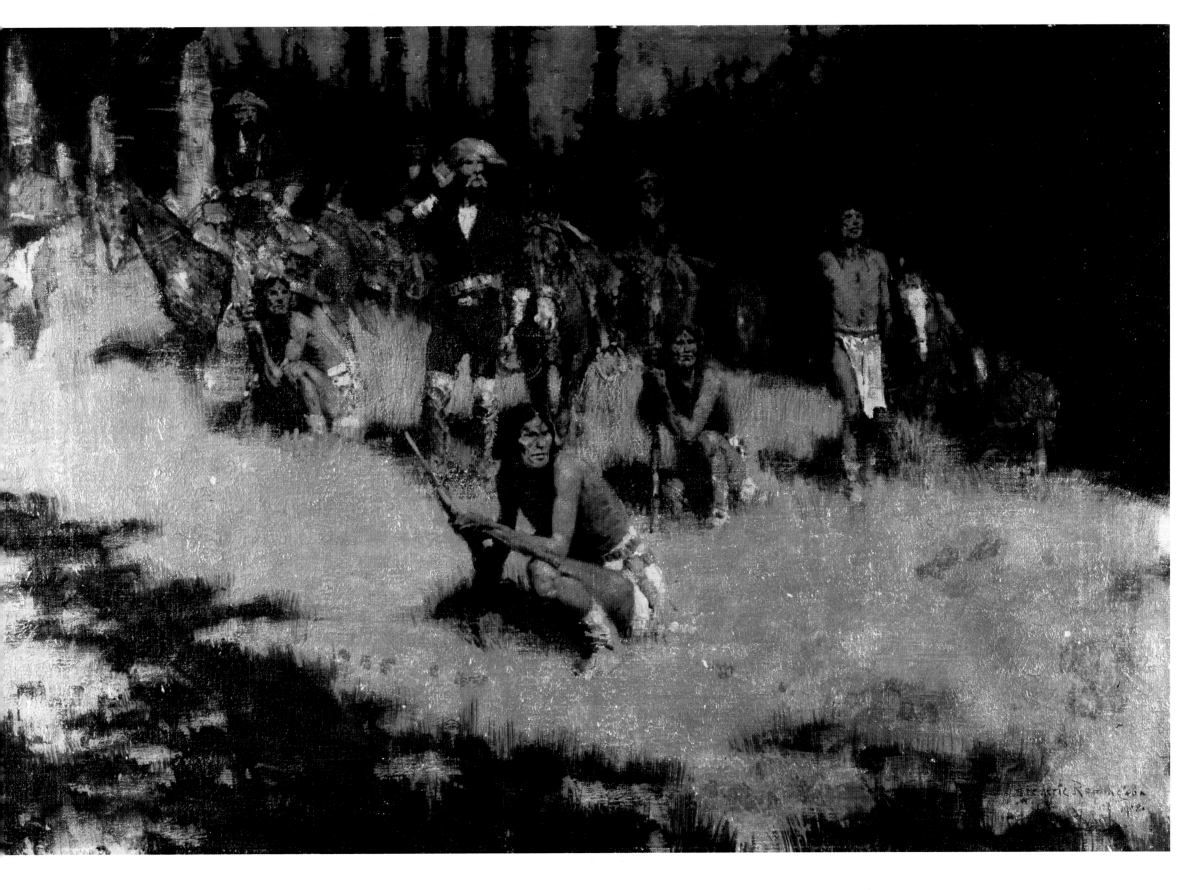

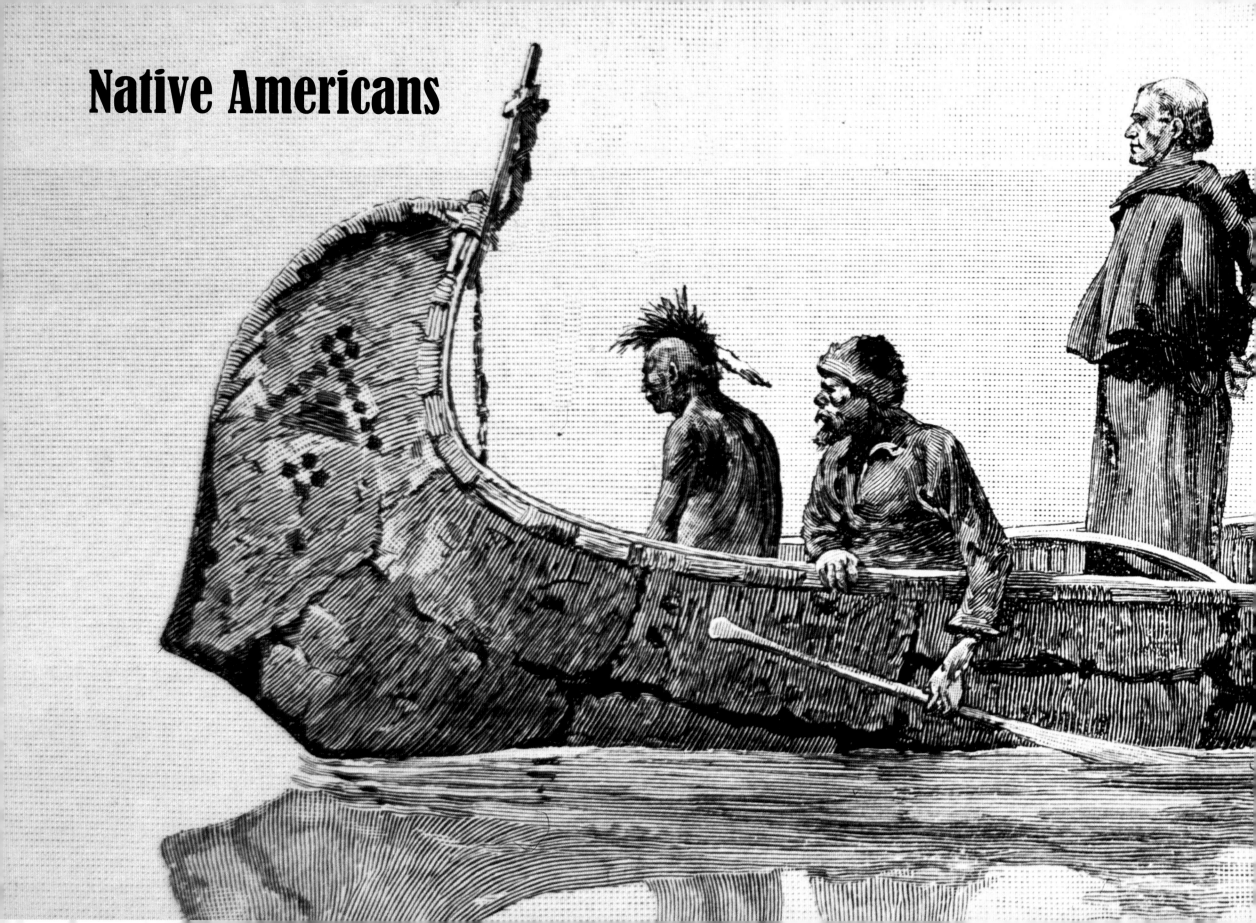

Native Americans

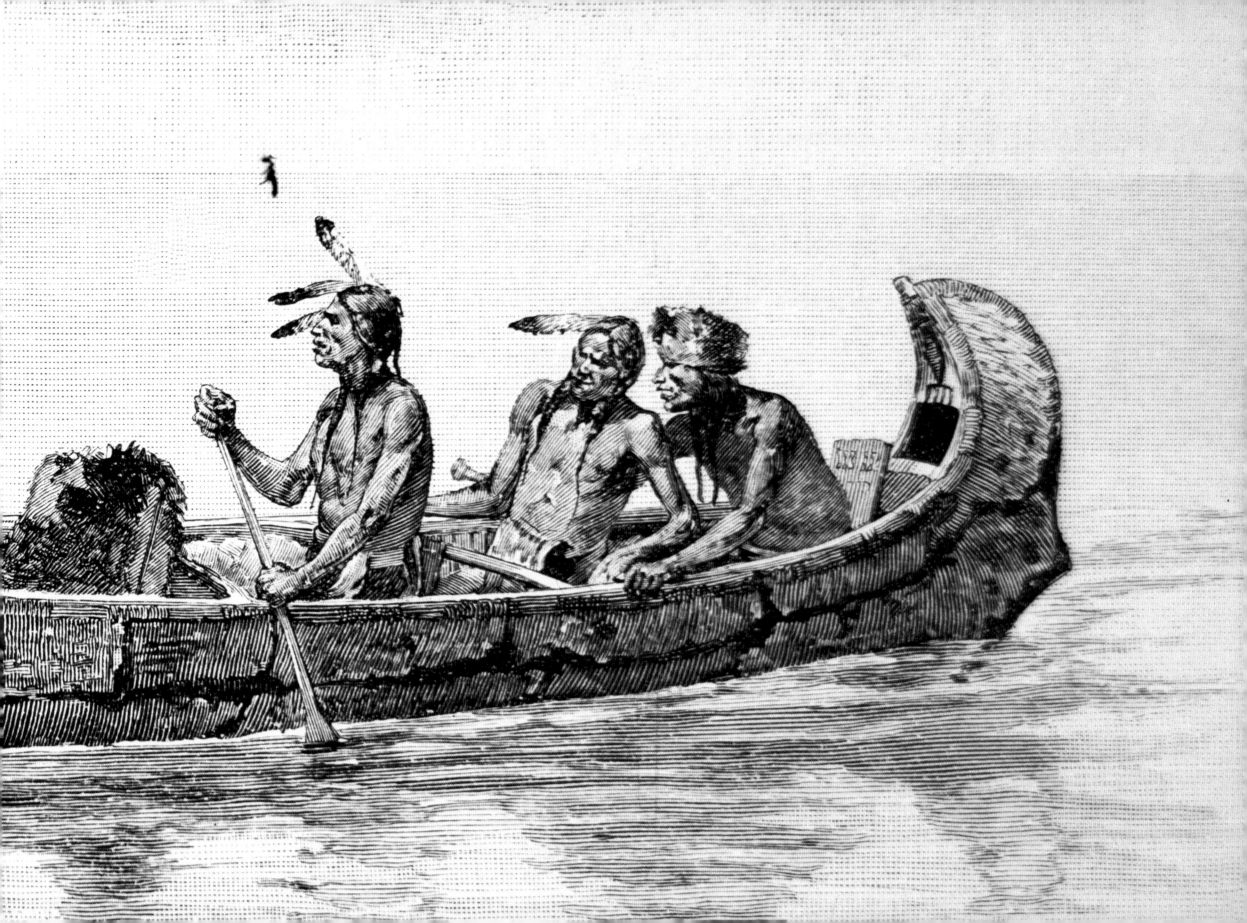

Native Americans

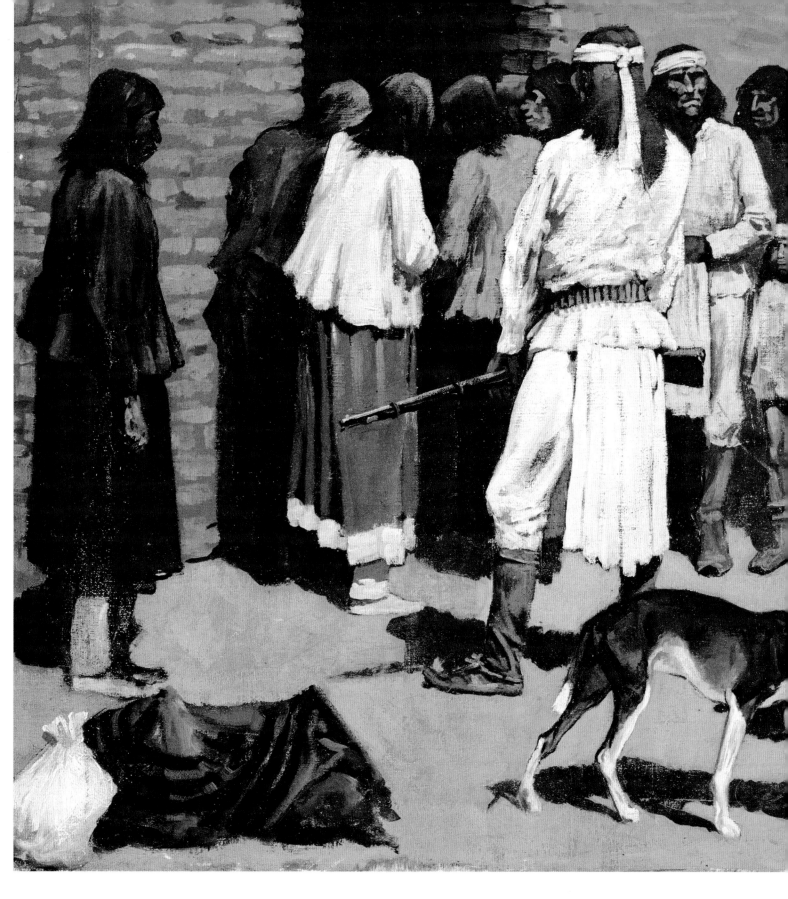

In common with his compatriots Frederic Remington was fascinated with the native tribes and with their unique way of life. Unlike most Americans, however, he journeyed to their lands he where he met and came to understand their plight and become not unsympathetic to their cause. He too felt that the rapid expansion westward was to the detriment of the previously unspoiled natural landscapes and of the indigenous peoples. Remington's interest in the Native American tribes started with his father's tales and intensified with stories of the Battle of Little Bighorn which were in common circulation at the time. Later, when he was a young man, all the public interest was in Geronimo, the elusive and charismatic leader of the Chiricahua Apaches in Arizona, and Remington was lucky enough to be commissioned by *Harper's Weekly* in June 1886 to go to the Southwest and find him. In fact, and despite his best endeavors, Remington never even apparently got close, but he did not let this hinder his words and pictures, and indeed most of his public believed that he had had personal contact with Geronimo, or how else could he depict him so convincingly? Remington wrote a number of articles about the Native Americans he encountered and through his numerous travels and personal interest was able to supply informed comment to his readers through articles such as *Artist Wanderings Among the Cheyennes, On the Indian Reservations, The Way of an Indian,* and *The Great Medicine-Horse.*

PREVIOUS PAGES: *The Missionary.* Lithograph after Remington, undated. © *Private Collection/Peter Newark American Pictures/The Bridgeman Art Library*

RIGHT: *Pueblo Indian Village (Distribution of Beef at San Carlos Agency).* Oil on canvas, c.1889. *Museum of Fine Arts, Houston, Texas, USA/Hogg Brothers Collection, Gift of Miss Ima Hogg/The Bridgeman Art Library*

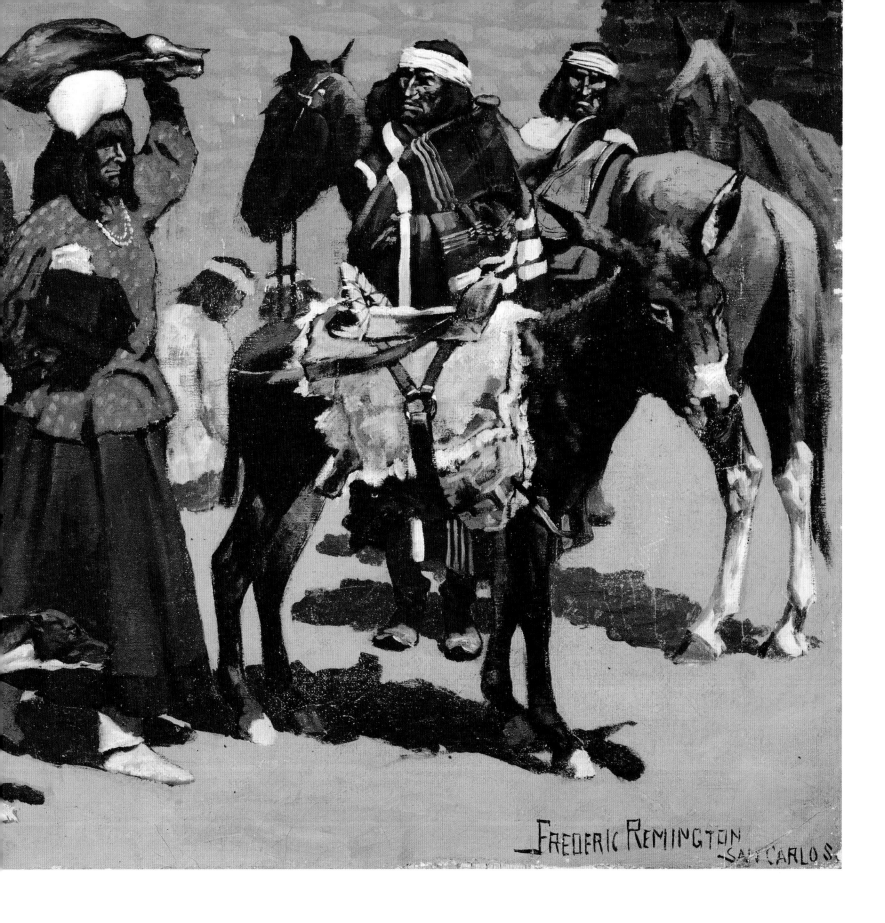

FREDERIC REMINGTON
SAN CARLOS

OVER PAGE LEFT: Untitled painting showing an Indian woman using a prehistoric hoe in a sprouting cornfield looking at an apparition of a ghost in the blue sky. Undated. *The Art Archive/Gift of the Coe Foundation/Buffalo Bill Historical Center, Cody, Wyoming/49.67*

OVER PAGE RIGHT: Untitled painting of two prehistoric Indians planting seeds, accompanied by a dog. Undated. *The Art Archive/ Gift of the Coe Foundation/ Buffalo Bill Historical Center, Cody, Wyoming/ 50.67*

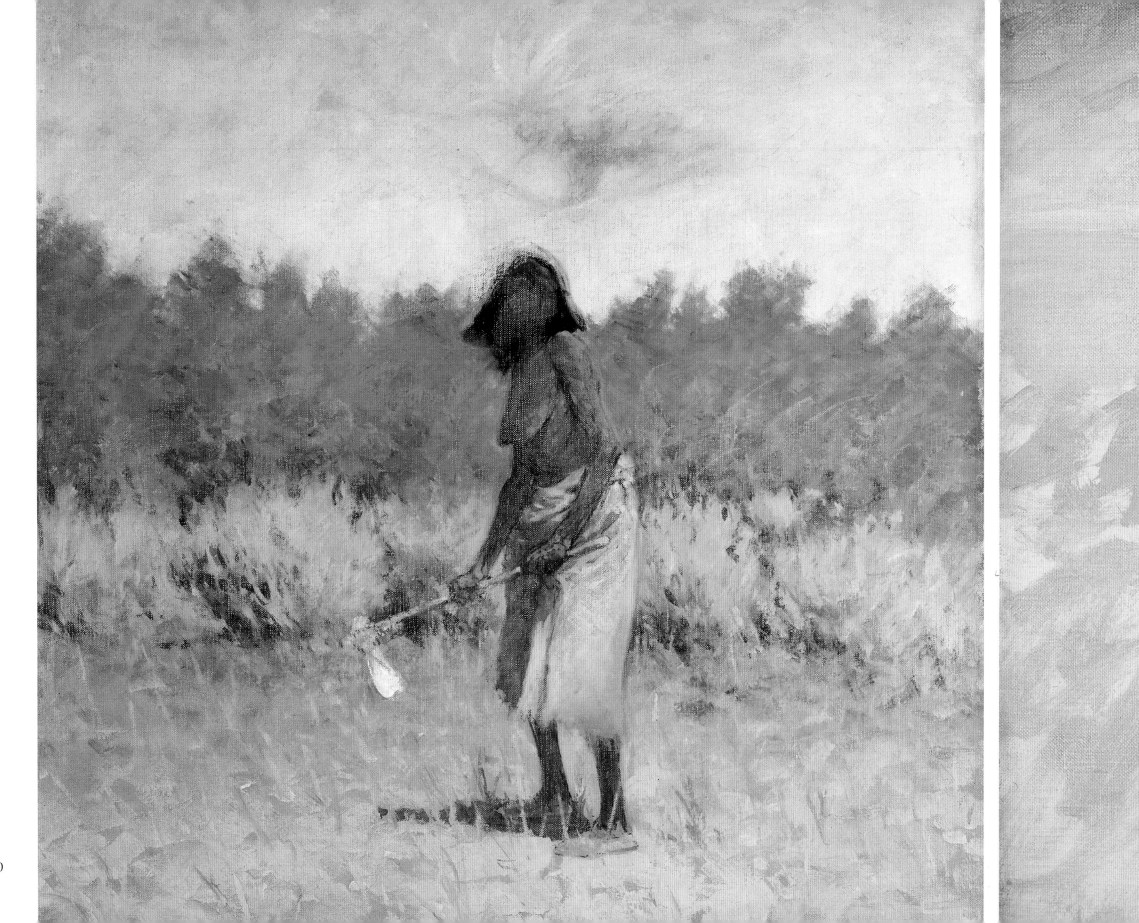

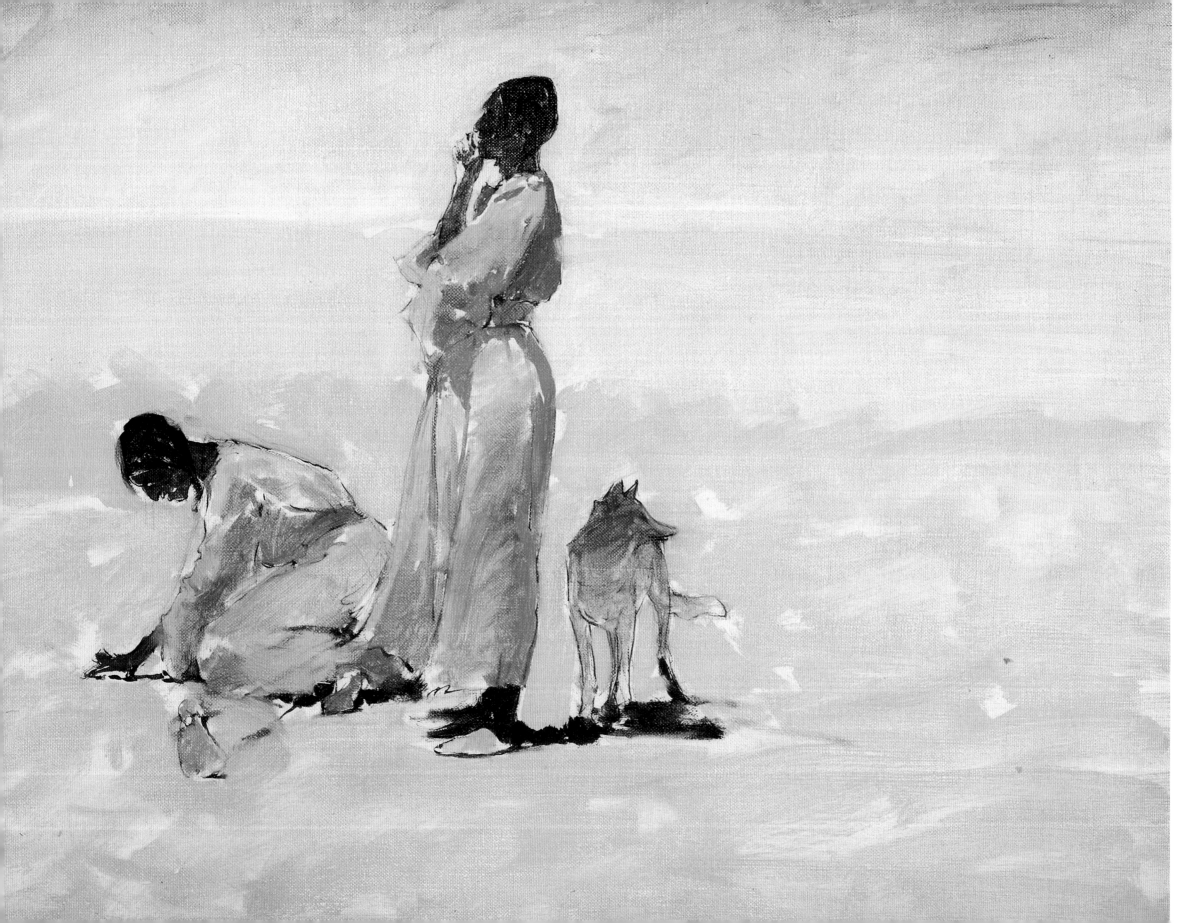

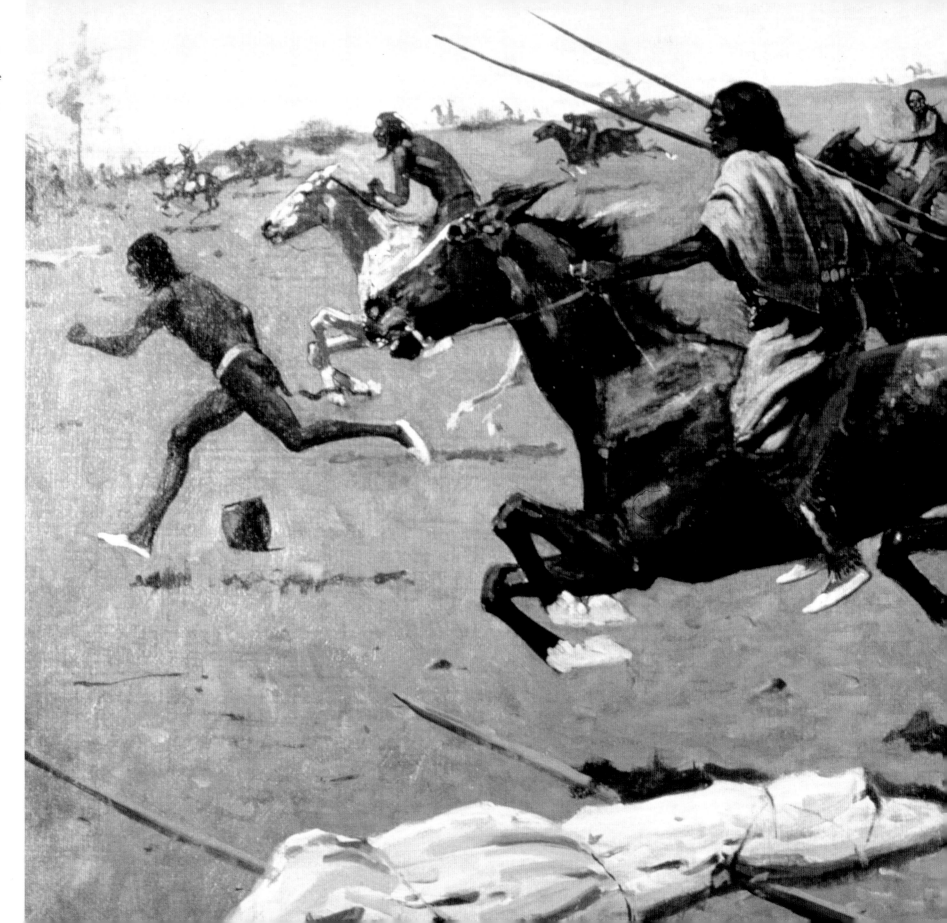

RIGHT: *Indian Village Routed: Geronimo Fleeing from Camp.* Oil on canvas, c. 1885. In 1876 the U.S. government ordered the Chiricahua Apaches to leave their Arizona mountain homelands and move to the San Carlos Reservation. They refused and under their leader Geronimo a small band of warriors raided settlements across Arizona and then attacked U.S. troops in the Whetstone Mountains in January 1877. © *Private Collection/The Bridgeman Art Library*

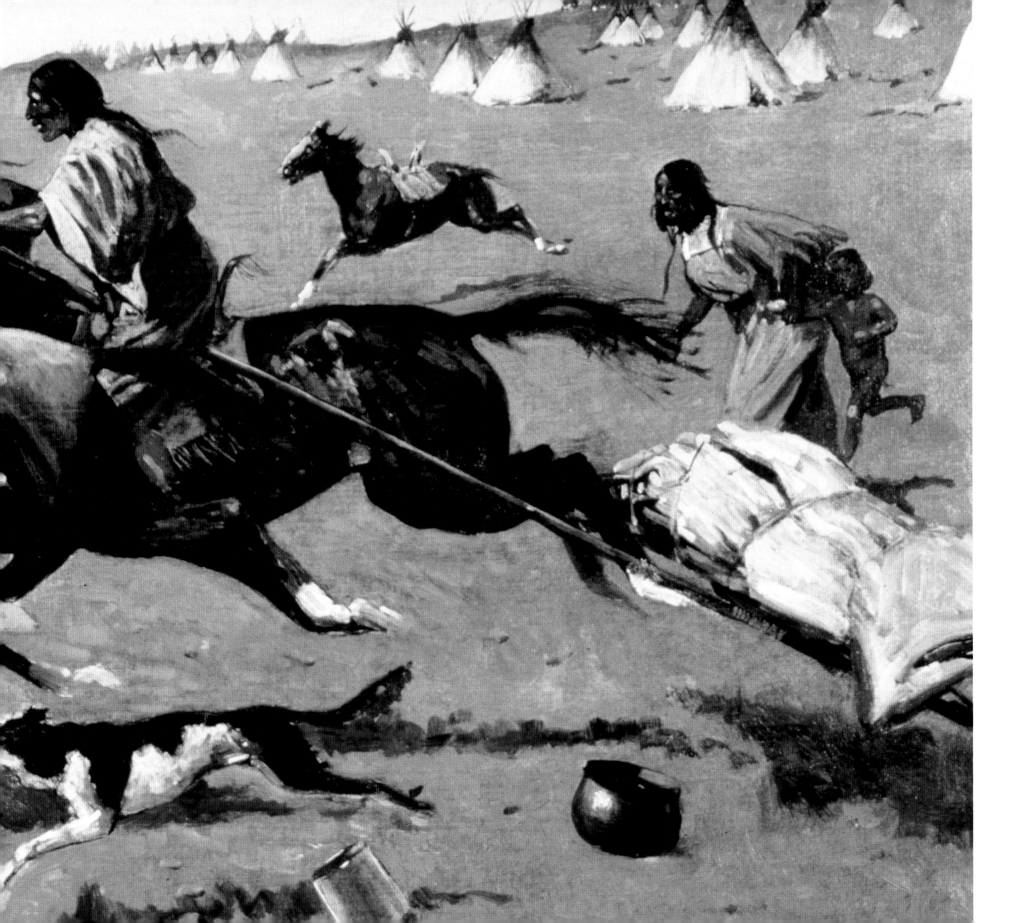

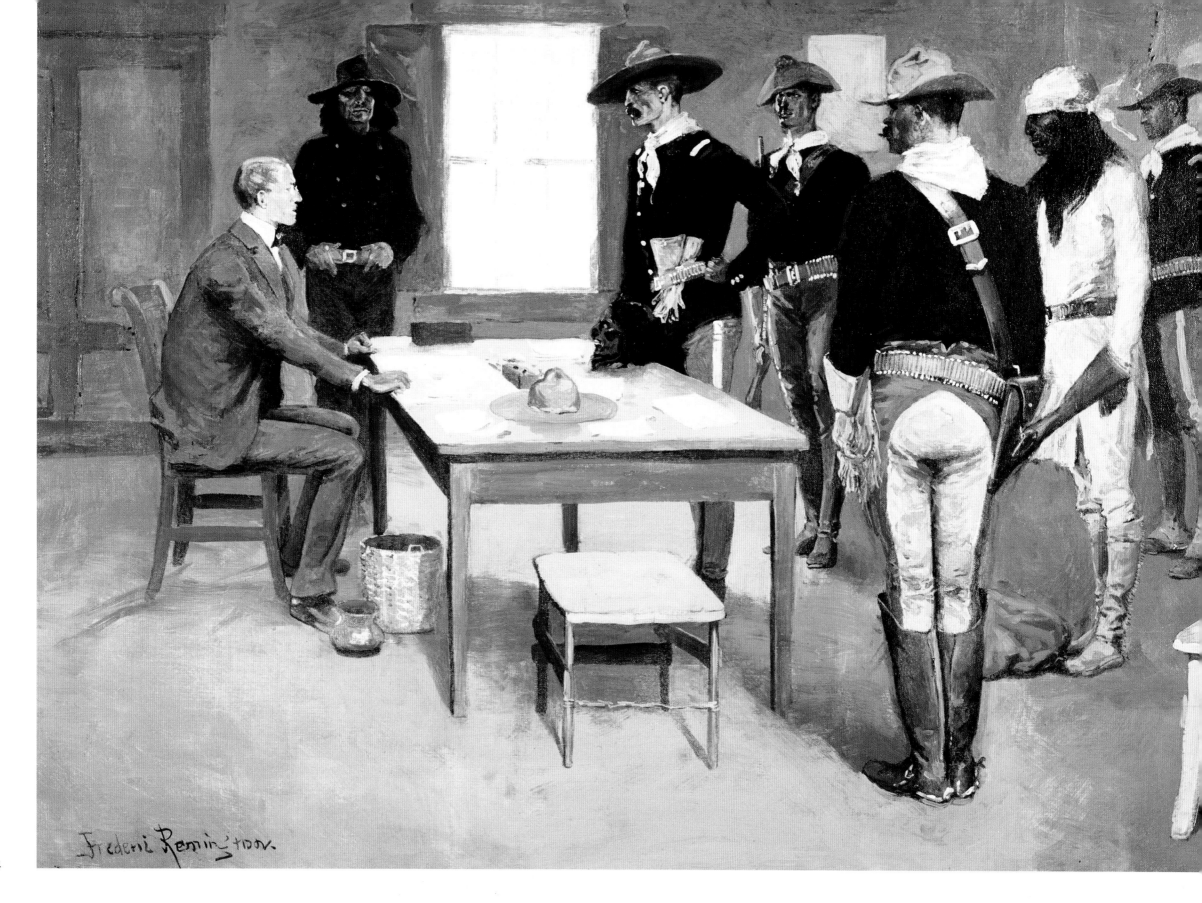

Frederic Remington.

LEFT: *Apache before the Indian Agency.* Oil on panel, undated. Native American affairs were overseen by Washington through appointed agents and local commissioners who were instructed to visit and report on the various tribes. These men could assume considerable local power. *Private Collection/The Bridgeman Art Library*

RIGHT: *The Blanket Signal.* Oil on canvas, c.1896. *Museum of Fine Arts, Houston, Texas, USA, Hogg Brothers Collection, Gift of Miss Ima Hogg/The Bridgeman Art Library*

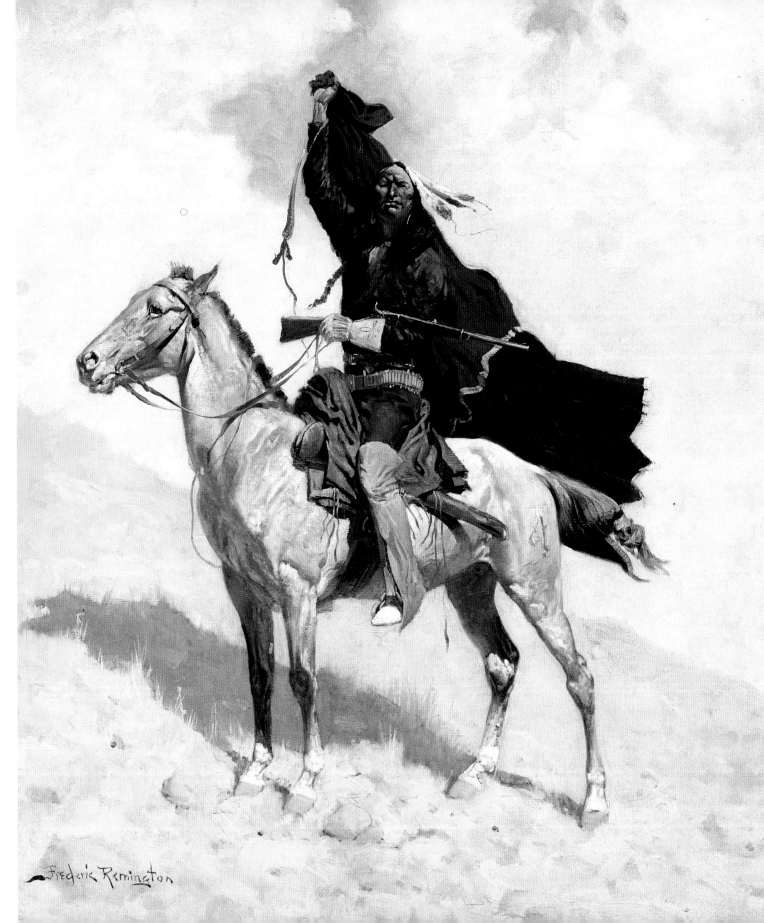

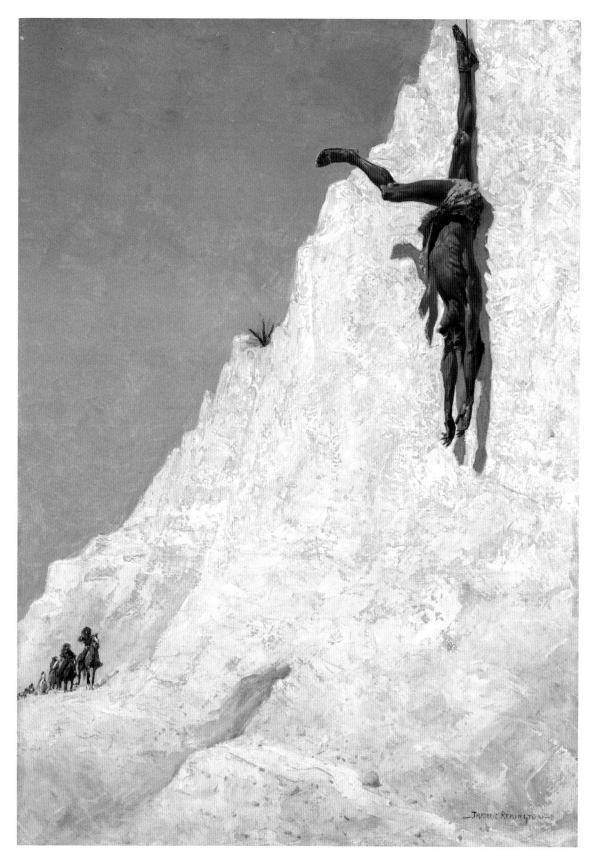

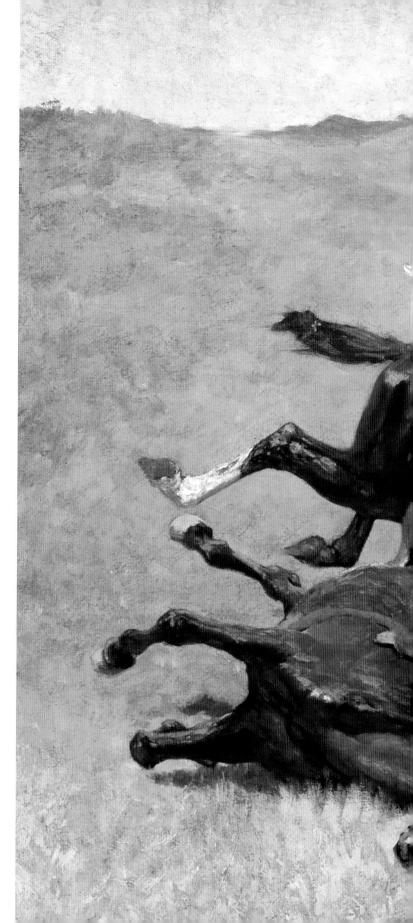

LEFT: *The Transgressor* (or *The Apache Trail: Tio Juan Hanging there Dead! The Way of the Transgressor*). Oil on canvas, 1891. © *Museum of Fine Arts, Houston, Texas, USA/Hogg Brothers Collection, Gift of Miss Ima Hogg/The Bridgeman Art Library*

RIGHT: *The Buffalo Hunt*. Pen and ink on paper, 1890. In the autumn of 1890, Remington traveled to Montana and the Big Horn Mountains to gather material for his paintings. He made such research trips out West every year and would always return loaded with Native artifacts and masses of sketches. *The Art Archive/Gift of William E. Weiss/Buffalo Bill Historical Center, Cody, Wyoming/23.62*

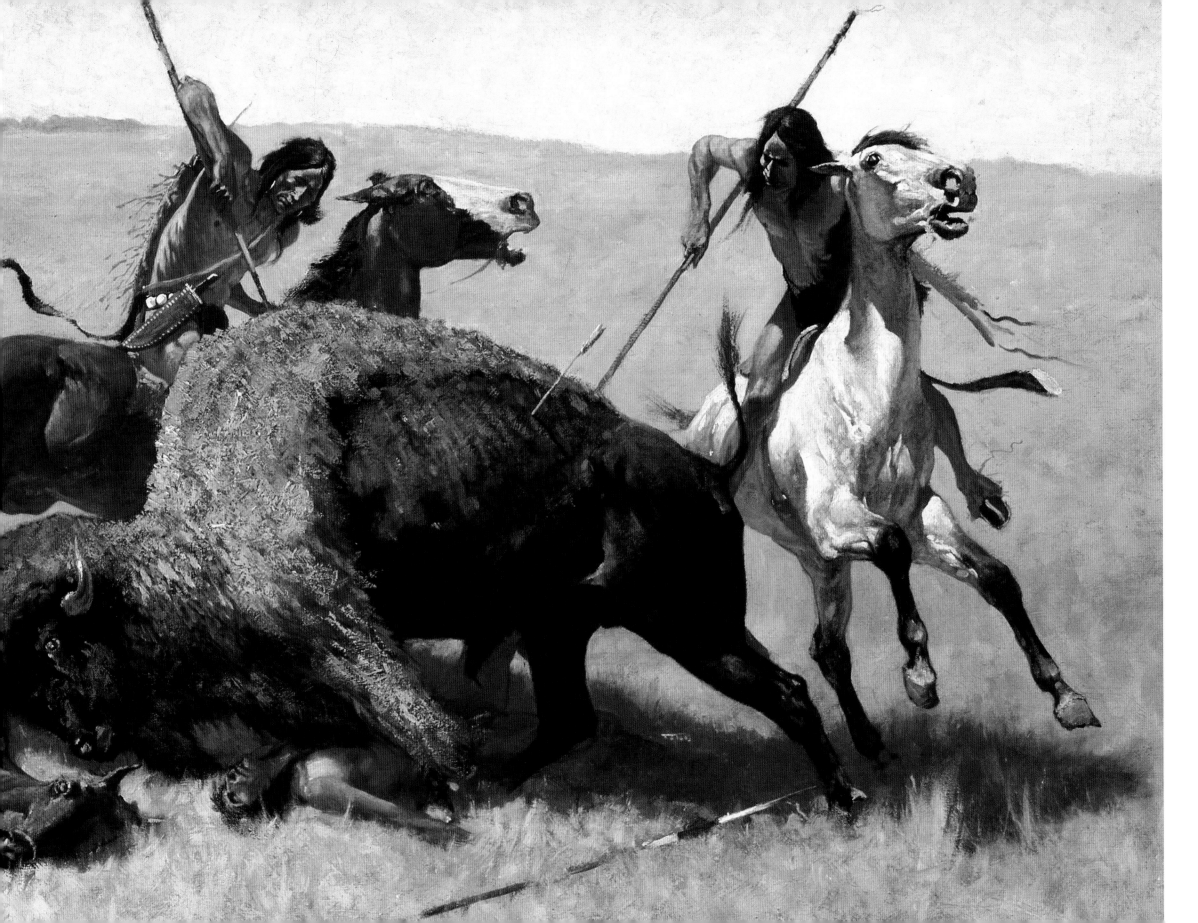

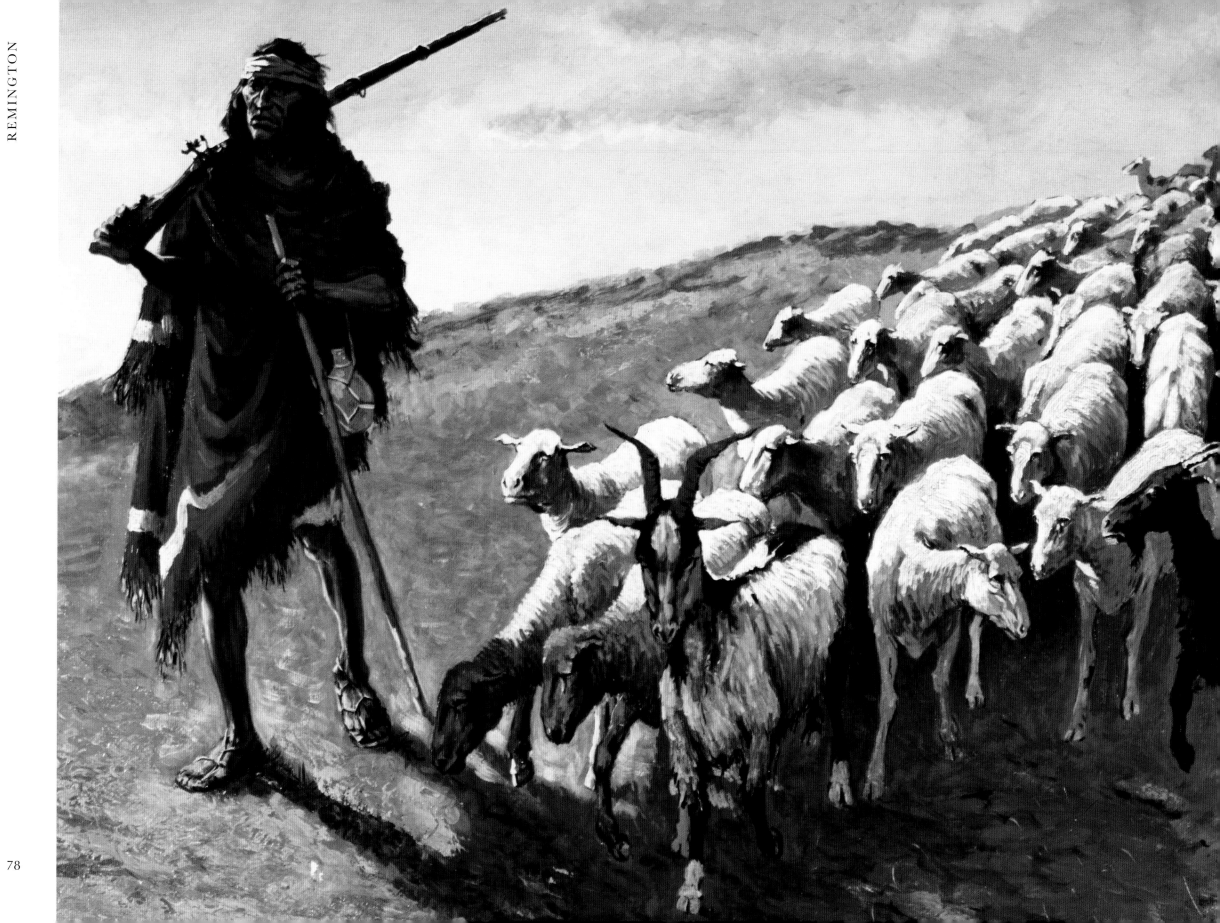

LEFT: *Navajo Sheepherder*. Oil on panel, undated. Navajo were (and still are) found in parts of Arizona, New Mexico, and Utah. The Navajo have historically farmed sheep and revered them for their benefits: their meat for food, wool for clothes and blankets, and skins for thicker blankets and sleeping mats. © *Private Collection/The Bridgeman Art Library*

RIGHT: *The Going of the Medicine-Horse (Indian Fire God)*. Oil on canvas, 1897. © *Museum of Fine Arts, Houston, Texas, USA/Hogg Brothers Collection, Gift of Miss Ima Hogg/The Bridgeman Art Library*

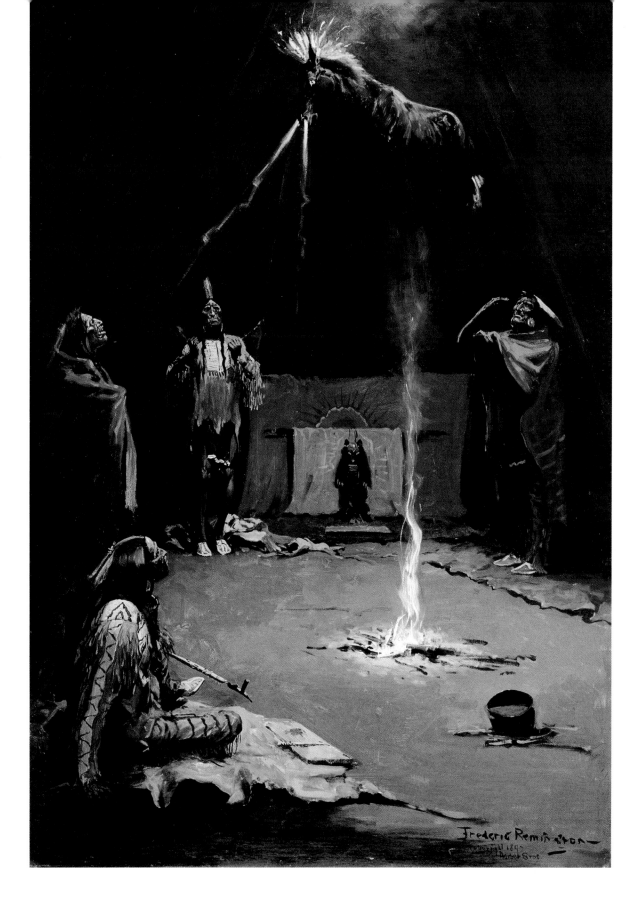

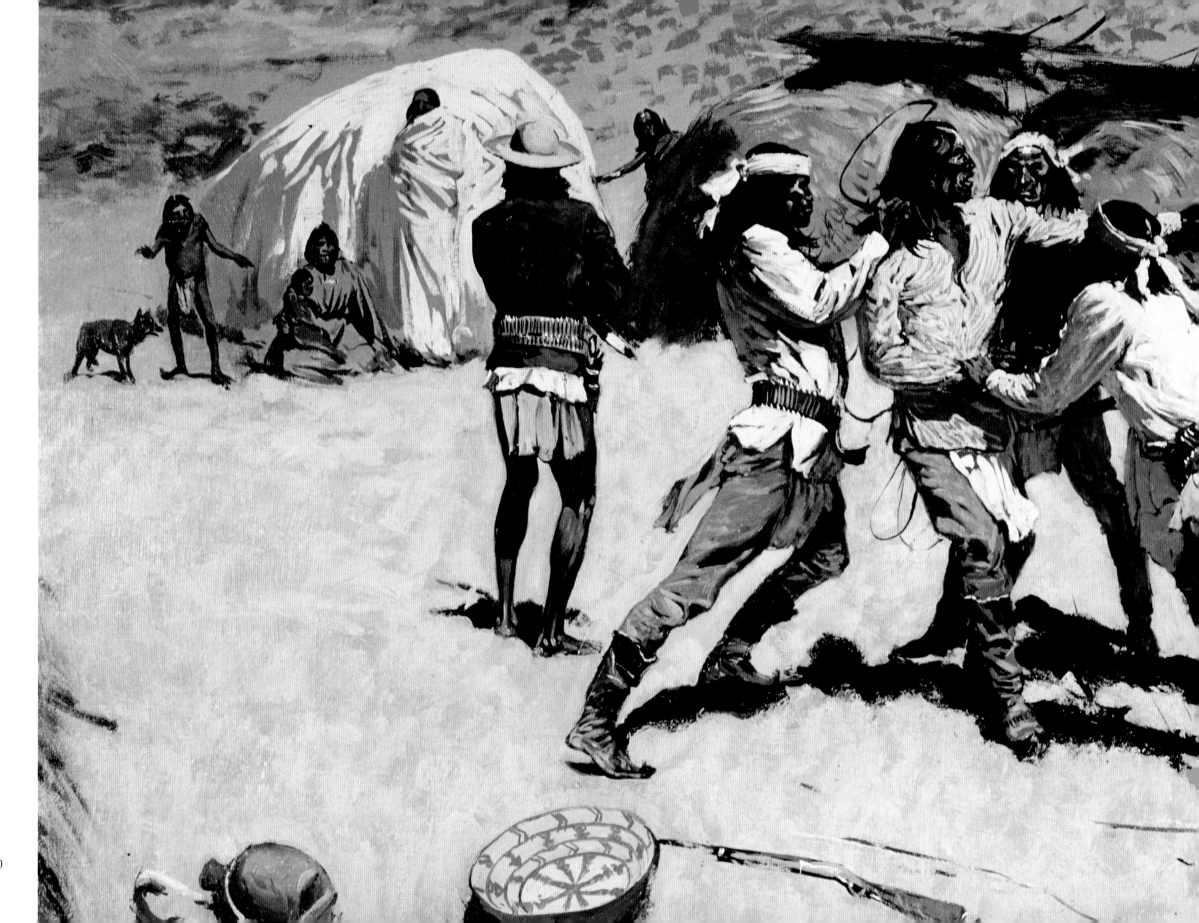

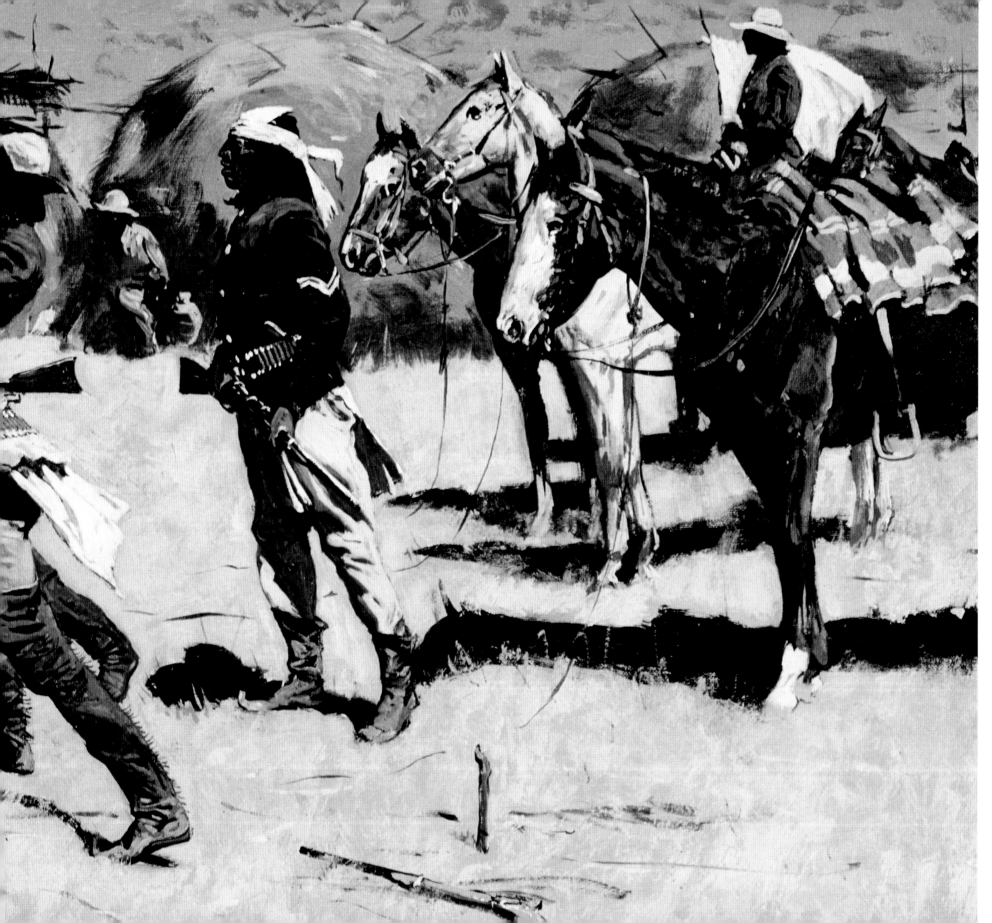

LEFT: *Arrest of the Scout*. Oil on canvas, undated. Remington did not flinch from showing the tensions between the Native Americans who resisted the U.S. government and those who worked for it. *Thomas Gilcrease Institute, USA/The Bridgeman Art Library*

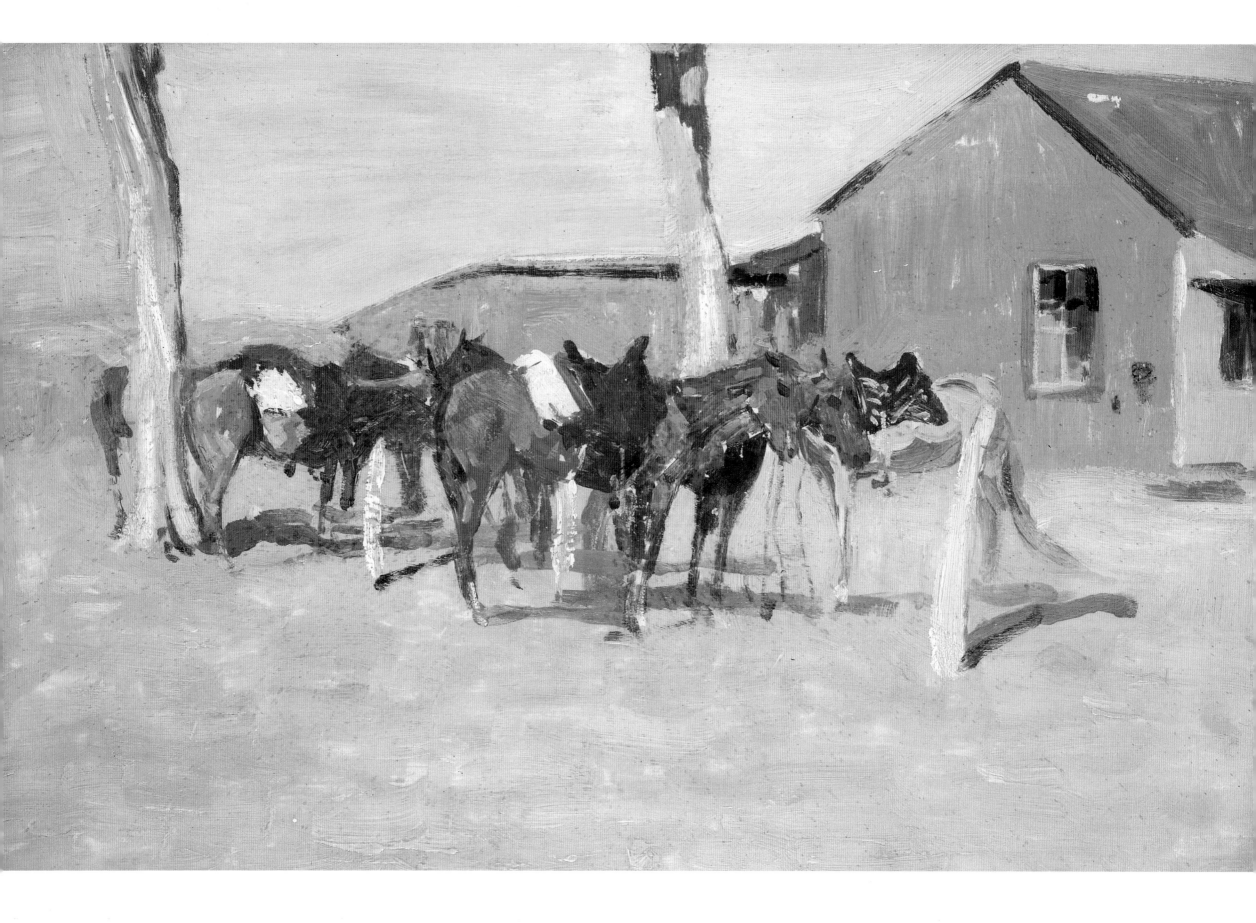

LEFT: Untitled, group of Indian ponies near the Ute reservation office. Undated. *The Art Archive/Gift of the Coe Foundation/Buffalo Bill Historical Center, Cody, Wyoming/48.67*

RIGHT: *Pony War Dance*. Watercolor on paper, undated. © *Private Collection/ The Bridgeman Art Library*

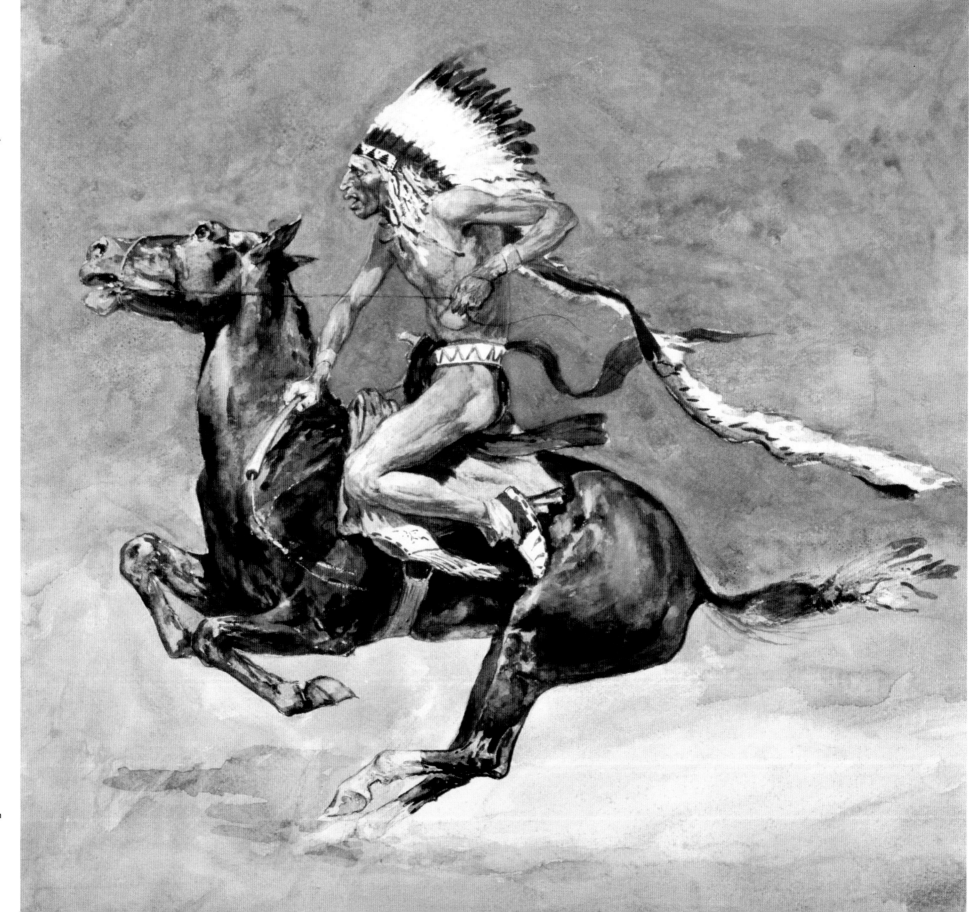

OVER PAGE LEFT: Untitled, Ute Indian Reservation, Ignacio, Colorado. 1900. *The Art Archive/Gift of the Coe Foundation/Buffalo Bill Historical Center, Cody, Wyoming/44.67*

OVER PAGE RIGHT: *Apache Ambush*. Oil on canvas, undated. © *Private Collection/Peter Newark American Pictures/The Bridgeman Art Library*

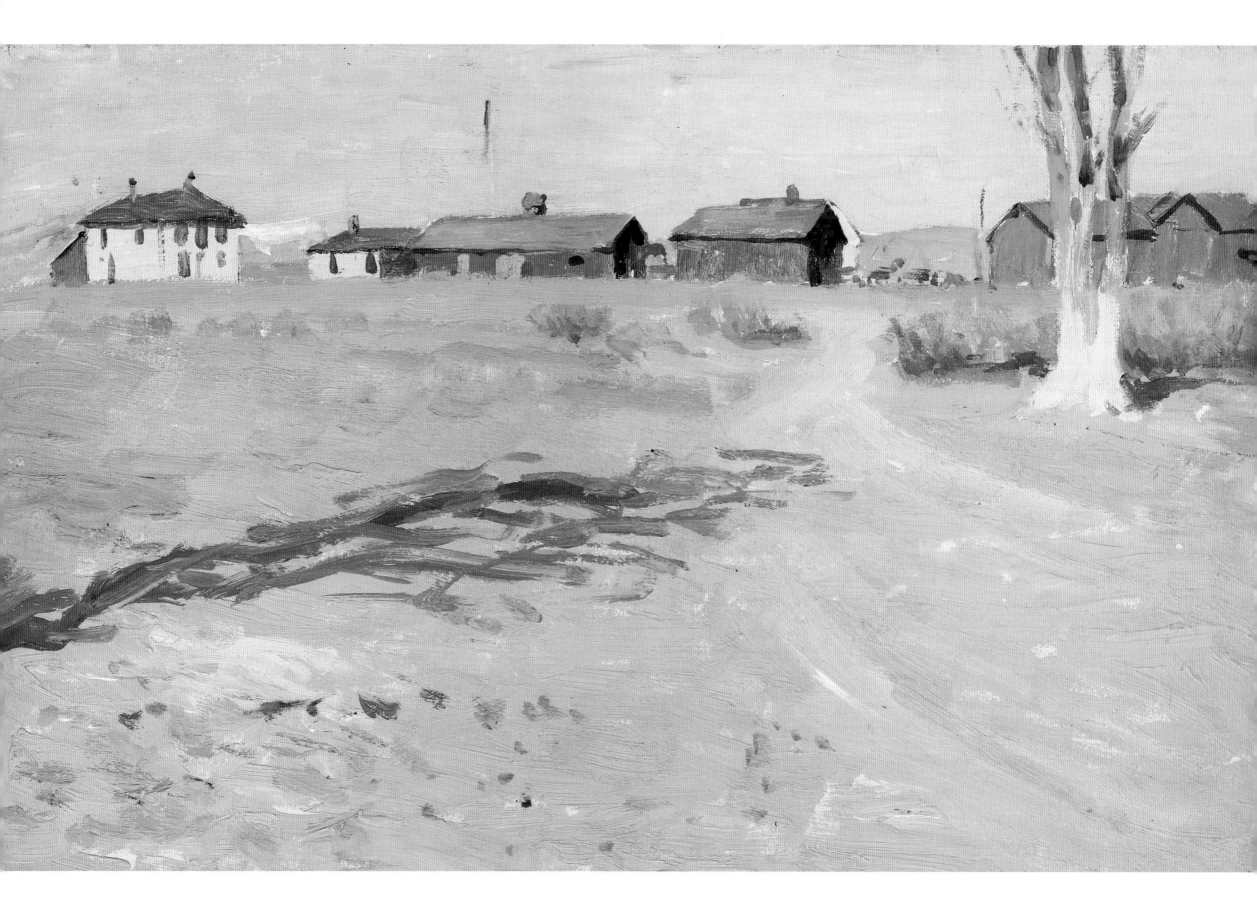

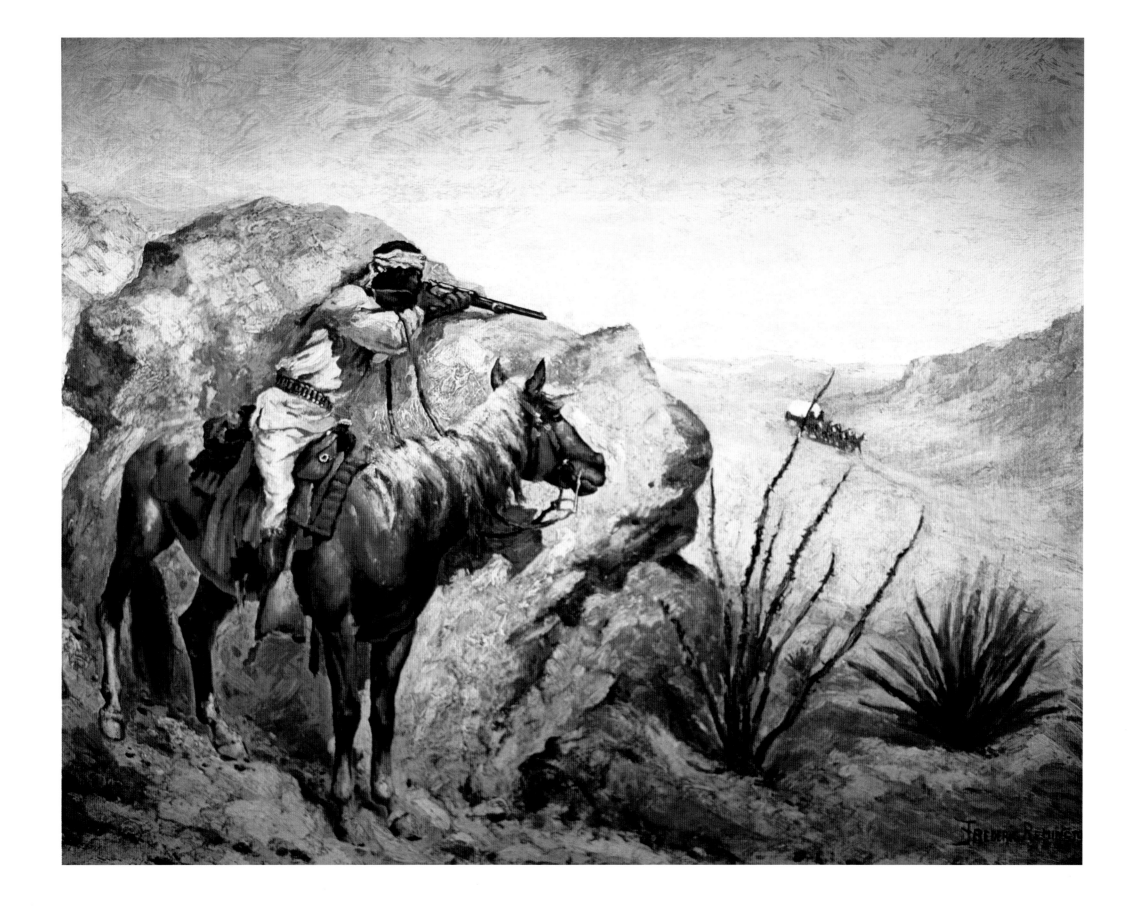

RIGHT: Untitled, Ute woman, study for *A Monte Game at the Southern Ute Agency*. 1900. *The Art Archive/Gift of the Coe Foundation/Buffalo Bill Historical Center, Cody, Wyoming/72.67*

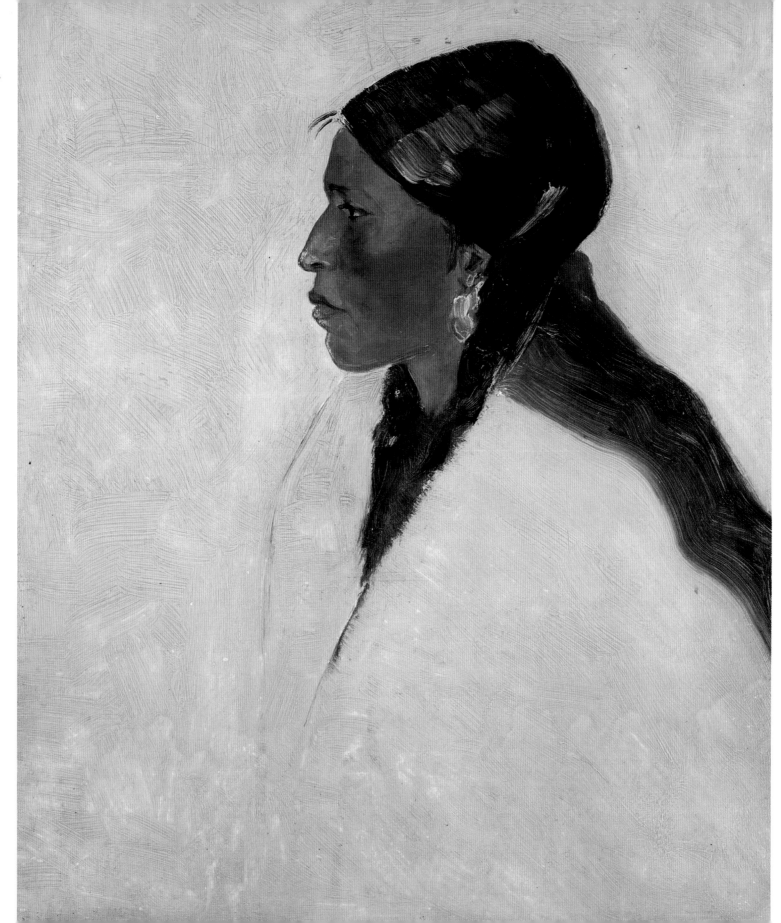

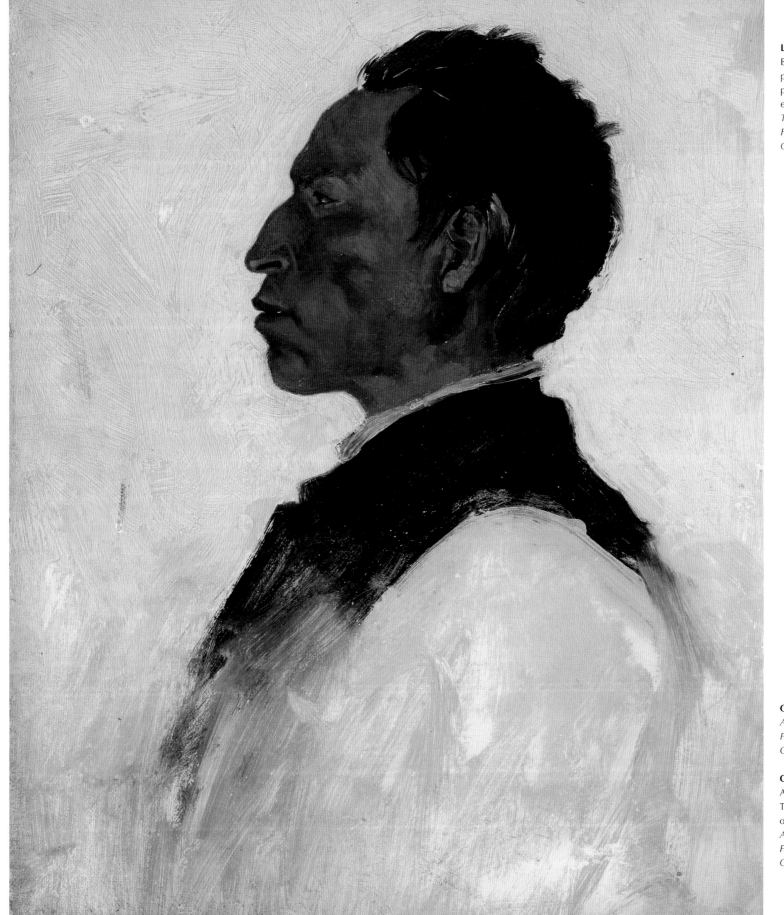

LEFT: Untitled, Indian in black coat, 1900. By this date Remington was the most popular artist in the U.S. and all his paintings were anticipated with enormous enthuasism by his fans. *The Art Archive/Gift of the Coe Foundation/Buffalo Bill Historical Center, Cody, Wyoming/71.67*

OVER PAGE LEFT: *Desert pueblo.* 1900. *The Art Archive/Gift of the Coe Foundation/Buffalo Bill Historical Center, Cody, Wyoming/96.67*

OVER PAGE RIGHT: Taos pueblo. 1900. Adobe built Taos pueblo (or Pueblo de Taos) has been continuously inhabited for over a thousand years. *The Art Archive/Gift of the Coe Foundation/Buffalo Bill Historical Center, Cody, Wyoming/97.67*

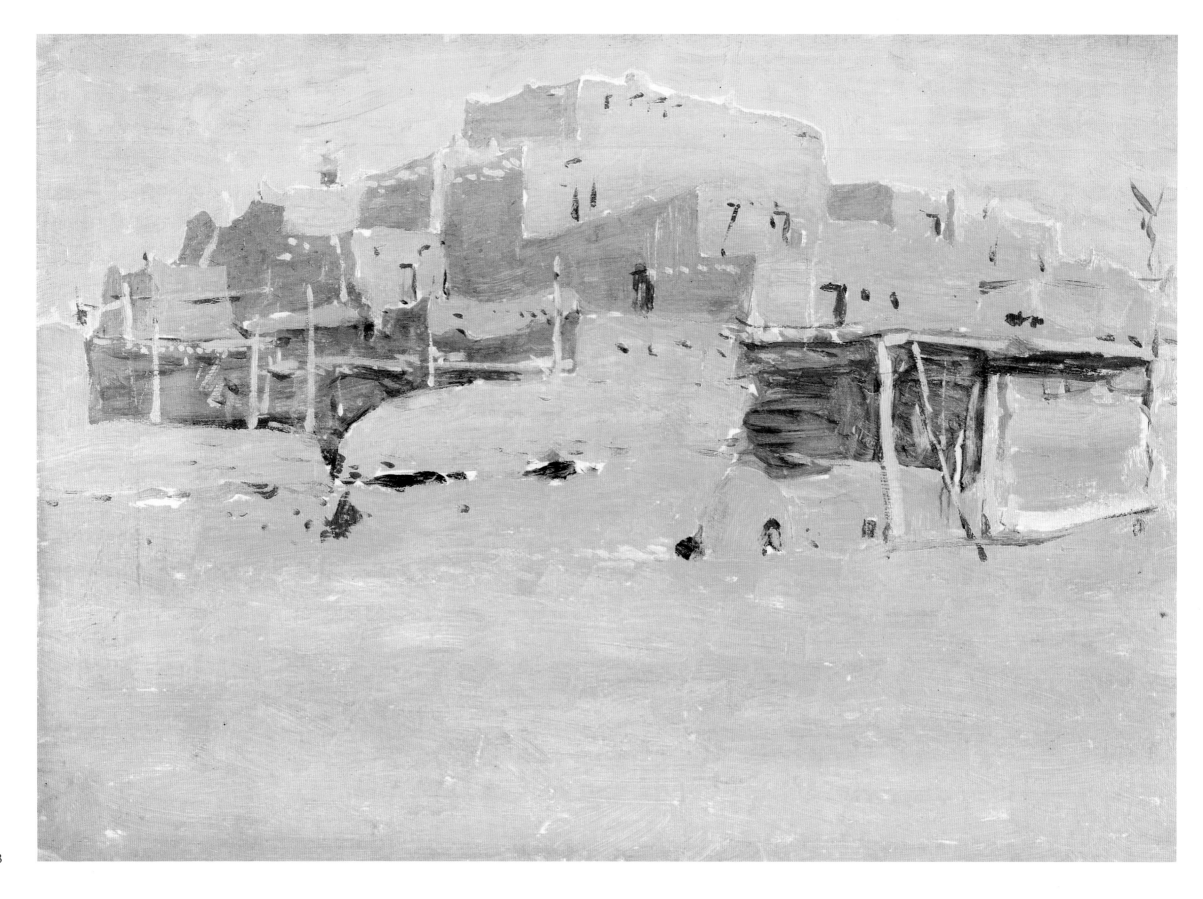

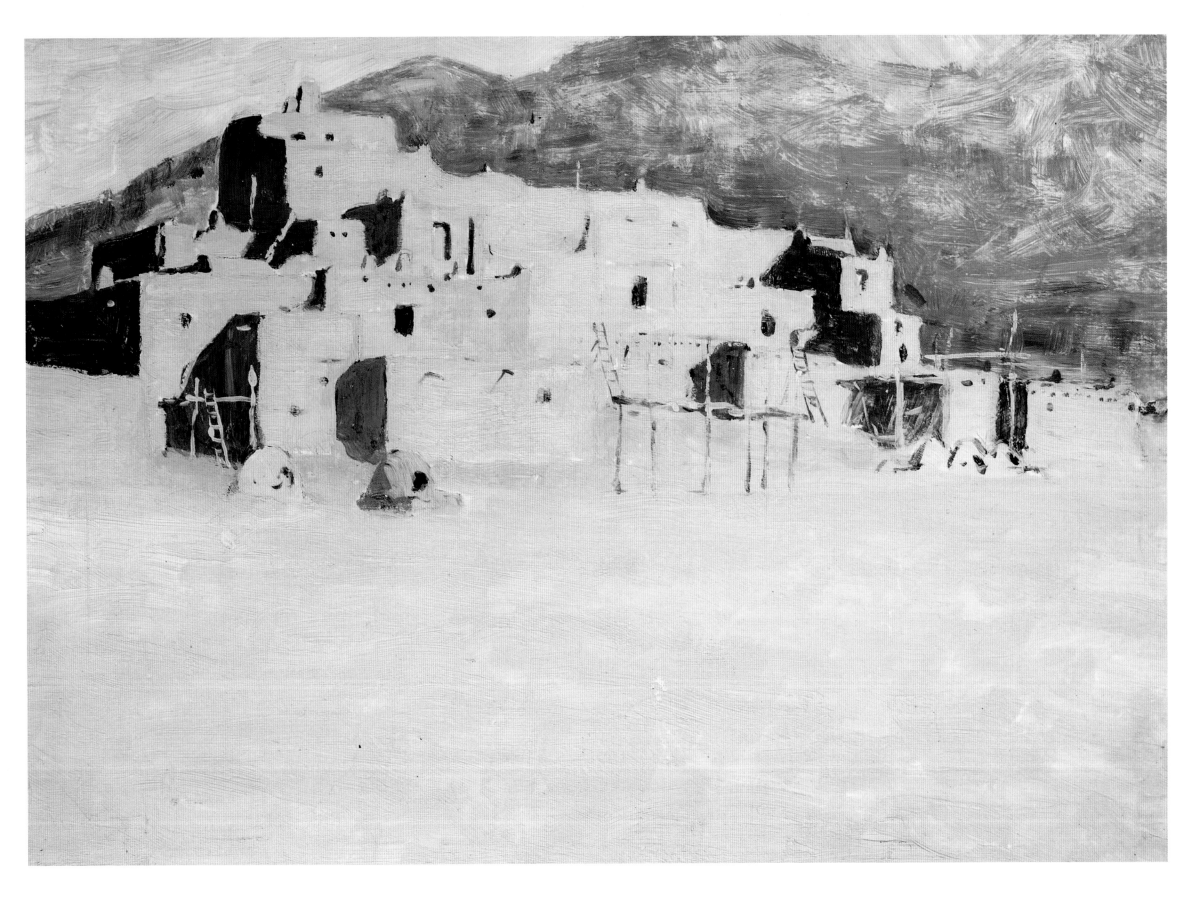

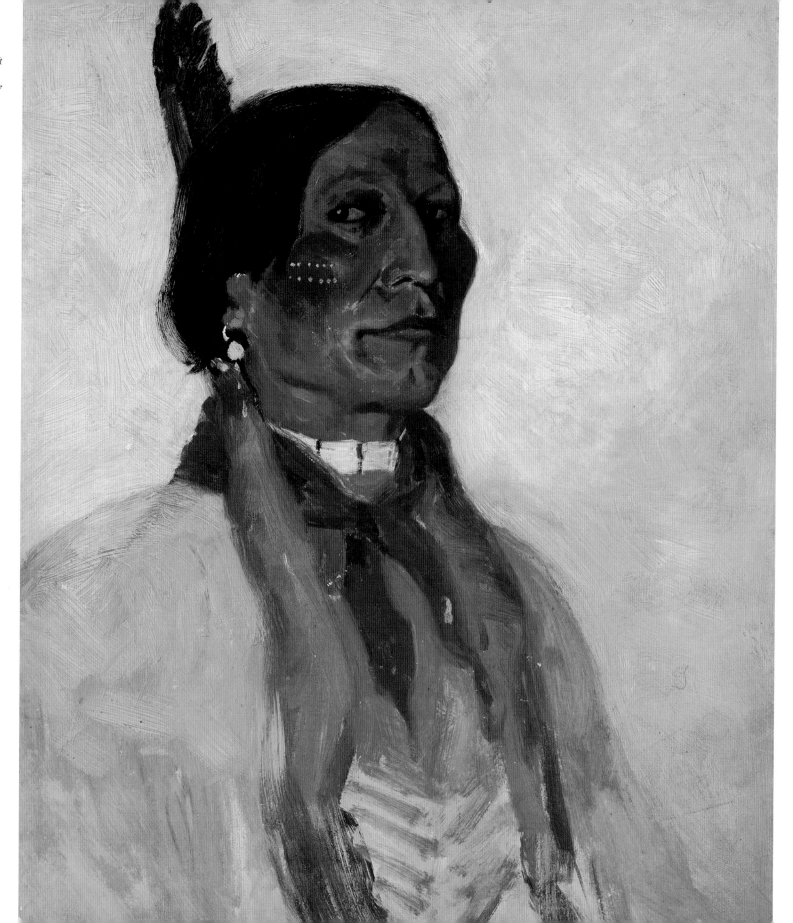

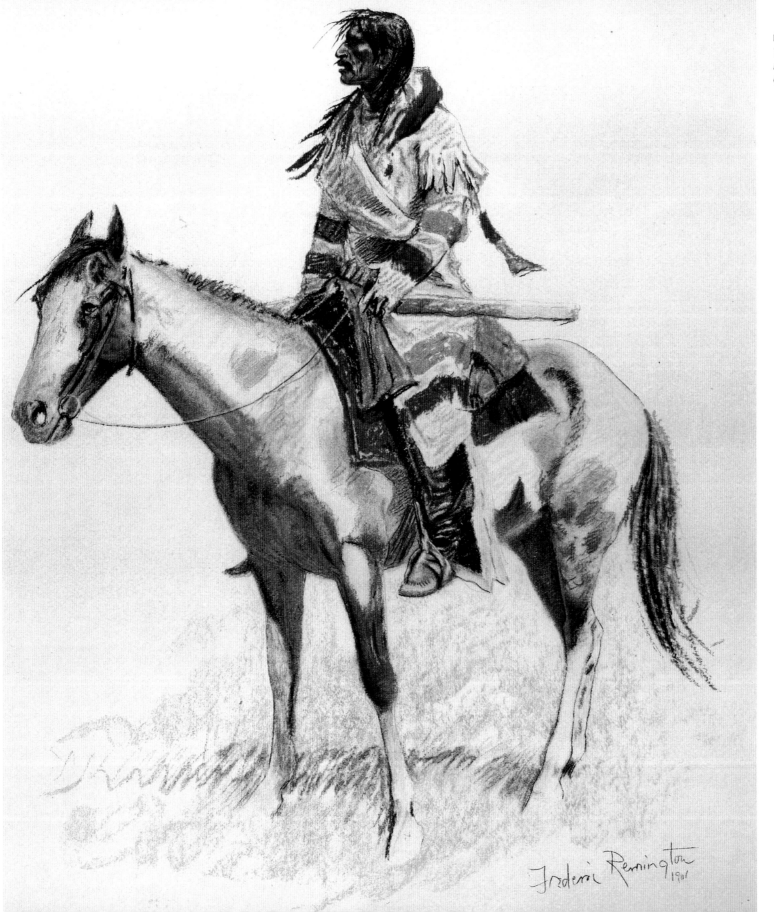

Frederic Remington
1901

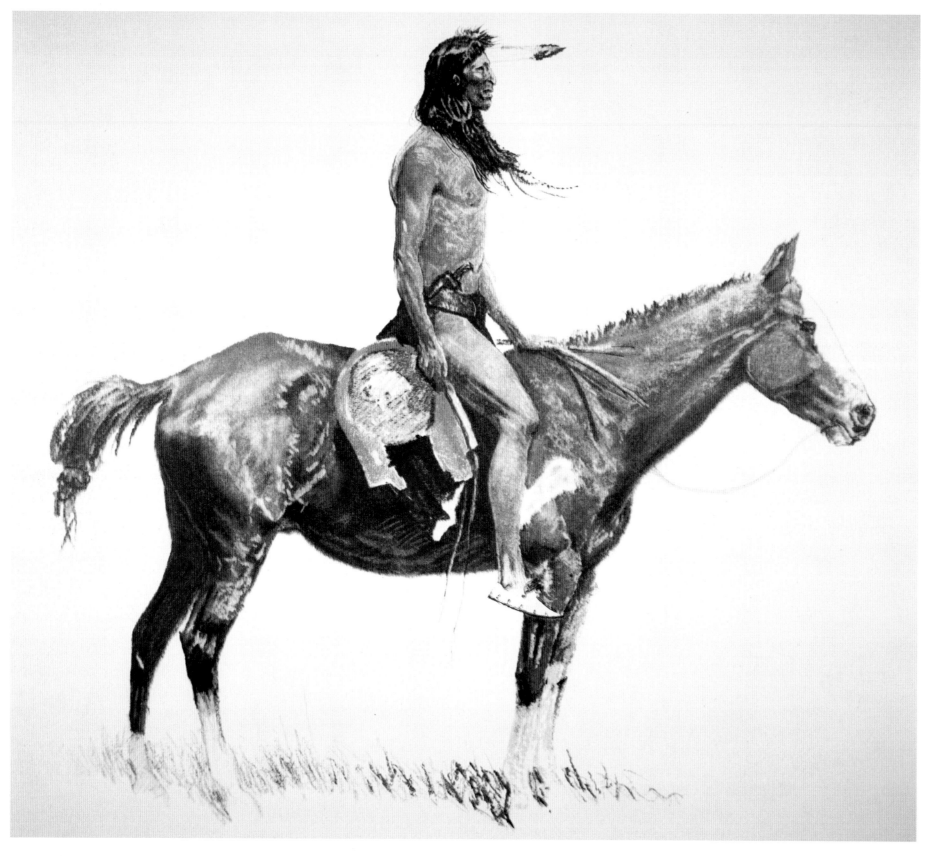

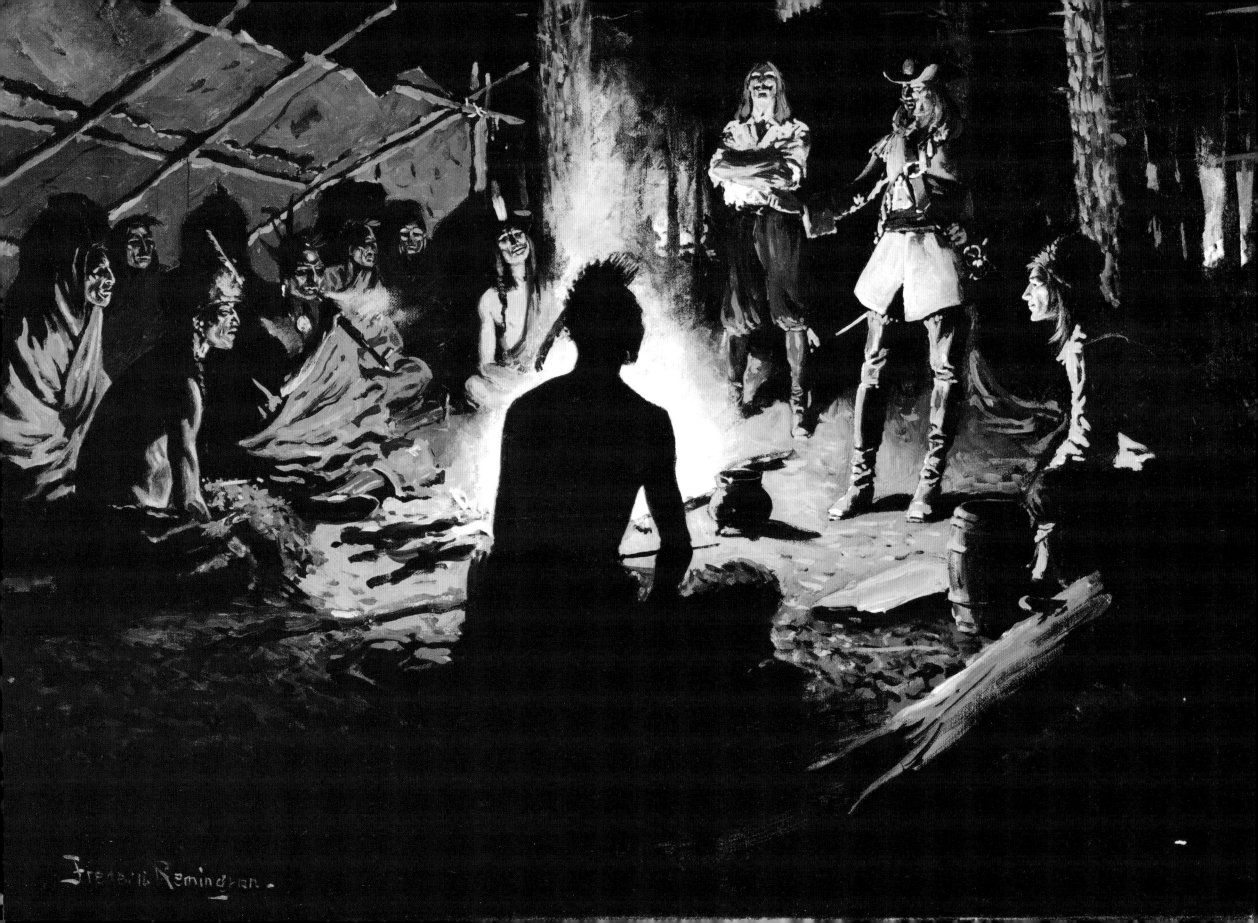

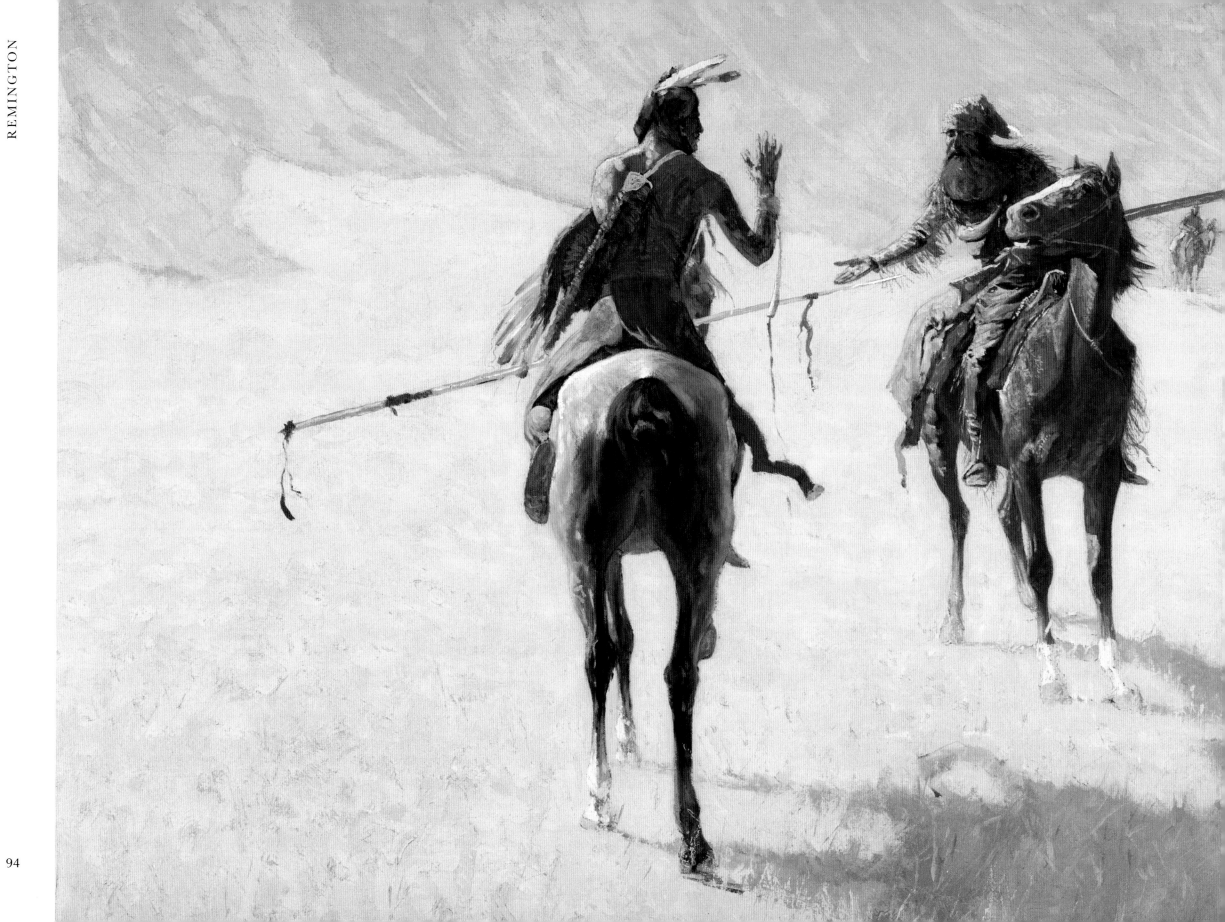

LEFT: *The Parley*. Oil on canvas, 1903. © *Museum of Fine Arts, Houston, Texas, USA/Hogg Brothers Collection, Gift of Miss Ima Hogg/The Bridgeman Art Library*

RIGHT: *Sioux Chief*. Color lithograph, undated. *Private Collection/Peter Newark Western Americana/The Bridgeman Art Library*

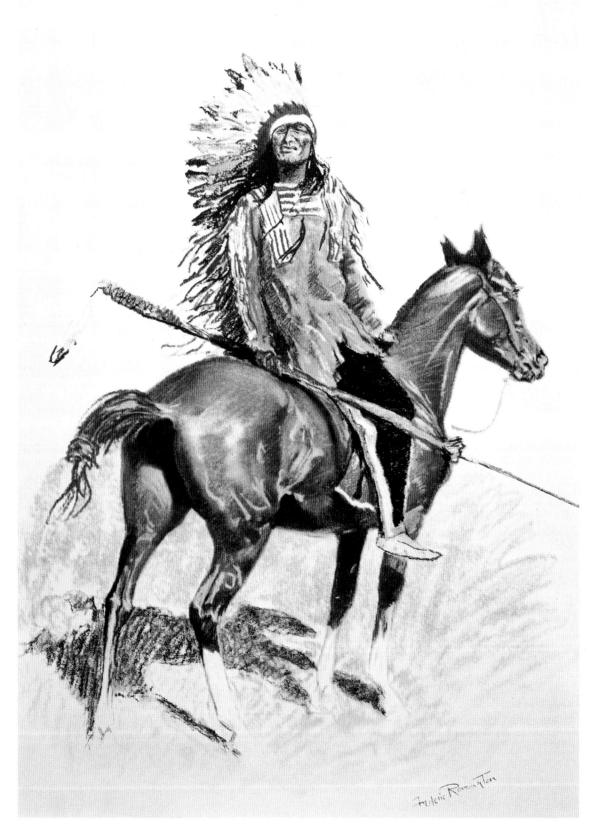

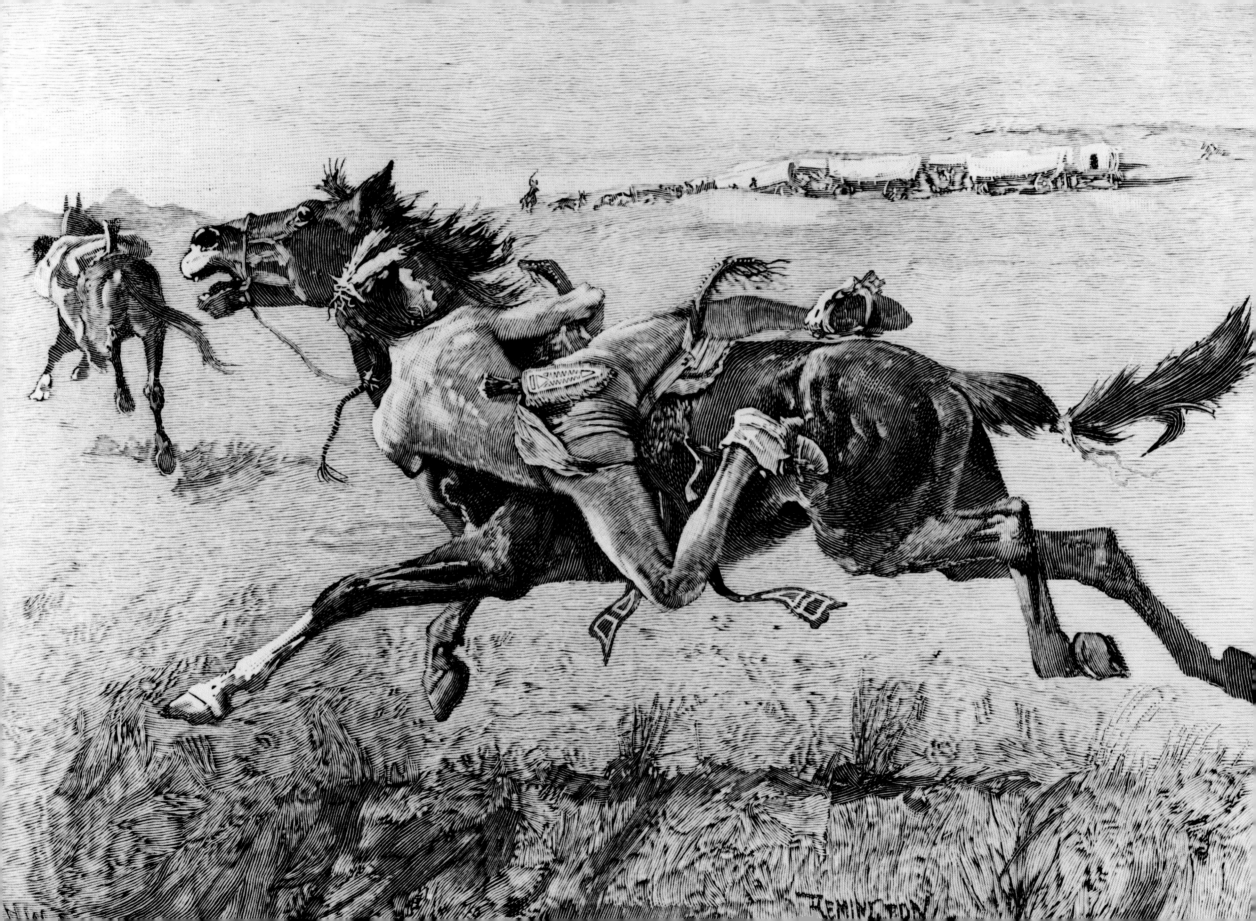

LEFT: *A Peril of the Plains, the First Emigrant Train to California,* engraving after Remington, c.1890. In the early days of his work for *Harper's Weekly, Remington's illustrations were redrawn by a house artist to be rendered suitable for publication. The Bridgeman Art Library*

LEFT: *A Blackfoot Indian.* Oil on canvas, undated. *Private Collection/ The Bridgeman Art Library*

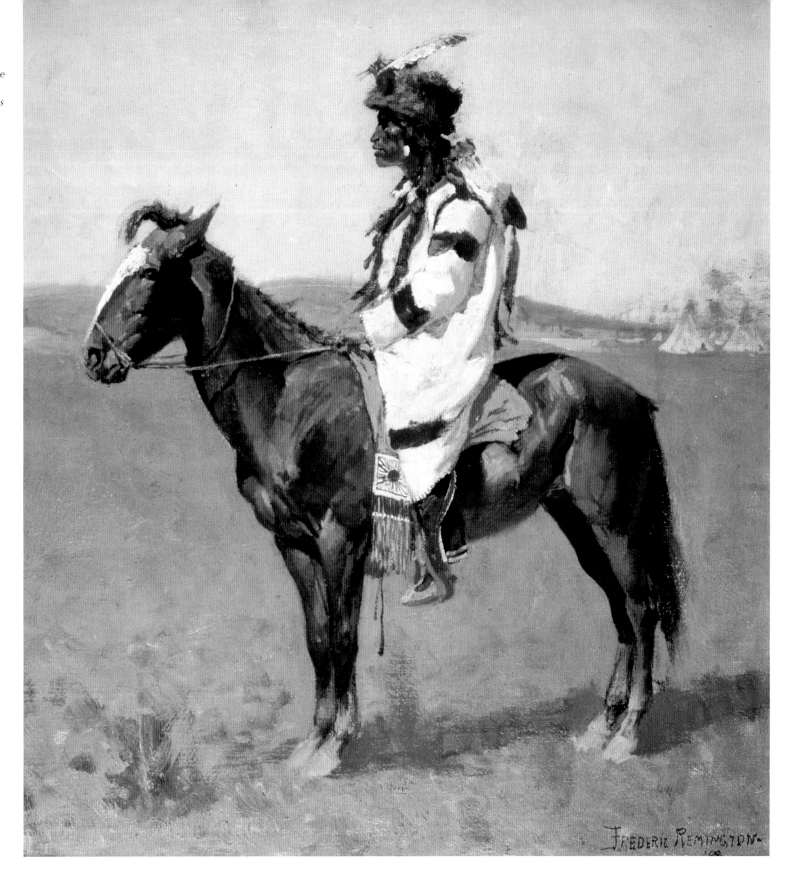

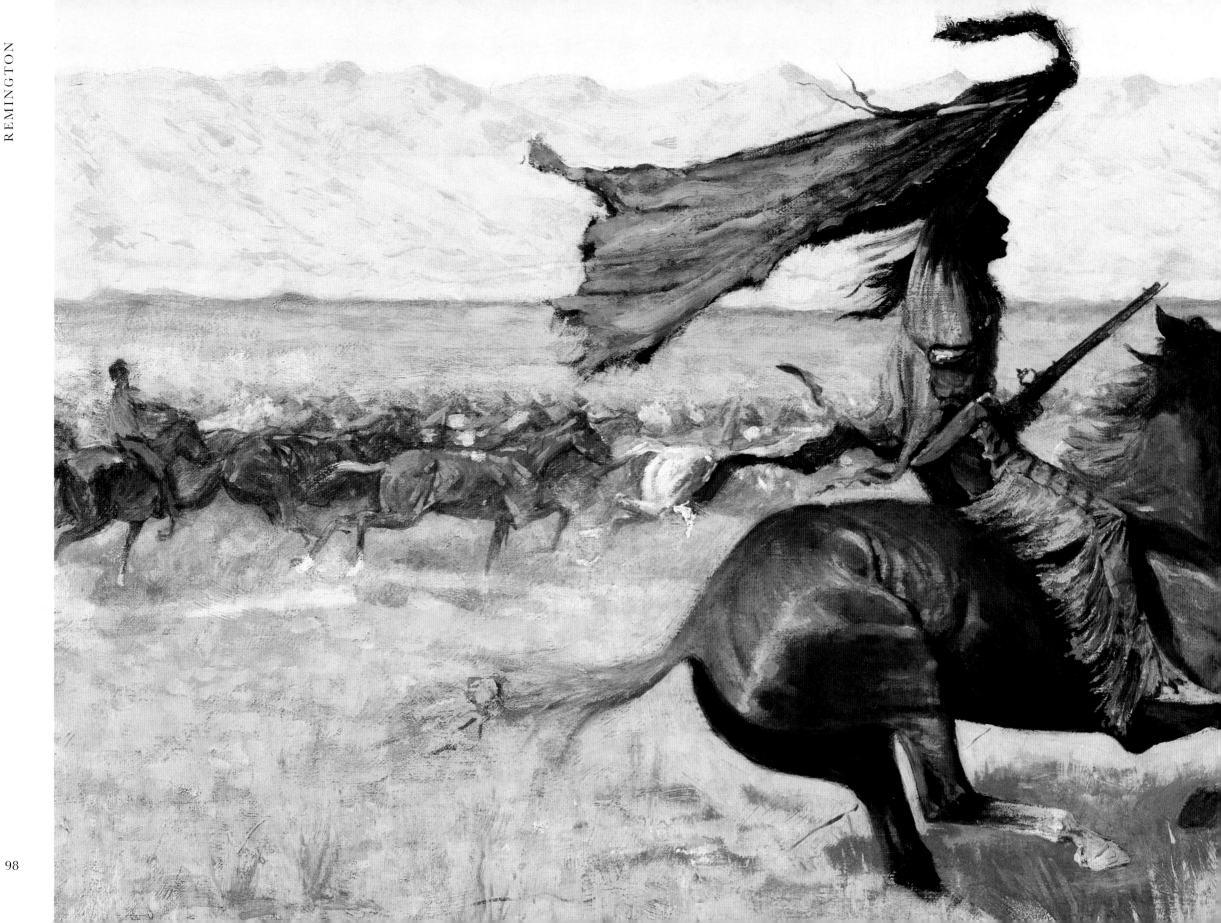

LEFT: *Change of Ownership* (*The Stampede: Horse Thieves*). Oil on canvas, 1903. © Museum of Fine Arts, Houston, Texas, USA/Hogg Brothers Collection, Gift of Miss Ima Hogg/The Bridgeman Art Library

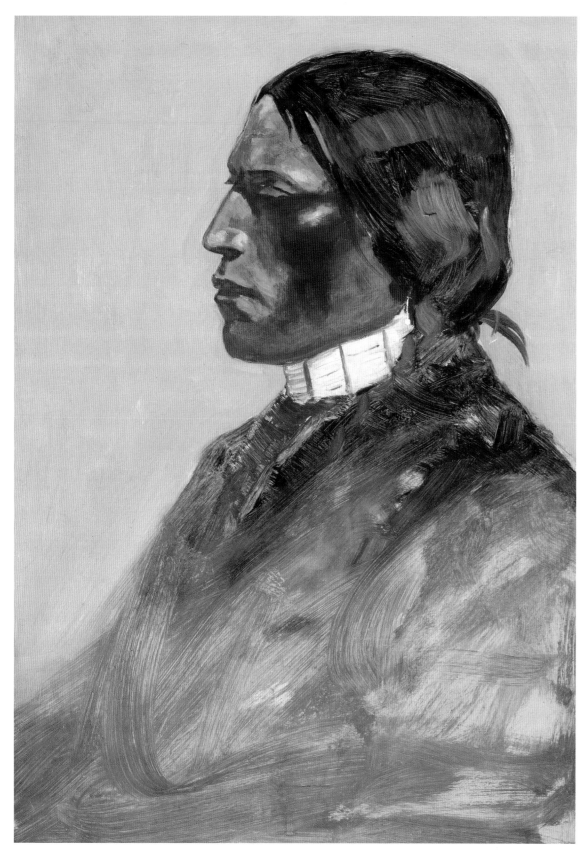

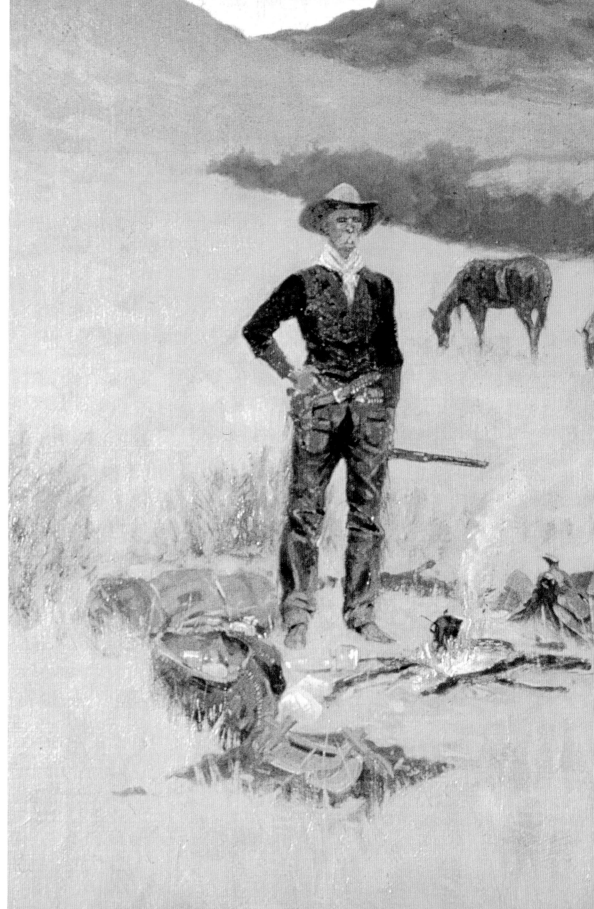

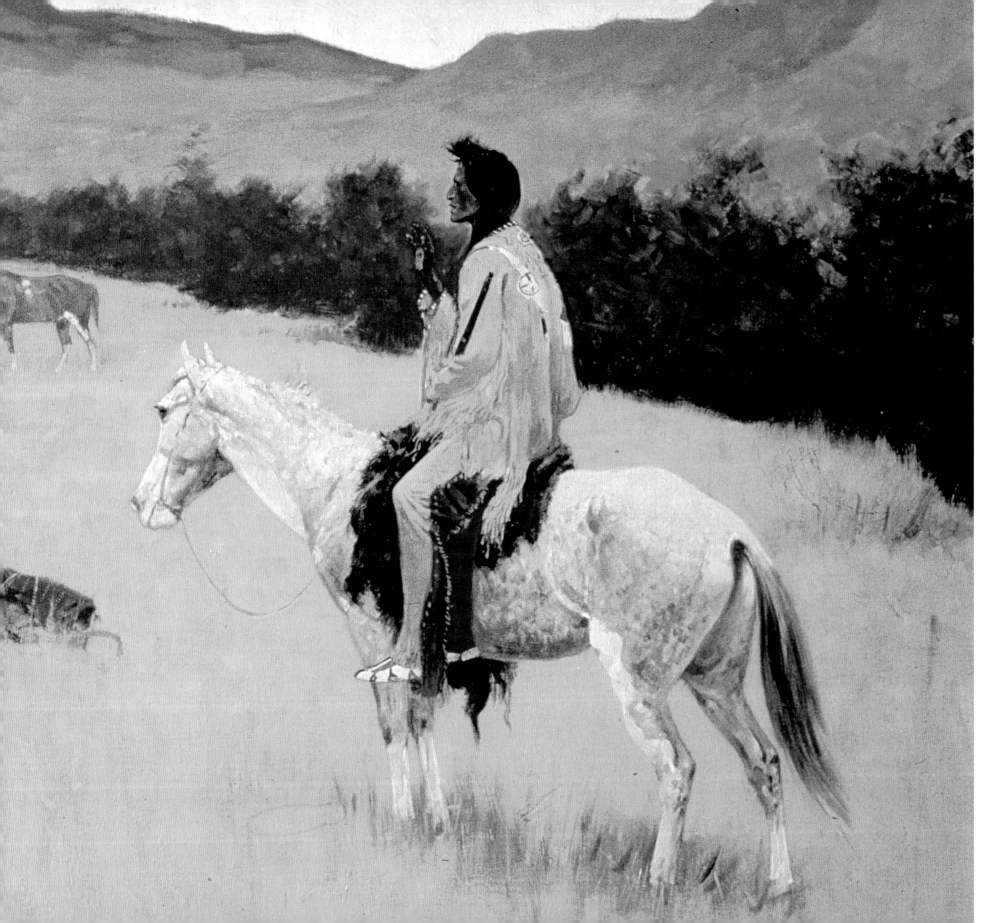

FAR LEFT: Untitled, Ute Indian, study for *A Monte Game at the Southern Ute Agency*. 1900. *The Art Archive/ Gift of the Coe Foundation/Buffalo Bill Historical Center, Cody, Wyoming/ 26.67*

LEFT: *The Conversation, or Dubious Company*. Oil on canvas, undated. *Private Collection, Index/The Bridgeman Art Library*

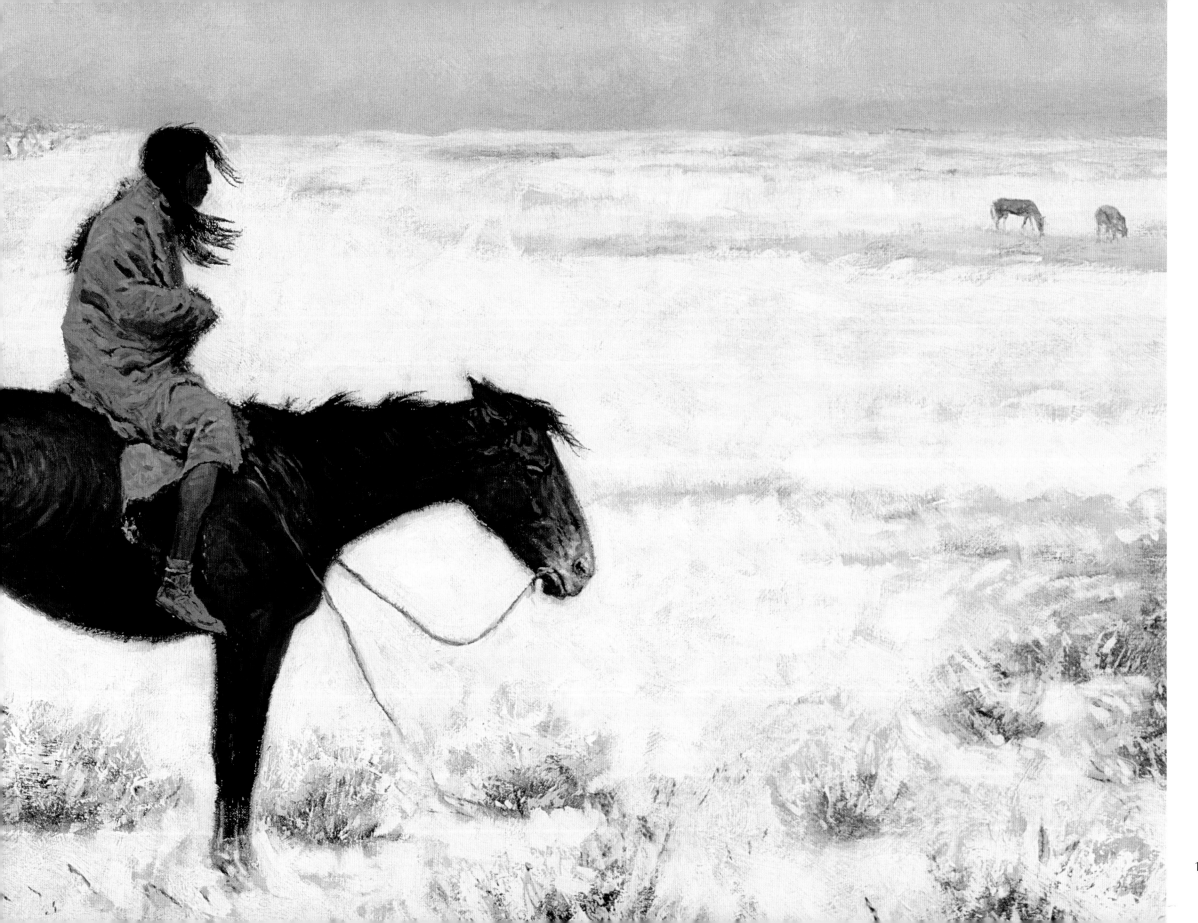

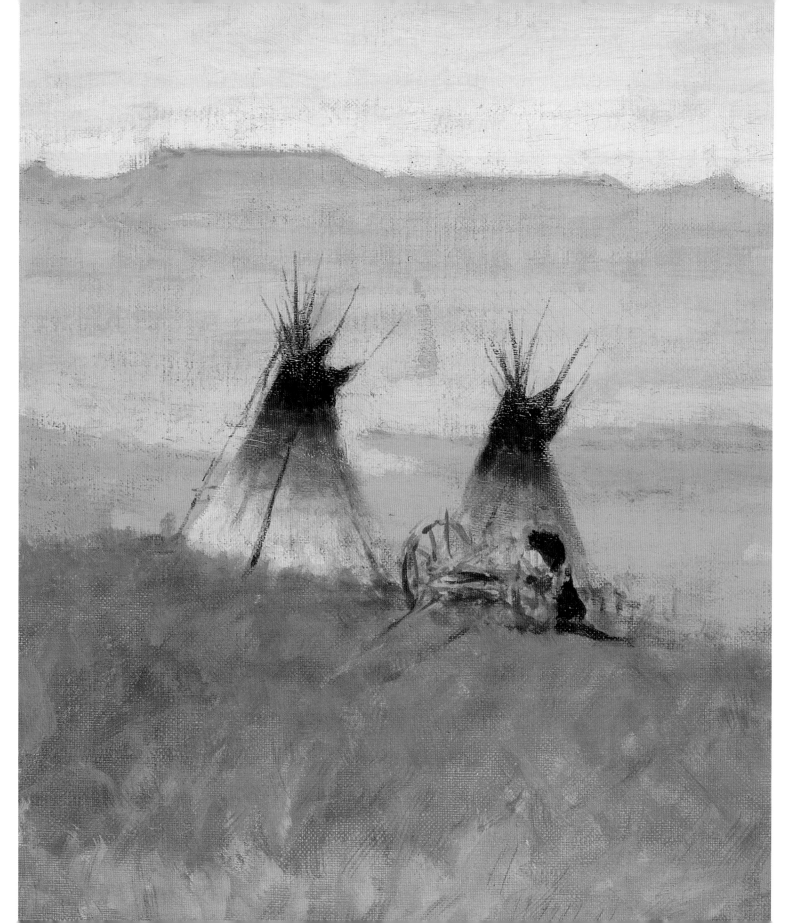

LEFT: *Stormy Morning in the Bad Lands.* 1906. *The Art Archive/Gift of the Coe Foundation/Buffalo Bill Historical Center, Cody, Wyoming/ 40.67*

RIGHT: *Smoke Signals.* Oil on canvas. c.1900. Native Americans could communicate over a long distance using smoke signals, but only simple, pre-determined messages could be conveyed. © *Private Collection/Peter Newark American Pictures/The Bridgeman Art Library*

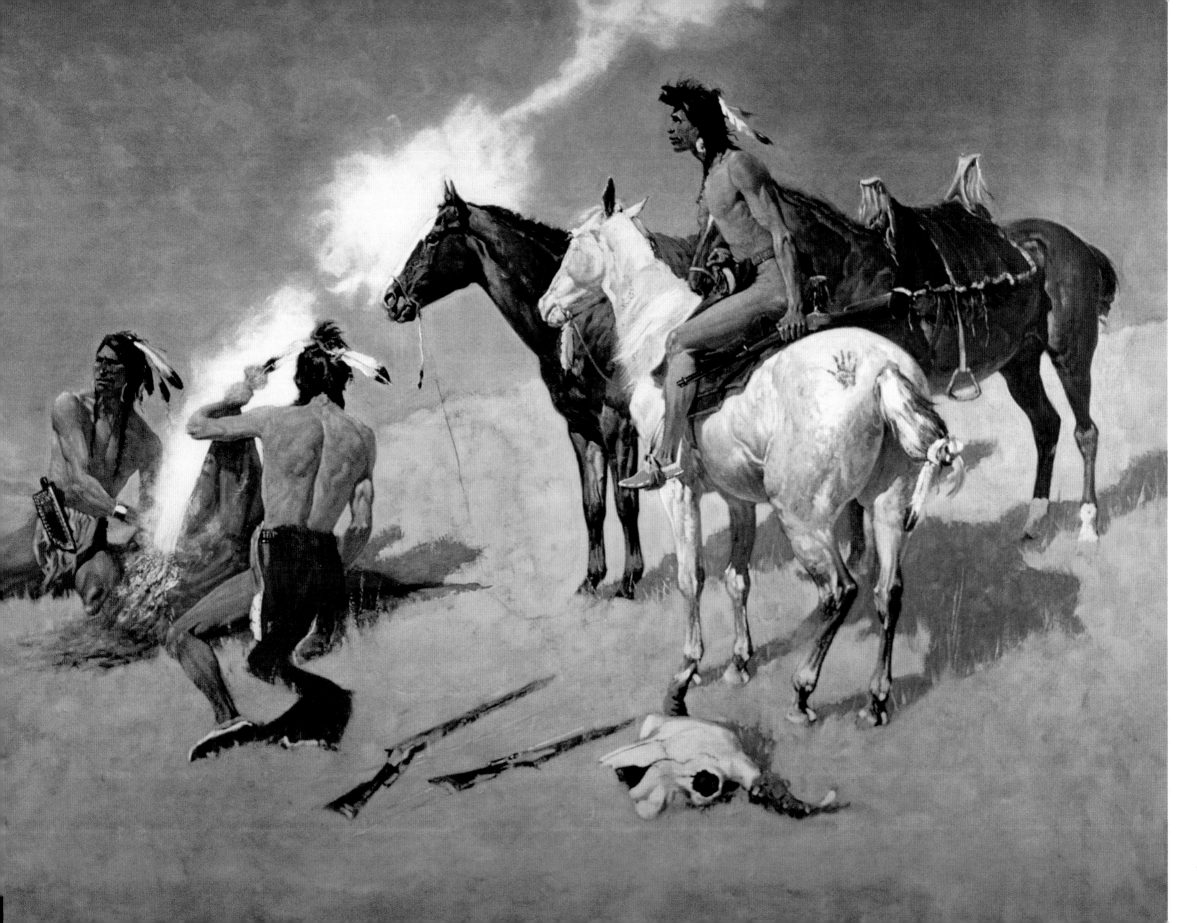

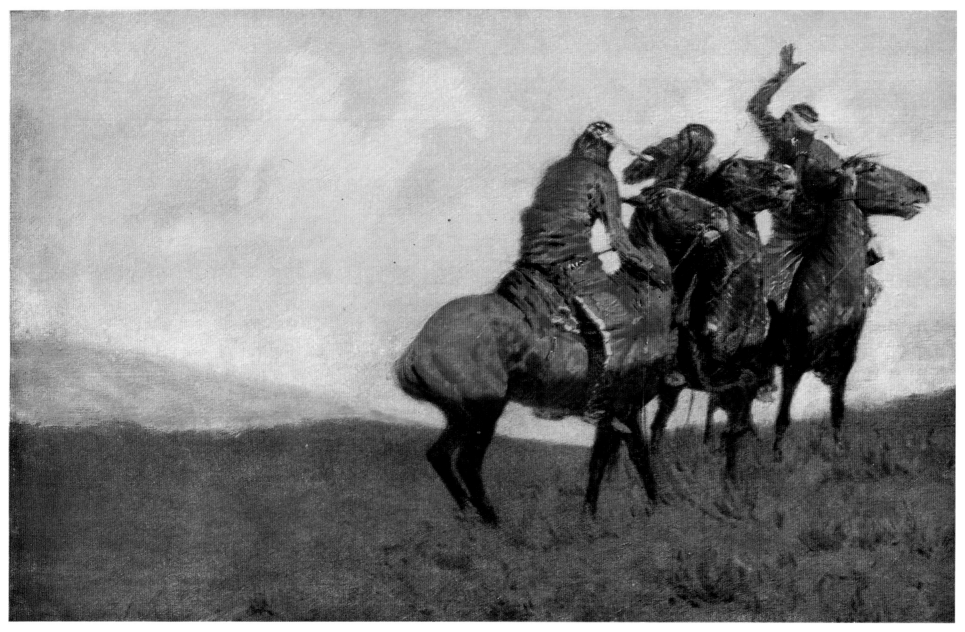

ABOVE: *With the Eye of the Mind.* Color print, 1909. *The Art Archive/Gift of William O. Sweet/Buffalo Bill Historical Center, Cody, Wyoming/ 63.72.44*

RIGHT: *Episode of the Buffalo Gun (or The Visitation of the Buffalo Gun: A Buffalo Episode).* Oil on canvas, 1909. © *Museum of Fine Arts, Houston, Texas, USA/Hogg Brothers Collection, Gift of Miss Ima Hogg/The Bridgeman Art Library*

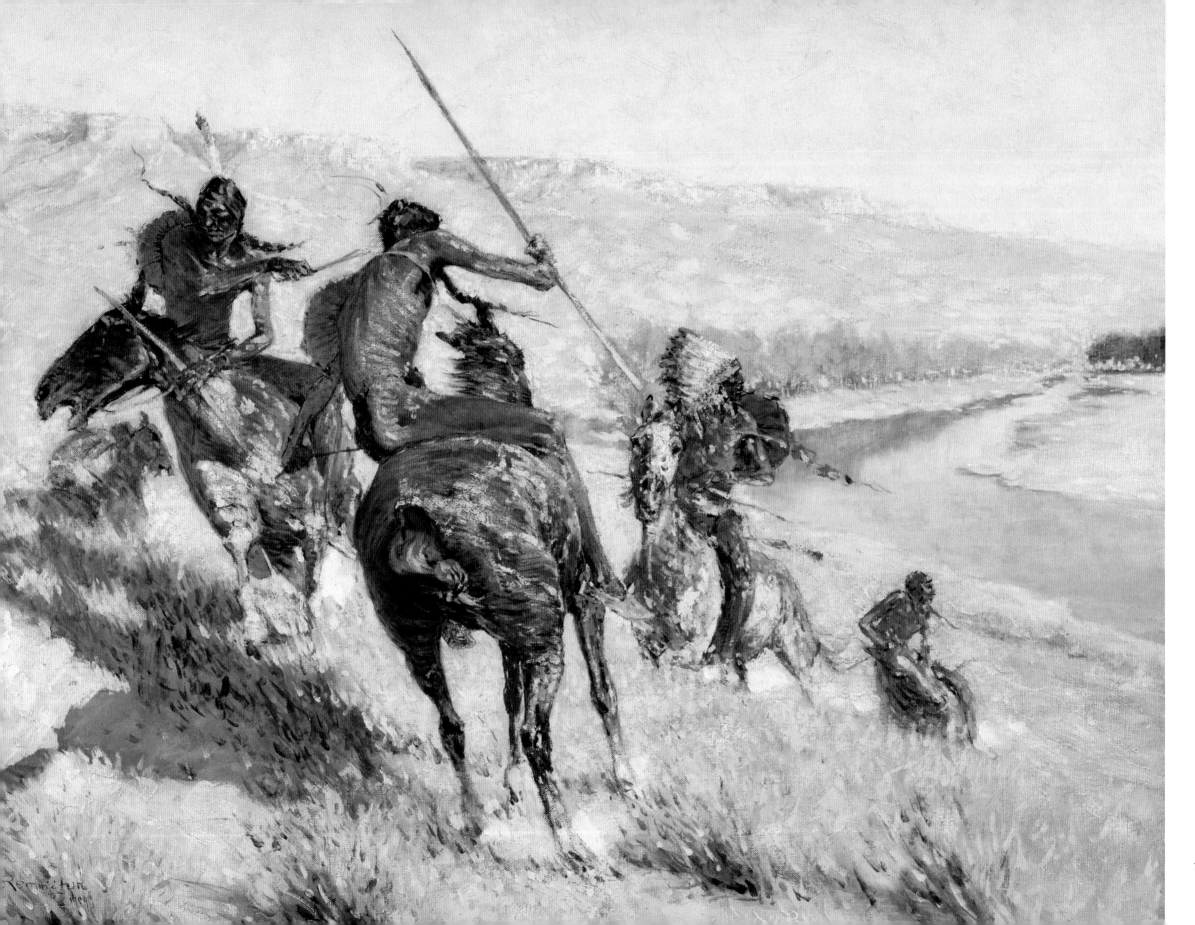

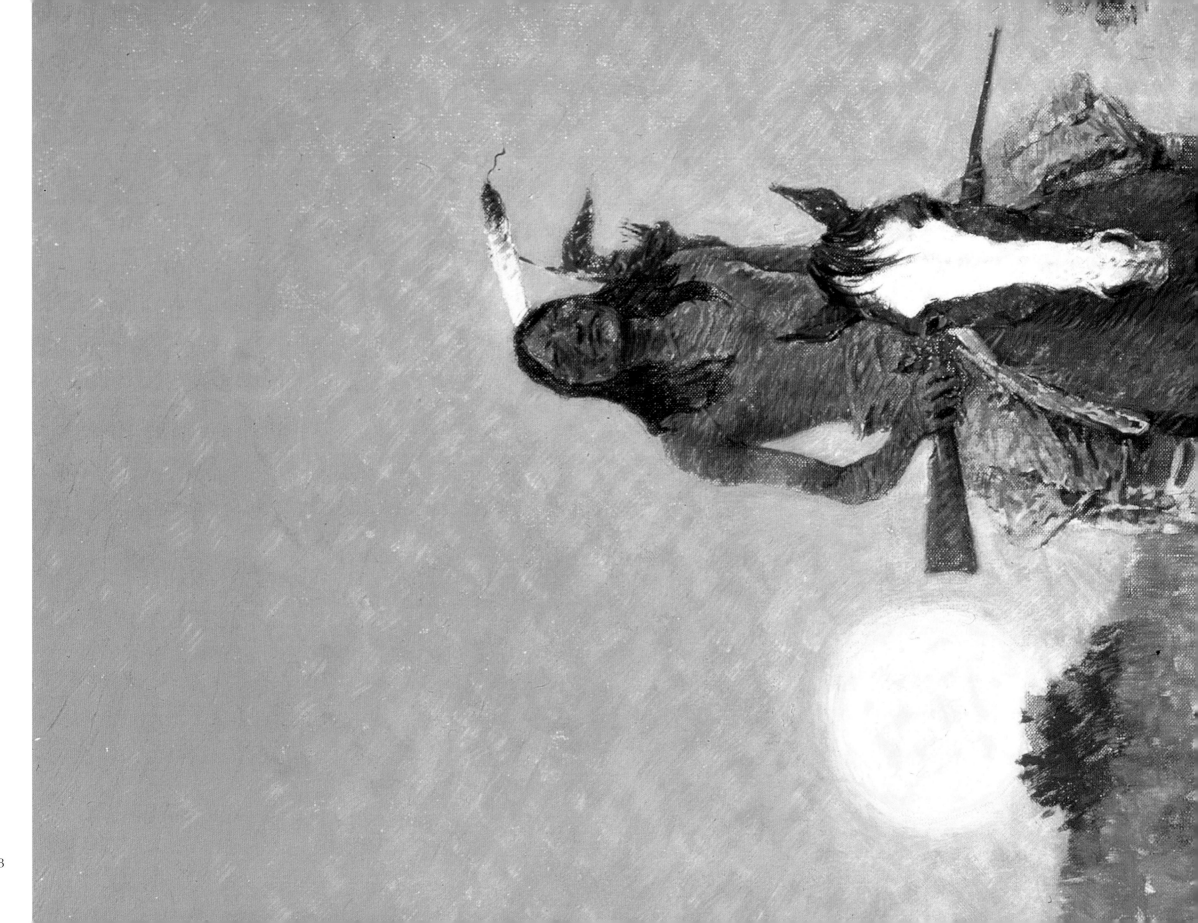

Left: *The Outlier*. Oil on canvas, 1909. *Brooklyn Museum of Art, New York, USA, Bequest of Miss Charlotte R. Stillman/The Bridgeman Art Library*

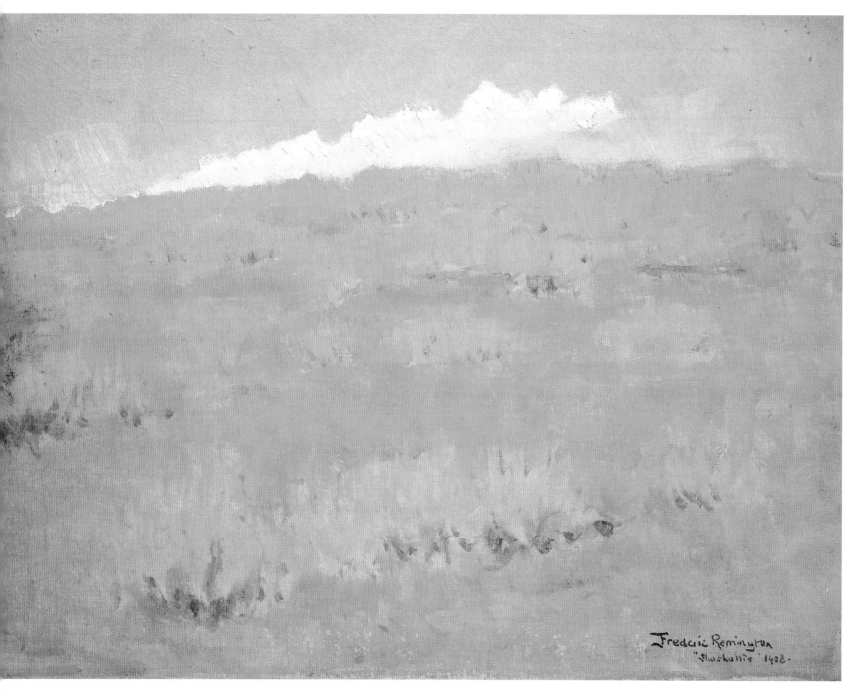

ABOVE: *Shoshonie*. Oil on canvas. 1908. *The Art Archive/Gift of the Coe Foundation/Buffalo Bill Historical Center, Cody, Wyoming/38.67*

RIGHT: *Ghost Riders*. 1908-09. *The Art Archive/Gift of the Coe Foundation/ Buffalo Bill Historical Center, Cody, Wyoming/53.67*

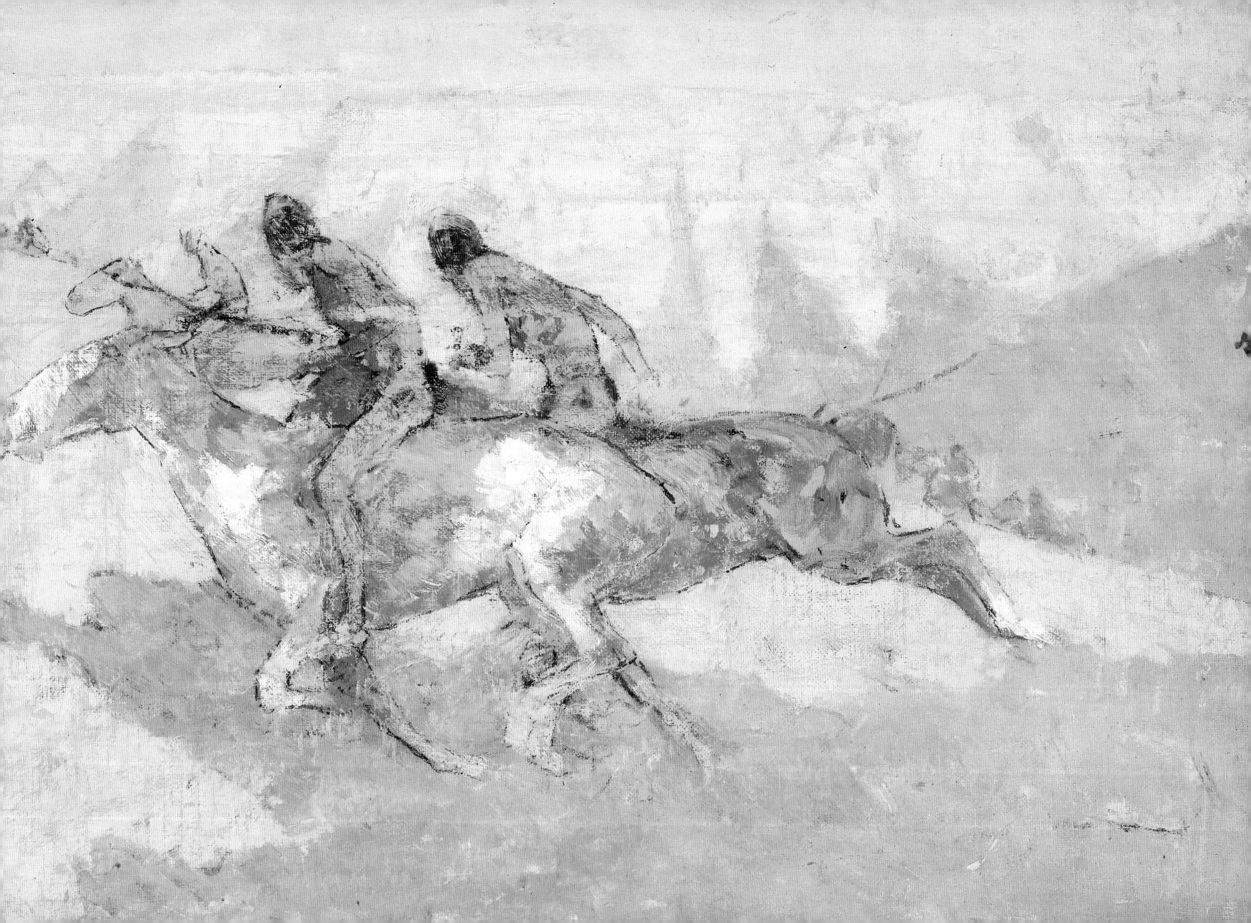

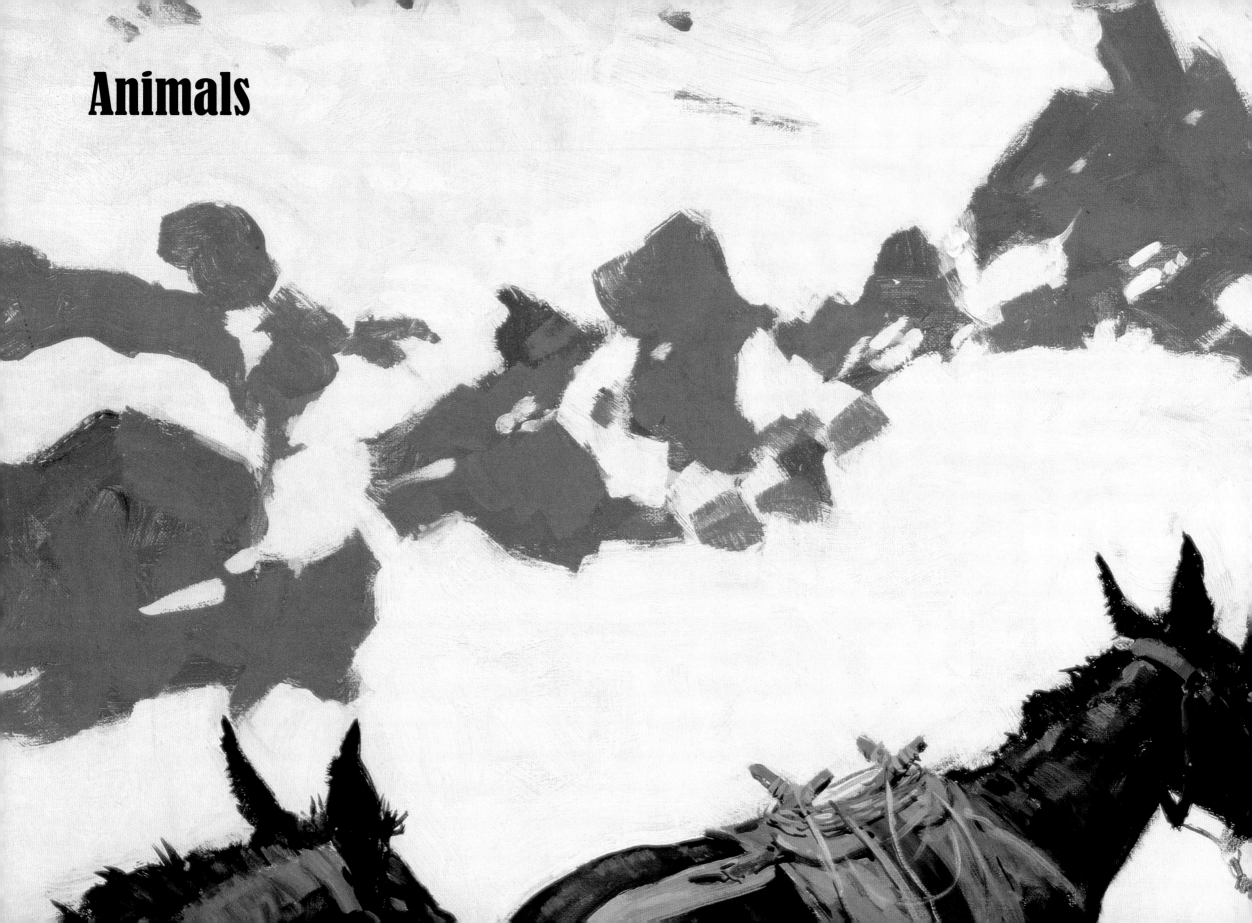

Animals

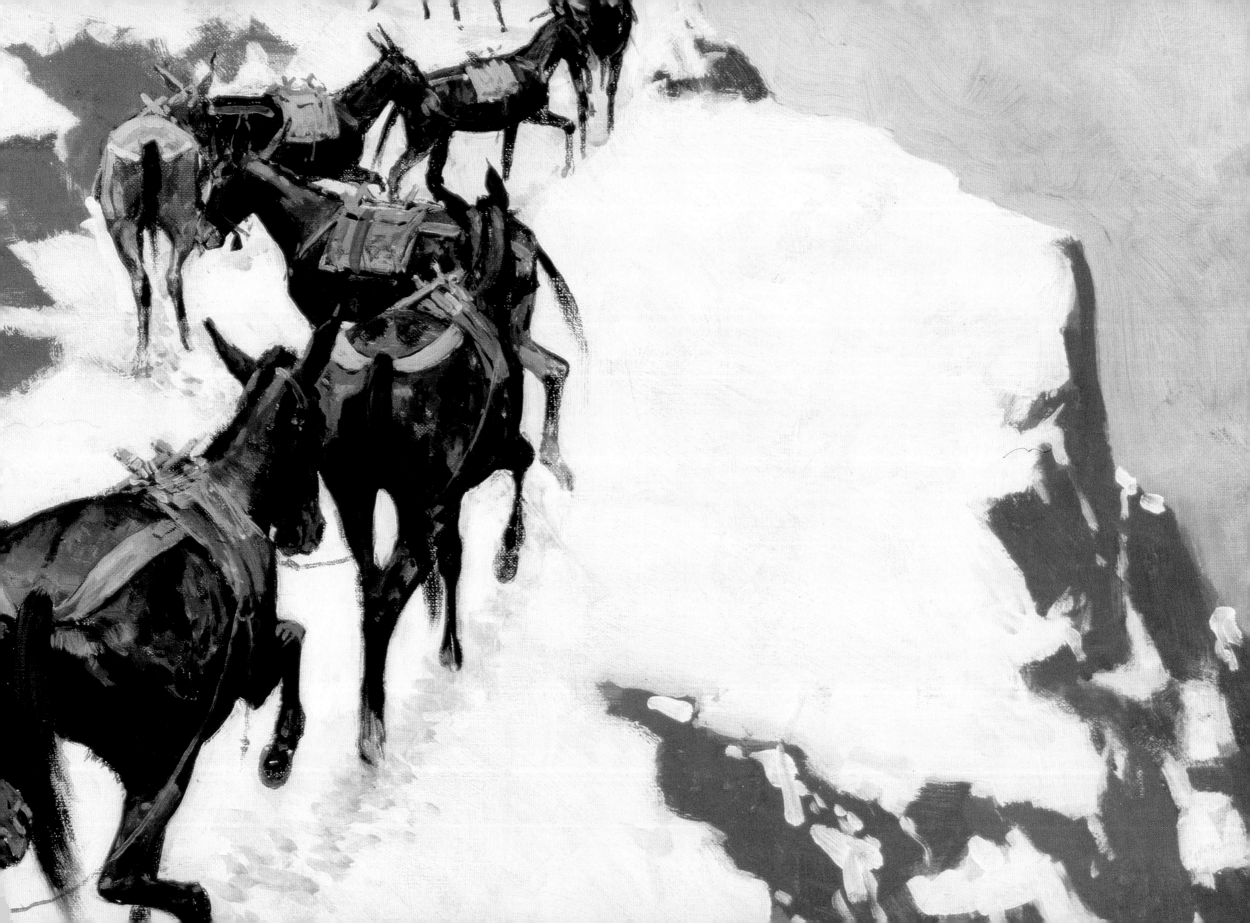

Animals

Frederic Remington's sheer love for horses is evident in his many sketches and paintings and his animals come alive on the page in a manner that no other artist can capture. Animals played a significant part in Remington's life, in particular he loved horses and was from an early age a very confident and competent horseman. He loved riding the range and even in later life when he put on too much weight, he still remained a tough horseman able to tackle even the roughest ride. In 1888 his skill was really put to the test by a "hard riding" lieutenant of the 10th U.S. Cavalry who had been ordered against his better judgement to take Remington out on an extended two-week scout up the San Carlos way in Arizona Territory. He had not been on a horse for a year and was regarded by the lieutenant "with that soldier's contempt for a citizen which is not openly expressed but is tacitly felt." And by his sturdy cavalry horse who, "eyed his citizen rider with malevolent gaze." The troopers were determined to ride Remington into the ground but although the going was rough Remington wrote that, "at times I reviled myself for being such a fool as to do this sort of thing under the delusion that it was an enjoyable experience." It proved a long, hot, and tough ride, but ultimately Remington loved it. Thanks to his love of horses, sharp observation, and skill with sketching, he was able to portray better than any other artist the way a horse moves, especially at speed when galloping over the land. Remington would show his horses with all their legs off the ground as they sped along, much to the derision of some critics. But he was completely vindicated when stop-motion photography—a very new development—utterly proved his contention.

PREVIOUS PAGES: *The Mule Pack (An Ore-Train Going into the Silver Mines, Colorado).* Oil on canvas, 1901. Silver was discovered in Colorado in the 1860s and turned into a boom in 1879 when a significant lode was discovered; the rush prevailed until the price of silver collapsed in 1893, thanks to Congress legislation. © *Museum of Fine Arts, Houston, Texas, USA/Hogg Brothers Collection, Gift of Miss Ima Hogg/The Bridgeman Art Library*

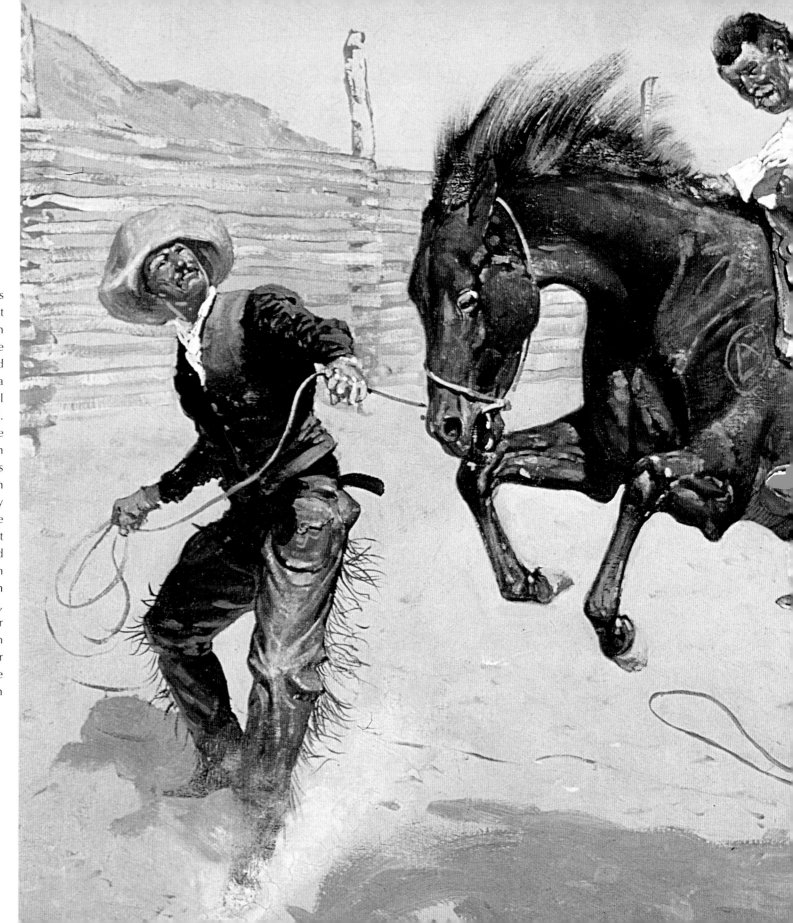

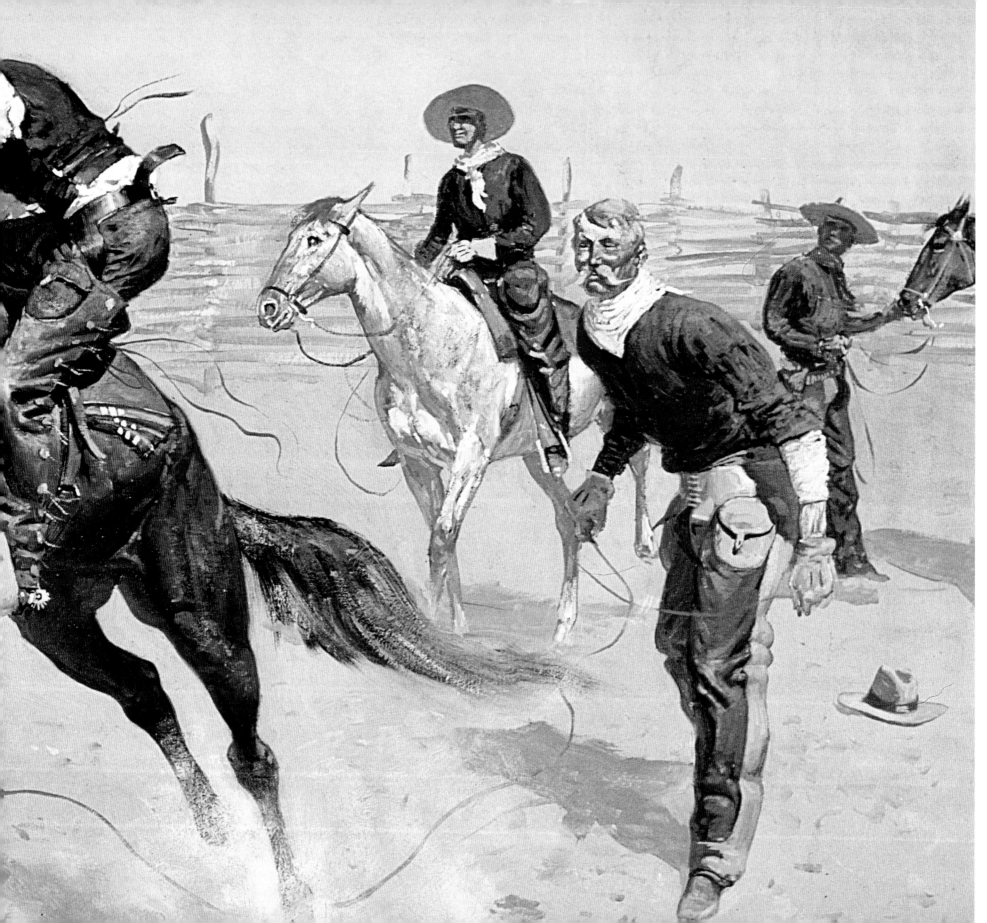

LEFT: *Turn Him Loose, Bill.* Oil on canvas, c.1893. © Anschutz Collection, Colorado, USA/Peter Newark Western Americana/The Bridgeman Art Library

OVER PAGE LEFT: *Buckskin horse with four white stockings.* Undated. *The Art Archive/Gift of the Coe Foundation/Buffalo Bill Historical Center, Cody, Wyoming/46.67*

OVER PAGE RIGHT: Pinto horse, with dark trees in the background. Undated. *The Art Archive/Gift of the Coe Foundation/Buffalo Bill Historical Center, Cody, Wyoming/28.67*

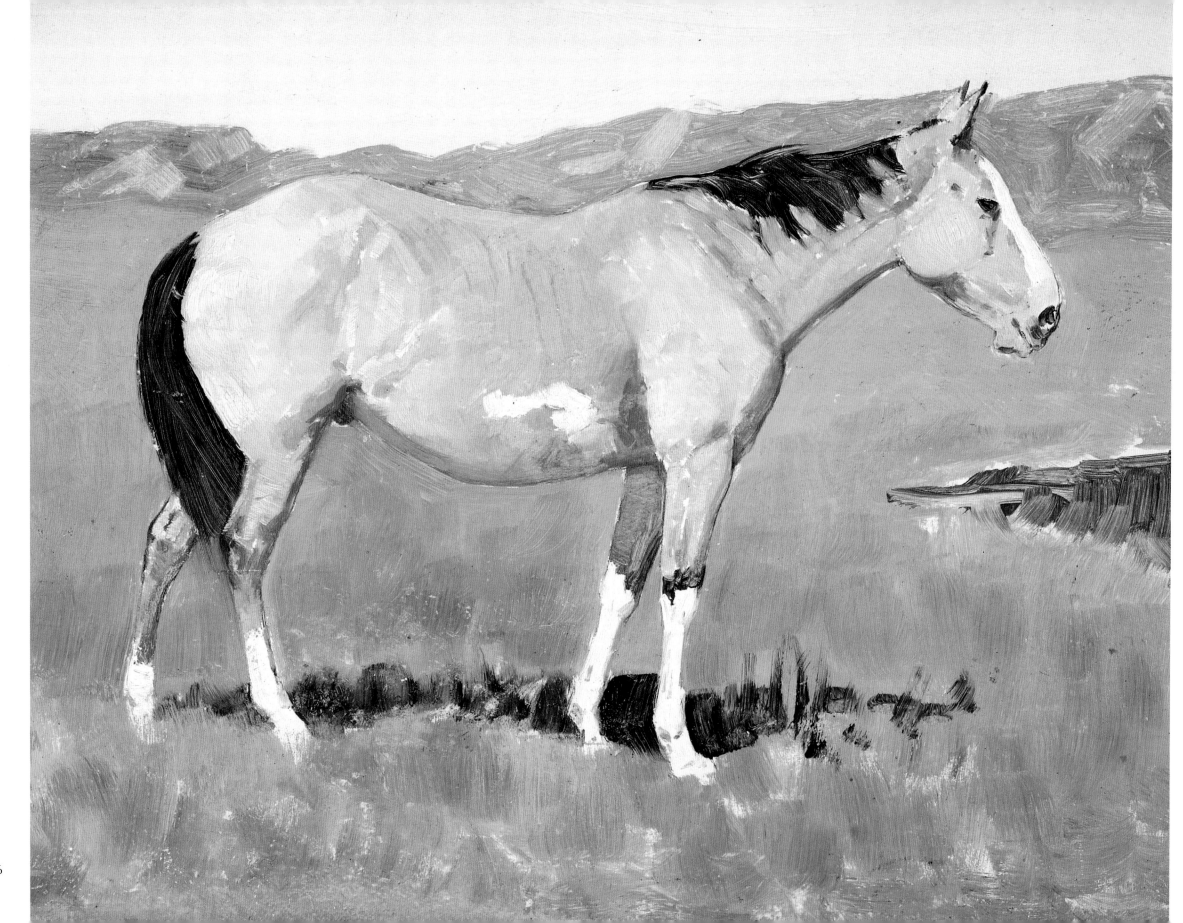

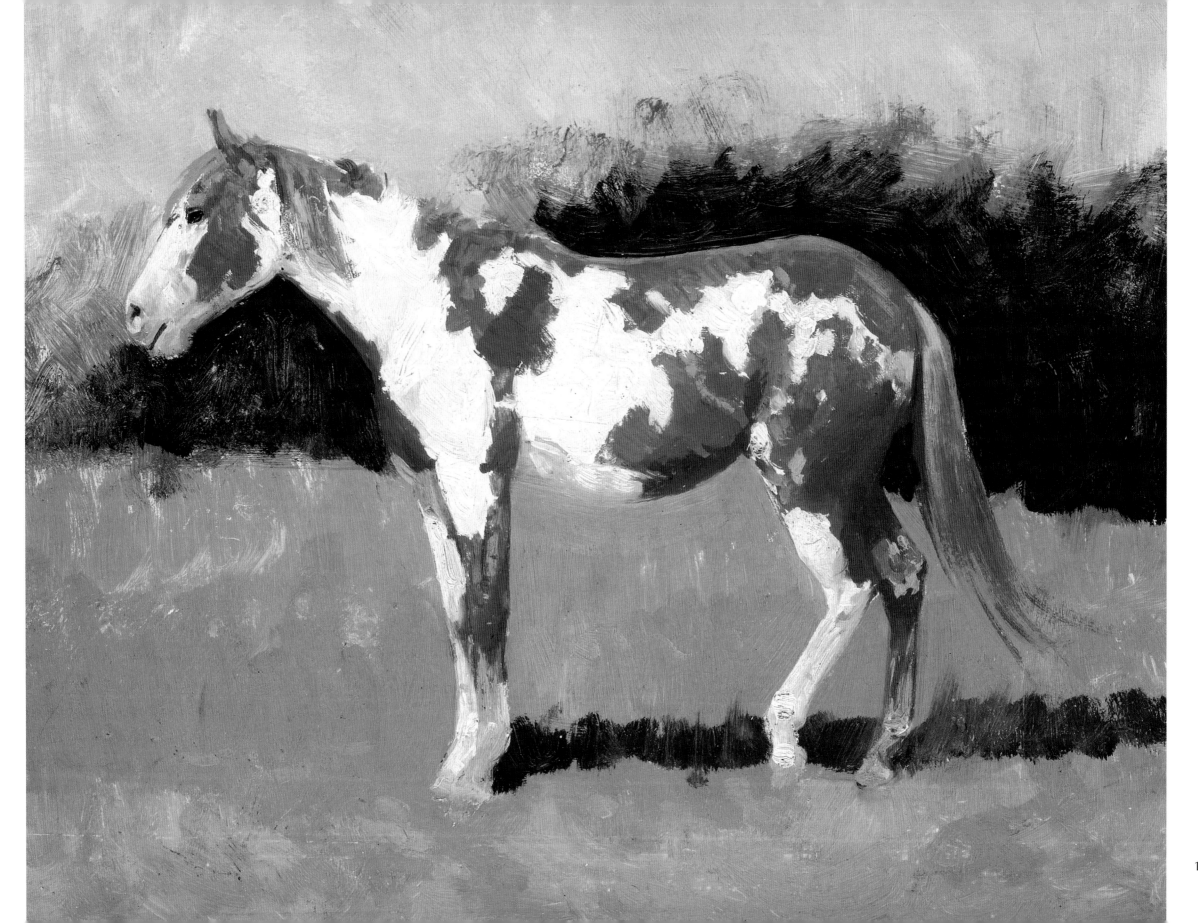

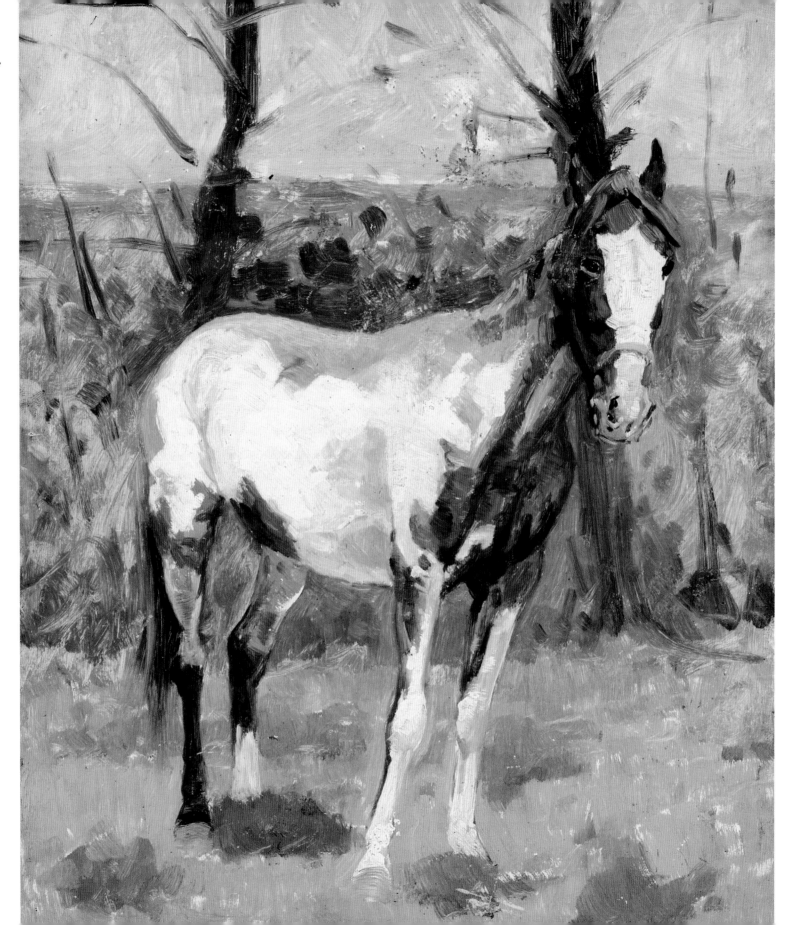

RIGHT: Pinto horse, with two bare trees and hill in the background. Undated. *The Art Archive/Gift of the Coe Foundation/Buffalo Bill Historical Center, Cody, Wyoming/73.67*

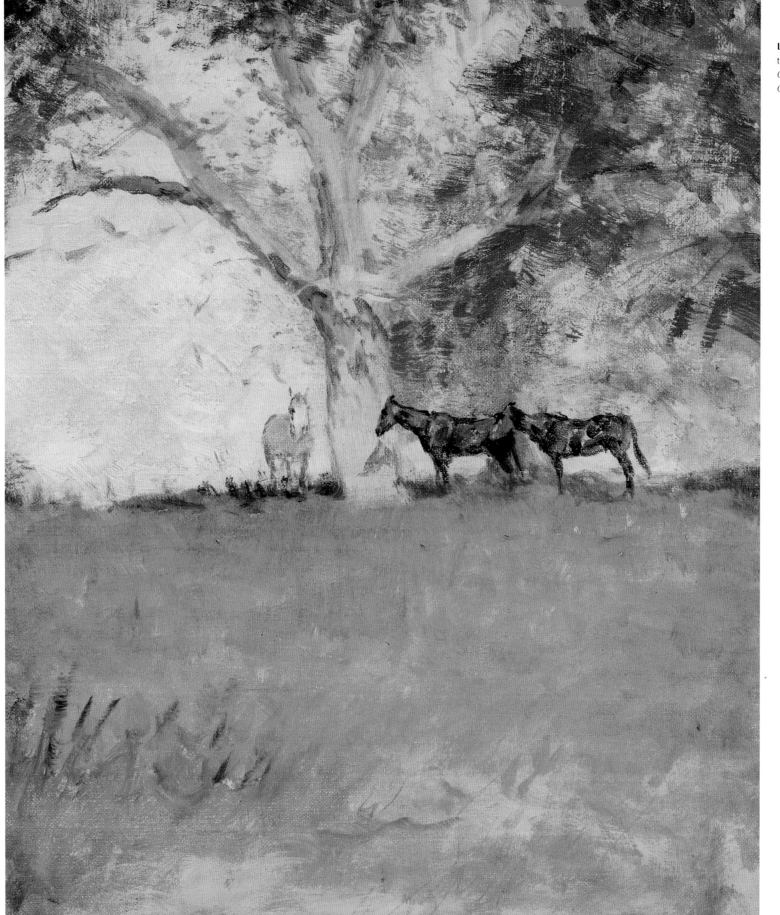

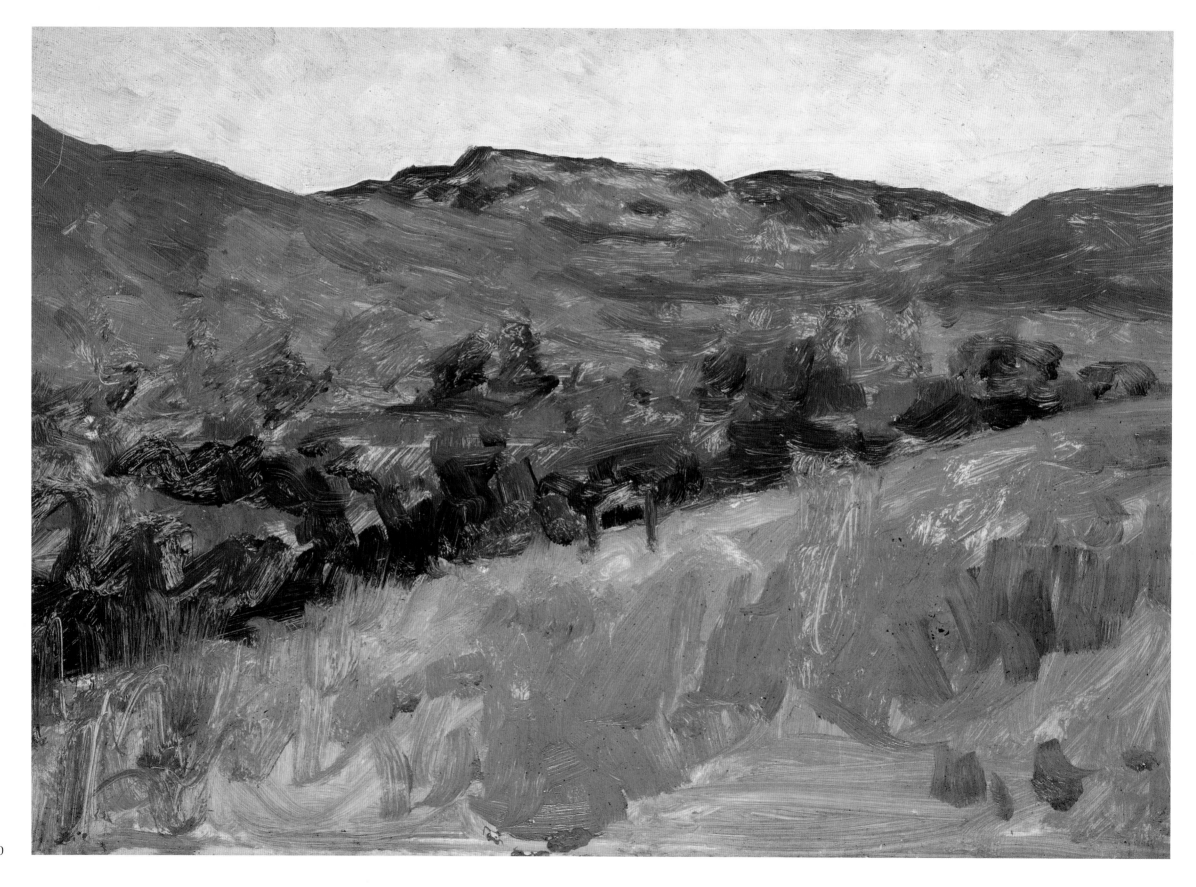

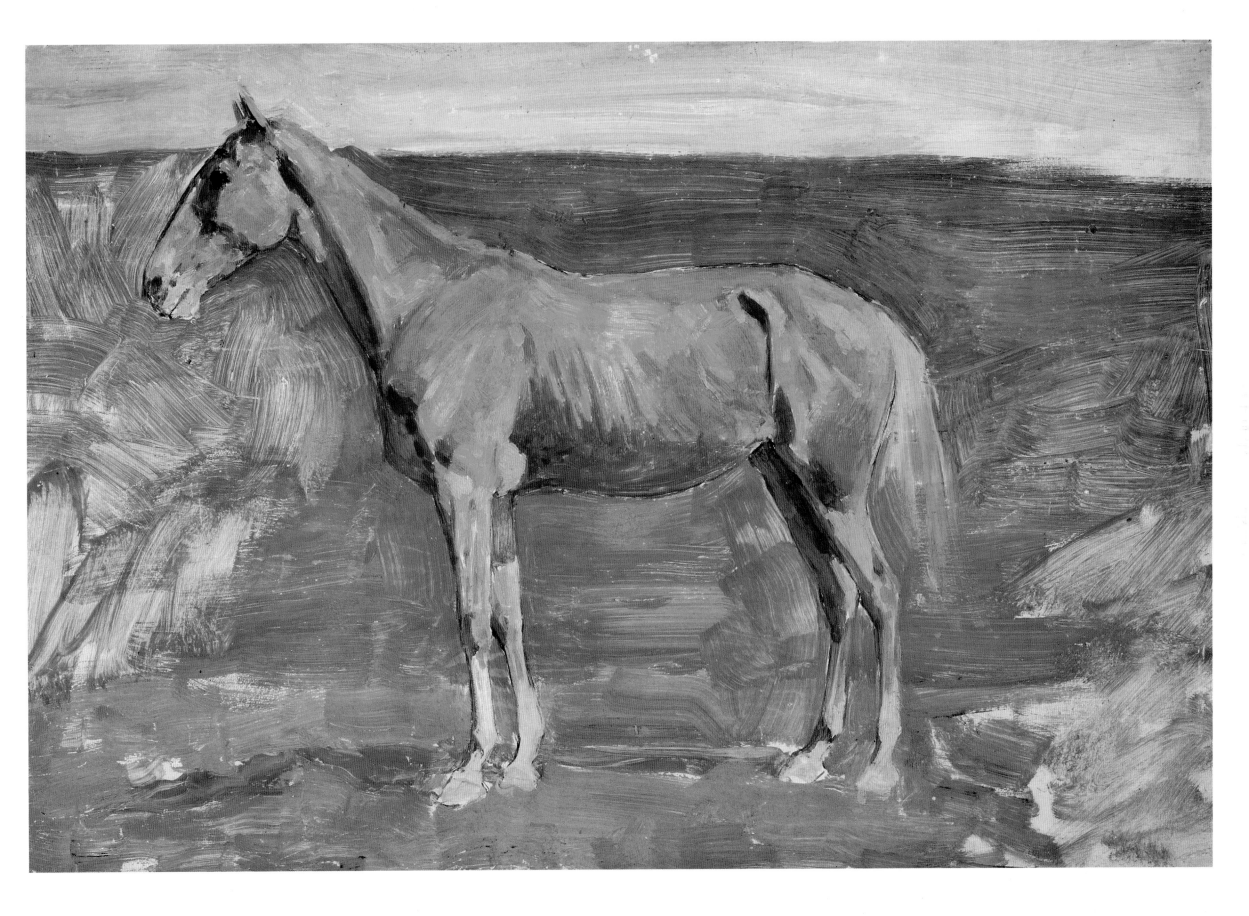

Previous page left: Horse in high prairie. Undated. *The Art Archive/Gift of the Coe Foundation/Buffalo Bill Historical Center, Cody, Wyoming/102.67*

Previous page right: *Sorrel Horse.* Undated. *The Art Archive/Gift of the Coe Foundation/Buffalo Bill Historical Center, Cody, Wyoming/68.67*

Right: Horse in high prairie. Undated. *The Art Archive/Gift of the Coe Foundation/Buffalo Bill Historical Center, Cody, Wyoming/107.67*

Far right: Sketch of cow. Undated. *The Art Archive/Gift of the Coe Foundation/Buffalo Bill Historical Center, Cody, Wyoming/10.67*

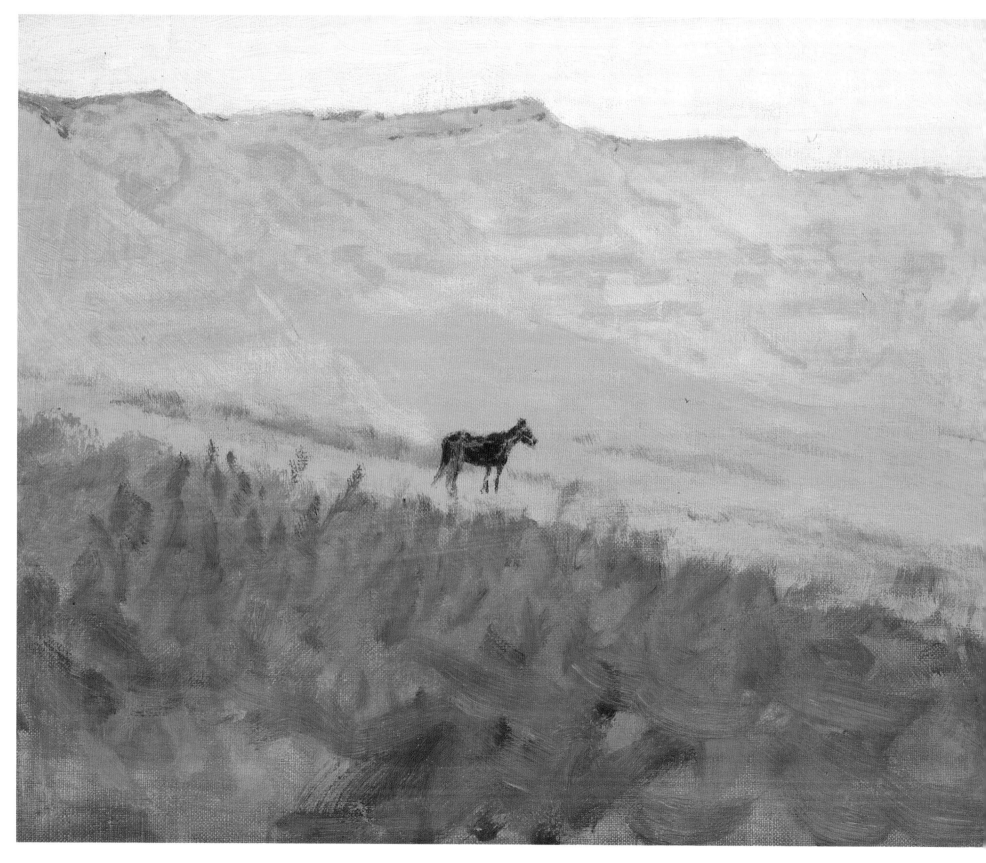

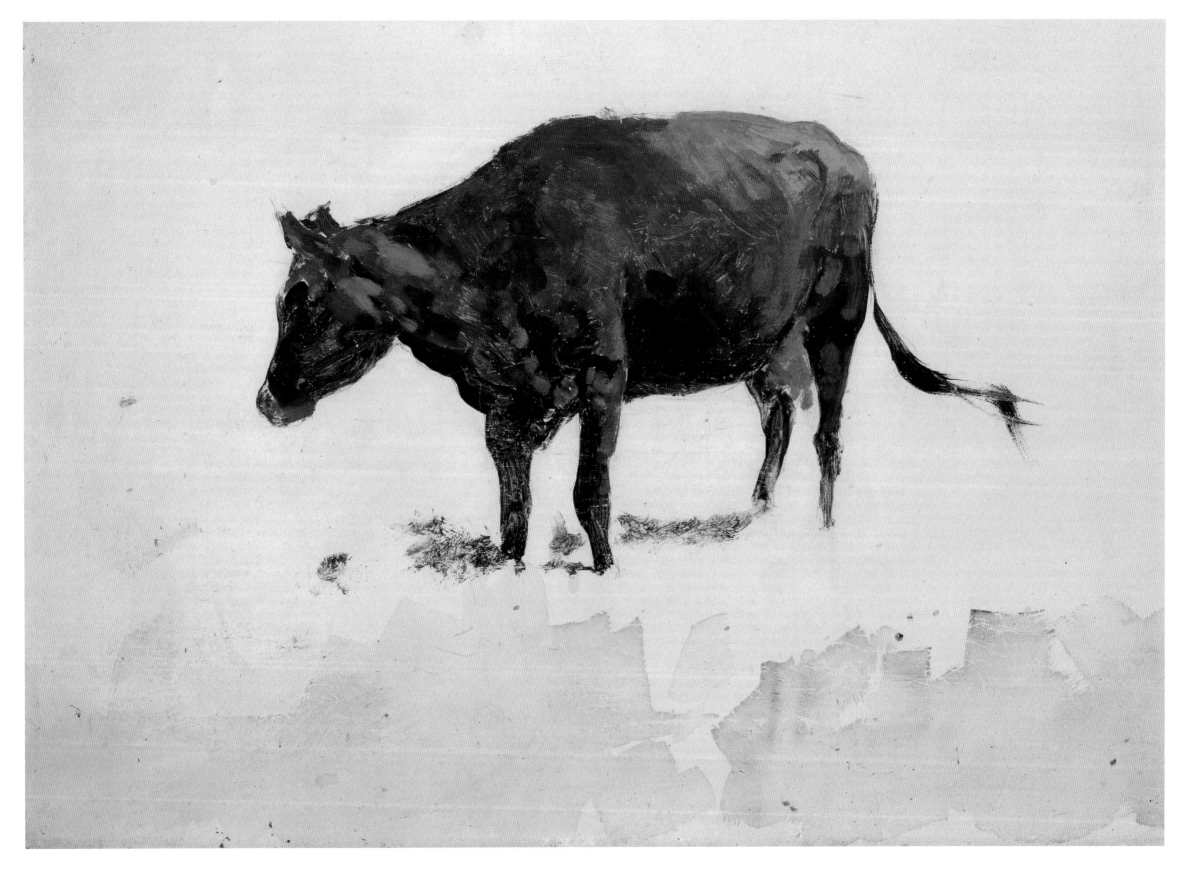

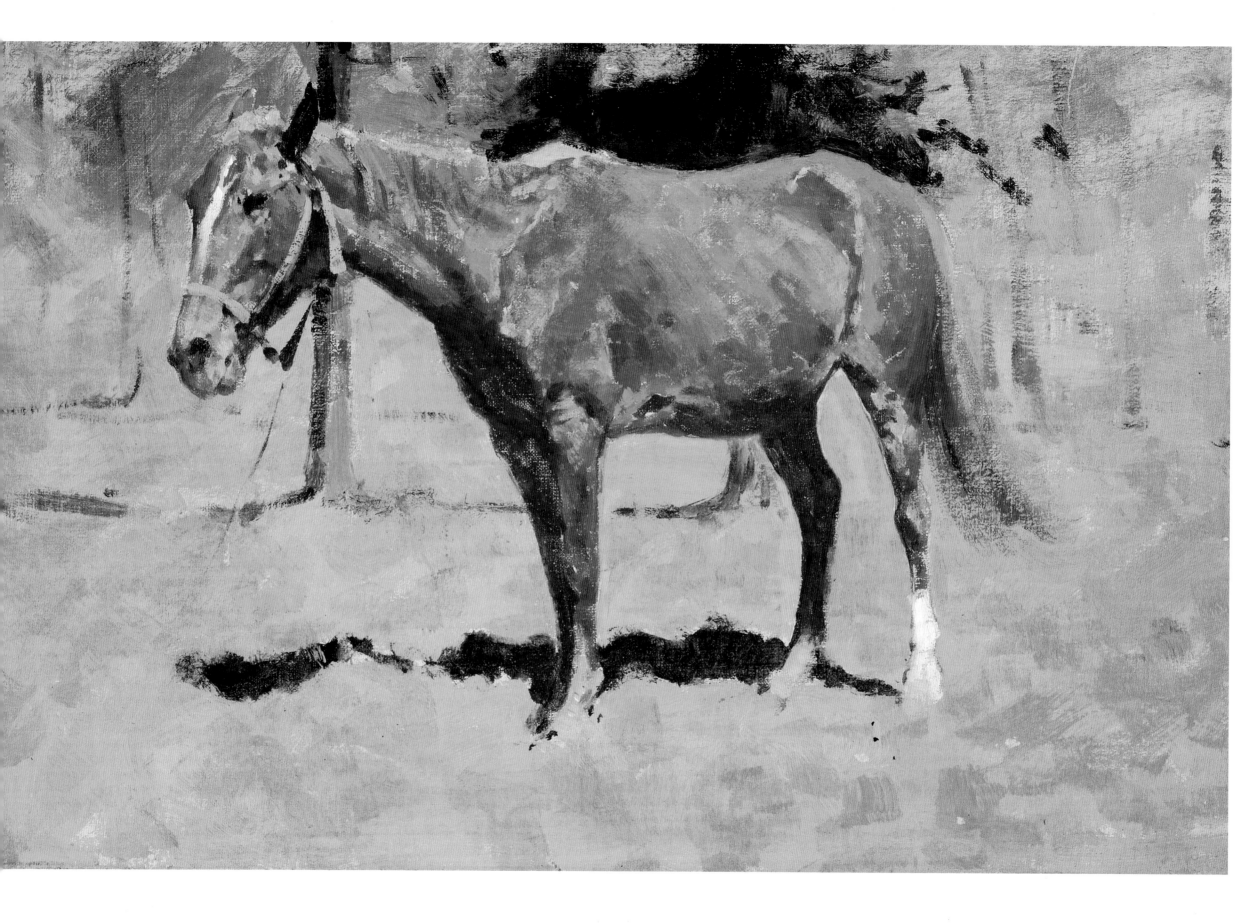

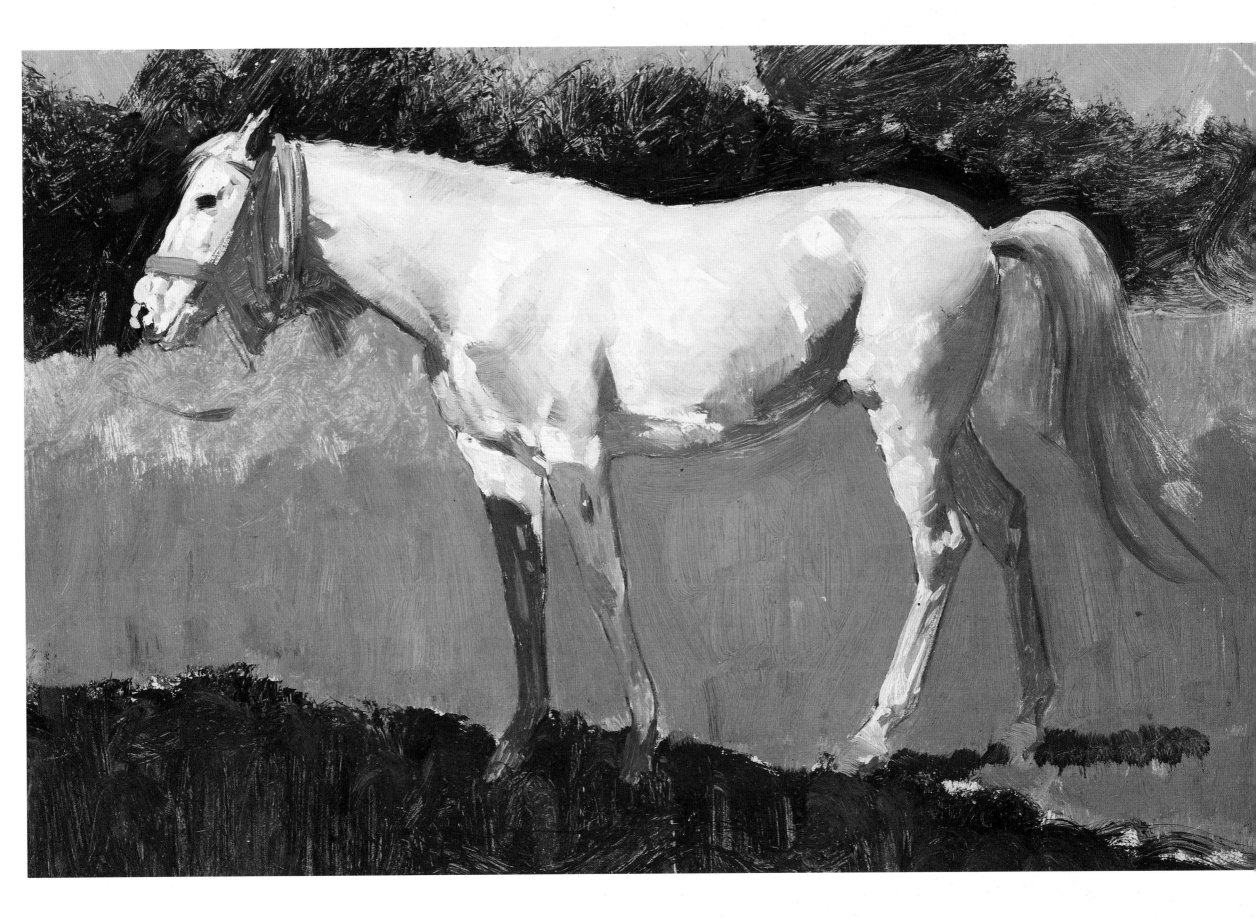

PREVIOUS PAGE LEFT: Sorrel horse with blaze face. Undated. *The Art Archive/Gift of the Coe Foundation/Buffalo Bill Historical Center, Cody, Wyoming/52.67*

PREVIOUS PAGE RIGHT: White horse, green grass, and trees. Undated. *The Art Archive/Gift of the Coe Foundation/Buffalo Bill Historical Center, Cody, Wyoming/27.67*

RIGHT: *Jump.* Watercolor on paper, undated. *David David Gallery, Philadelphia, PA, USA/The Bridgeman Art Library*

FAR RIGHT: Sketch of brown horse. Undated. *The Art Archive/Gift of the Coe Foundation/Buffalo Bill Historical Center, Cody, Wyoming/4.67*

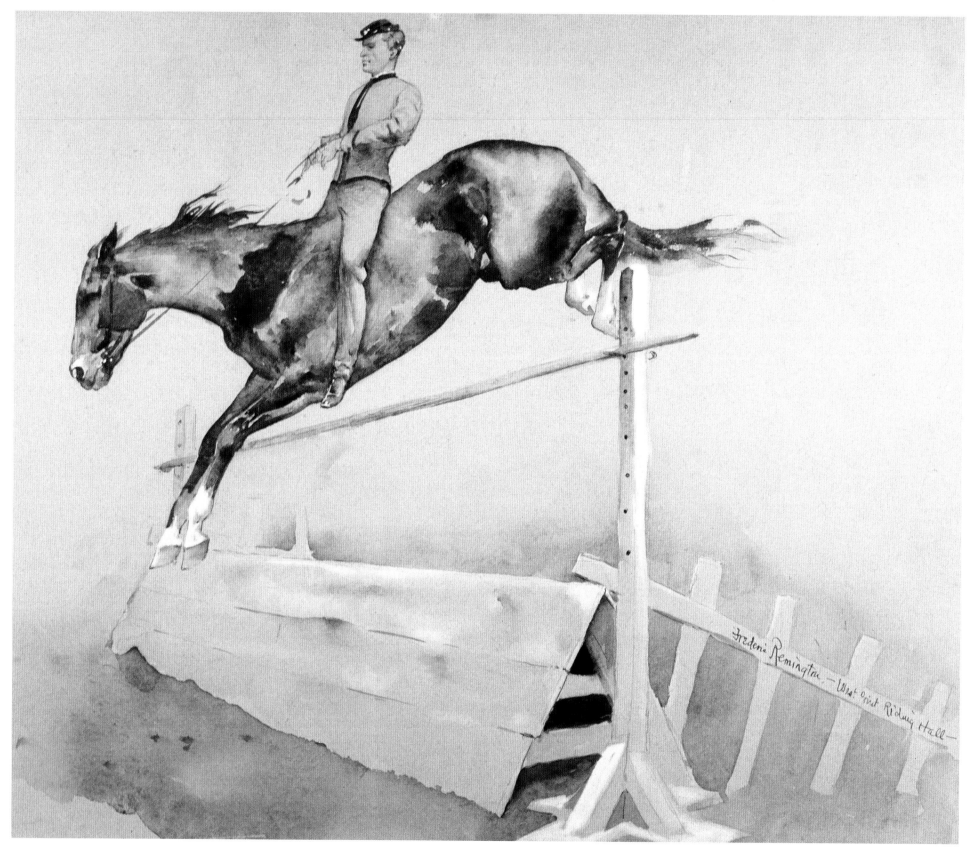

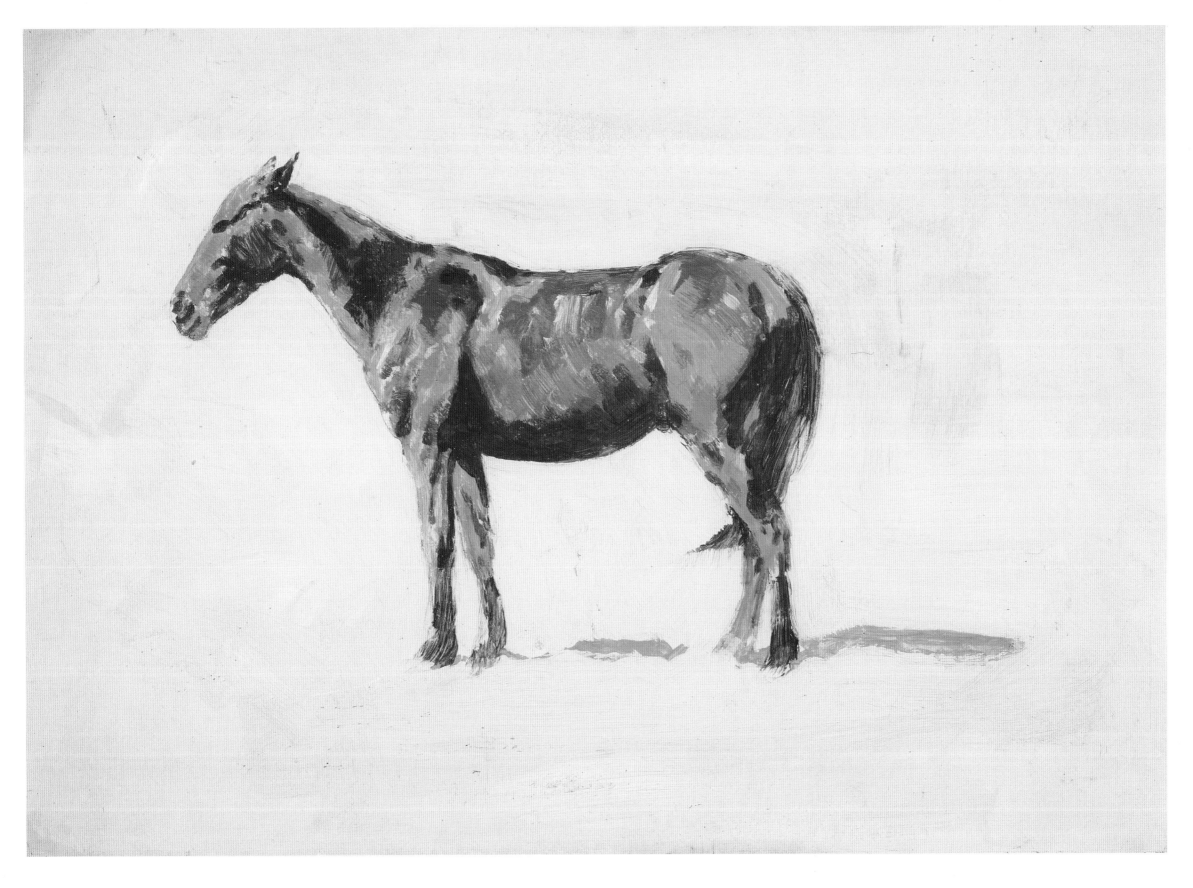

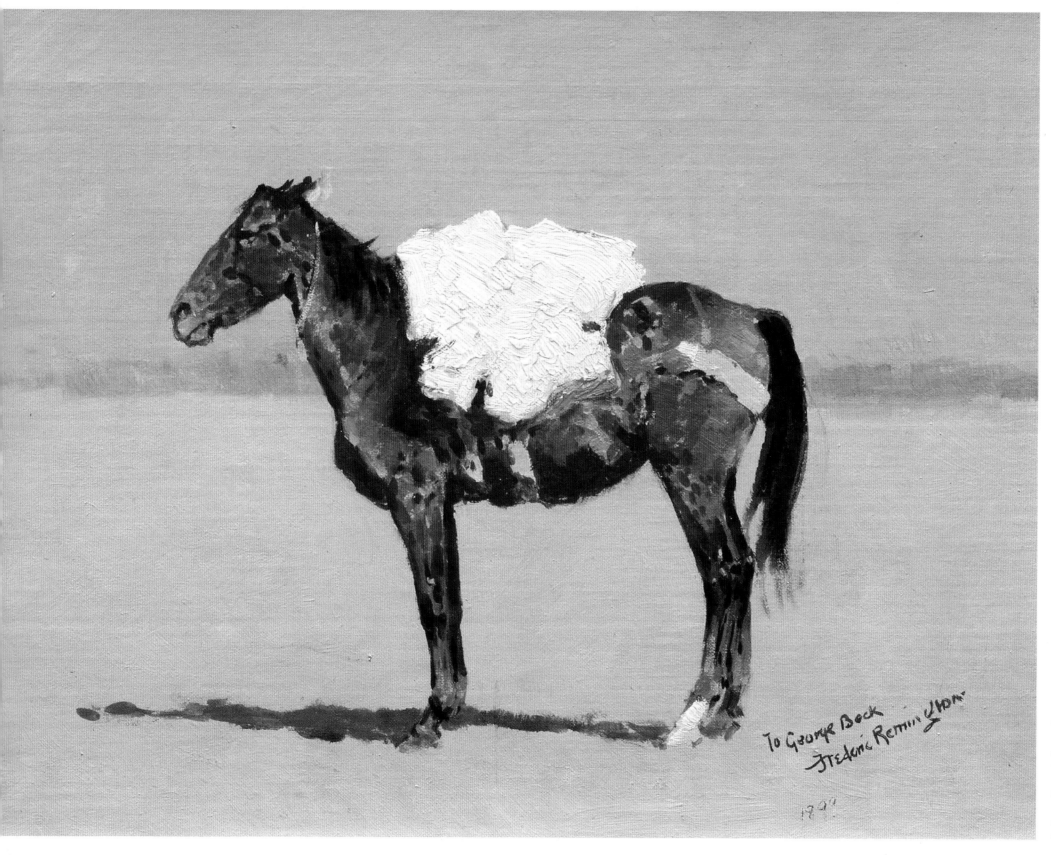

To George Beck
Frederic Remington

1899

Left: *Unhaltered Pack Horse*, 1899. On October 17, 1908, Remington sent this sketch to George T. Beck, whom he had visited the previous month in Cody. *The Art Archive/Gift of Dr Peter Kooi Simpson and Sen Alan Kooi Simpson in fond memory of our dear parents Hon. Milward Lee and Lorna Kooi Simpson/Buffalo Bill Historical Center, Cody, Wyoming/21.98.1*

Right: *Army Mule with Harness Marks.* Undated. Although he had early training at two different military academies, Remington never joined the Army, he did however, spend time with various troops and regiments, most notably those forces charged with controling the Native American tribes. *The Art Archive/Gift of the Coe Foundation/Buffalo Bill Historical Center, Cody, Wyoming/23.67*

Over page left: *Gray Burrow.* Undated. *The Art Archive/Gift of the Coe Foundation/Buffalo Bill Historical Center, Cody, Wyoming/24.67*

Over page right: *Irish Hunter.* Undated. *The Art Archive/Gift of the Coe Foundation/Buffalo Bill Historical Center, Cody, Wyoming/1.67*

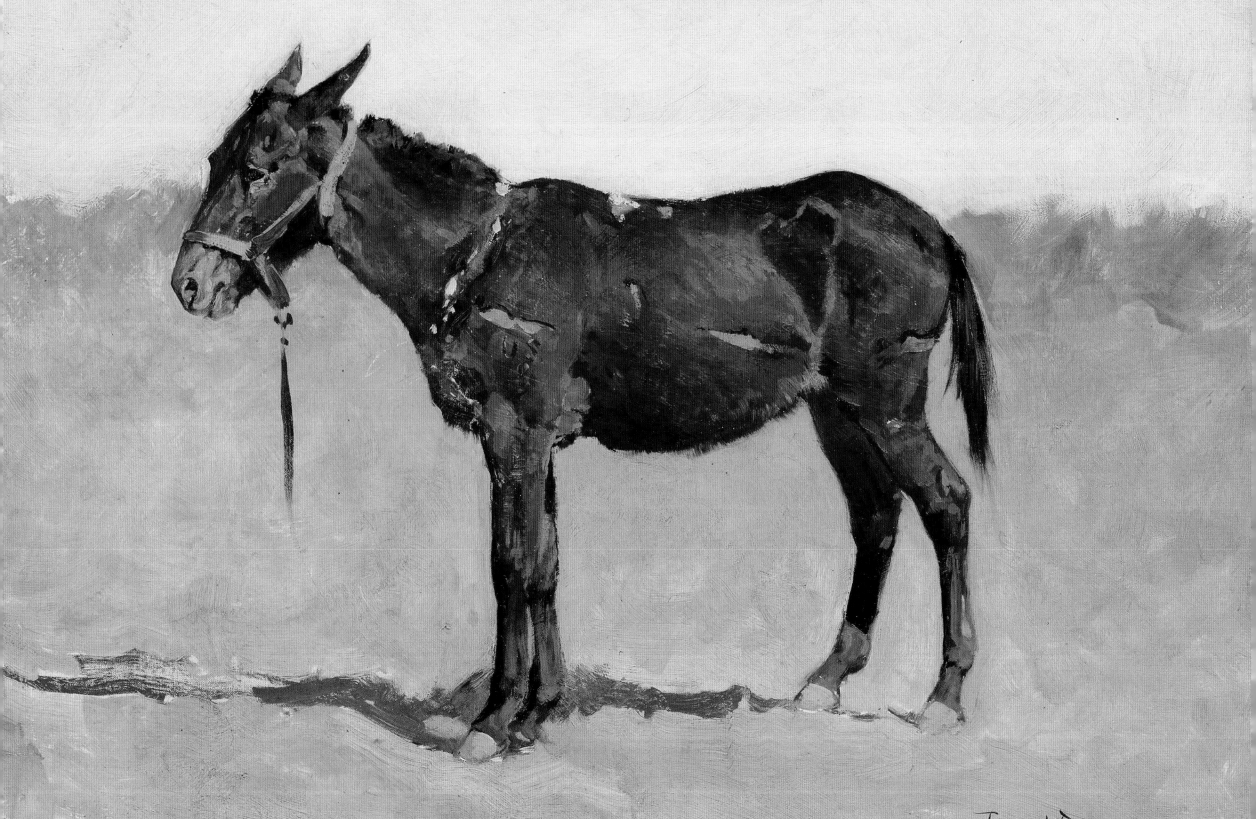

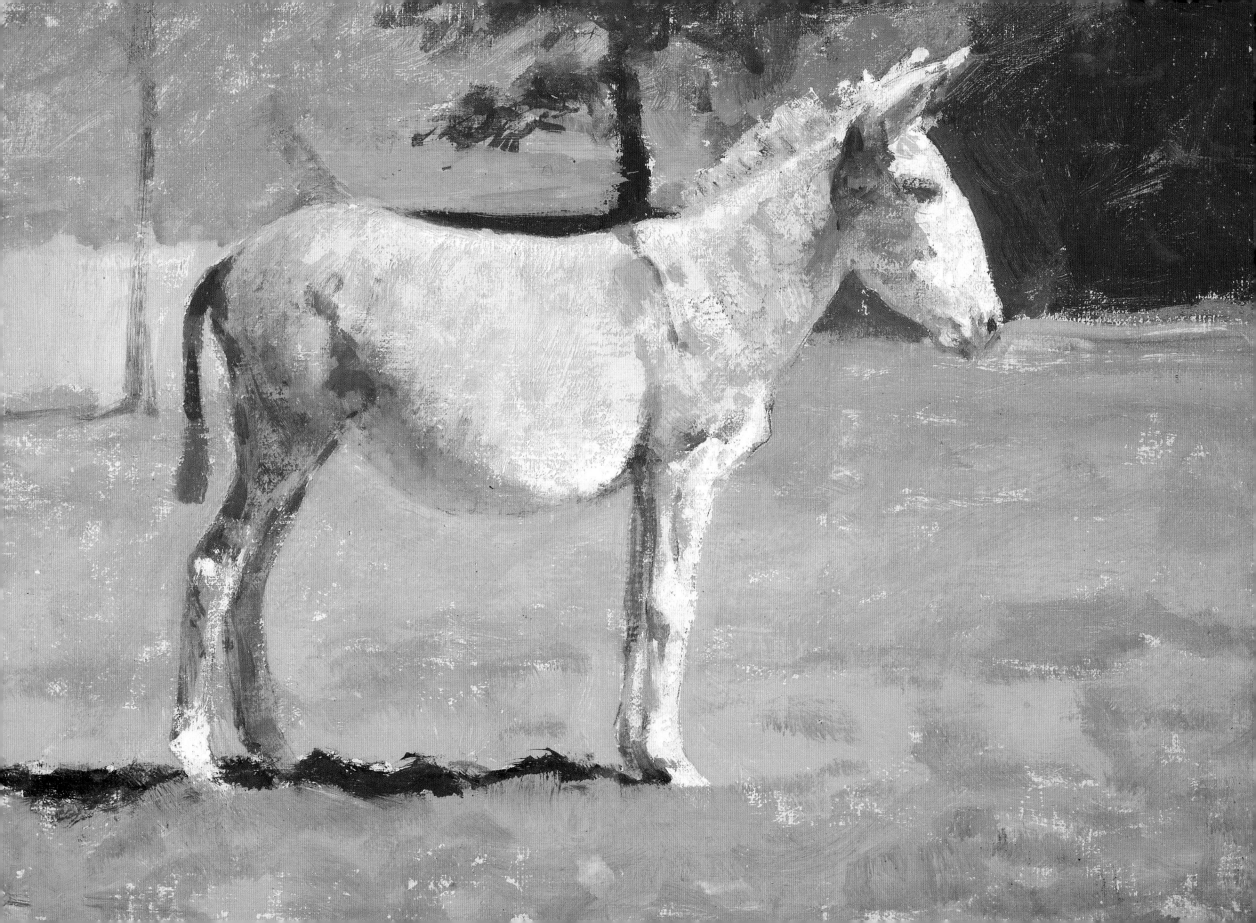

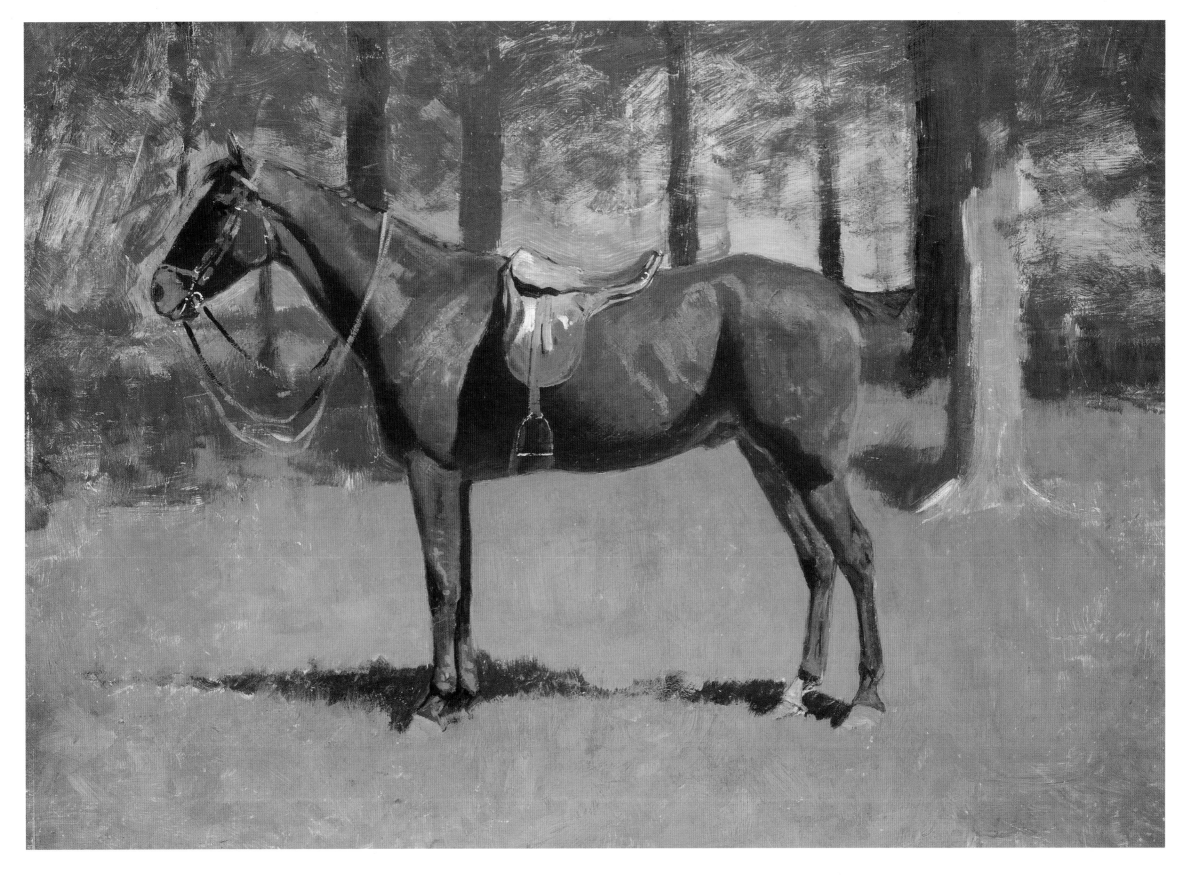

LEFT: *Bull Durham.* Undated. *The Art Archive/Gift of the Coe Foundation/ Buffalo Bill Historical Center, Cody, Wyoming/109.67*

RIGHT: *The Call for Help (At Bay).* Oil on canvas, c.1908. *Museum of Fine Arts, Houston, Texas, USA, Hogg Brothers Collection, Gift of Miss Ima Hogg/The Bridgeman Art Library*

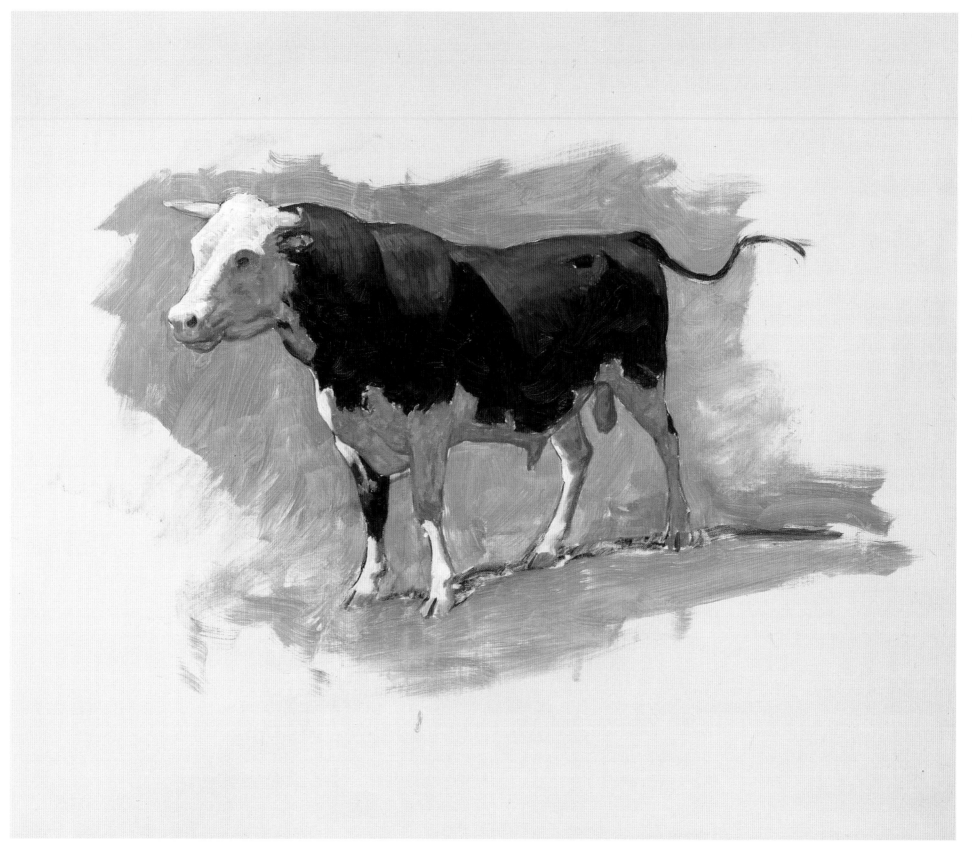

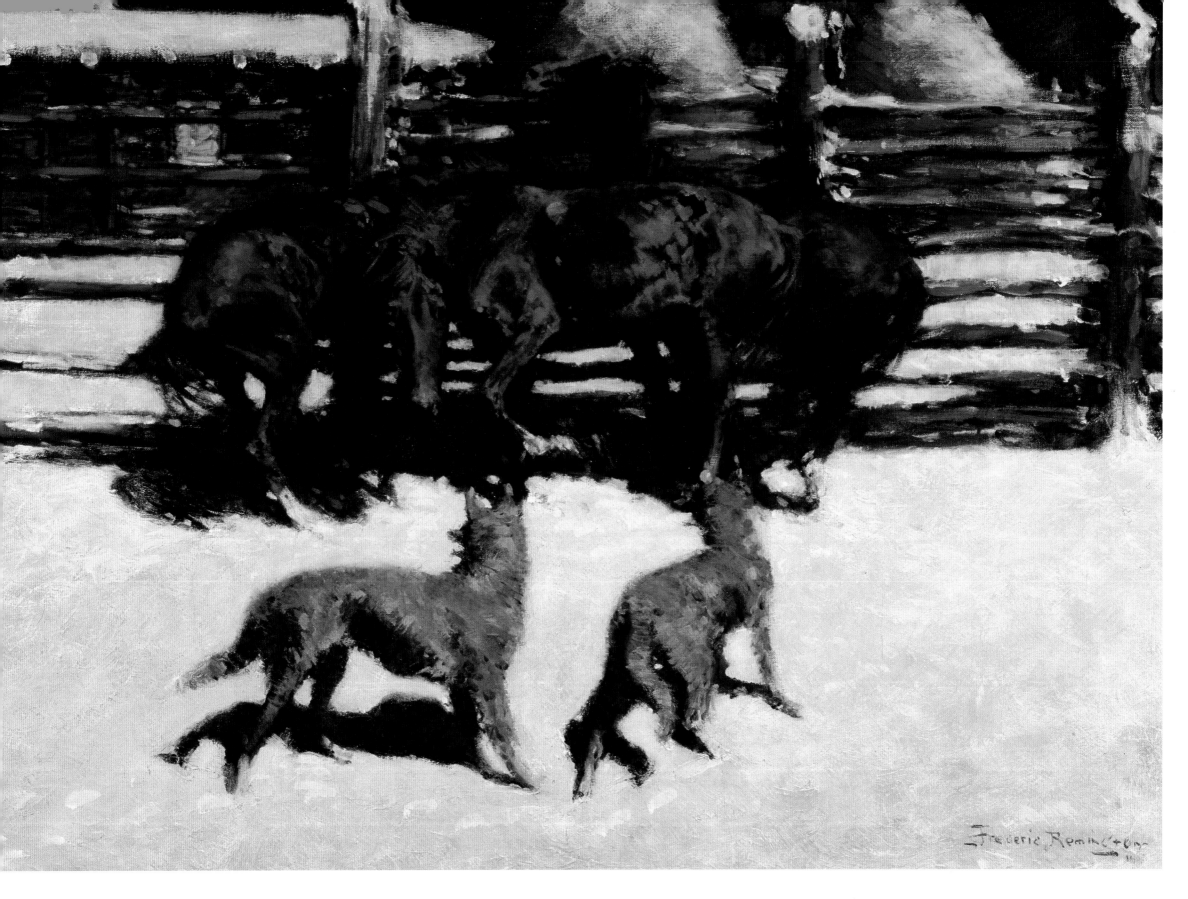

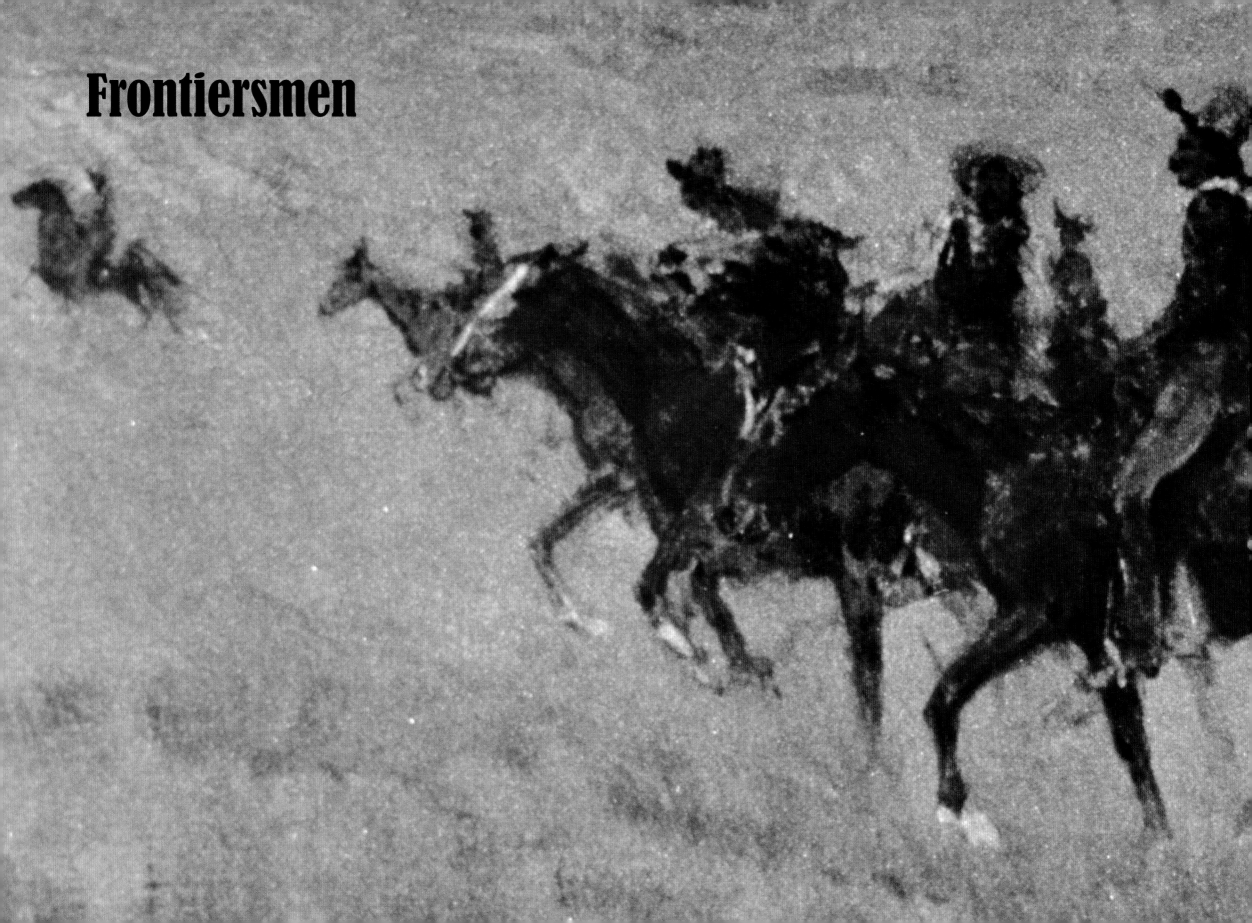

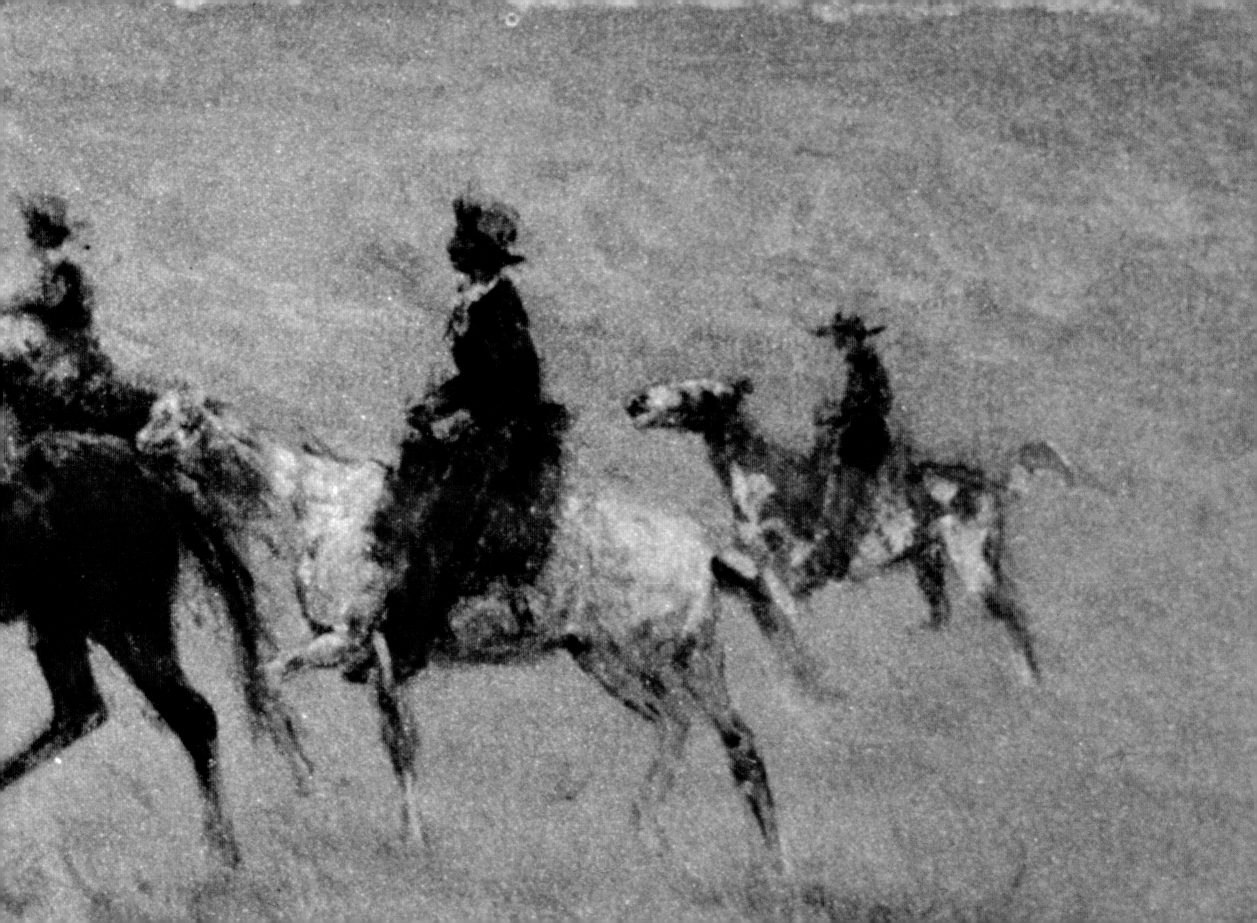

Frontiersmen

Frederic Remington loved mixing and talking to the men of the western frontier, the hard men who were taming the land and bringing a measure of civilization to the trackless and largely unknown landscapes. He would spend hours talking and listening to the tales of cowboys and frontiersmen; their lives were a constant source of inspiration and stories for him to portray and relate to his passionate readership back East. He did not just listen, he also loved to go out into the untamed lands where he and his companions would live rough according to the terrain and weather. He greatly admired their toughness and affinity with the land and wrote many stories explaining their lives to his readership. After he died his widow, Eva, lived on in their last house in Ogdensburg from where she oversaw his estate, principally authorizing new castings of his bronzes. When she died in 1918 she left her own personal collection of Remington's papers, archives, paintings, drawings, and bronzes to the people and city of Ogdensburg and their house as the Frederic Remington Museum.

PREVIOUS PAGES: *The Cowpunchers.* Watercolor on paper, undated. A cowpuncher is another name for a cowboy. © *Whitney Gallery of Western Art, Cody, Wyoming, USA/Peter Newark Western Americana/The Bridgeman Art Library*

RIGHT: *Prospecting for Cattle Range. 1889. Milton E. Milner and Judge Kennon in Montana Territory. The Art Archive/Gift of Cornelius Vanderbilt Whitney/Buffalo Bill Historical Center, Cody, Wyoming/85.60*

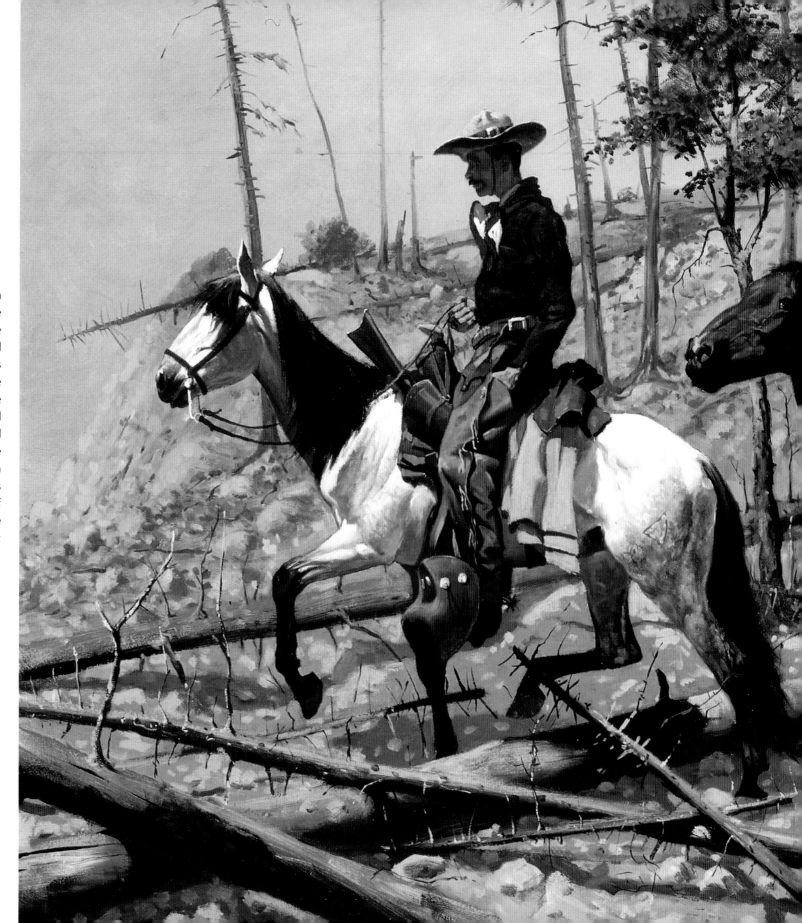

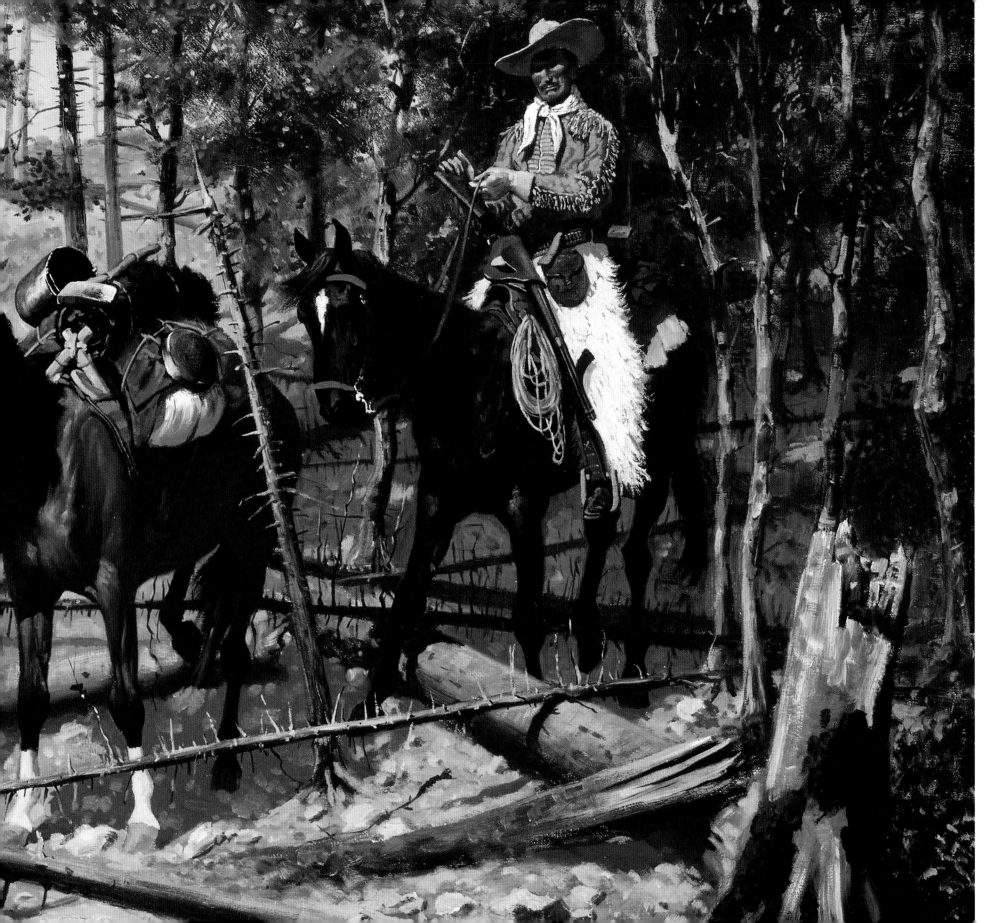

OVER PAGE LEFT: *Night Herder*, (or *The Night Rider*). Oil on board, undated. *The Art Archive/Gift of the Coe Foundation/Buffalo Bill Historical Center, Cody, Wyoming/47.67*

OVER PAGE RIGHT: *Cattle in a Kansas Corn Corral*, illustration from *Harper's Weekly*, 1888, engraving from *The Pageant of America, Vol.3*, by Ralph Henry Gabriel, (1926), after Remington. *Private Collection/The Bridgeman Art Library*

137

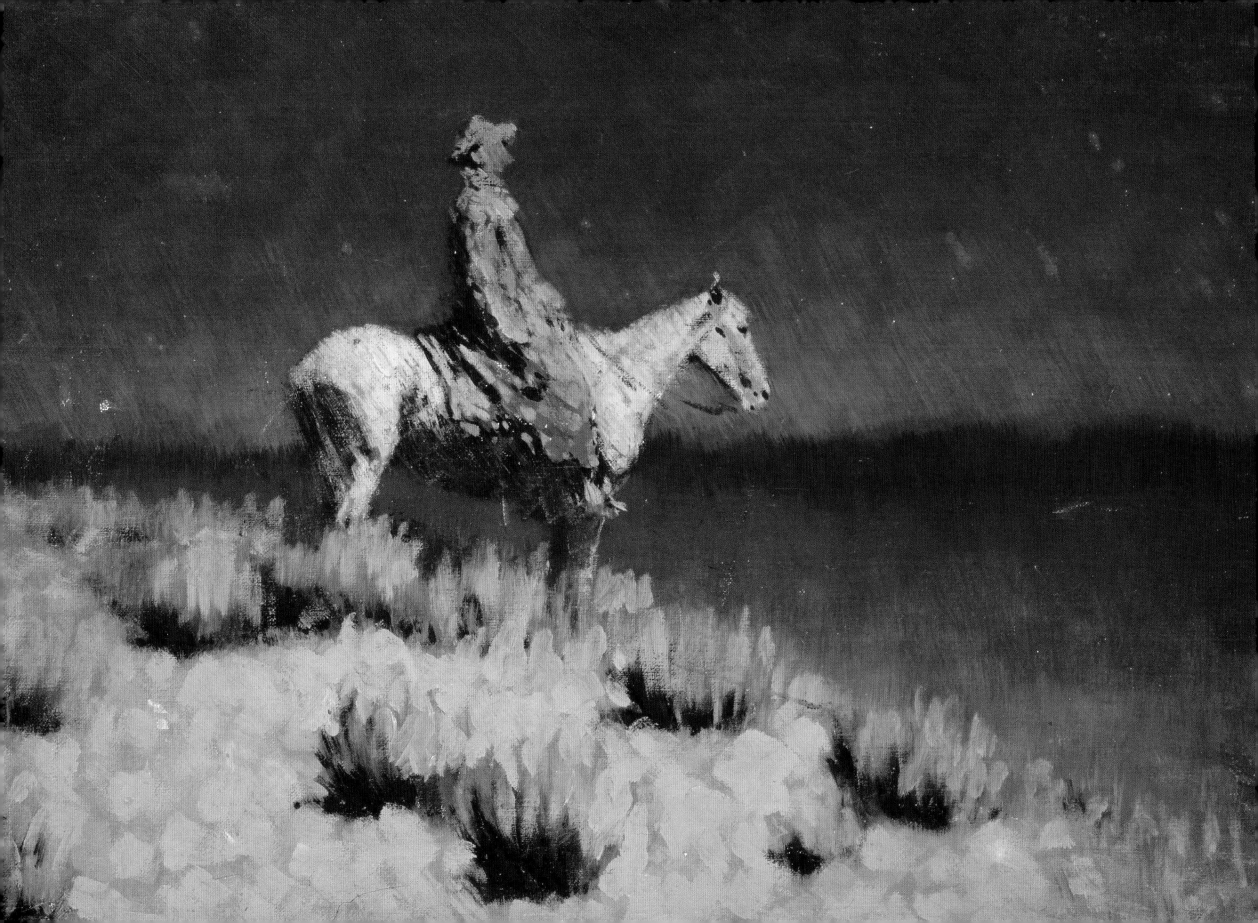

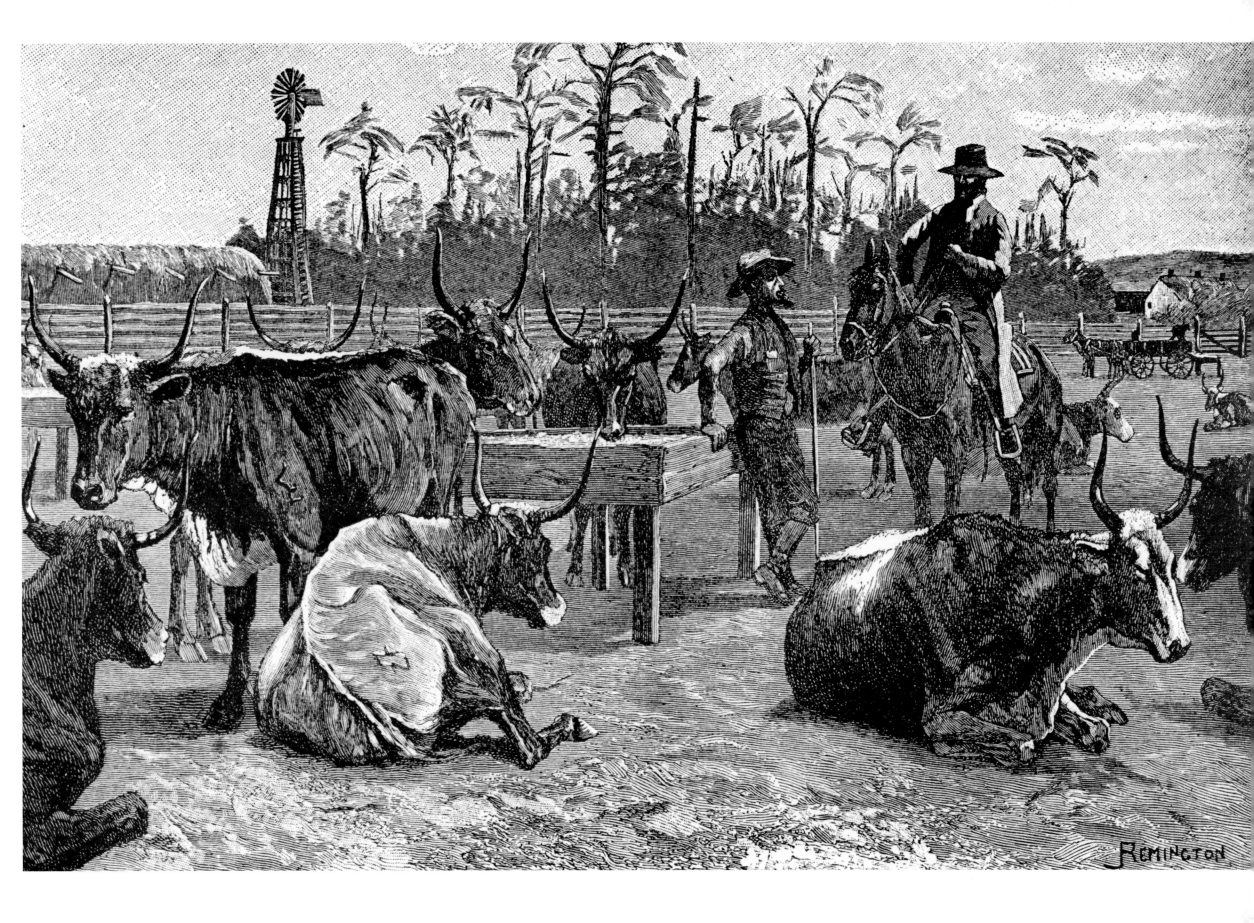

LEFT: *Texas Cowboy.* Oil on canvas, c.1890. The cowboy was typically an itinerant man who hired himself out to different outfits as work opportunities changed with the seasons and times. *Private Collection/Peter Newark American Pictures/The Bridgeman Art Library*

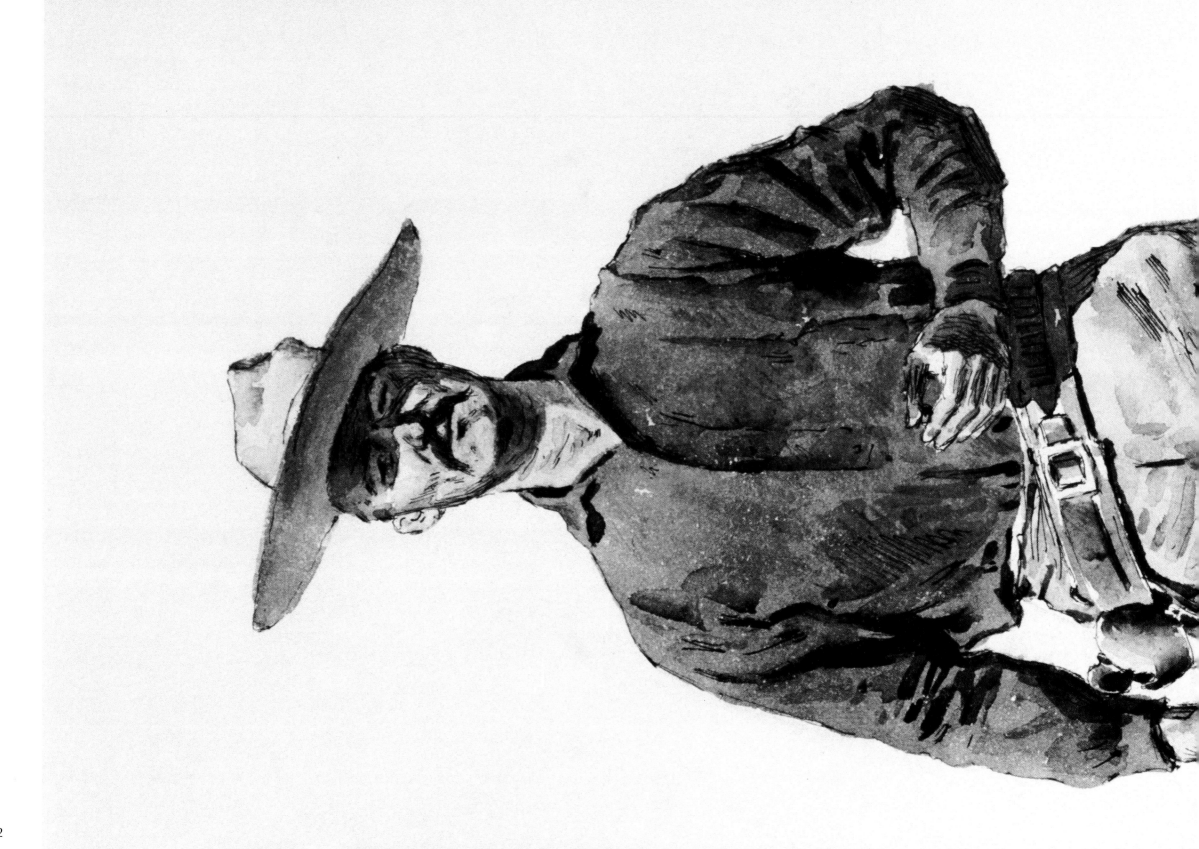

LEFT: *Portrait of Specimen Jones.* Watercolor on paper, undated. *Private Collection/The Bridgeman Art Library*

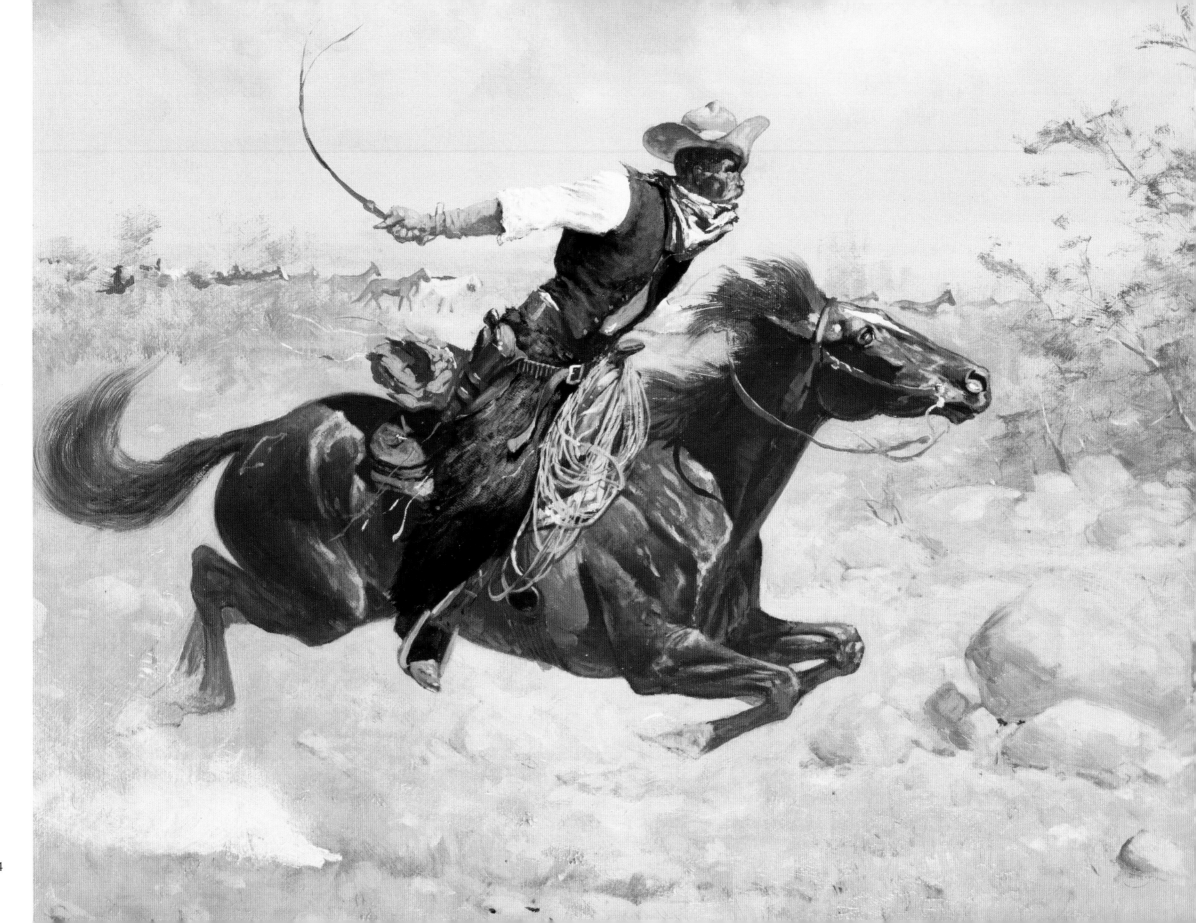

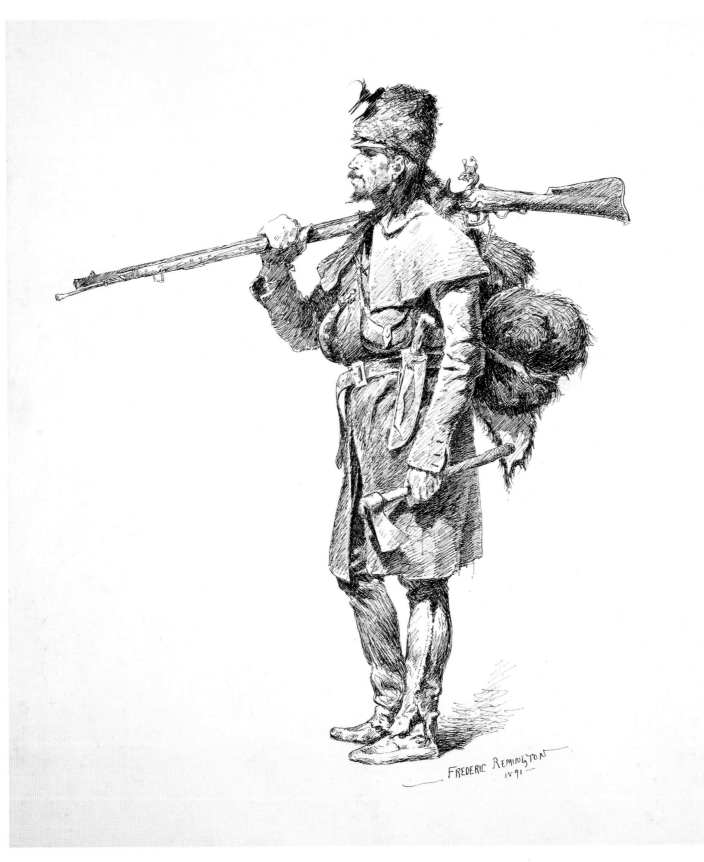

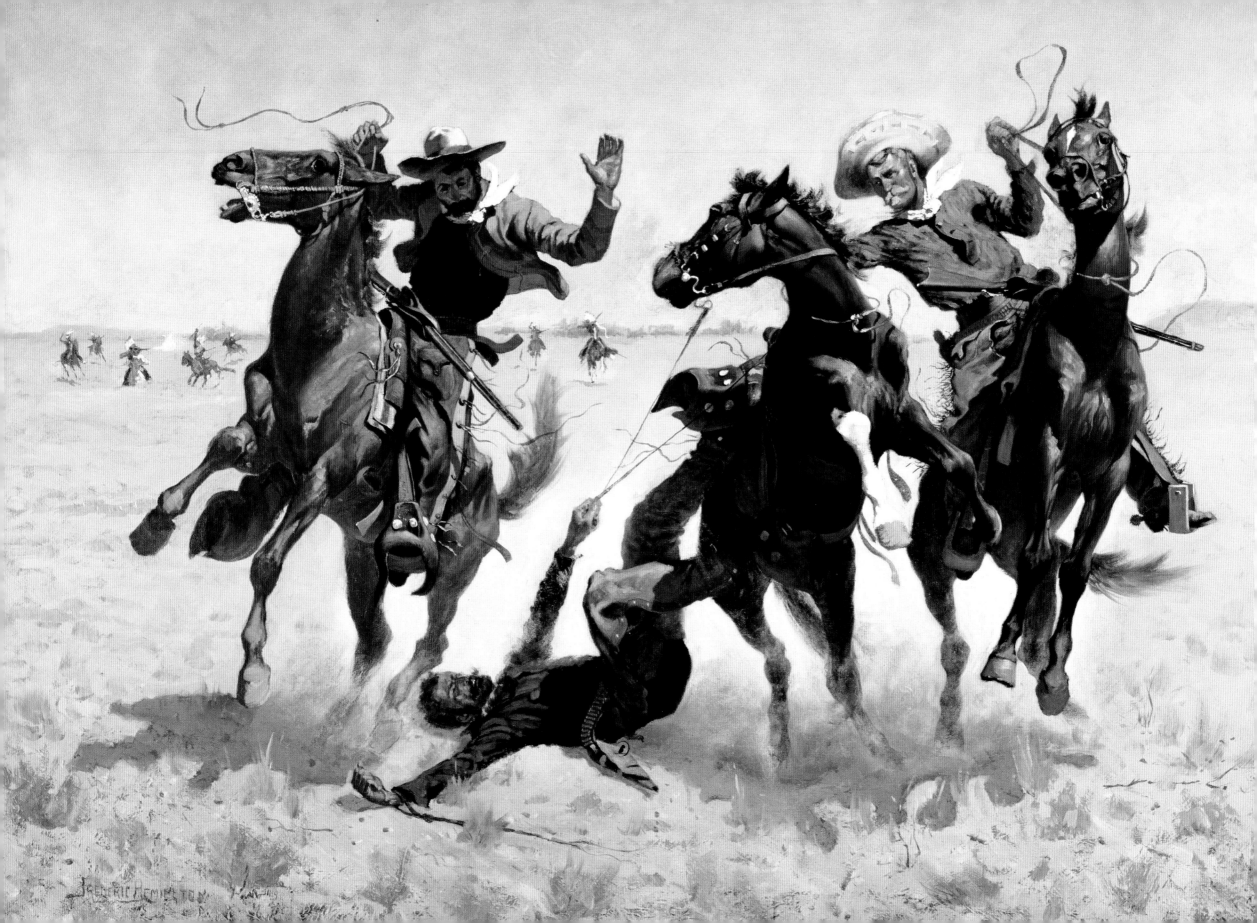

LEFT: *Aiding a Comrade.* Oil on canvas c.1890. One of Remington's most familiar and popular paintings shows the determined attempts of two cowboys to rescue their fallen comrade while the Indian firefight carries on in the background. *Museum of Fine Arts, Houston, Texas, USA/Hogg Brothers Collection, Gift of Miss Ima Hogg/The Bridgeman Art Library*

RIGHT: *The Cowboy.* Oil on canvas, undated. © *Private Collection/Peter Newark American Pictures/The Bridgeman Art Library*

OVER PAGE LEFT: *The Last Stand* (or *Twenty-Five to One*). Oil on canvas, c.1896. © *Museum of Fine Arts, Houston, Texas, USA/Hogg Brothers Collection, Gift of Miss Ima Hogg/The Bridgeman Art Library*

OVER PAGE RIGHT: *Ghosts of the Past.* Undated. Remington's title for this painting shows how he feels about the development of the West. With this group of ten mounted cowboys on the high prairie he is showing a fast disappearing, if not already vanished, way of life. *The Art Archive/Gift of the Coe Foundation/Buffalo Bill Historical Center, Cody, Wyoming/60.67*

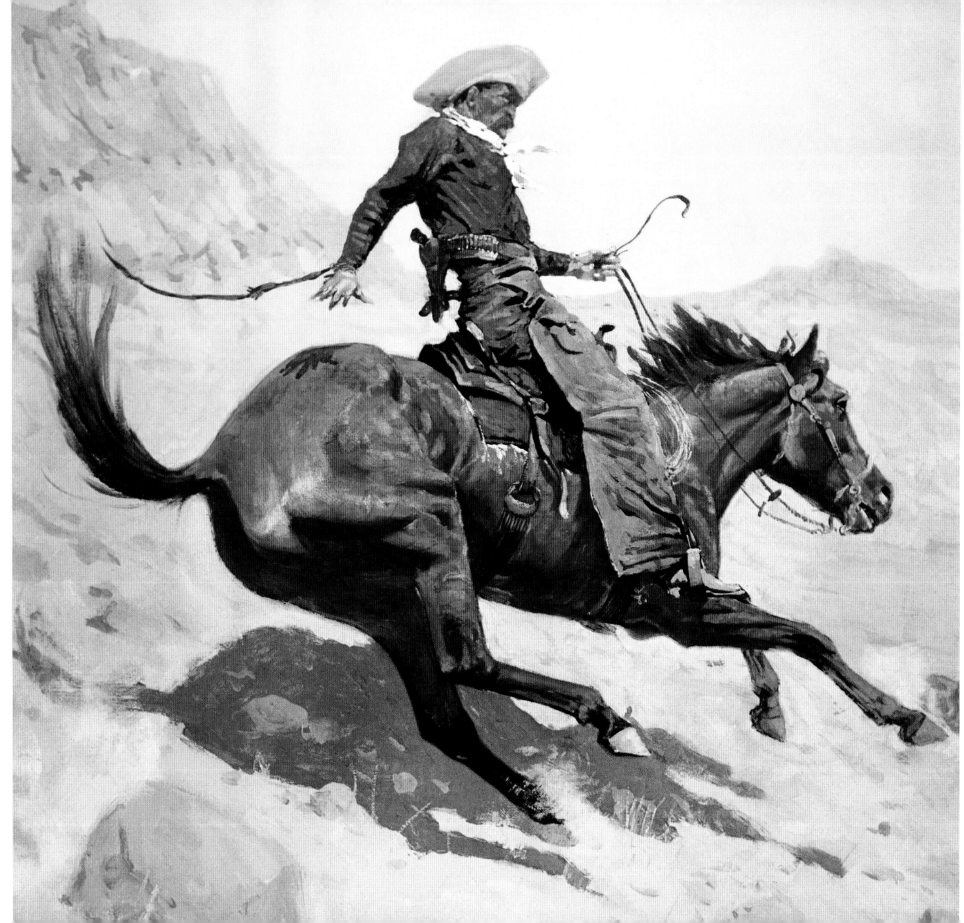

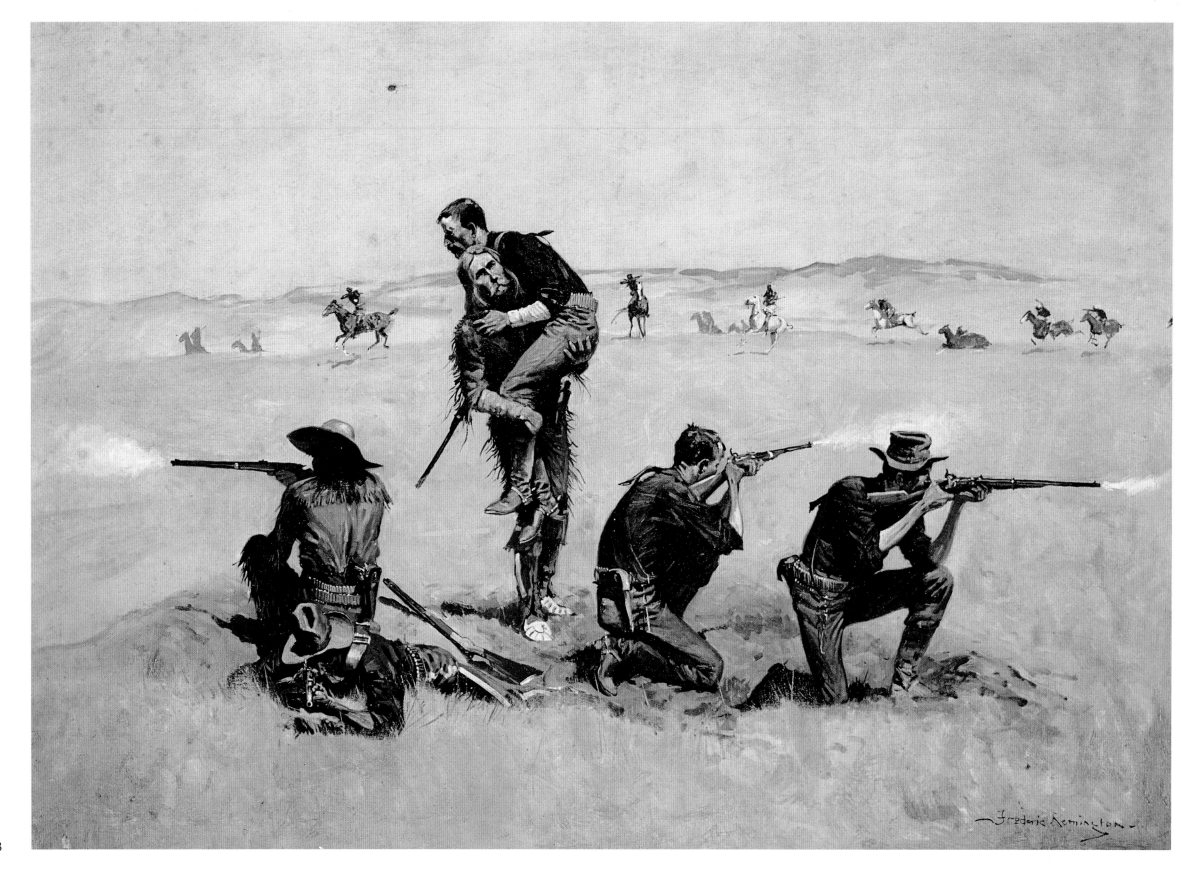

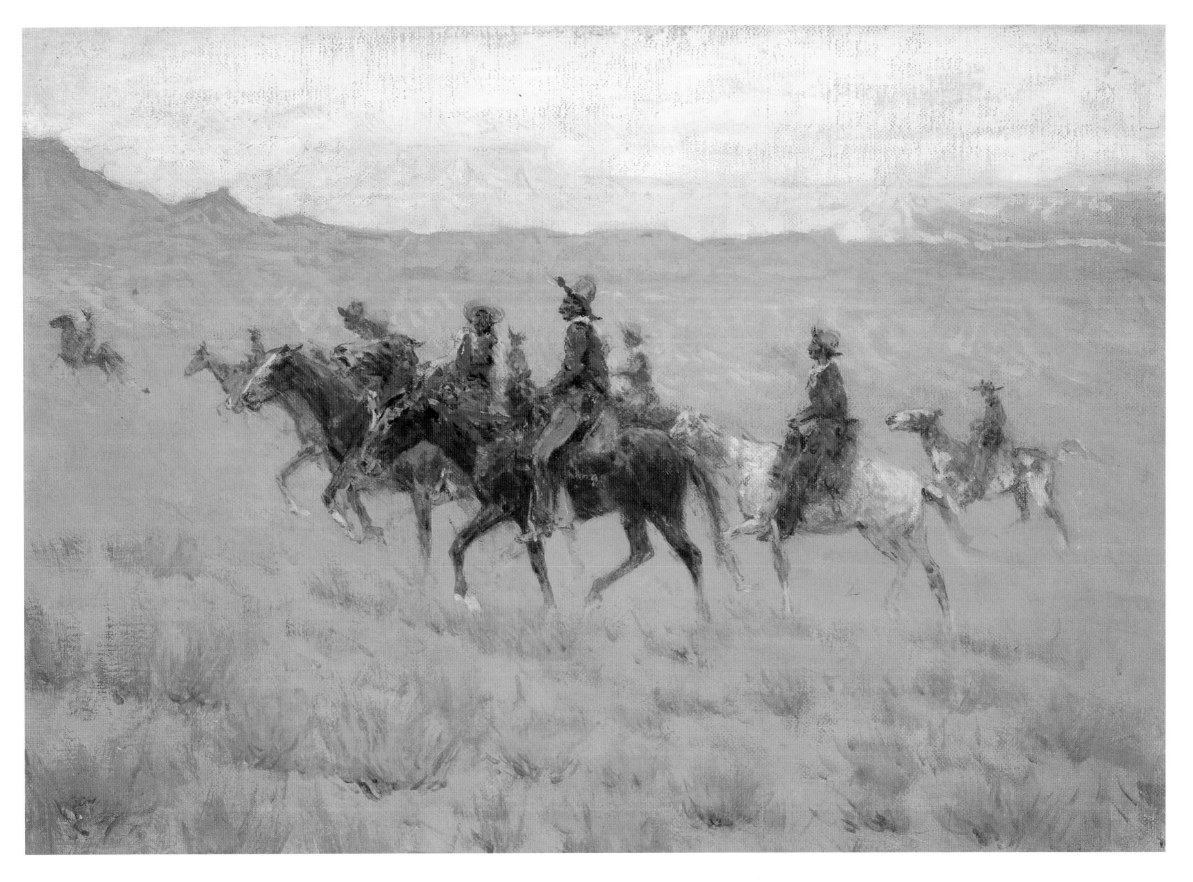

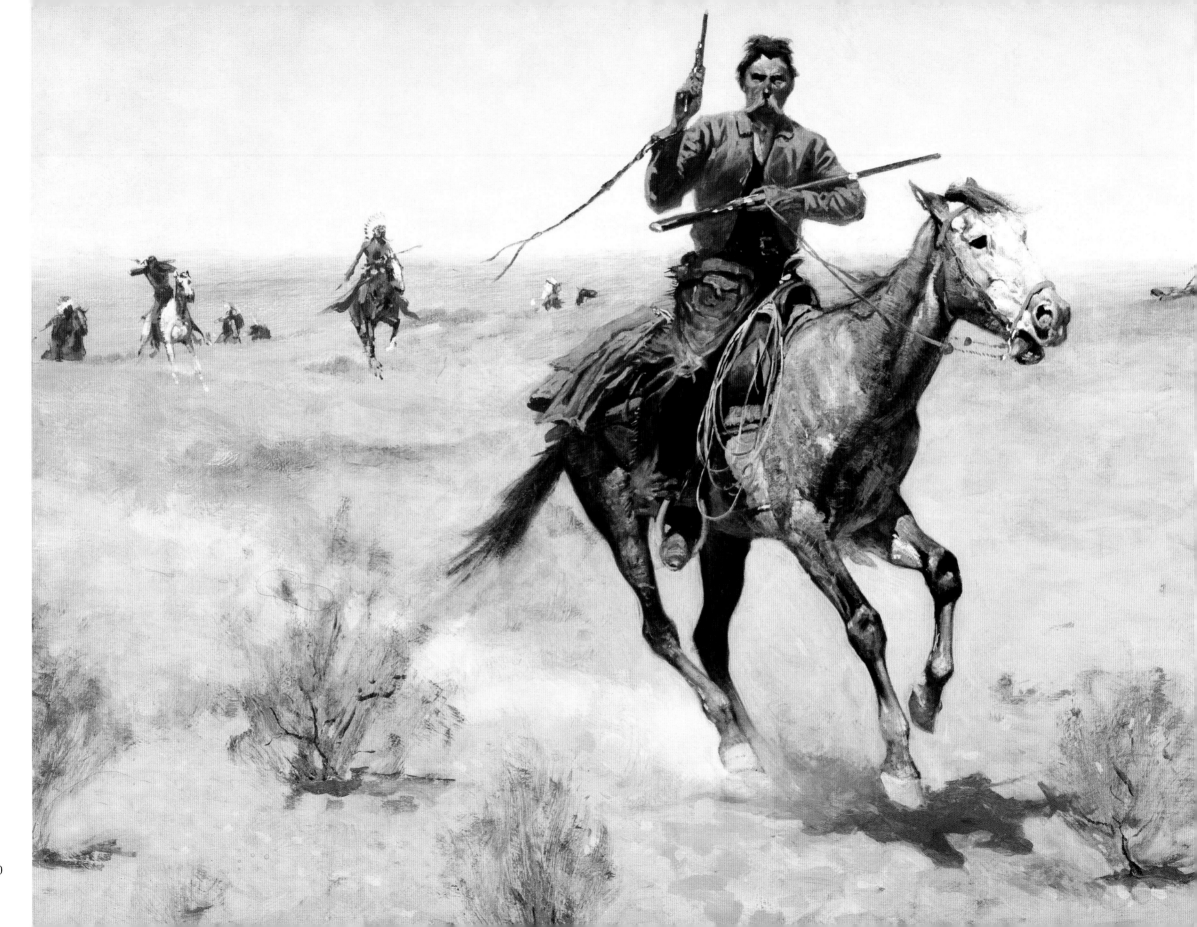

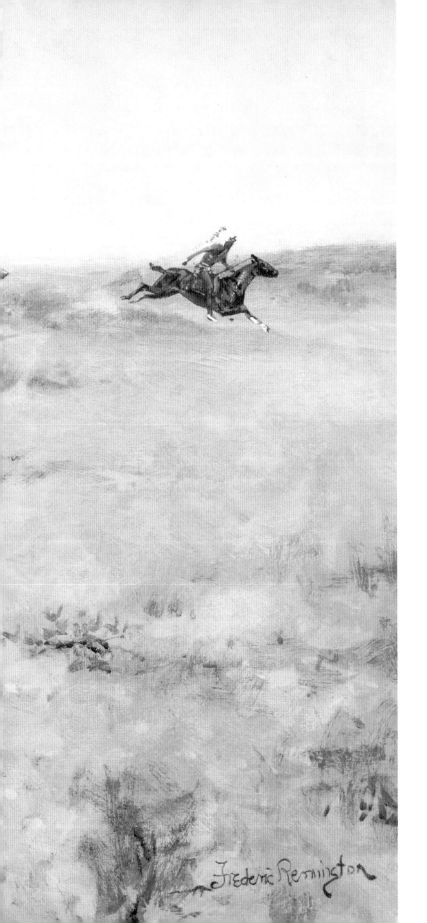

Frederic Remington

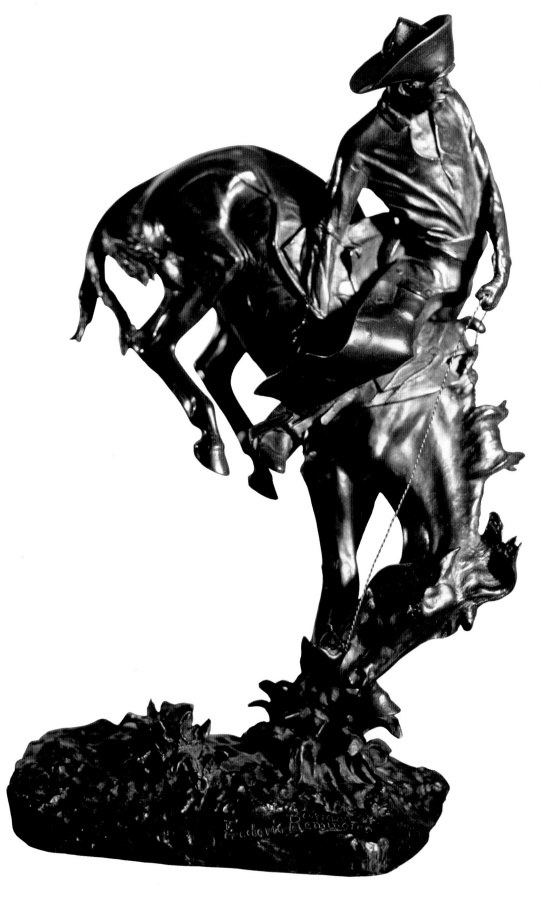

FAR LEFT: *The Flight* (or A *Sage-Brush Pioneer*). Oil on canvas, 1895. Sagebrush is found along river beds and in the relatively wetter areas of the Western U.S., particularly across the Great Basin desert. It's strong, pungent smell is said to discourage cattle from grazing its silver-gray foliage. *Museum of Fine Arts, Houston, Texas, USA, Hogg Brothers Collection, Gift of Miss Ima Hogg/The Bridgeman Art Library*

LEFT: *The Bronco Buster*, bronze. Easily Remington's most successful bronze; an original given by Remington to Theodore Roosevelt sits in the Oval Office of the White House. *Private Collection/Peter Newark Western Americana/The Bridgeman Art Library*

RIGHT: *Bronco-Buster.* Colored engraving after Remington, undated. Remington's iconic image of the cowboy came to represent the popular image of the cowboy as a rough, tough, no nonsence man who was totally at ease with the hard lifestyle of the Wild West. © *Private Collection/Peter Newark Western Americana/The Bridgeman Art Library*

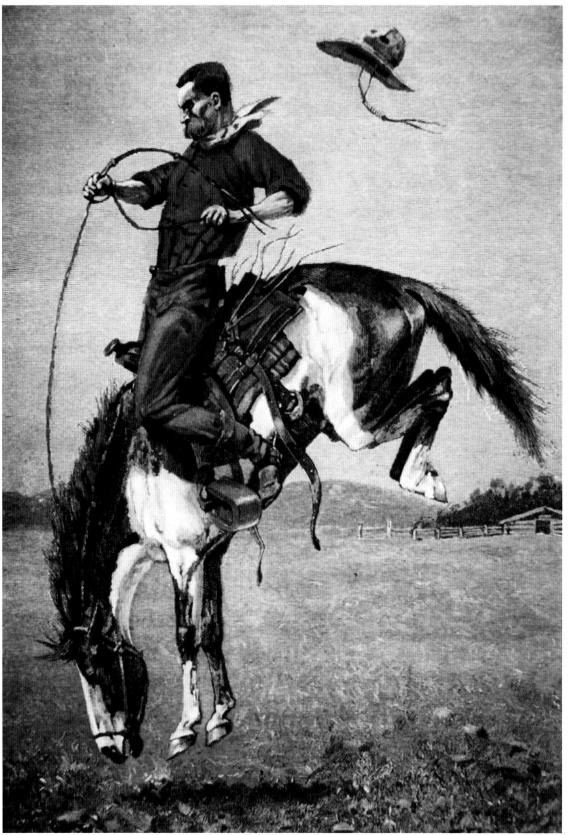

RIGHT: *Birchbark canoe and paddler.* Undated. The Ojibwe tribe were the supreme makers of birchbark canoes. The canoe frame is usually of white cedar which is covered with birch bark stripped from suitable trees in the summer months. The bark is laced to the frame using split spruce roots (a lengthy process) and the whole completed with internal ribs made from cedar. *The Art Archive/Gift of the Coe Foundation/Buffalo Bill Historical Center, Cody, Wyoming/6.67*

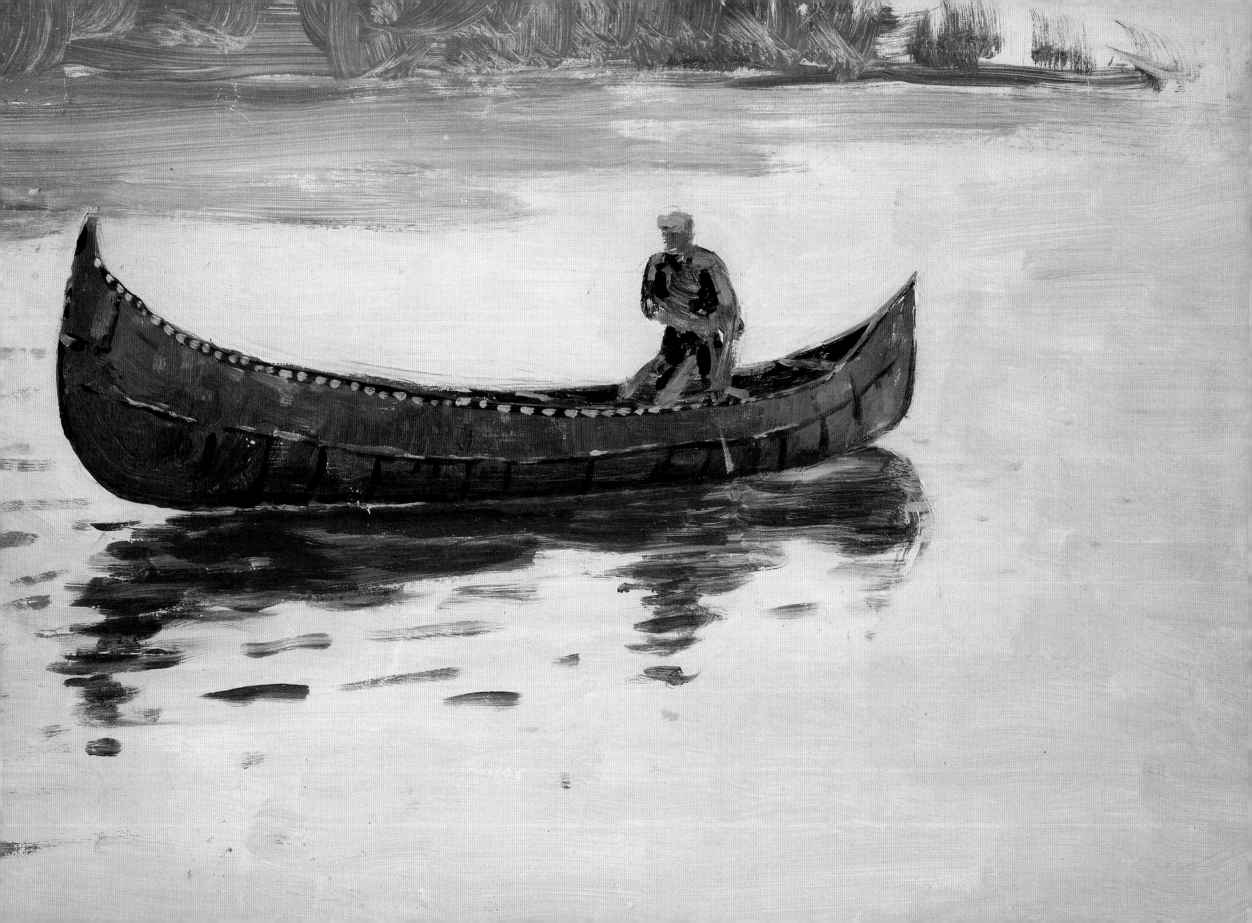

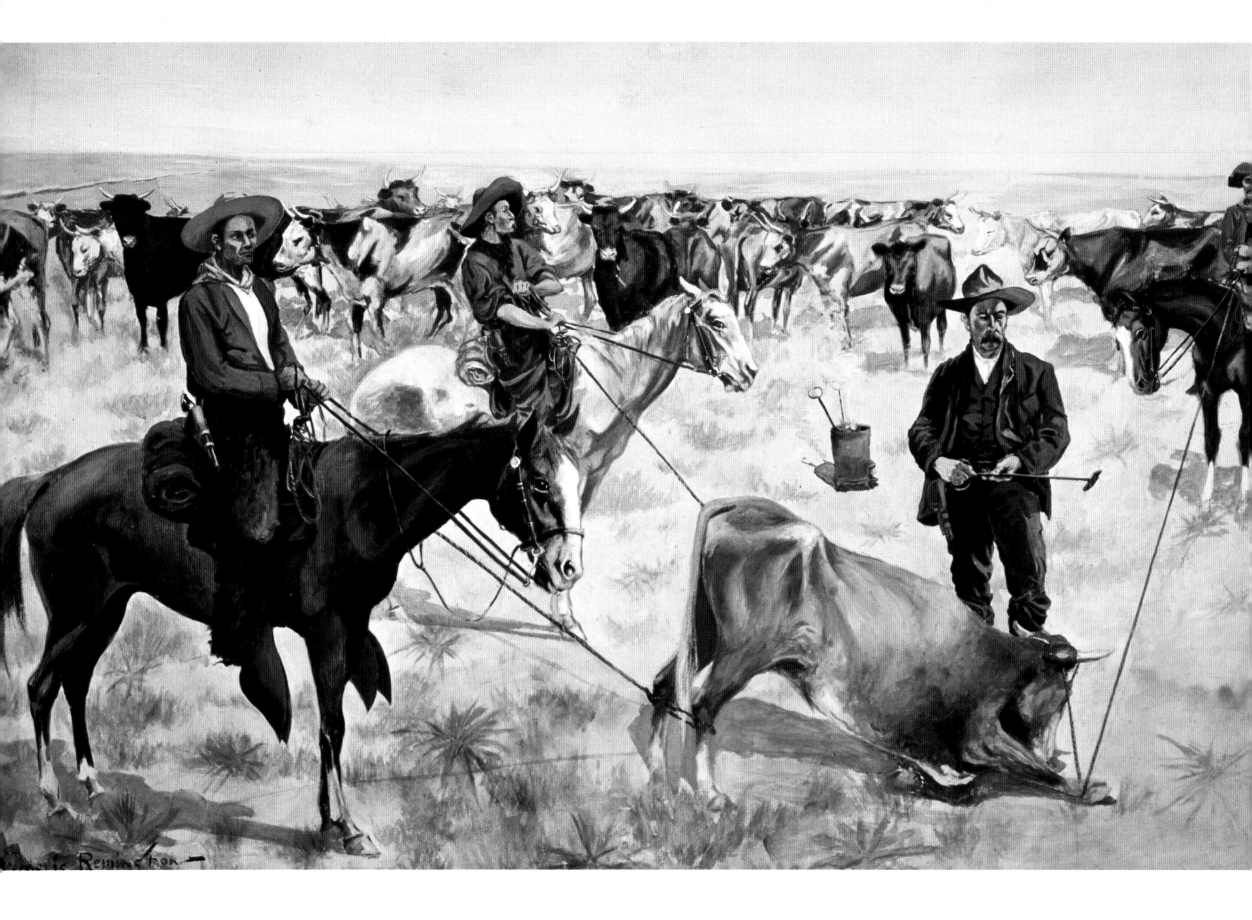

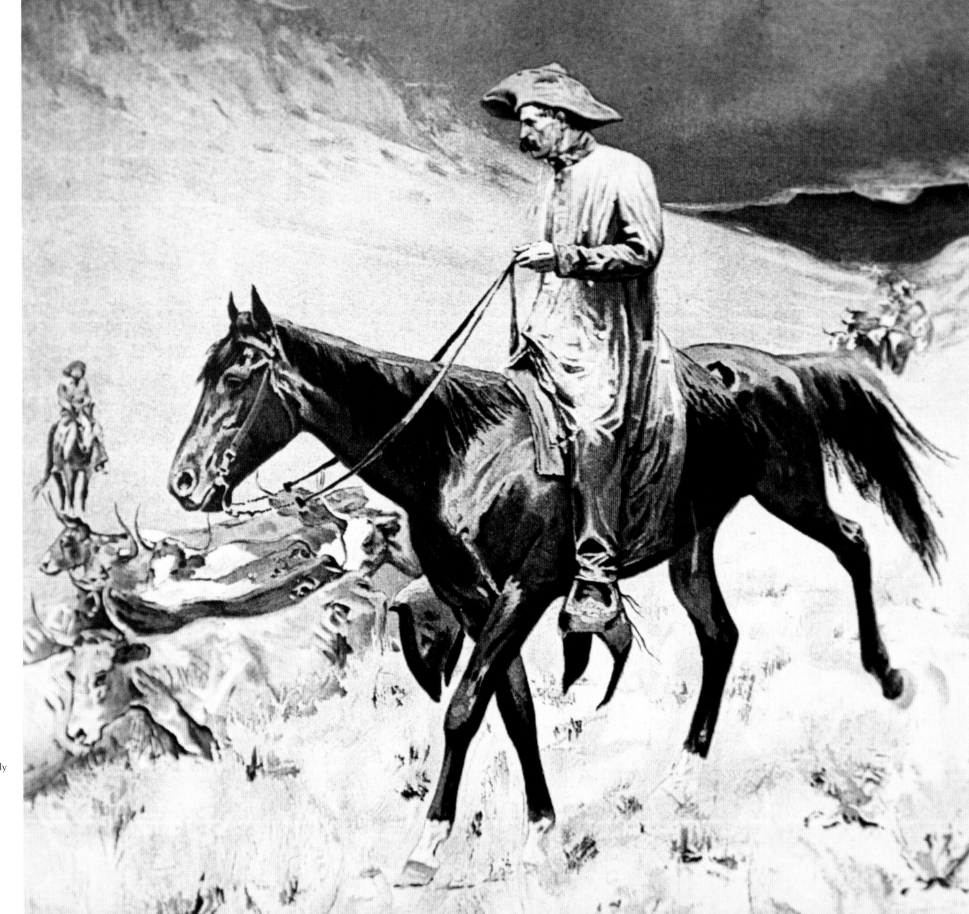

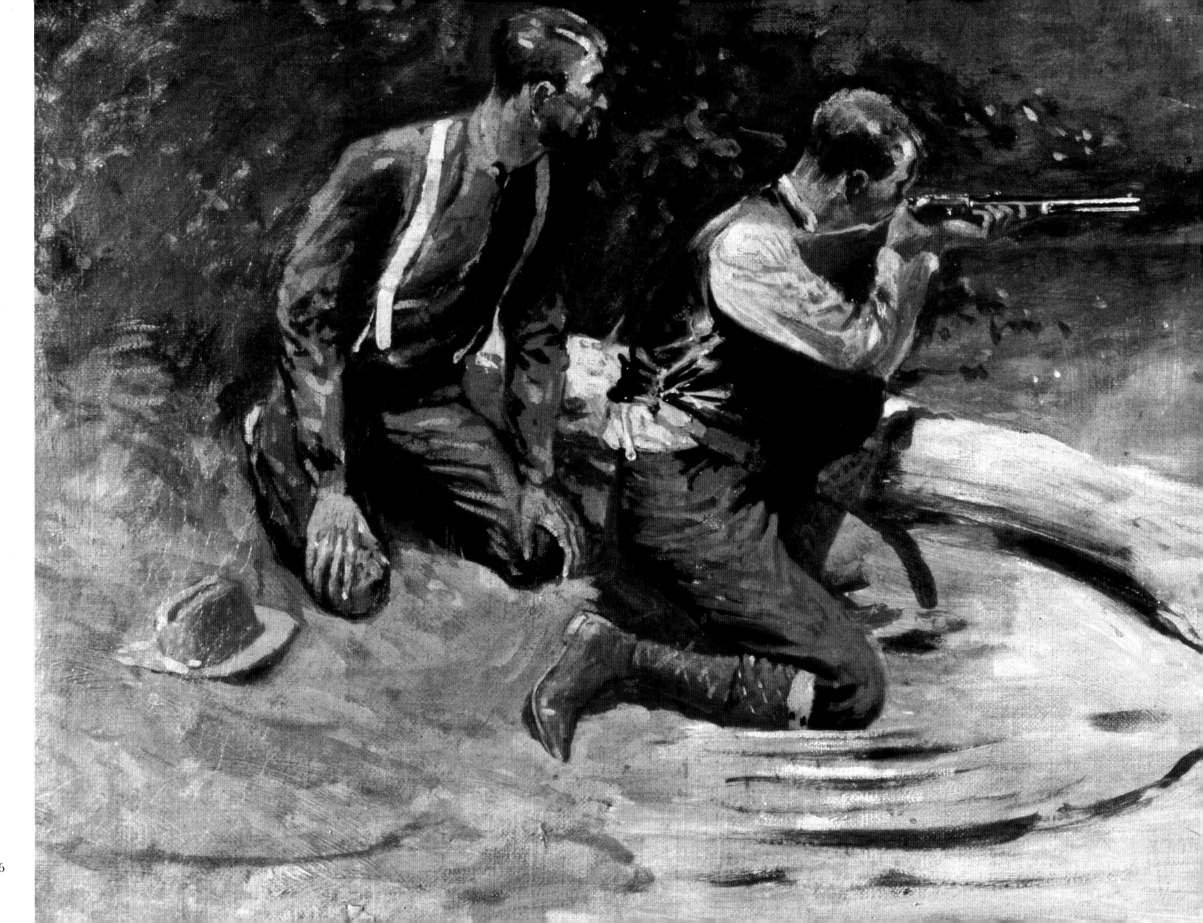

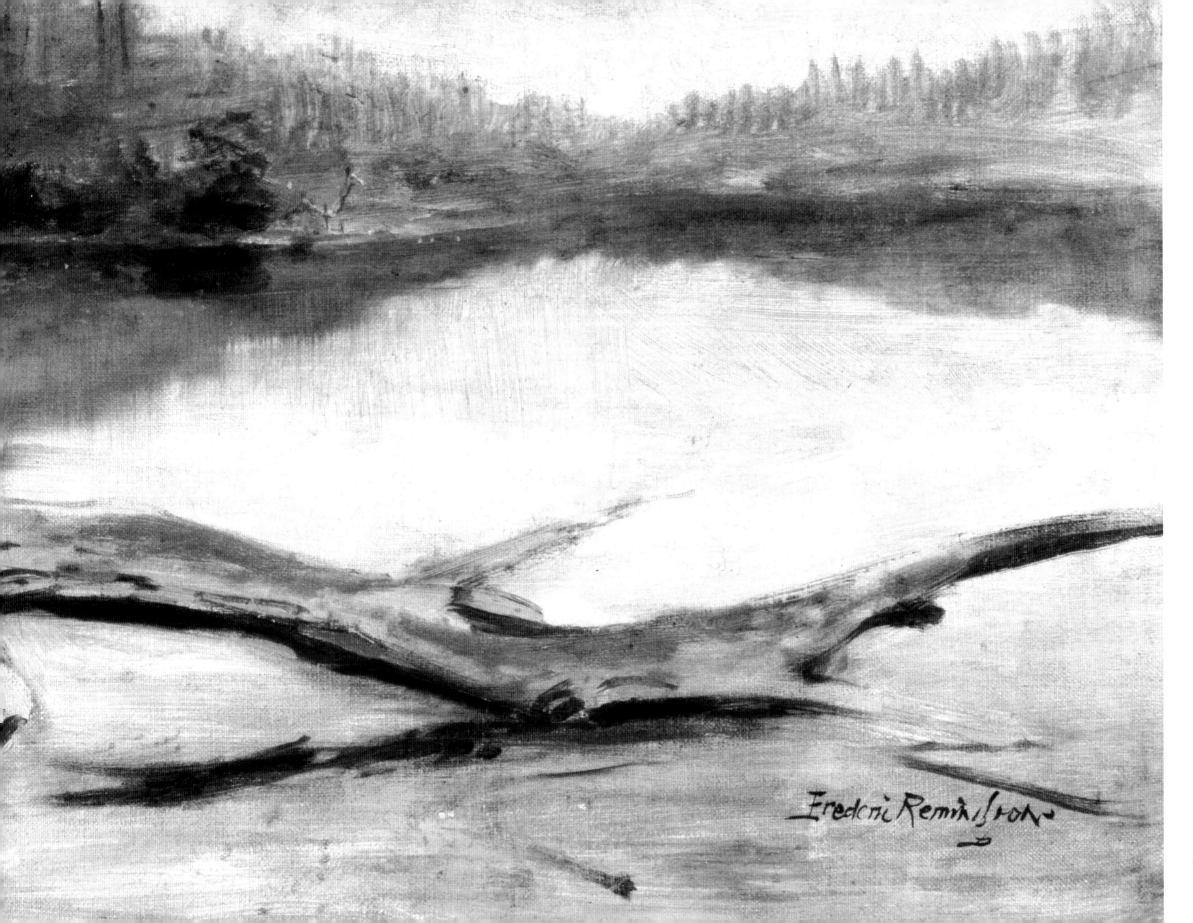

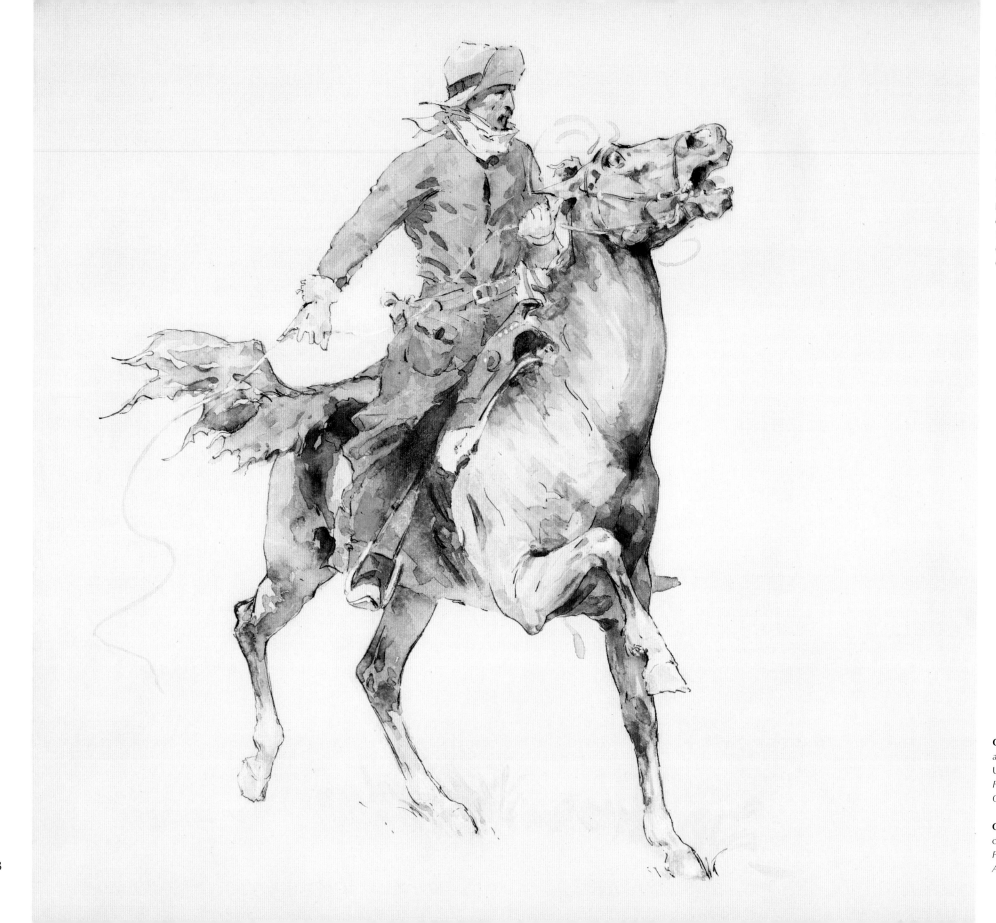

LEFT: *The Cowboy*. Watercolor on paper, c.1897. *Museum of Fine Arts, Houston, Texas, USA, Hogg Brothers Collection, Gift of Miss Ima Hogg/The Bridgeman Art Library*

RIGHT: *Riding Herd in the Rain*. Wash drawing on paper, undated. Remington used this profiled horserider as a compositional element in several works. It depicts the grim reality of the long and boring hours in the saddle that cowboys endured, and the stoicism of their horses. *The Art Archive/Gift of Hon. C.V.Whitney/Buffalo Bill Historical Center, Cody, Wyoming/1.63*

OVER PAGE LEFT: *Tent camp with fireplace and utensils with forest background.* Undated. *The Art Archive/Gift of the Coe Foundation/ Buffalo Bill Historical Center, Cody, Wyoming/67.67*

OVER PAGE RIGHT: *The Hold Up*. Oil on canvas, c.1900. © *Valley National Bank, Phoenix, Arizona/Peter Newark Western Americana/The Bridgeman Art Library*

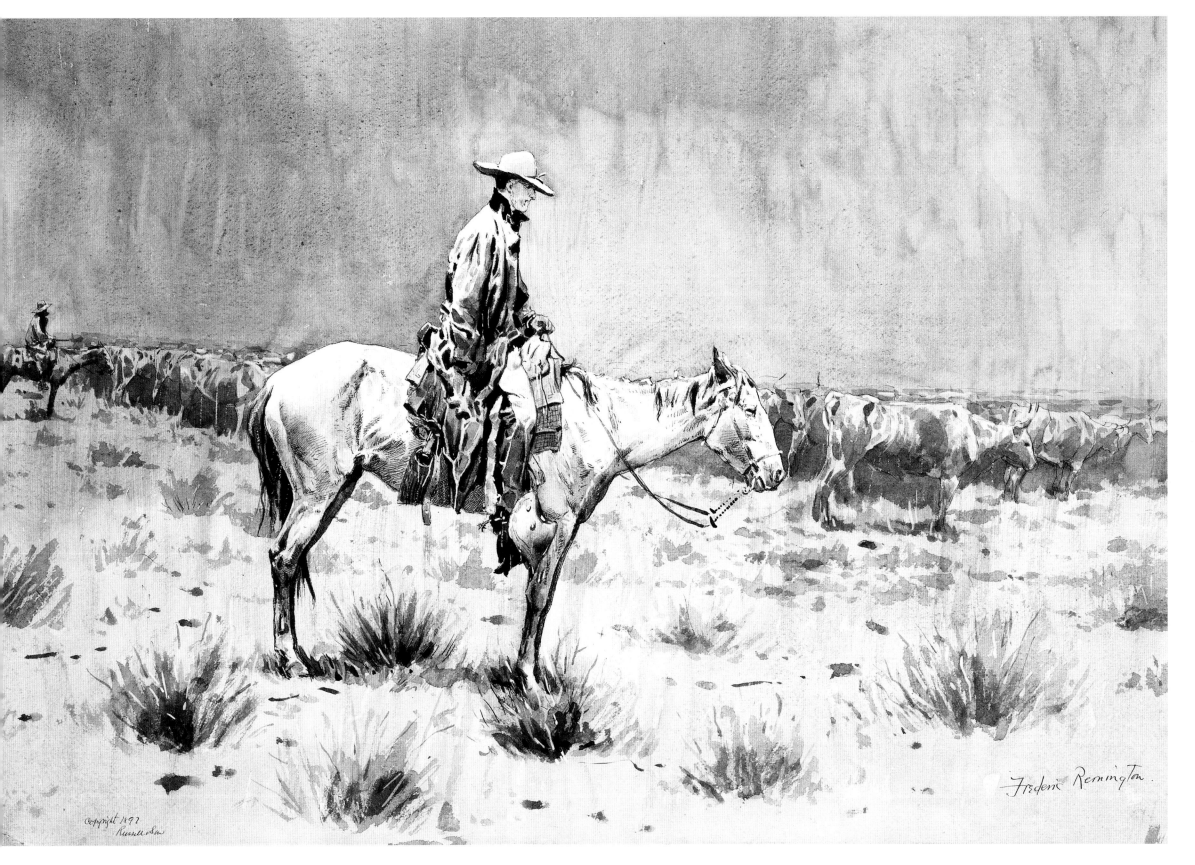

Copyright 1892
Russell & Son

Frederic Remington.

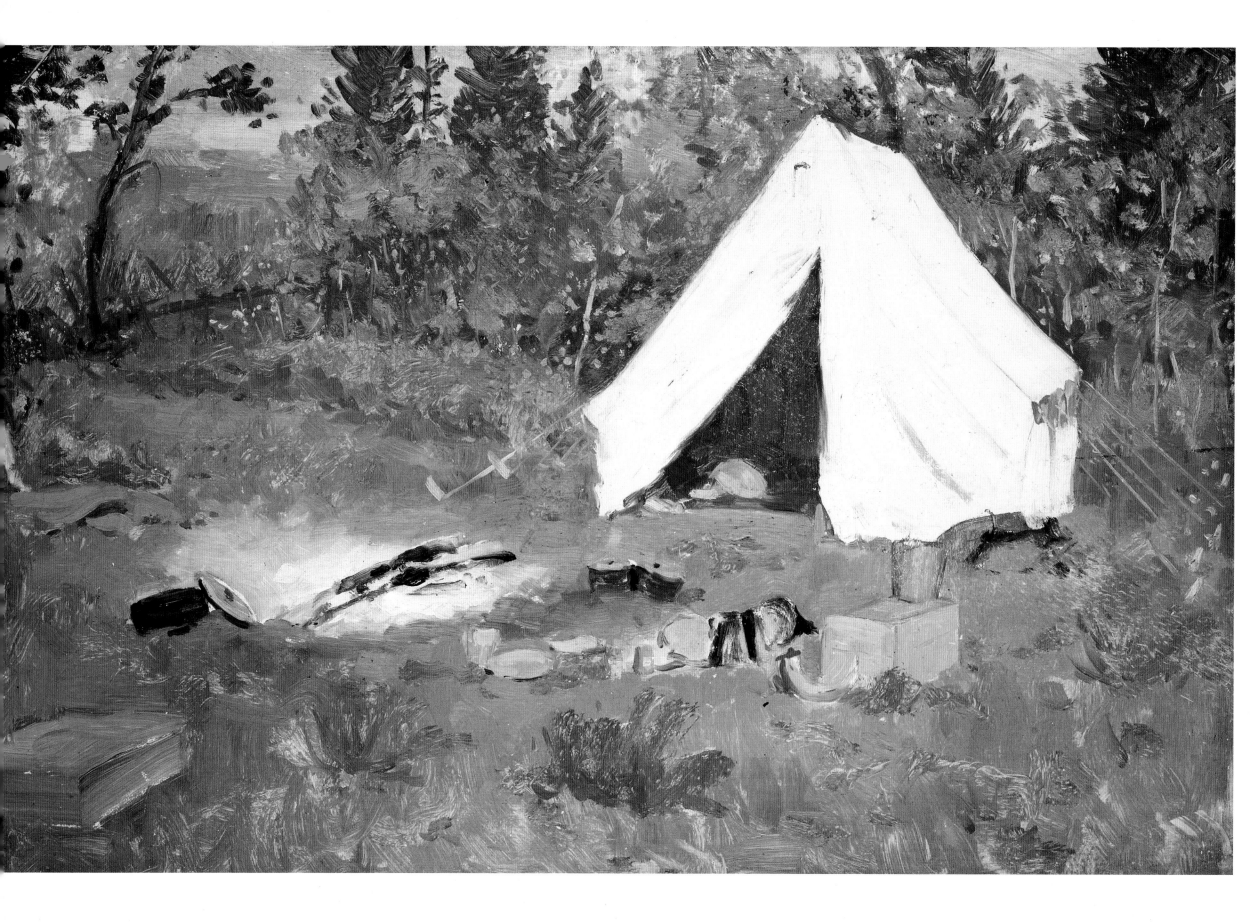

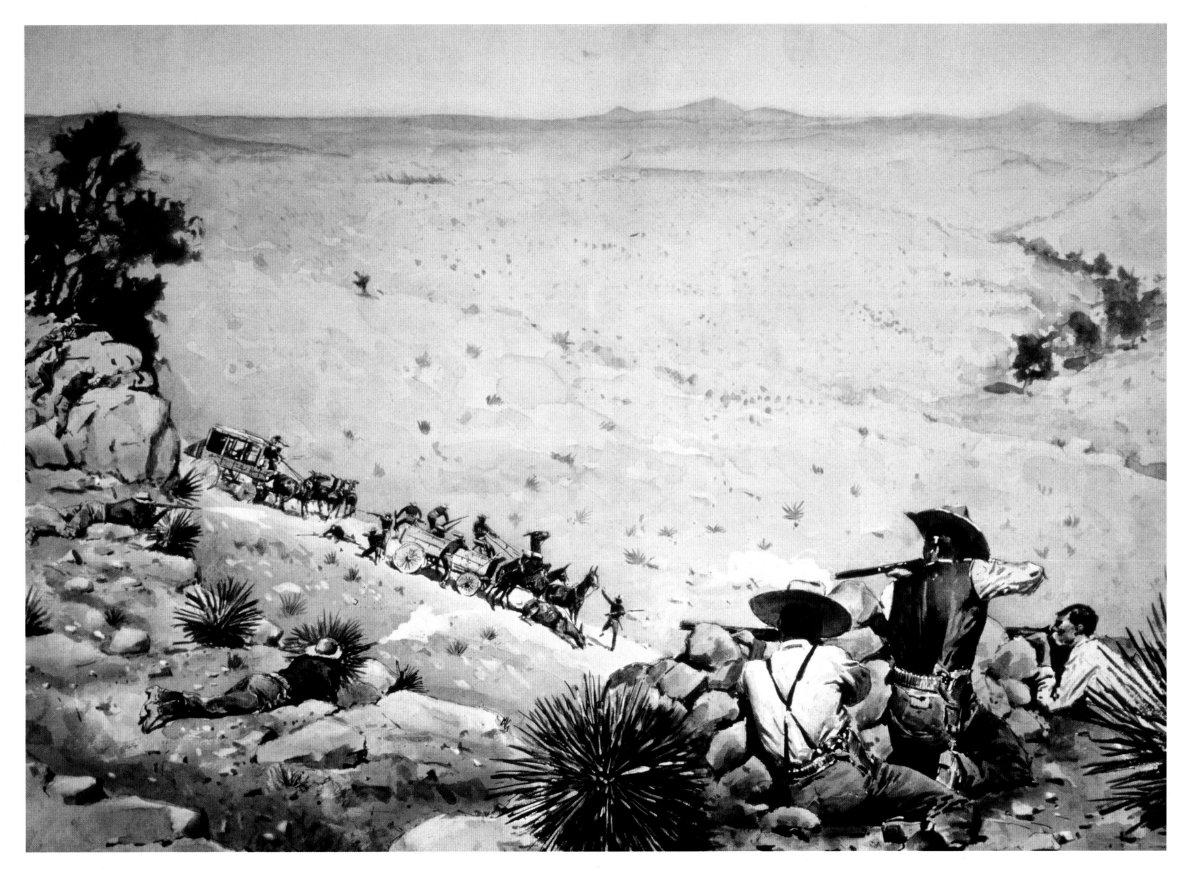

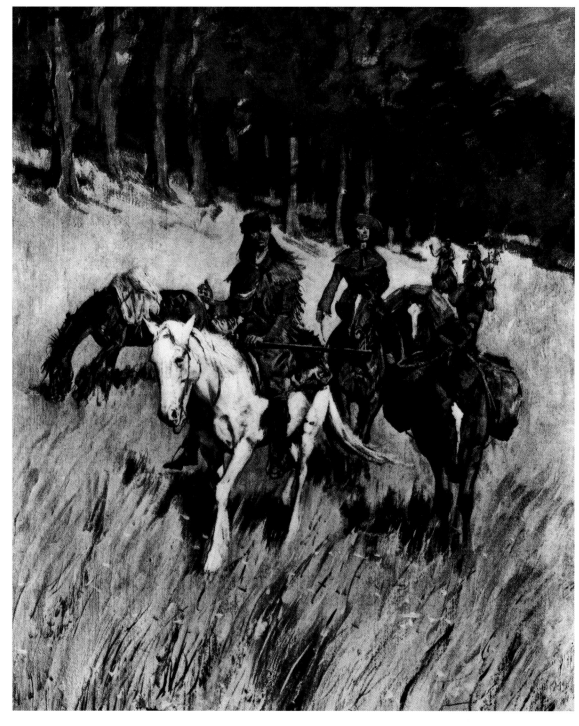

ABOVE: *Early Pioneers on the Blue Ridge,* engraved by F. H. Wellington, from *Century Magazine,* November 1901 after Frederic Remington. *Library of Congress, Washington D.C., USA/The Bridgeman Art Library*

RIGHT: *Trailing Texas Longhorns.* Oil on canvas, undated. Texas Longhorn cattle, immediately identifiable by their magnificent horns, are especially tough animals, able to subsist in hot arid areas where other animals would quickly perish and they can even survive the coldest winters. Their outstanding survival instinct enables them to find food in even desperate situations. © *Private Collection/Peter Newark American Pictures/The Bridgeman Art Library*

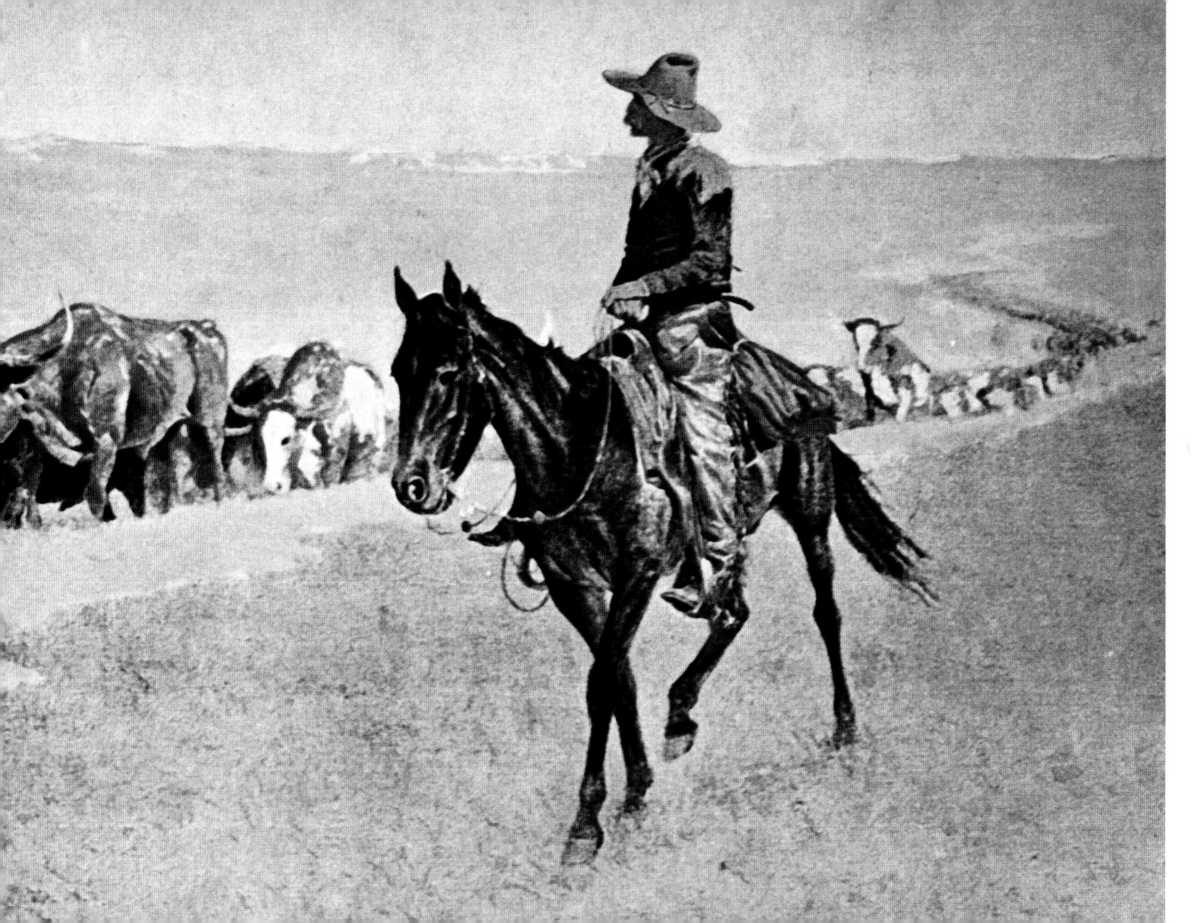

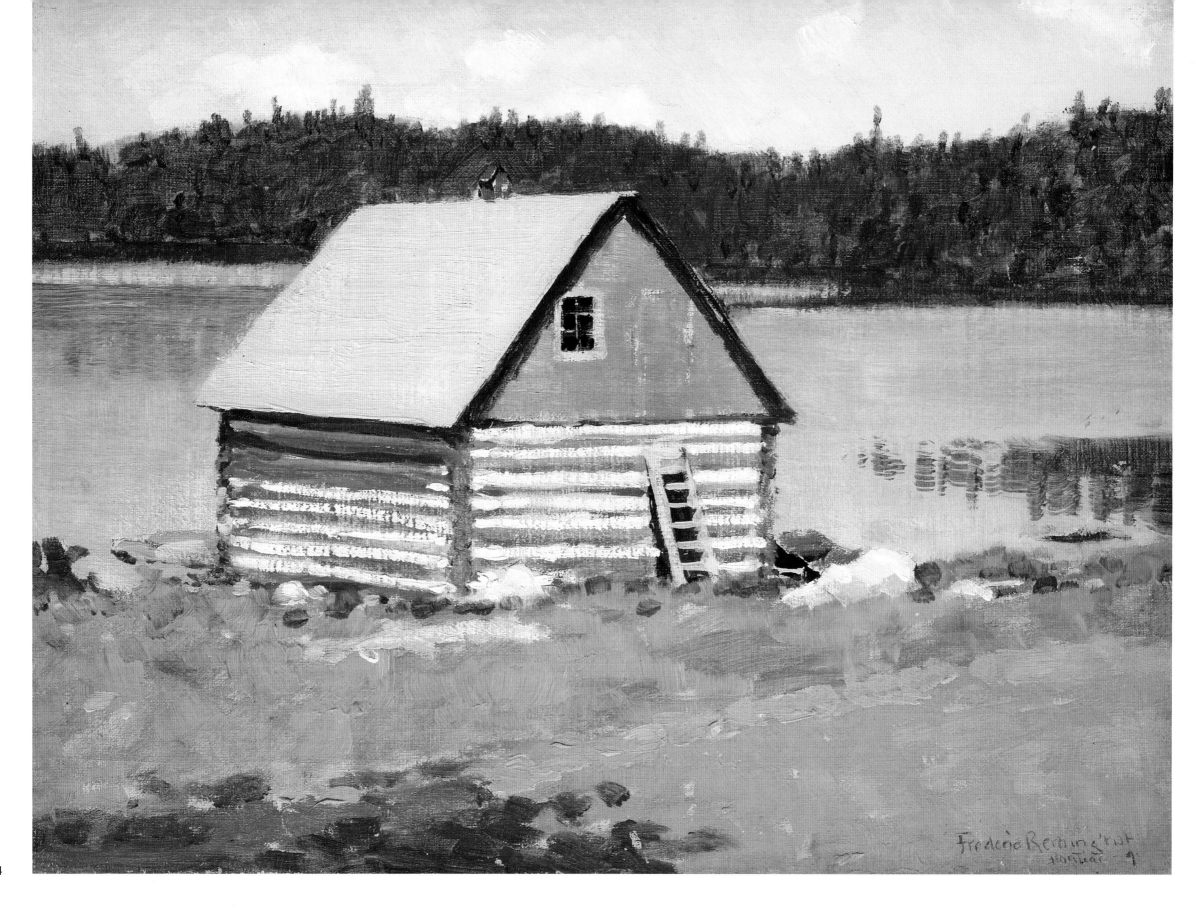

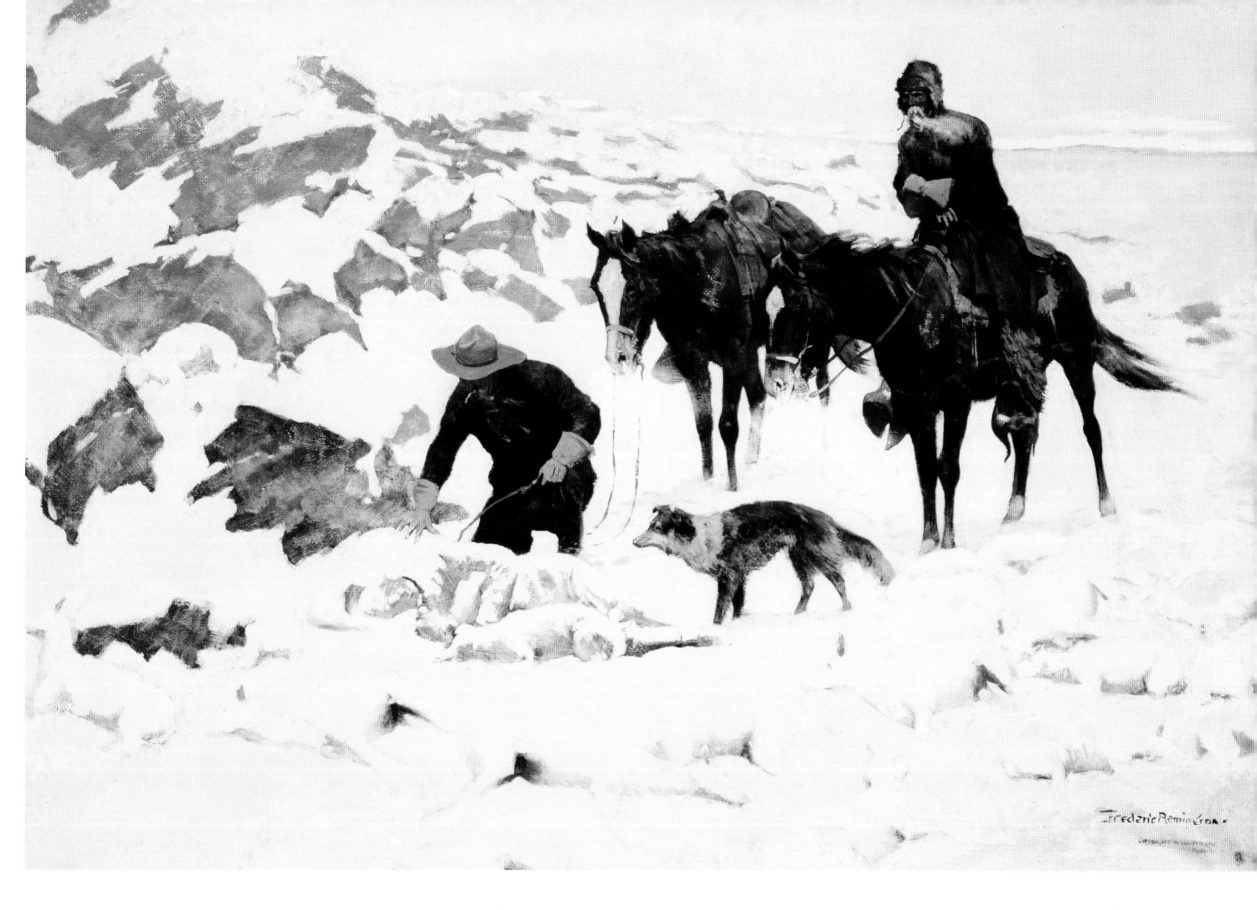

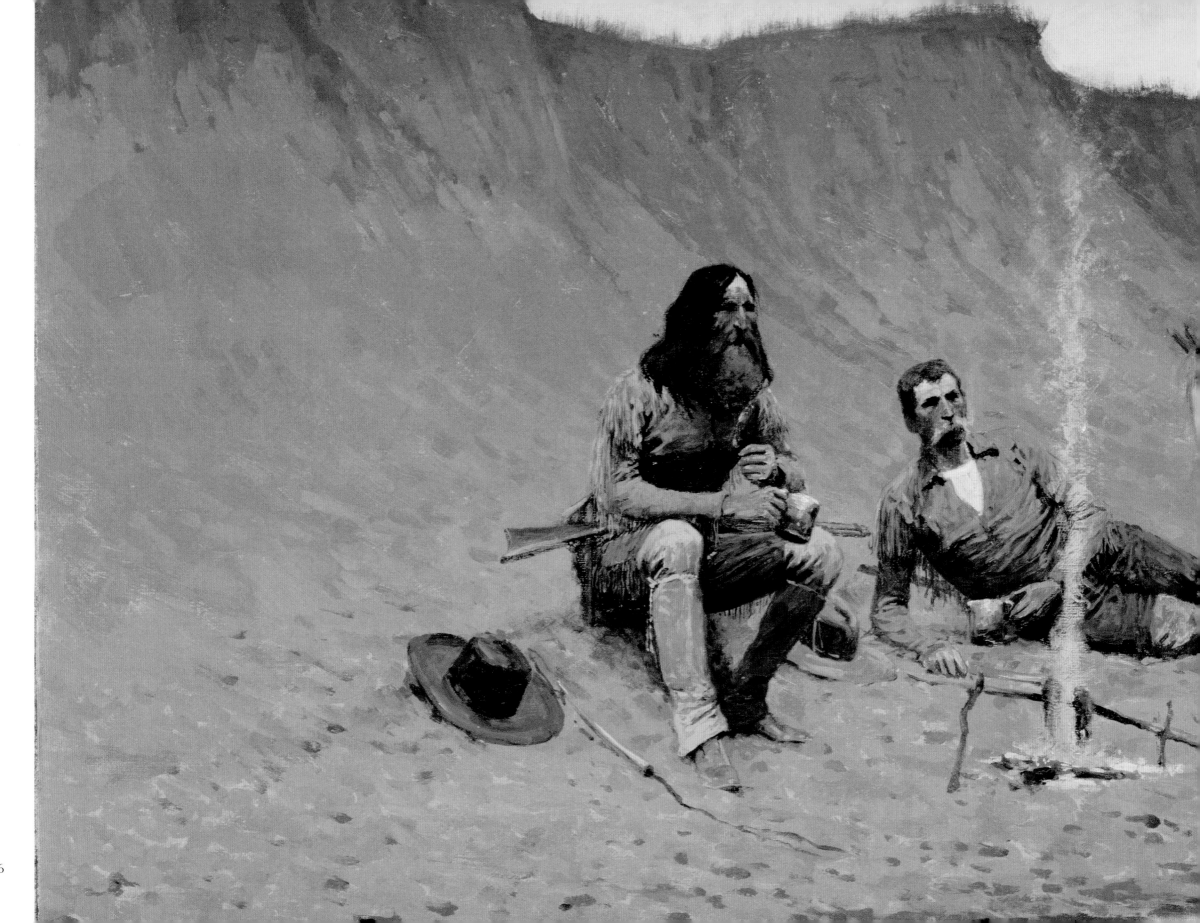

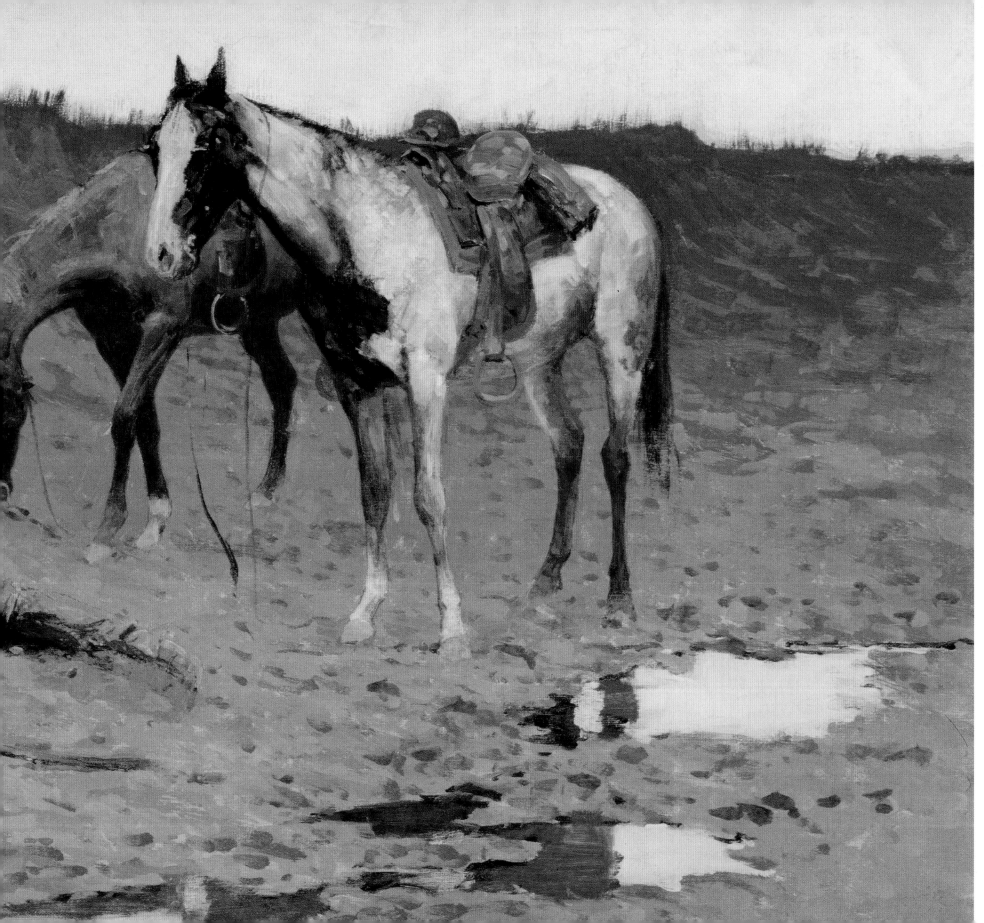

PREVIOUS PAGE LEFT: *Cabin on Lake.* Undated. *The Art Archive/Gift of the Coe Foundation/Buffalo Bill Historical Center, Cody, Wyoming/5.67*

PREVIOUS PAGE RIGHT: *The Frozen Sheepherder.* 1900. Remington's critics would often accuse him of romanticizing the West, it shows that they did not look seriously at his work. © *Private Collection/Photo © Christie's Images/The Bridgeman Art Library*

LEFT: *A New Year on the Cimarron.* Oil on canvas, 1901. The Cimarron river runs from northern New Mexico through Oklahoma, Colorado, and Kansas. Part of the pioneer Santa Fe Trail worked down to the Cimarron and in the early days proved a substantial challenge to even the toughest pioneers. *Museum of Fine Arts, Houston, Texas, USA, Hogg Brothers Collection, Gift of Miss Ima Hogg/The Bridgeman Art Library*

167

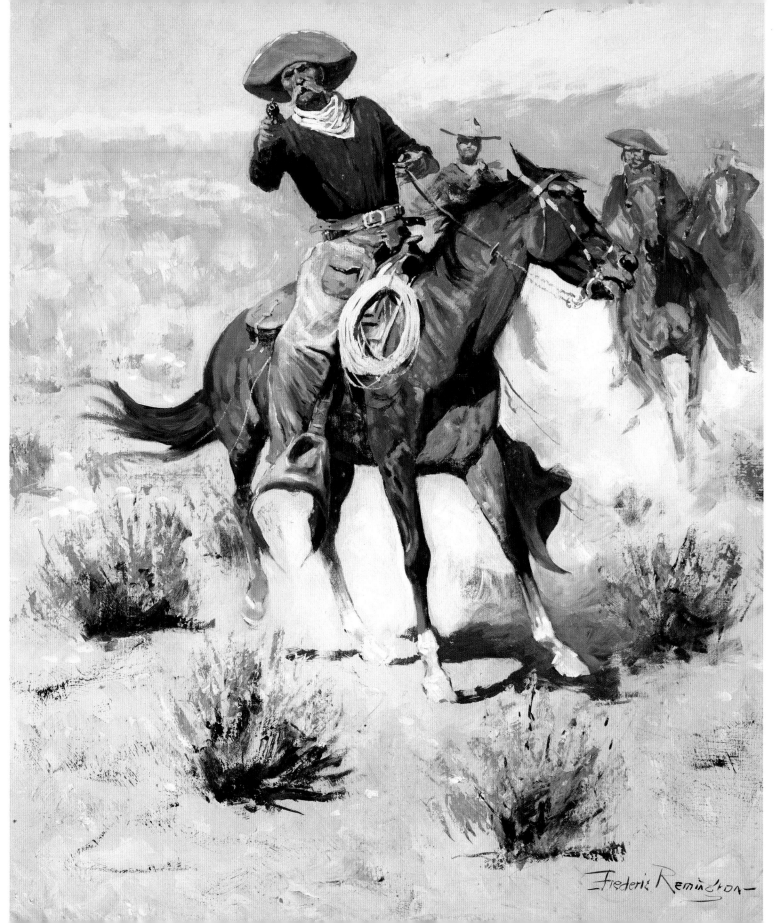

RIGHT: *Days on the Range* (or *Hands Up*). Oil on canvas, c.1902. By pointing a gun straight at the viewer Remington brings a shock of reality to his Eastern fans, as if to ask, are you really tough enough to face this? *Museum of Fine Arts, Houston, Texas, USA/ Hogg Brothers Collection, Gift of Miss Ima Hogg/The Bridgeman Art Library*

RIGHT: Two cowboys and saddle on the high prairie, with red rimrocks and blue sky in the background. Undated. *The Art Archive/Gift of the Coe Foundation/Buffalo Bill Historical Center, Cody, Wyoming/43.67*

OVER PAGE LEFT: Sketch of a ranch on the prairie. Undated. *The Art Archive/Gift of the Coe Foundation/ Buffalo Bill Historical Center, Cody, Wyoming/3.67*

OVER PAGE RIGHT: *Life in the Cattle Country: Driving the Roundup.* Grisaille, c. 1901. Published in *Collier's Weekly*, August 24, 1901. Nineteenth century newspaper illustrators deliberately worked in this strong tonal palette for better reproduction in print. *The Art Archive/Buffalo Bill Historical Center, Cody, Wyoming/62.72*

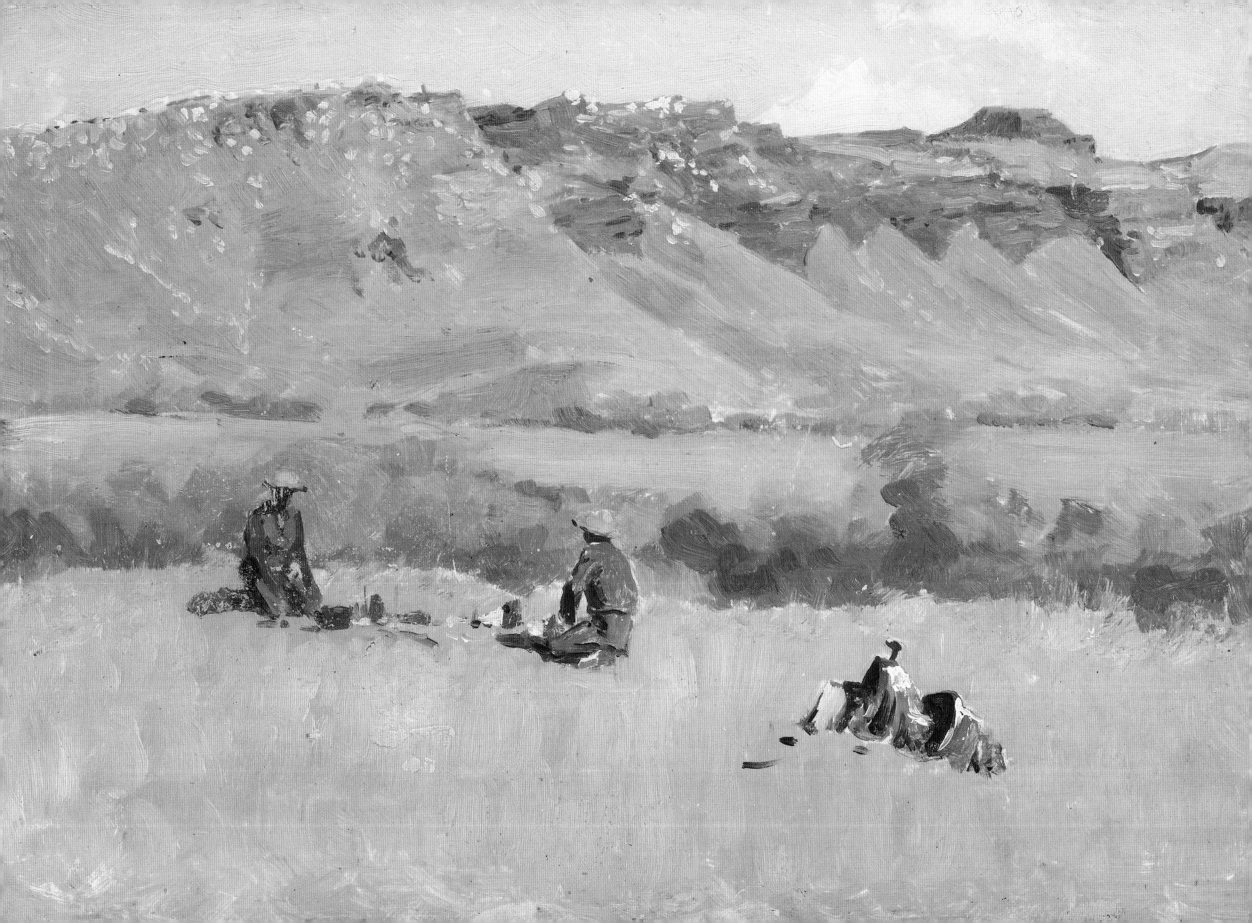

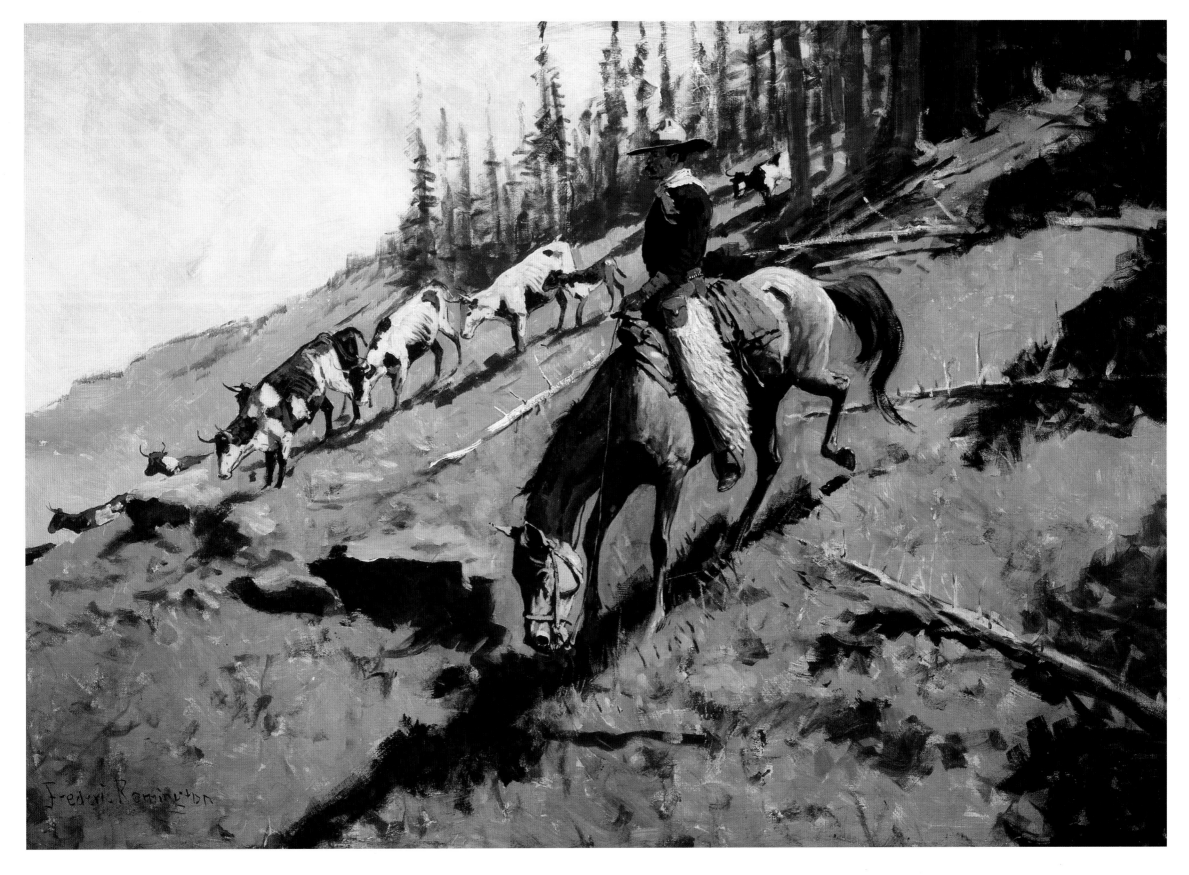

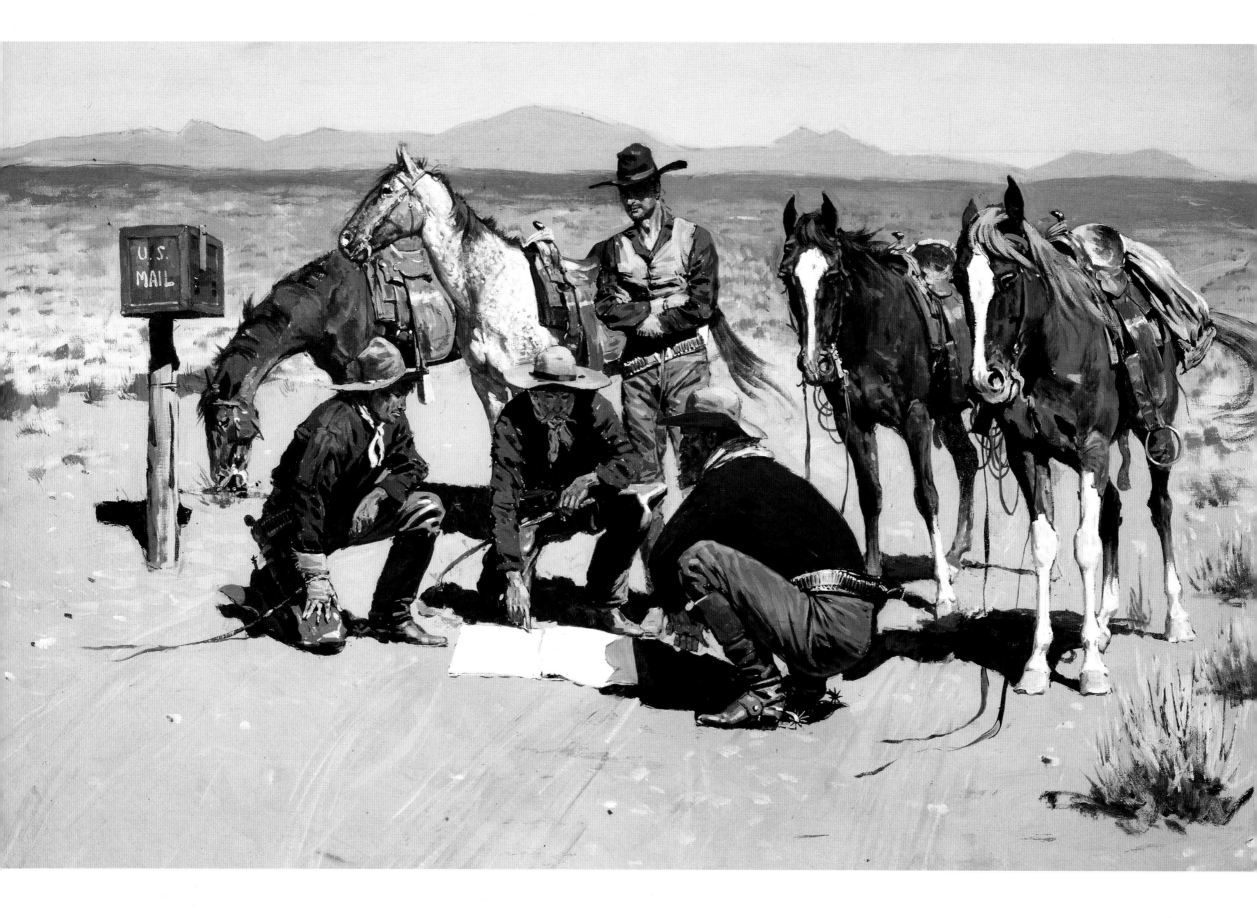

LEFT: *Post Office in Cow Country.* c. 1901. This painting may show the settlement of Cody, originally named Shoshone, near the McCullough Peaks in Wyoming. Remington visited Wyoming in 1900, and collected photos of Cody and the region. *The Art Archive/Buffalo Bill Historical Center, Cody, Wyoming/11.76*

RIGHT: *Arizona Cowboy.* Crayon on paper, 1901. *Private Collection/Peter Newark Western Americana/The Bridgeman Art Library*

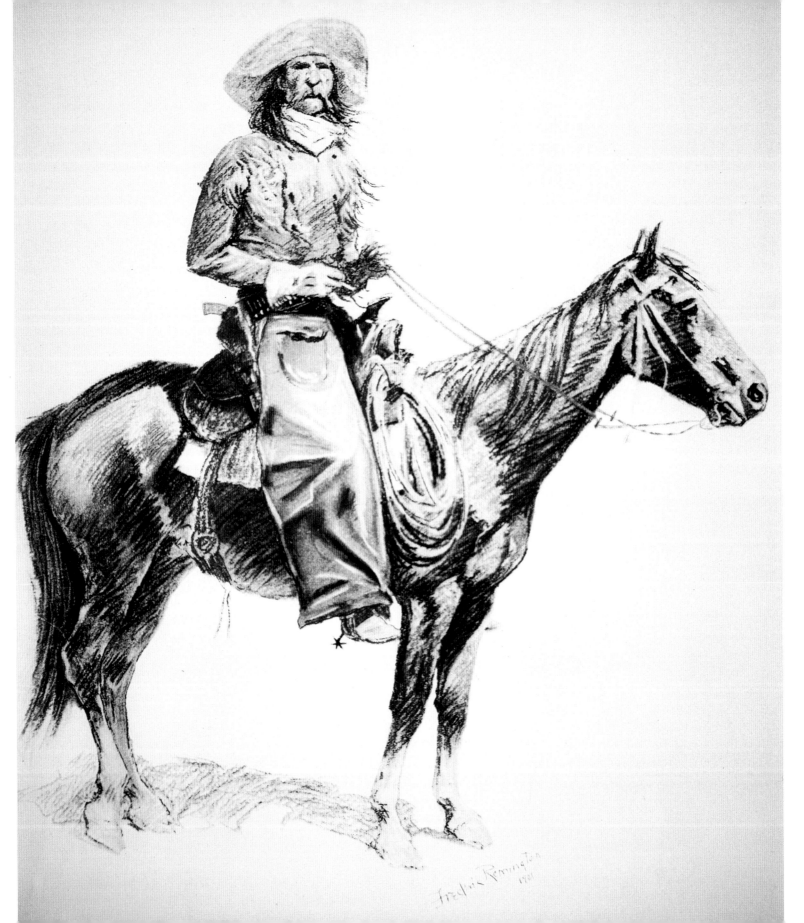

OVER PAGE LEFT: *He Lay Where he had Been Jerked, Still as a Log.* Oil on canvas, undated. © *Private Collection/ Photo © Christie's Images/The Bridgeman Art Library*

OVER PAGE RIGHT: *Buffalo hunter wagon covered with tarp.* Undated. *The Art Archive/Gift of the Coe Foundation/ Buffalo Bill Historical Center, Cody, Wyoming/39.67*

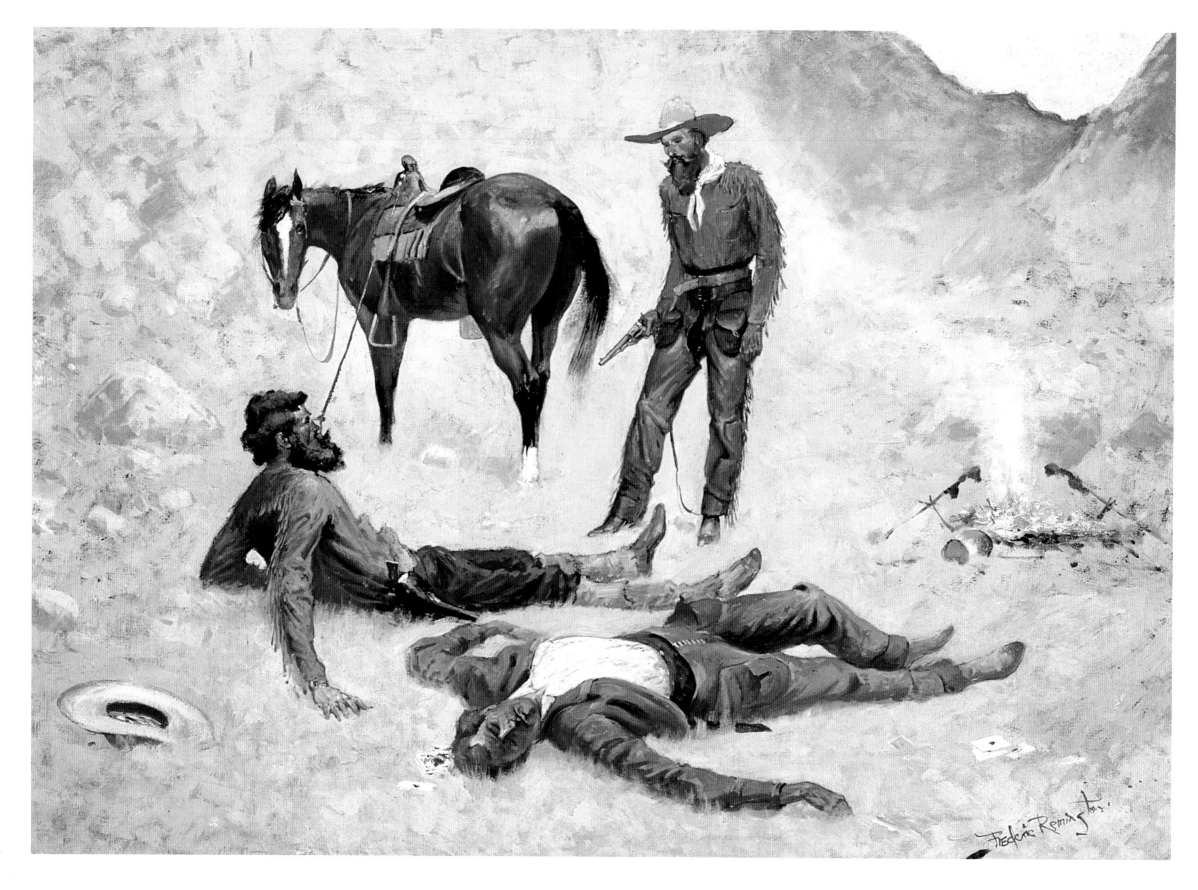

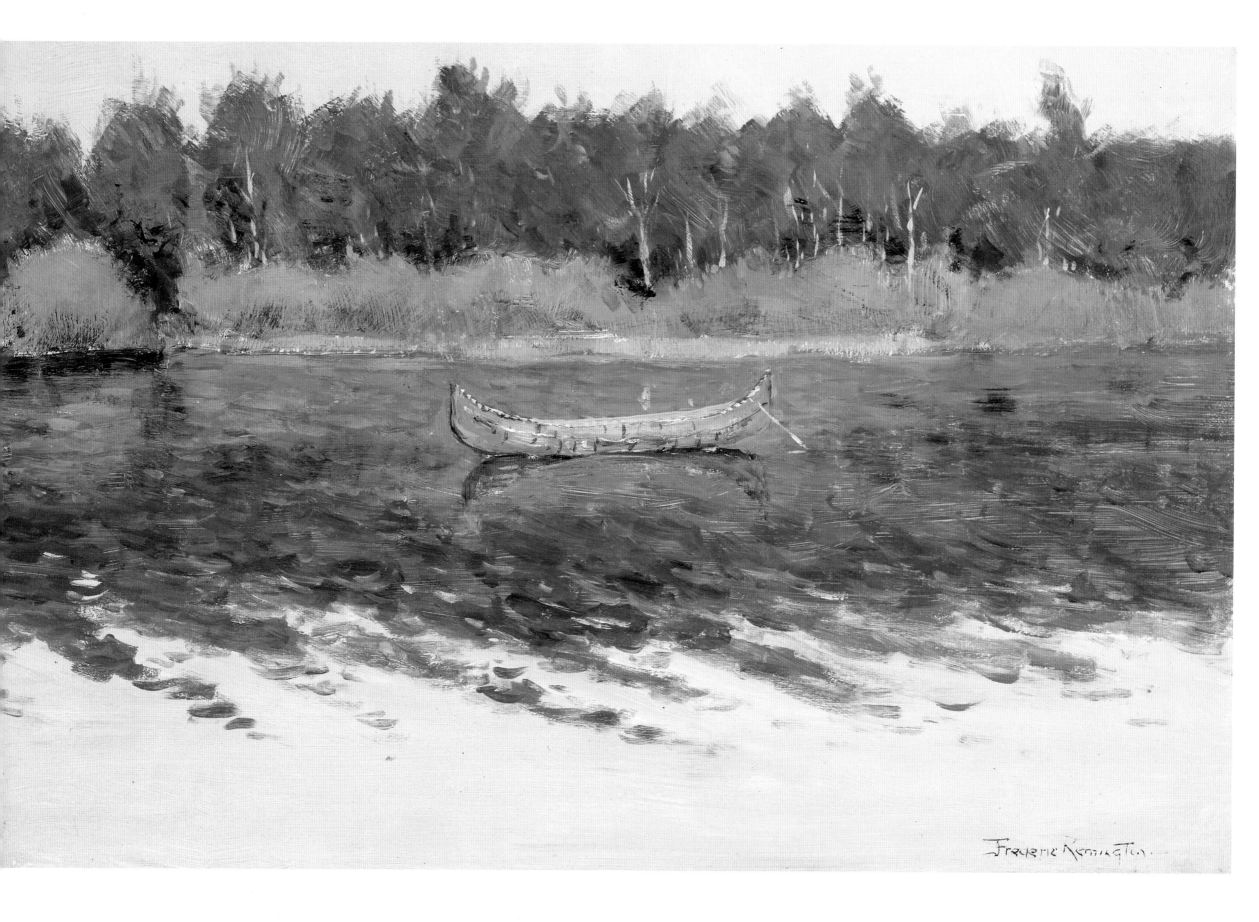

Frederic Remington.

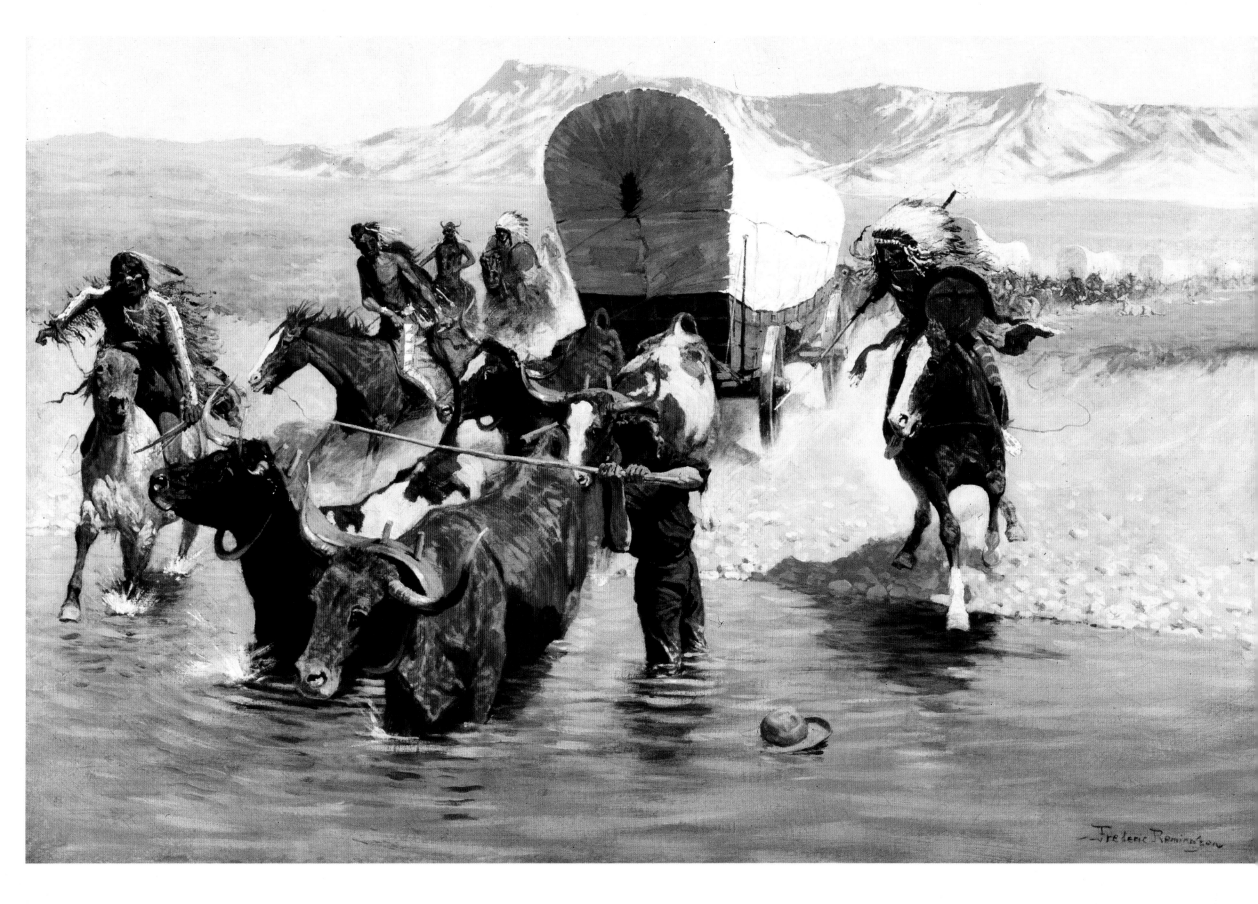

Previous page left: Sketch of birchbark canoe anchored against a background of trees. Undated. *The Art Archive/ Gift of the Coe Foundation/Buffalo Bill Historical Center, Cody, Wyoming/ 9.67*

Previous page right: *The Emigrants.* Oil on canvas, c.1904. © *Museum of Fine Arts, Houston, Texas, USA/Hogg Brothers Collection, Gift of Miss Ima Hogg/The Bridgeman Art Library*

Right: *Jedediah Smith making his way across the desert from Green River to the Spanish settlements at San Diego, from The Great Explorers. Oil on canvas, 1906. Private Collection/The Bridgeman Art Library*

OVER PAGE LEFT: Untitled, ranch, haystack, and wagon with mountain in background, or Valley Home Ranch, Southfork, Cody, Wyoming. 1908. *The Art Archive/Gift of the Coe Foundation/Buffalo Bill Historical Center, Cody, Wyoming/69.67*

OVER PAGE RIGHT: Landscape of lake with barren hillside. Unfinished, undated, oil painting. *The Art Archive/Gift of the Coe Foundation/ Buffalo Bill Historical Center, Cody, Wyoming/95.67*

179

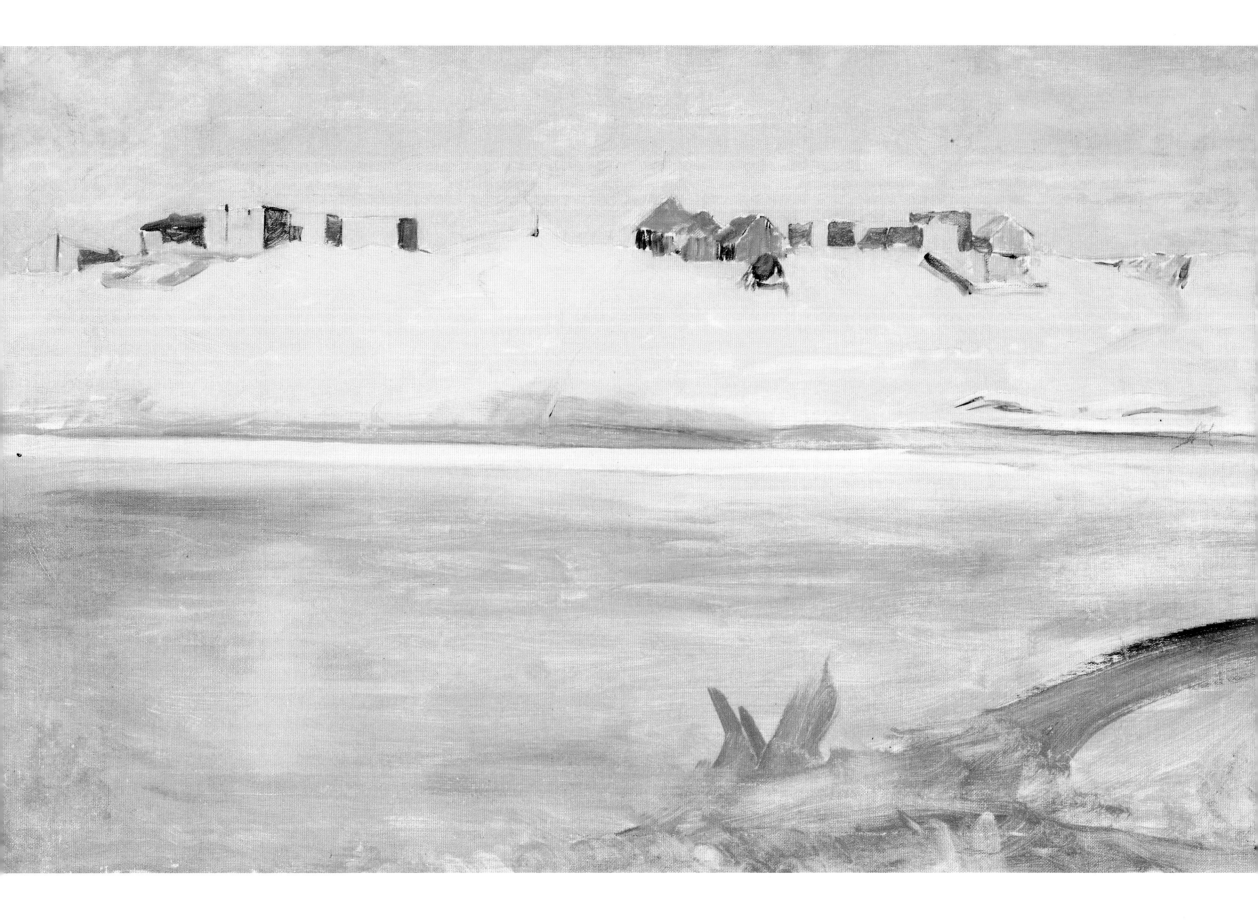

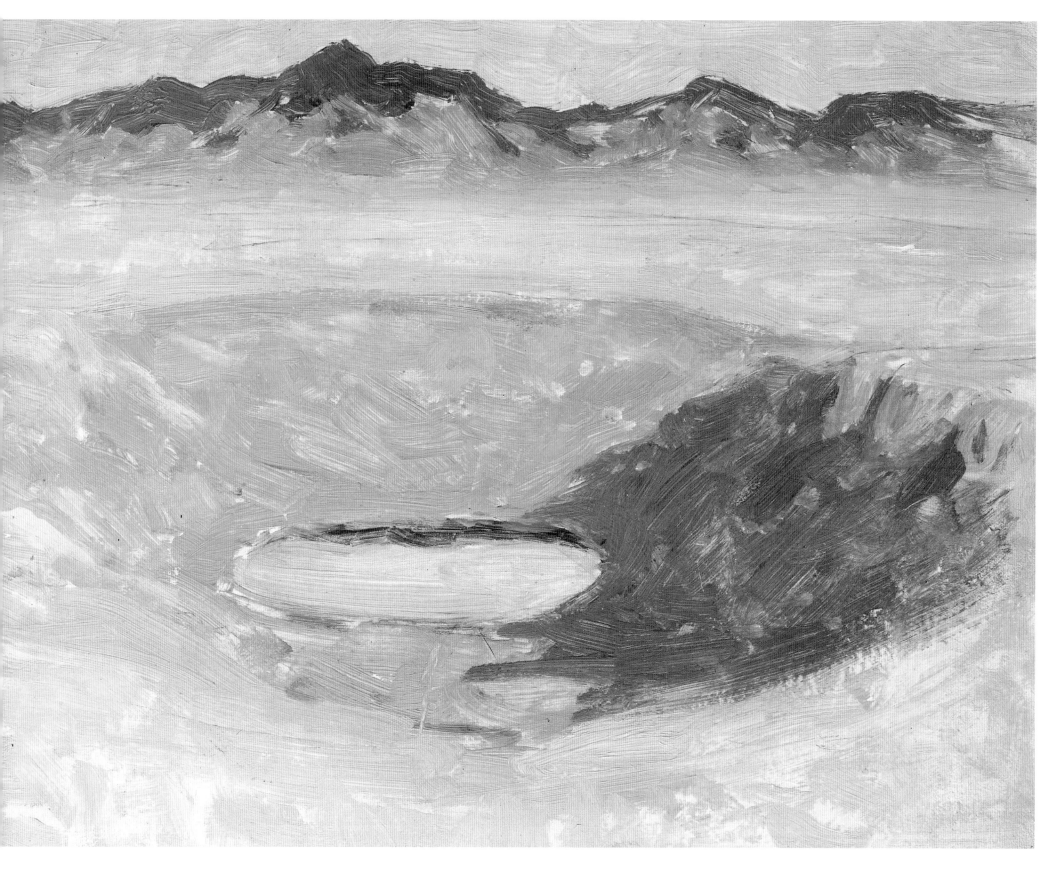

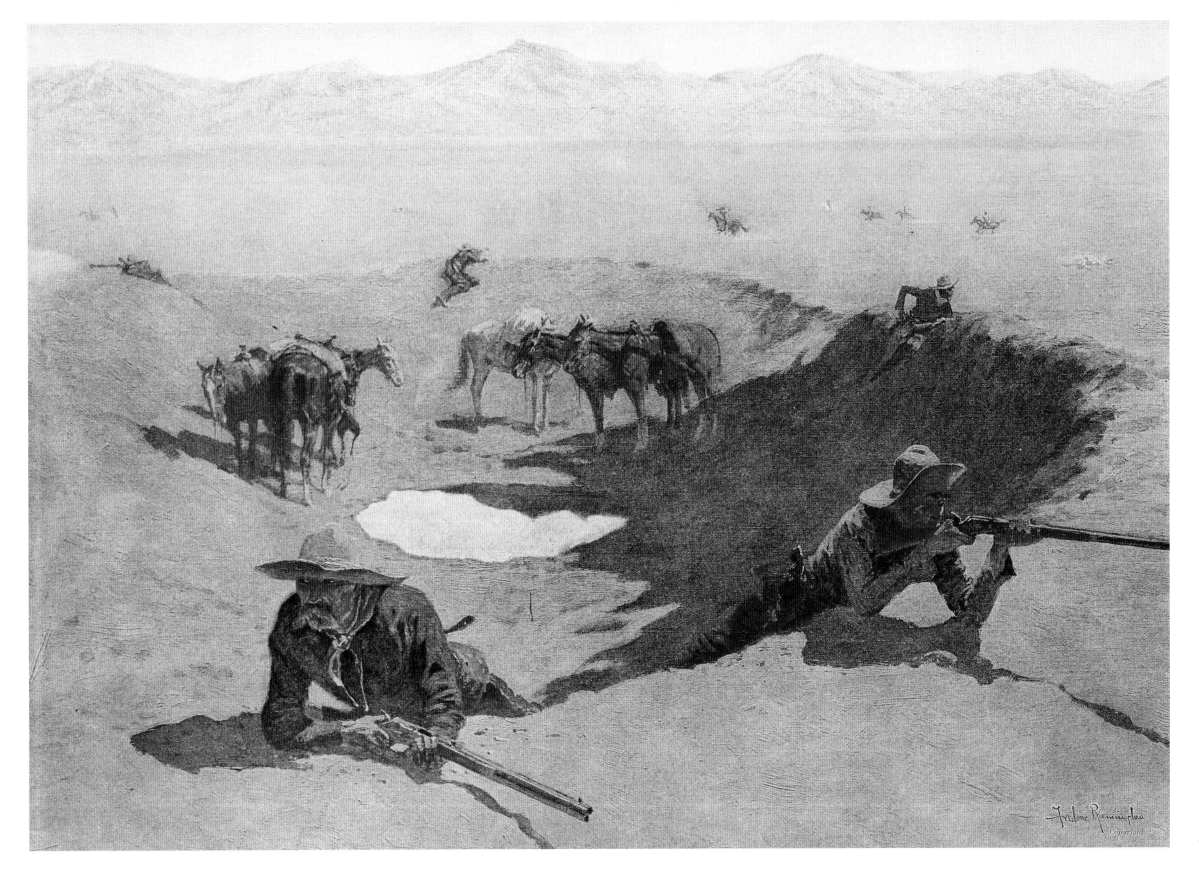

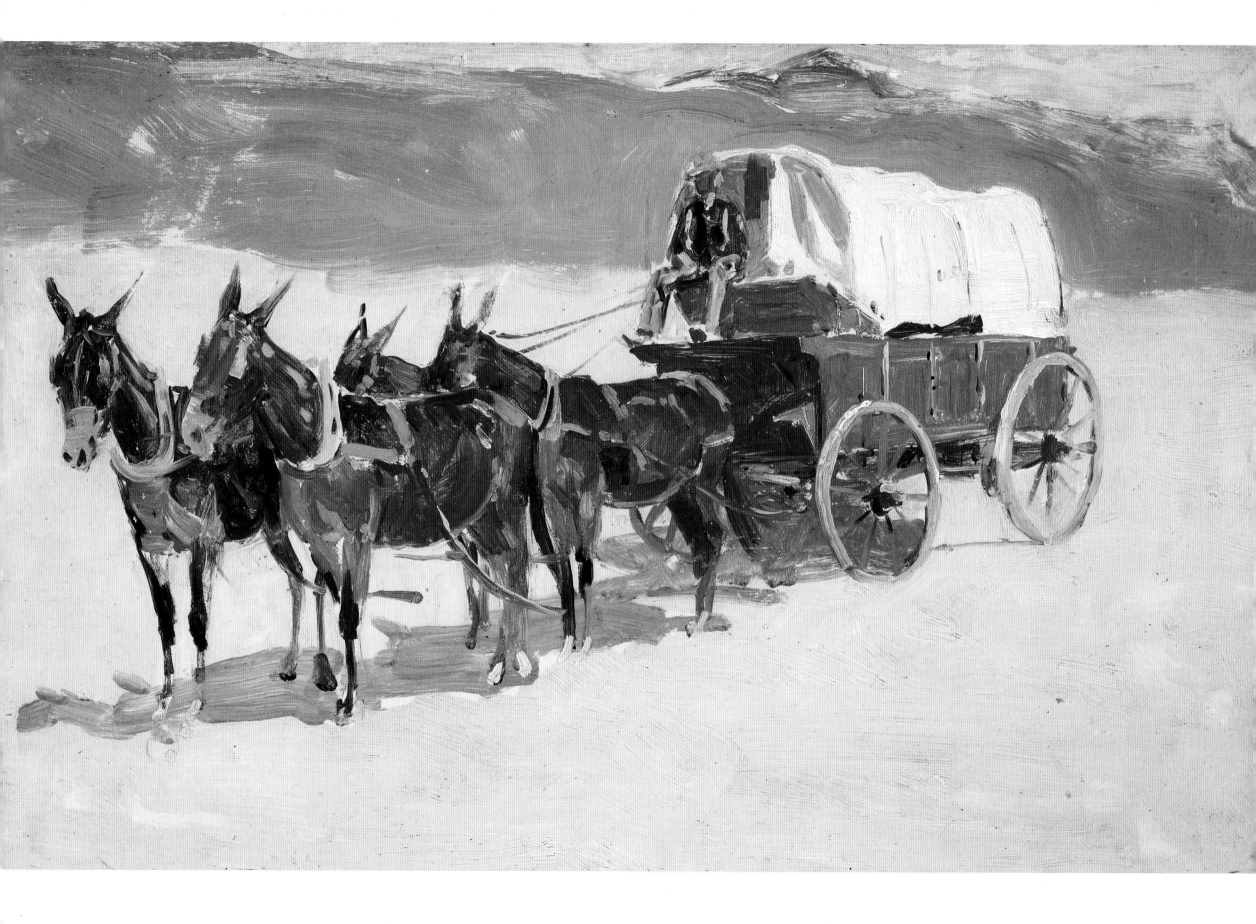

Left: Cattle outfit freight wagon with driver and four mules. Undated. *The Art Archive/Gift of the Coe Foundation/Buffalo Bill Historical Center, Cody, Wyoming/54.67*

Right: *Campfire.* Undated. *The Art Archive/Gift of the Coe Foundation/ Buffalo Bill Historical Center, Cody, Wyoming/101.67*

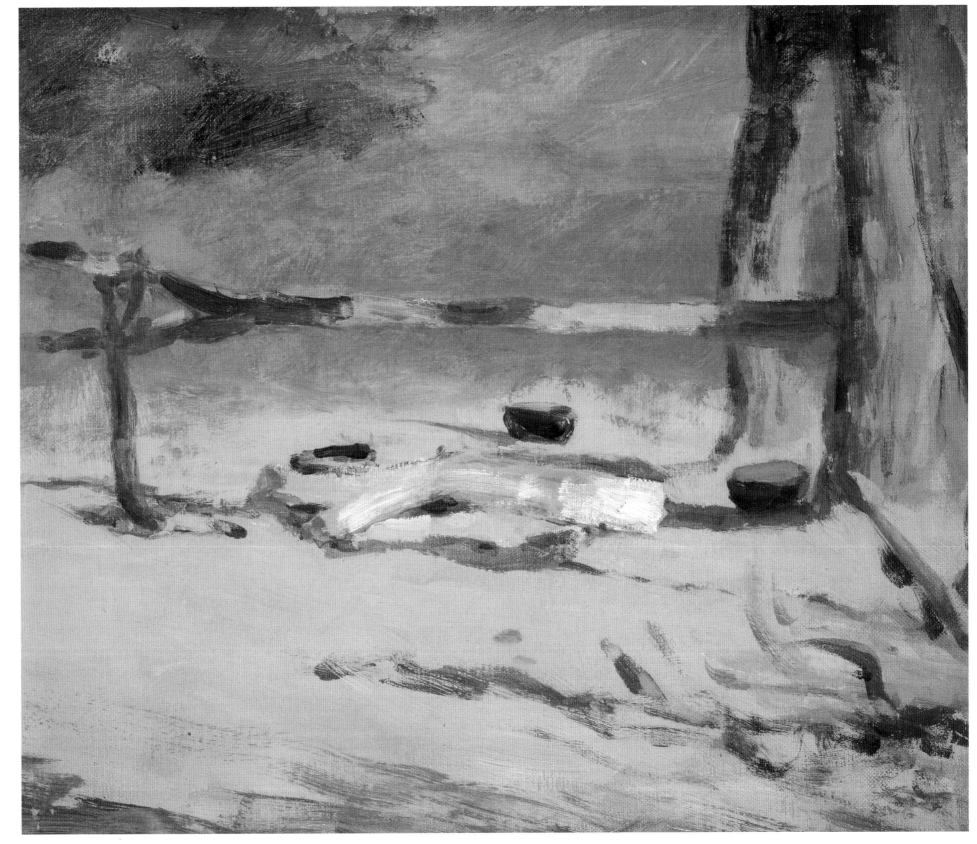

RIGHT: Untitled, mounted cowboy in chaps with bay horse. 1908. *The Art Archive/Gift of the Coe Foundation/ Buffalo Bill Historical Center, Cody, Wyoming/65.67*

RIGHT: Two men and a dog in a canoe. c. 1908. Such men for Remington were the ultimate pioneers, paddling up unknown watercourses in search of adventure. *Library of Congress, Prints & Photographs Division, LC-USZCN4-14*

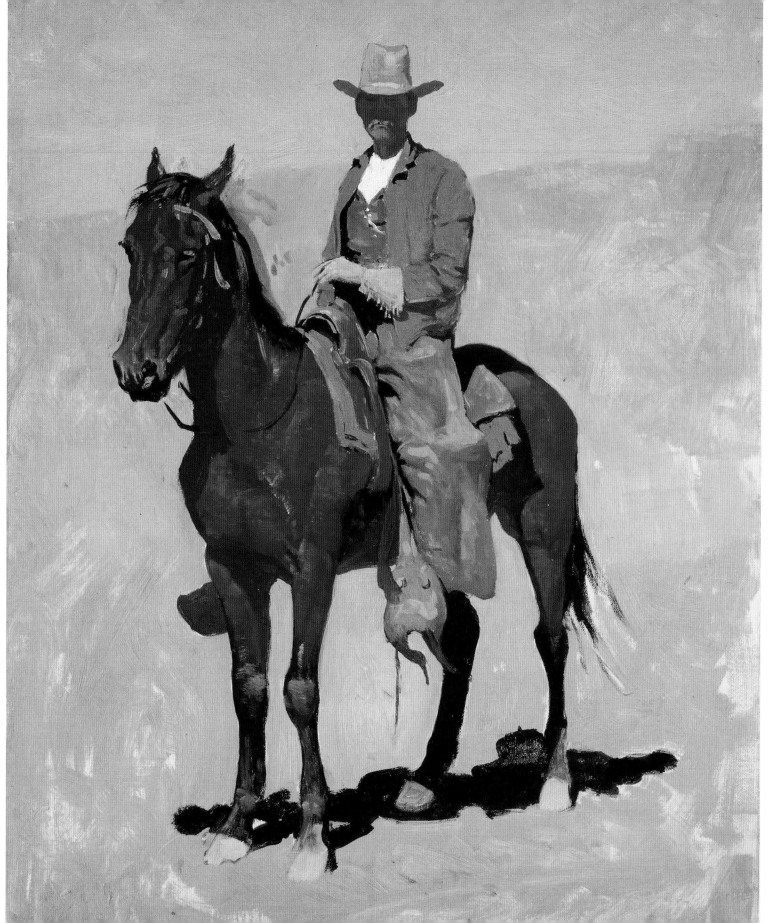

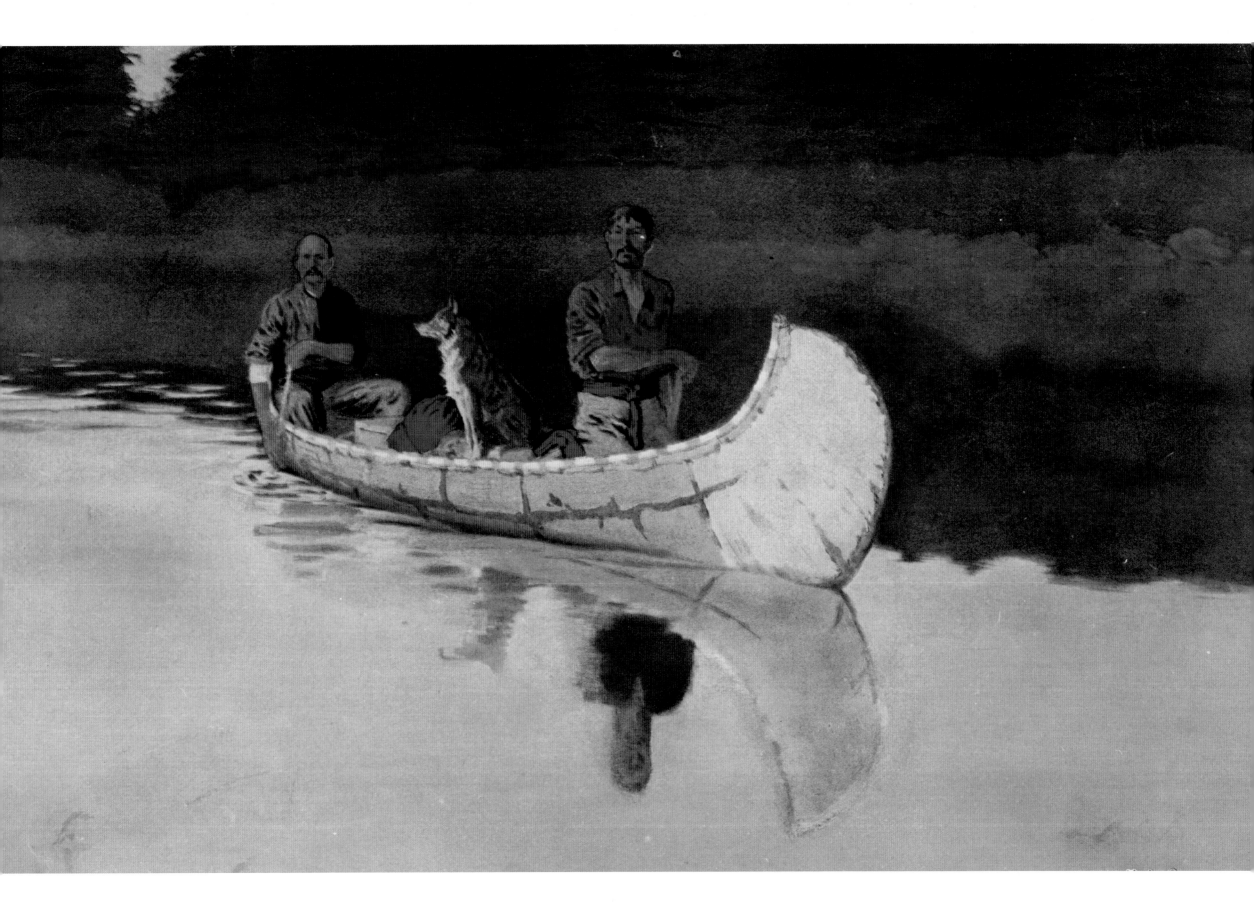

Landscapes

Landscapes

Frederic Remington made a huge number of landscape studies, the vast majority of them when he was out West, as reference for background material which he took back to his studio in the East for incorporation into his paintings. Many of these studies are hastily painted landscapes, quickly dashed together to capture a particular play of light on mountains, trees, or rocks. Remington made few pure landscape paintings, but his love of the outdoors is evident in the sheer number of his works. The majority of the sketches show vast plains that stretch into the distance with a backdrop of mountains, most of them in western America. He produced such vast numbers of these sketches that most of them are both untitled and undated. Many of his other landscapes are studies he made while on summer vacation around Cranberry Lake and the Adirondacks, then later when he bought his island on the St.Lawrence, of the islets, waterways, and trees of the Thousand Islands and Chippewa Bay area.

RIGHT: Winter scene of a snow-covered log cabin, with a man on snow shoes at the door, and spruce trees in the background. Undated. *The Art Archive/Gift of the Coe Foundation/Buffalo Bill Historical Center, Cody, Wyoming/78.67*

FAR RIGHT: Rocks, prairie, purple mountains, and blue sky. Undated. *The Art Archive/Gift of the Coe Foundation/Buffalo Bill Historical Center, Cody, Wyoming/22.67*

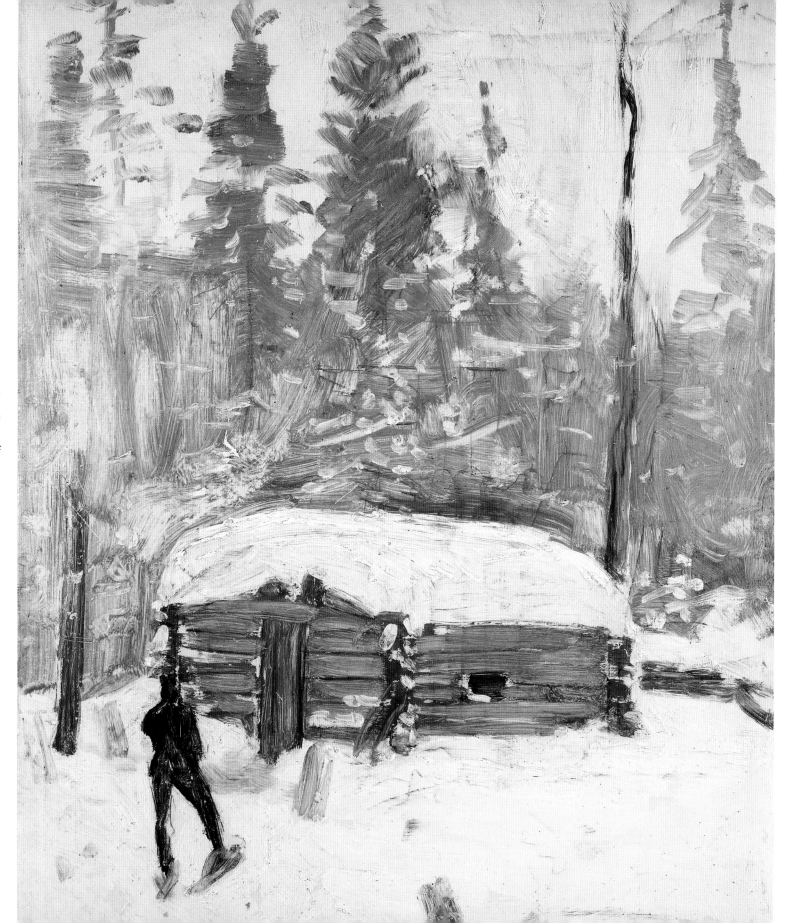

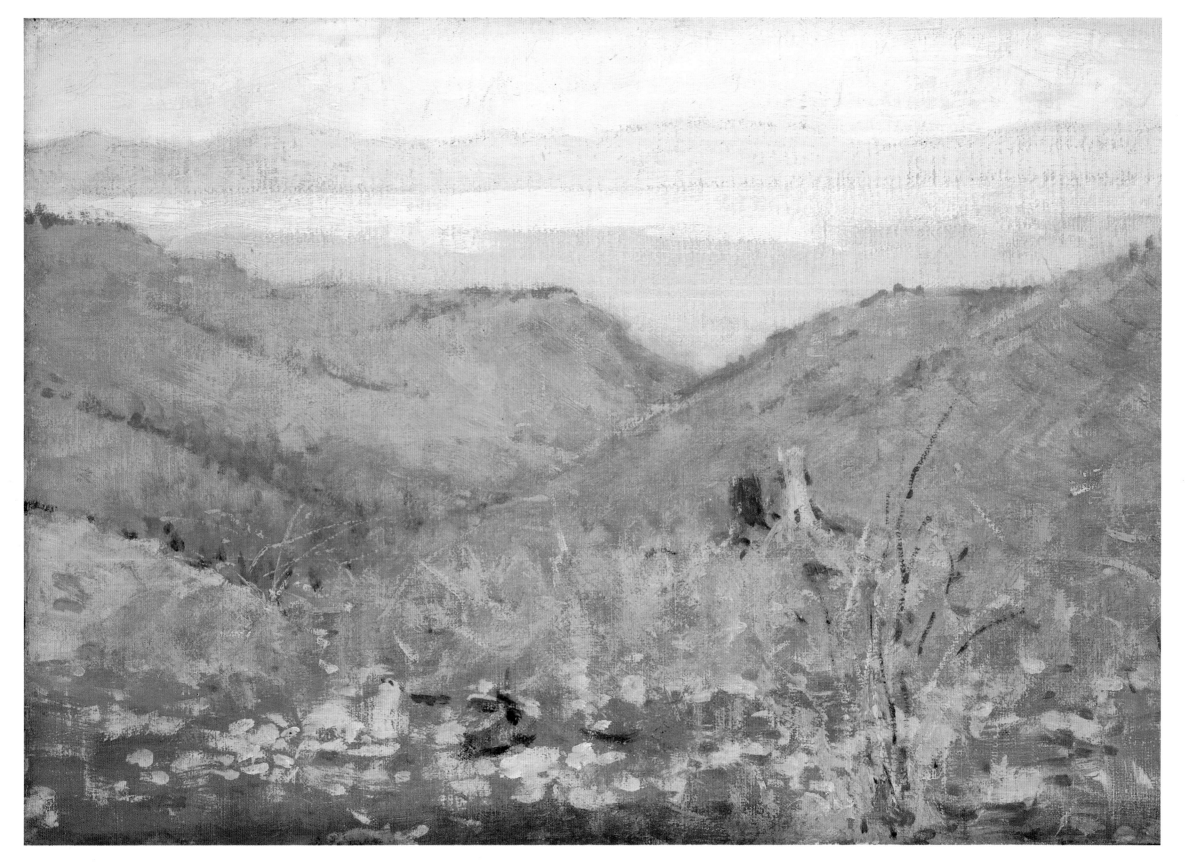

PREVIOUS PAGE LEFT: Impressionistic winter scene of frozen stream, bare trees, and hills. Undated. *The Art Archive/Gift of the Coe Foundation/ Buffalo Bill Historical Center, Cody, Wyoming/83.67*

PREVIOUS PAGE RIGHT: High prairie, valley, and mountains in the background. Undated. *The Art Archive/Gift of the Coe Foundation/ Buffalo Bill Historical Center, Cody, Wyoming/32.67*

RIGHT: Impressionistic winter scene of bare trees and snow covered ground. *The Art Archive/Gift of the Coe Foundation/Buffalo Bill Historical Center, Cody, Wyoming/80.67*

FAR RIGHT: Prairie brush with mountain background. Undated. *The Art Archive/Gift of the Coe Foundation/ Buffalo Bill Historical Center, Cody, Wyoming/61.67*

OVER PAGE LEFT: Prairie, trees, and sky. Undated. *The Art Archive/Gift of the Coe Foundation/Buffalo Bill Historical Center, Cody, Wyoming/20.67*

OVER PAGE RIGHT: Winter scene of maple syrup camp, surrounded by bare trees and snow covered ground. Undated. *The Art Archive/Gift of the Coe Foundation/Buffalo Bill Historical Center, Cody, Wyoming/81.67*

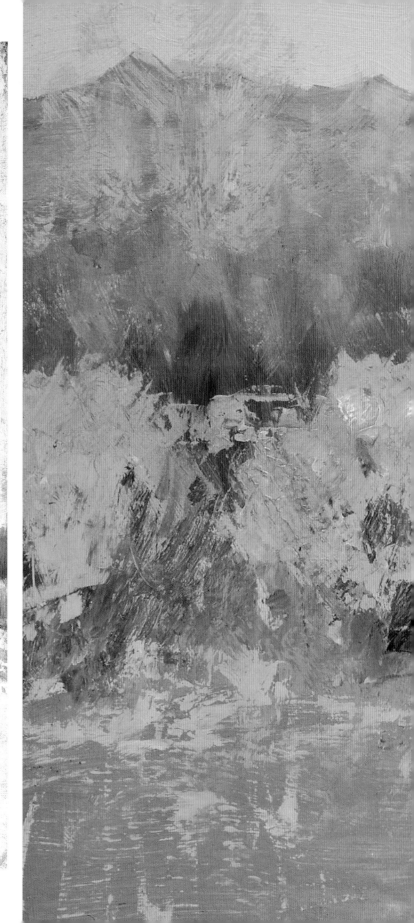

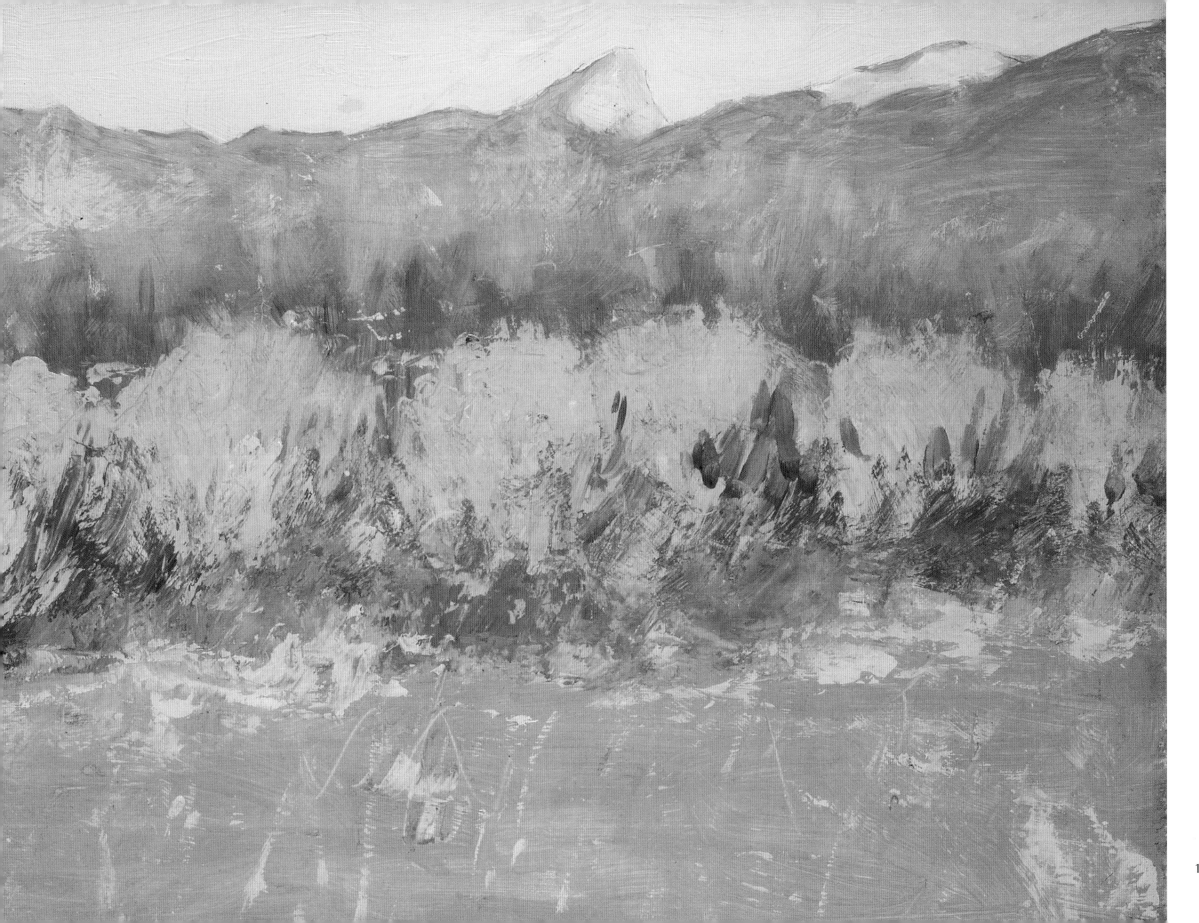

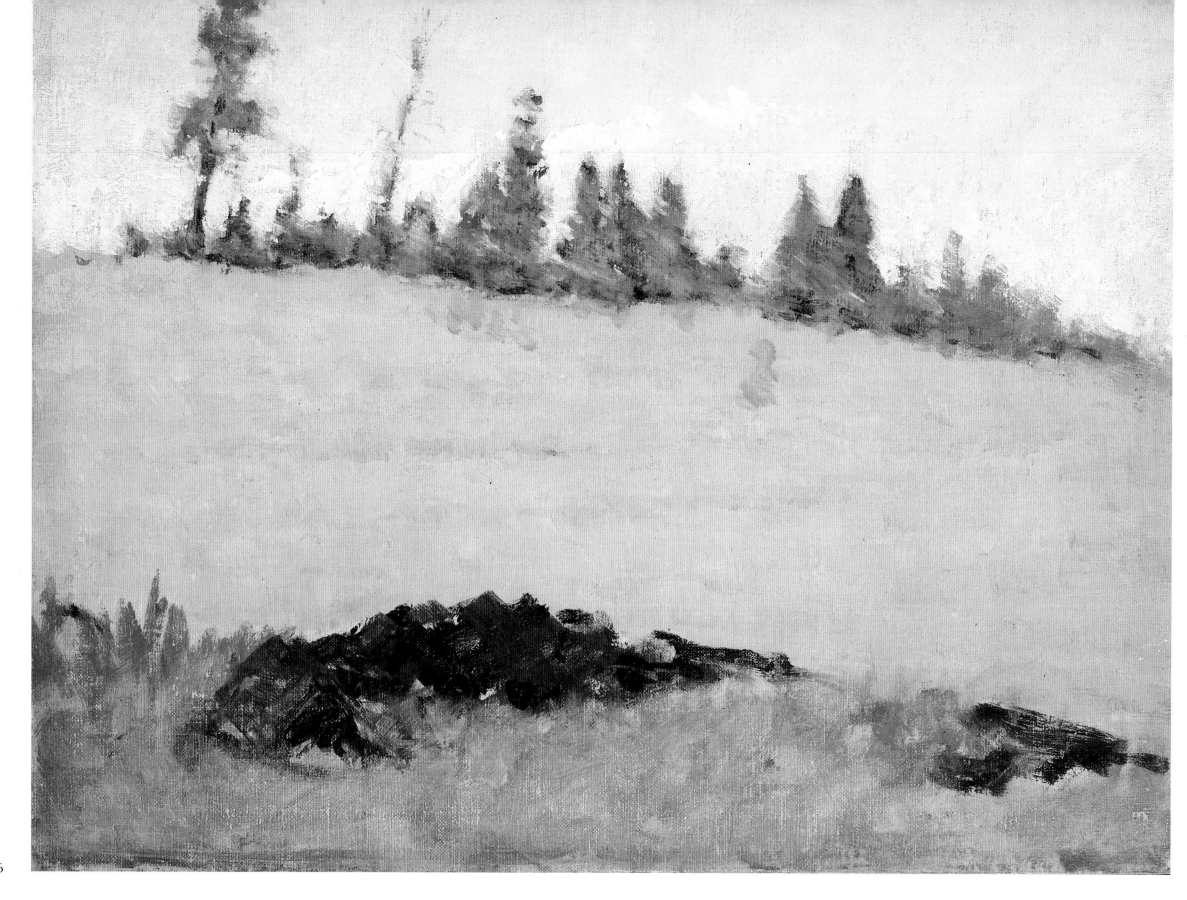

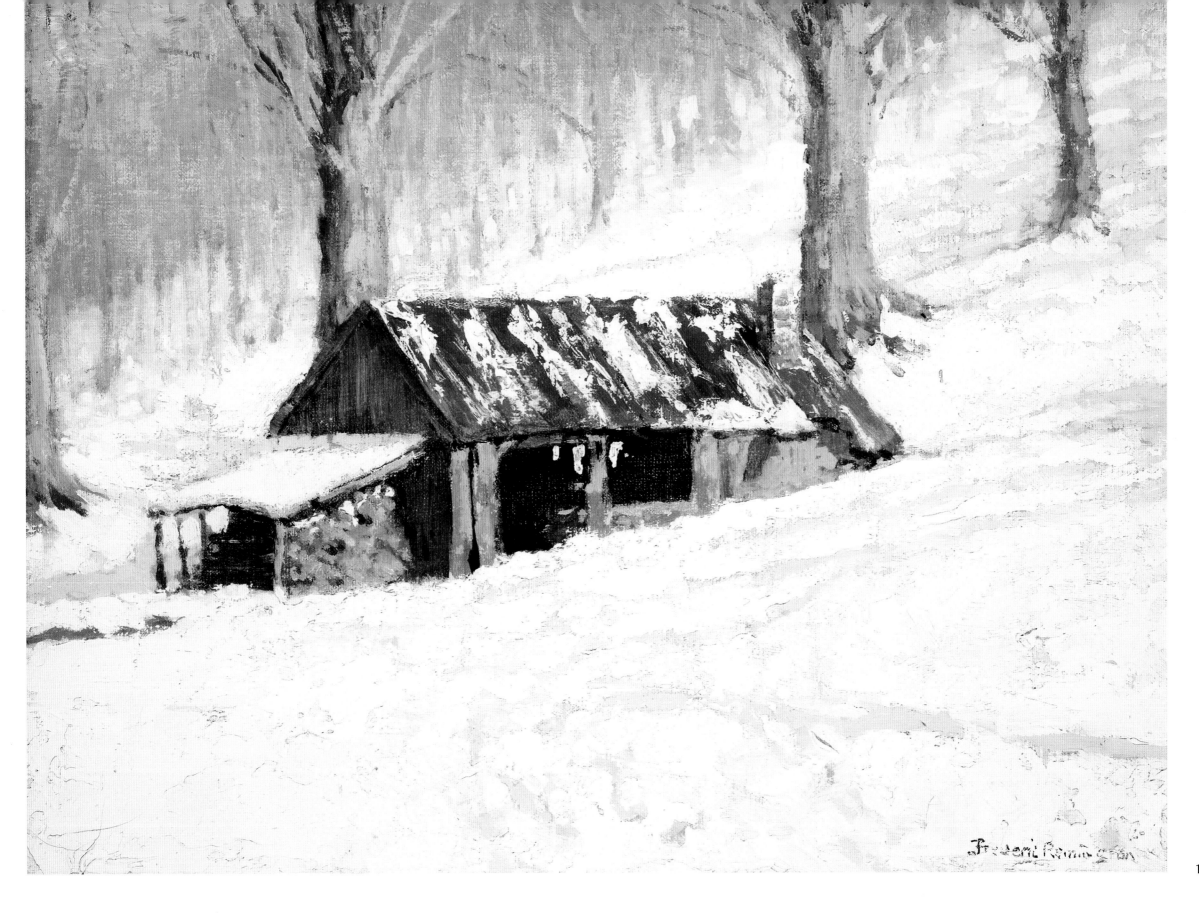

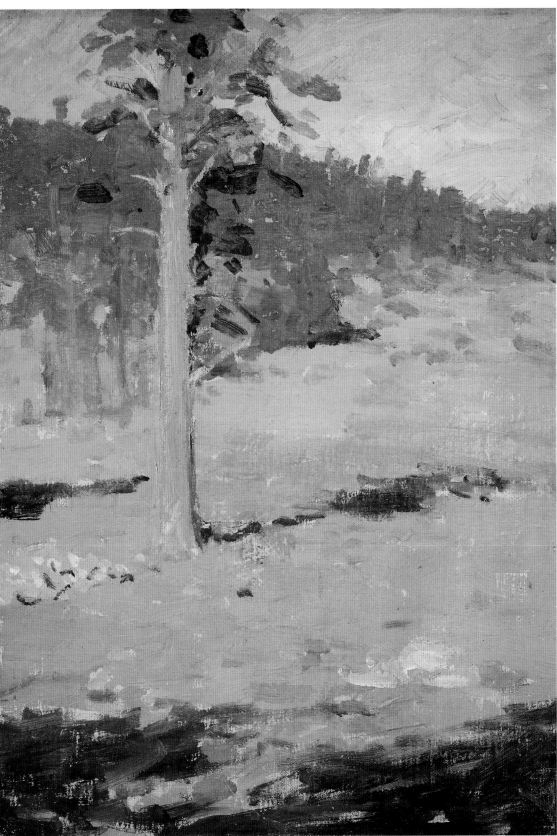

FAR LEFT: Sketch of prairie sagebrush and trees. Undated. *The Art Archive/Gift of the Coe Foundation/ Buffalo Bill Historical Center, Cody, Wyoming/66.67*

LEFT: Prairie, featuring a lone tree, with trees in the background. Undated. *The Art Archive/Gift of the Coe Foundation/Buffalo Bill Historical Center, Cody, Wyoming/19.67*

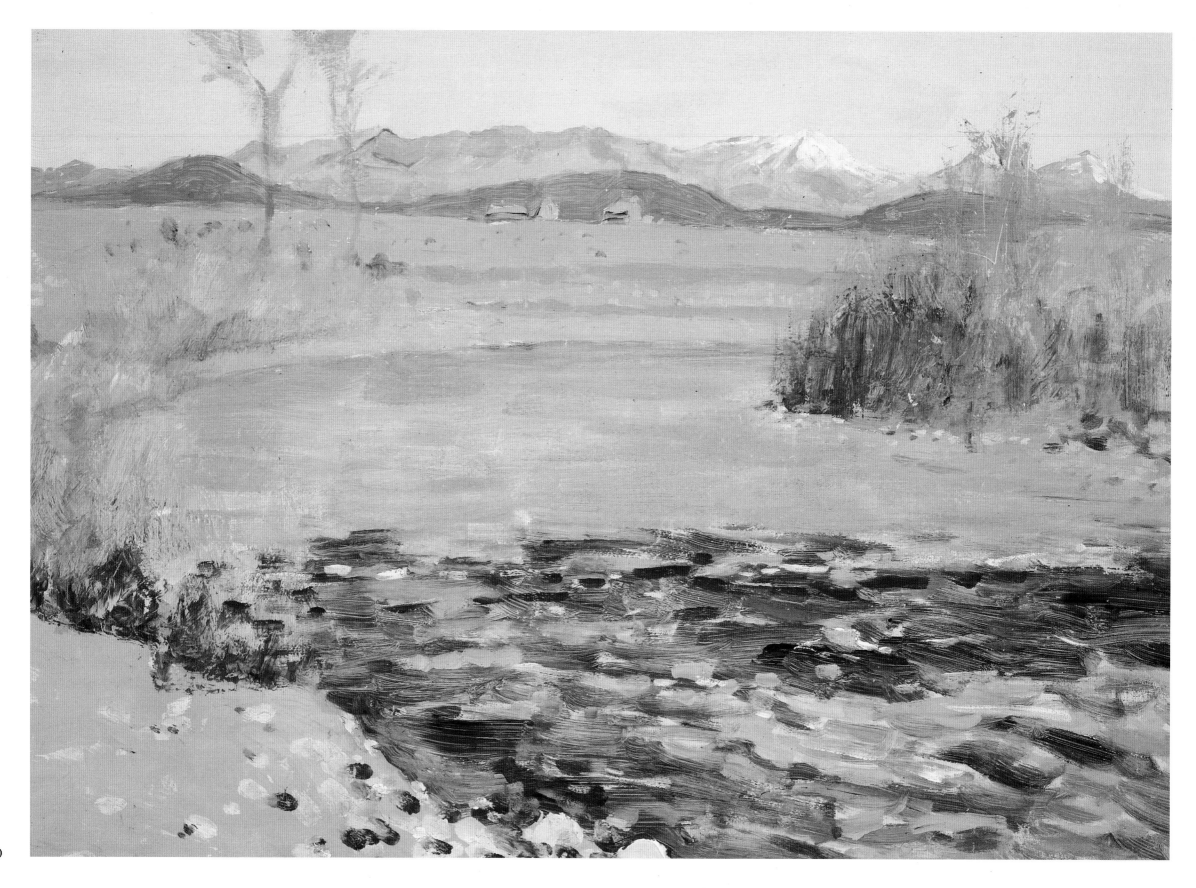

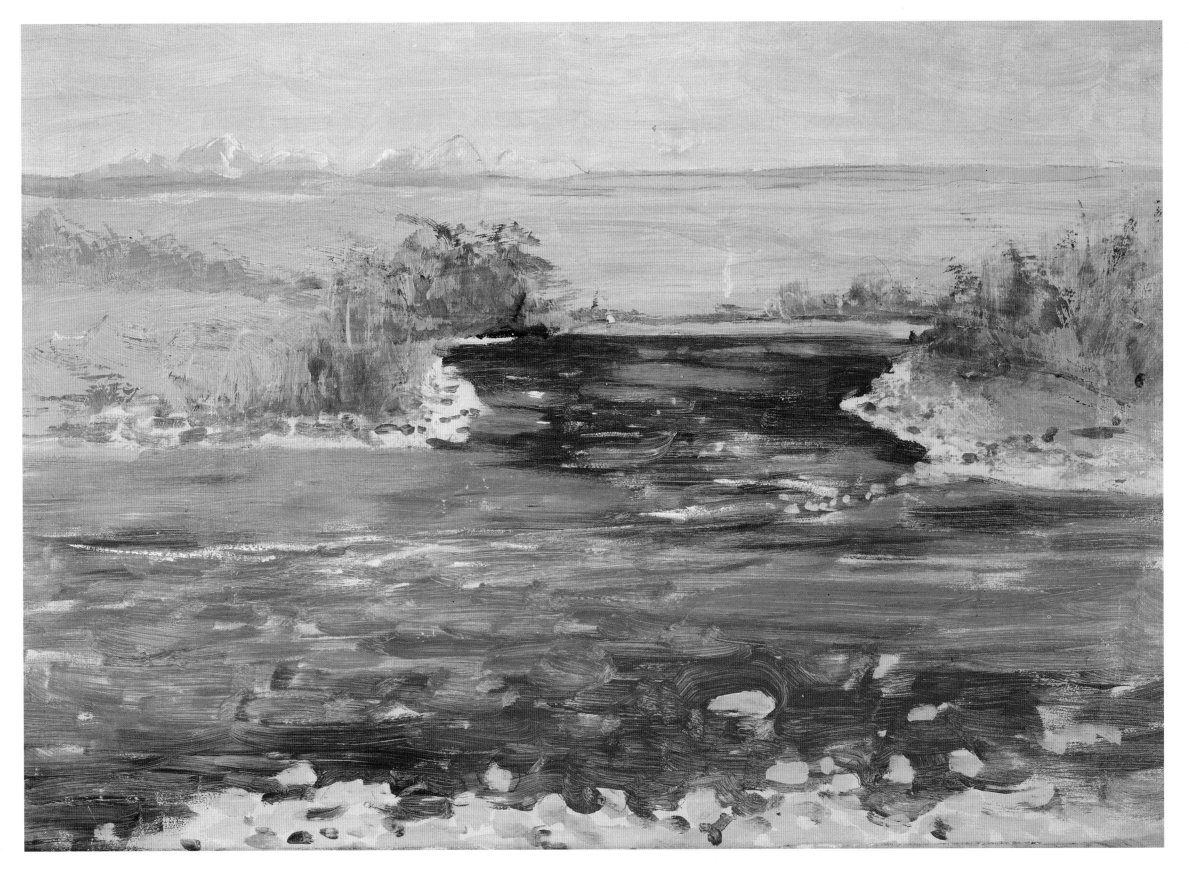

PREVIOUS PAGE LEFT: River and prairie with mountain background. Undated. *The Art Archive/Gift of the Coe Foundation/Buffalo Bill Historical Center, Cody, Wyoming/45.67*

PREVIOUS PAGE RIGHT: River, prairie, and mountain in background. Undated. *The Art Archive/Gift of the Coe Foundation/Buffalo Bill Historical Center, Cody, Wyoming/51.67*

RIGHT: Sketch of barren mountains. Undated. *The Art Archive/Gift of the Coe Foundation/Buffalo Bill Historical Center, Cody, Wyoming/17.67*

FAR RIGHT: Landscape, mountains, and prairie. Undated. *The Art Archive/Gift of the Coe Foundation /Buffalo Bill Historical Center, Cody, Wyoming/ 108.67*

OVER PAGE LEFT: Indian reservation buildings. Undated. *The Art Archive/Gift of the Coe Foundation/ Buffalo Bill Historical Center, Cody, Wyoming/58.67*

OVER PAGE RIGHT: Prairie, trees, and mountains in winter storm. Undated. *The Art Archive/Gift of the Coe Foundation/Buffalo Bill Historical Center, Cody, Wyoming/41.67*

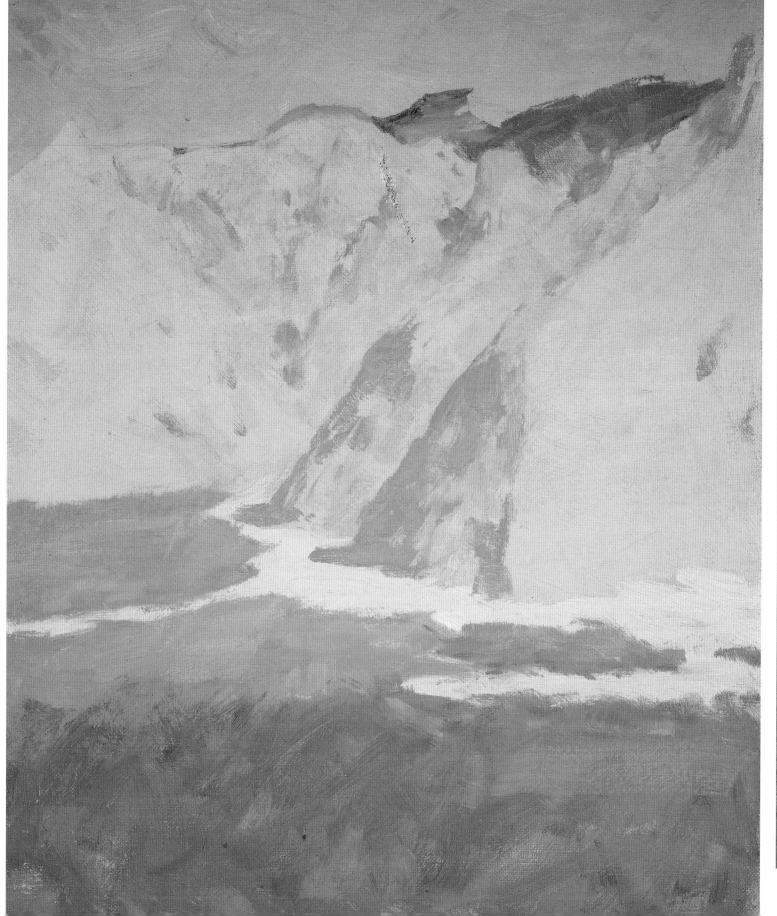

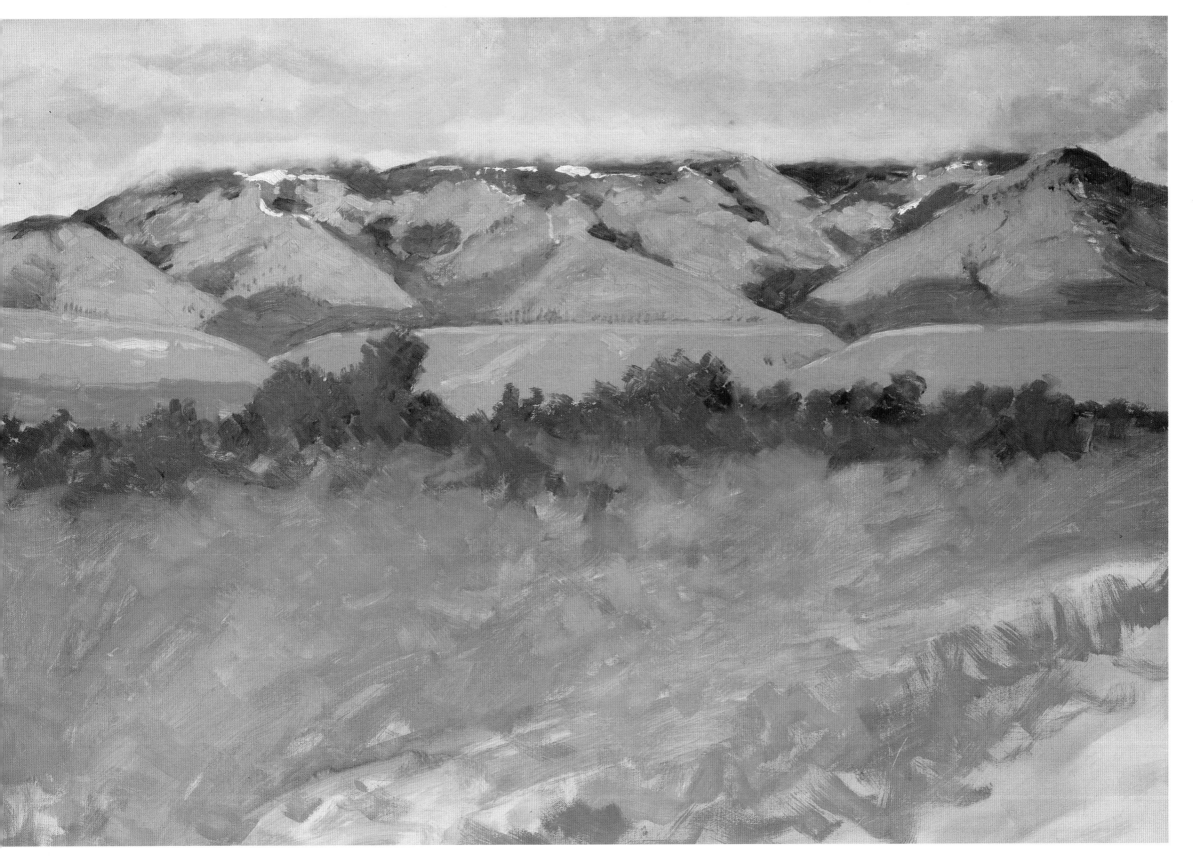

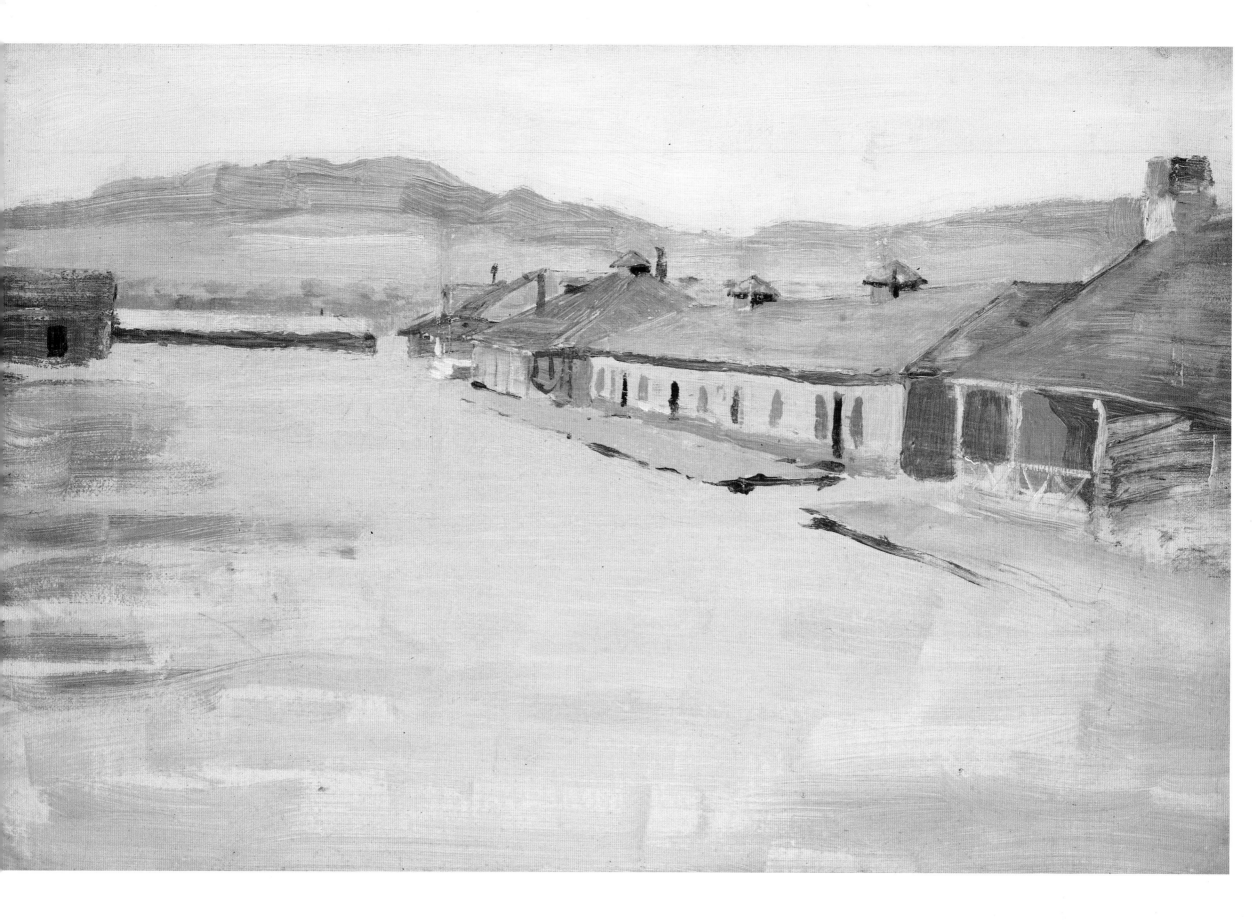

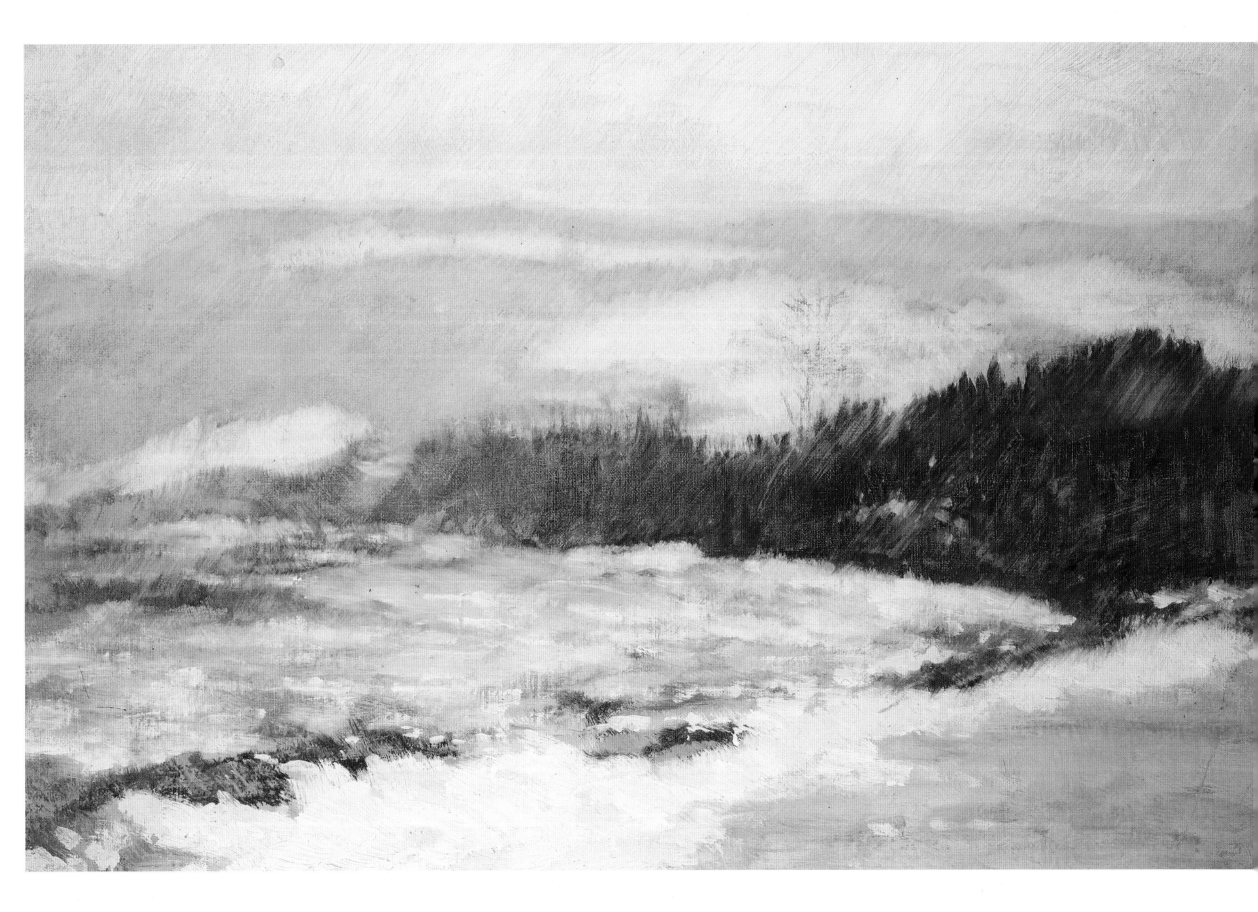

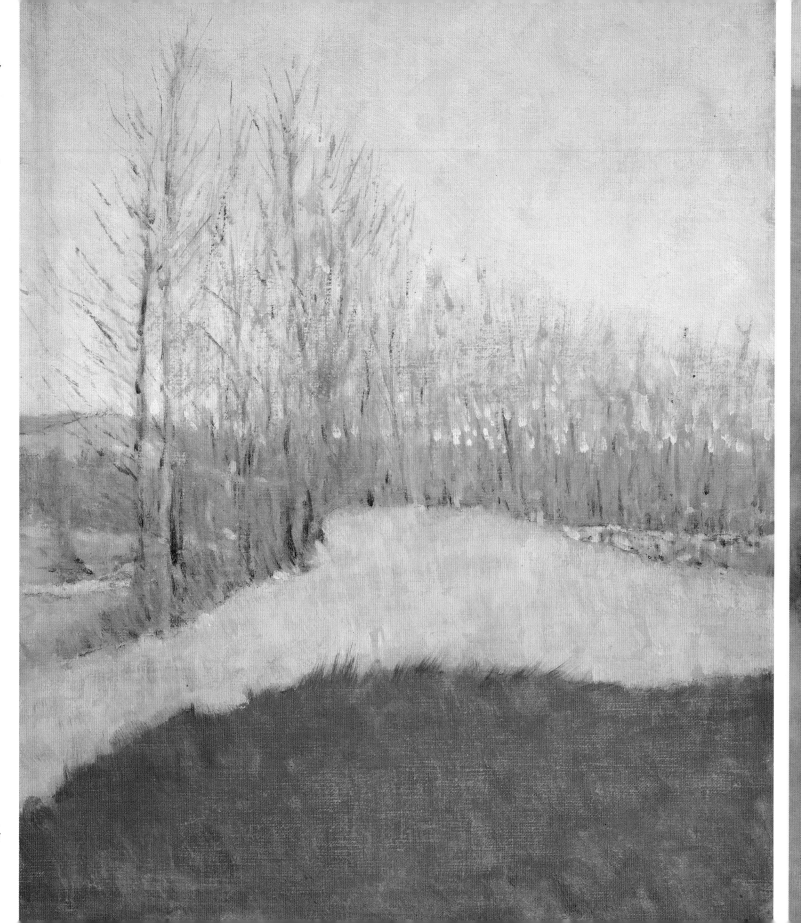

RIGHT: Impressionistic fall scene of bare quaking aspens against hills and blue sky, gold, and violet foreground. Undated. *The Art Archive/Gift of the Coe Foundation/Buffalo Bill Historical Center, Cody, Wyoming/76.67*

FAR RIGHT: Landscape, high prairie, sagebrush, and mountains. Undated. *The Art Archive/Gift of the Coe Foundation/Buffalo Bill Historical Center, Cody, Wyoming/84.67*

OVER PAGE LEFT: Untitled, log ranch buildings, haystack, and pole fence, 1908. *The Art Archive/Gift of the Coe Foundation/Buffalo Bill Historical Center, Cody, Wyoming/64.67*

OVER PAGE RIGHT: Blue prairie, mountains, and sky. Undated. *The Art Archive/Gift of the Coe Foundation/ Buffalo Bill Historical Center, Cody, Wyoming/31.67*

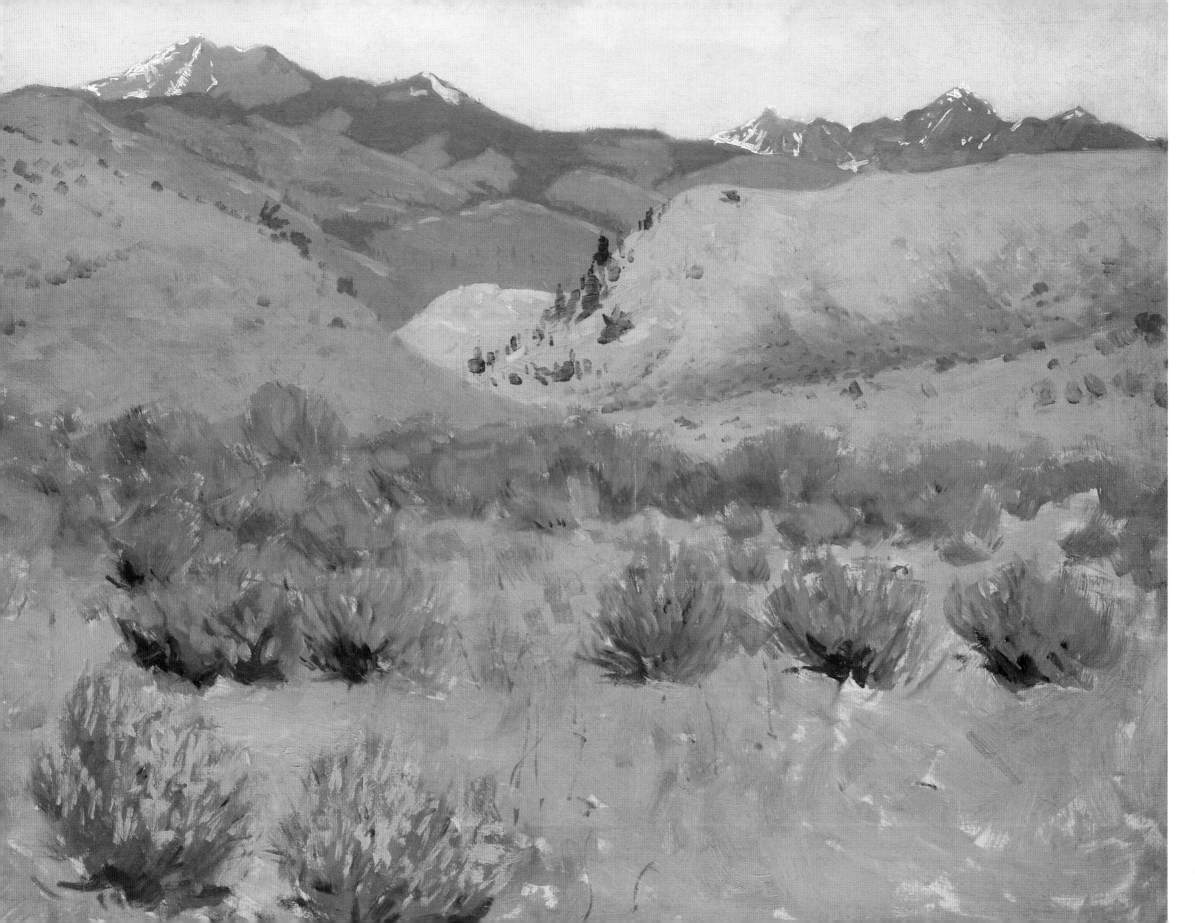

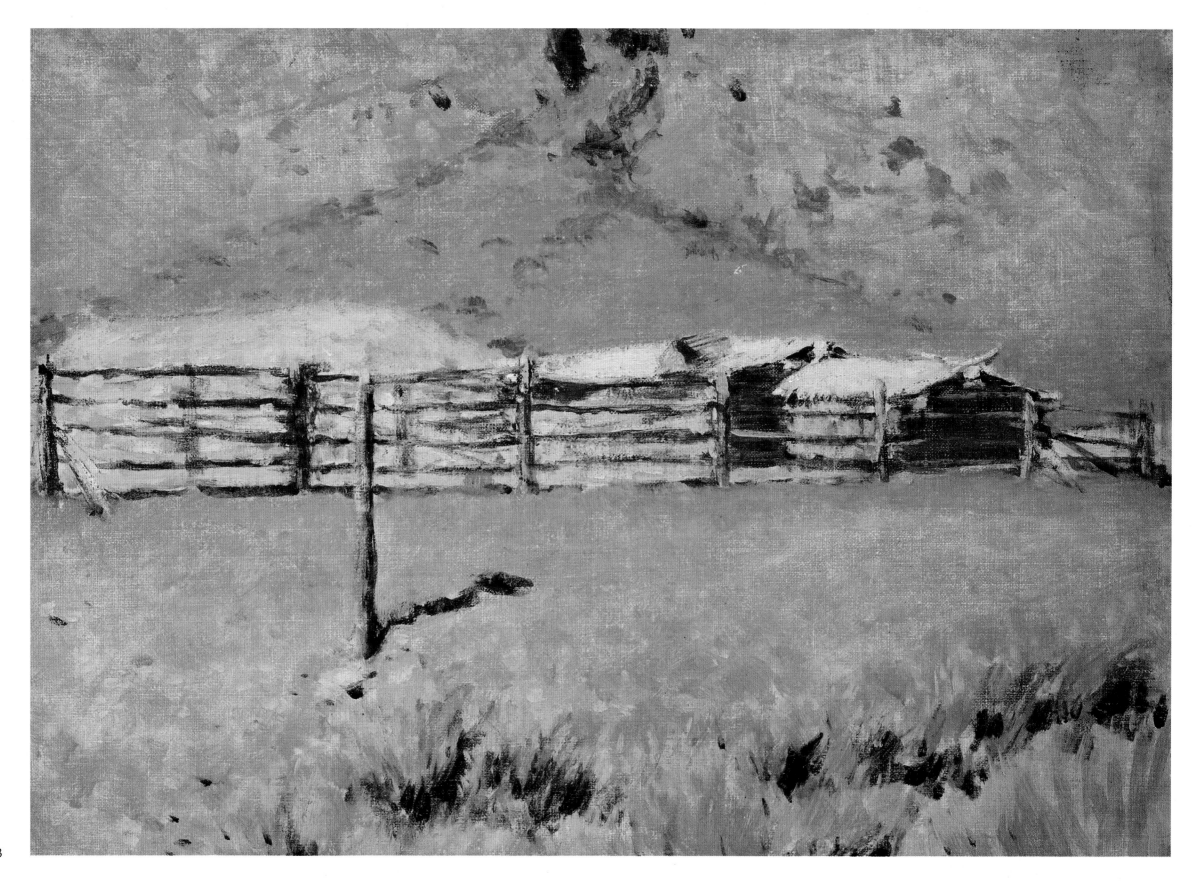

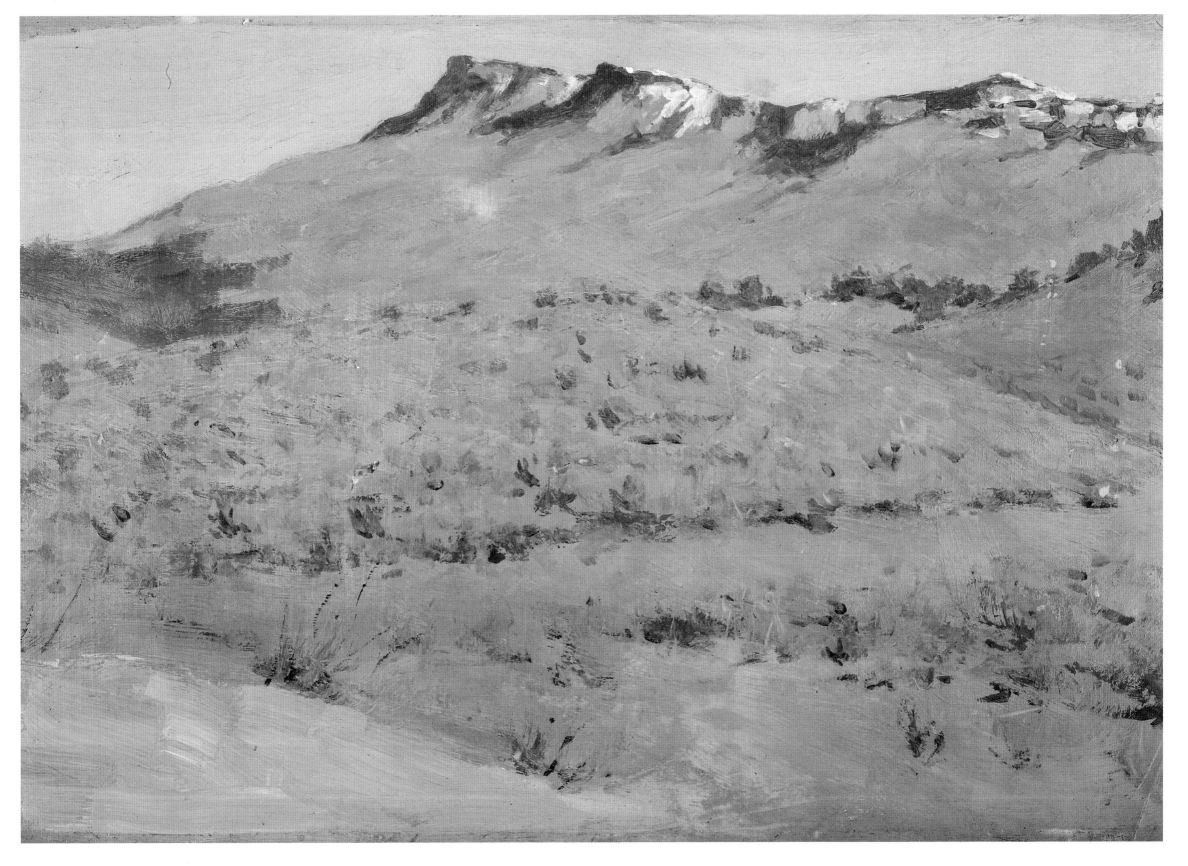

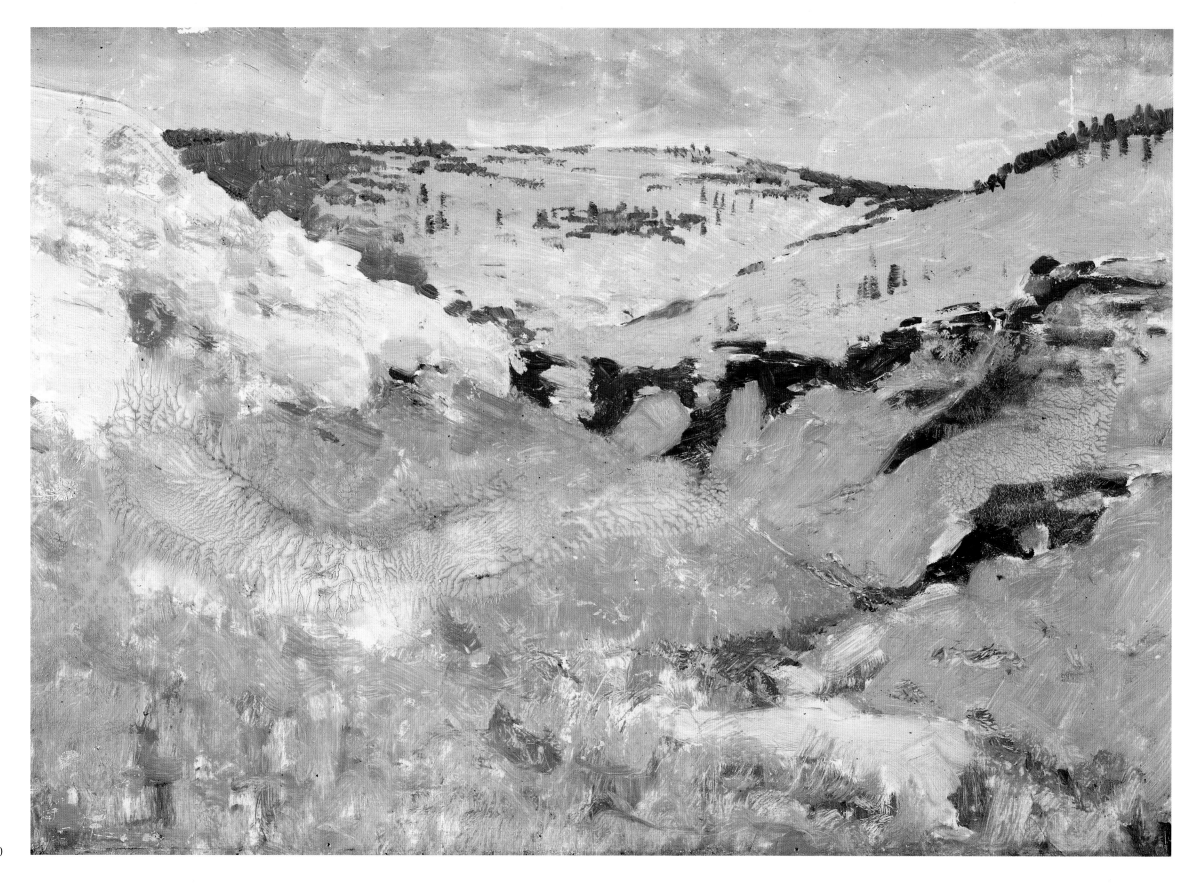

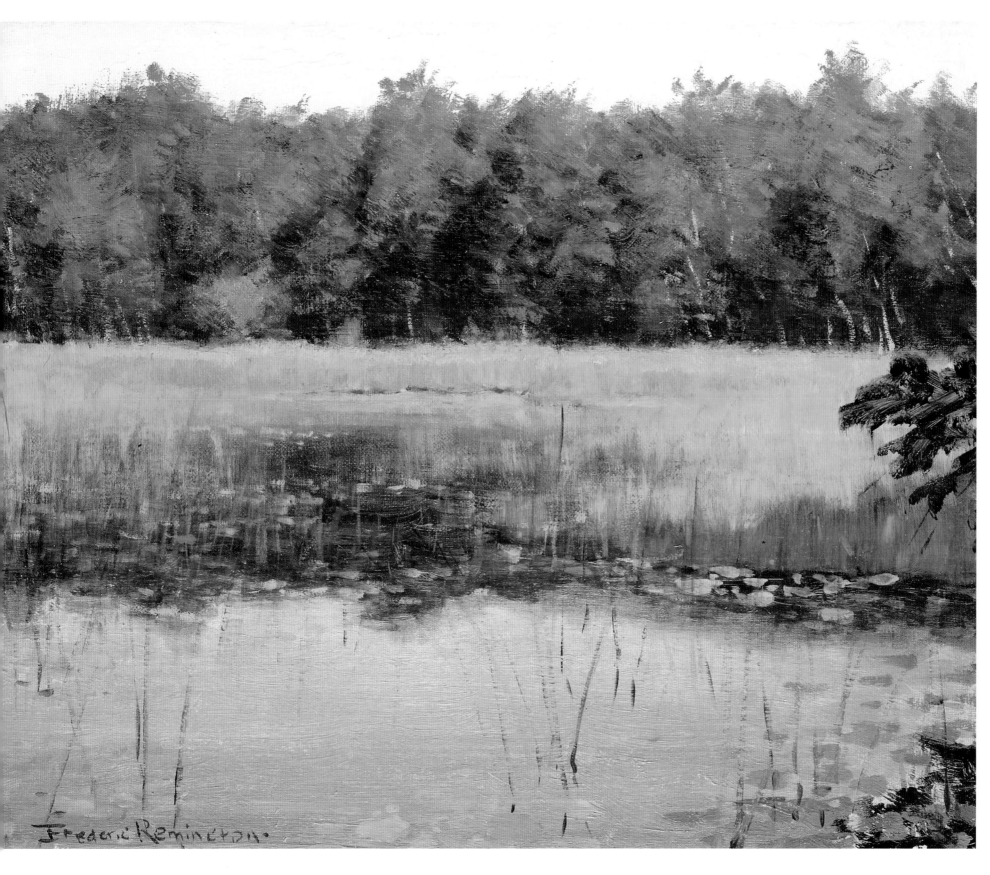

Frederic Remington.

FAR LEFT: Ravine in high country. Undated. *The Art Archive/Gift of the Coe Foundation/Buffalo Bill Historical Center, Cody, Wyoming/35.67*

LEFT: Landscape, lake with lily-pads. Undated. *The Art Archive/Gift of the Coe Foundation/Buffalo Bill Historical Center, Cody, Wyoming/88.67*

Right: Impressionistic winter scene of New England farm barn and bare trees, hill, and snowy background. Undated. *The Art Archive/Gift of the Coe Foundation/Buffalo Bill Historical Center, Cody, Wyoming/82.67*

Far right: Impressionistic winter scene of streams, rocks, and trees. Undated. *The Art Archive/Gift of the Coe Foundation/Buffalo Bill Historical Center, Cody, Wyoming/75.67*

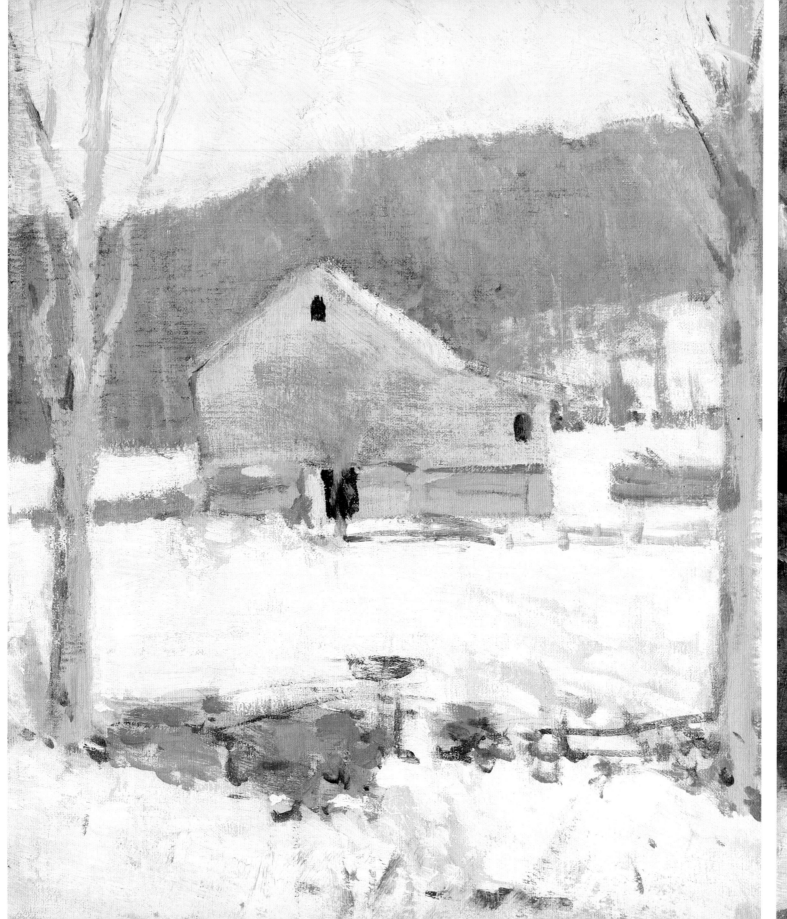

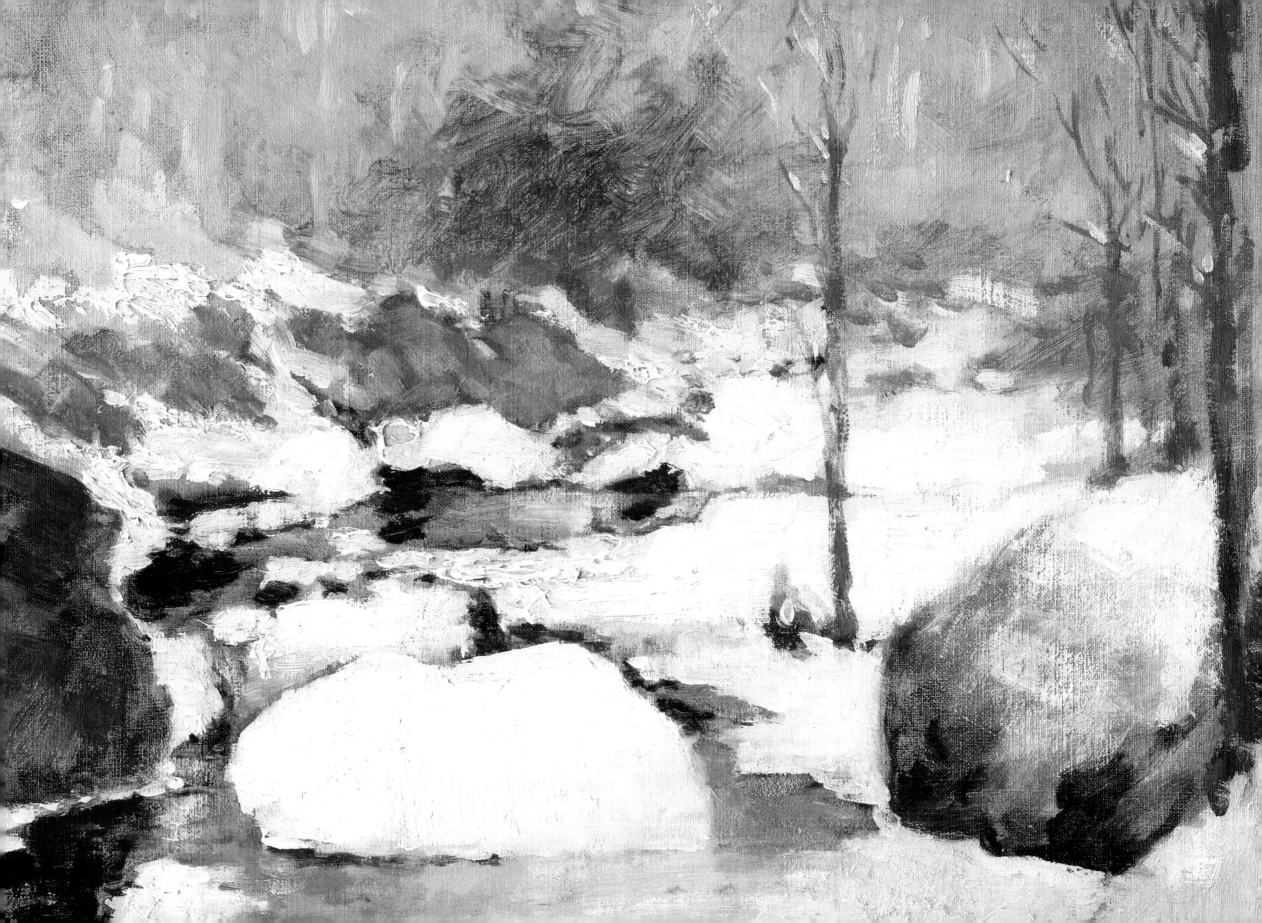

RIGHT: Untitled, Fall landscape, c.1907-08. Undated. *The Art Archive/Gift of the Coe Foundation/Buffalo Bill Historical Center, Cody, Wyoming/74.67*

FAR RIGHT: Unfinished painting of prairie and rimrocks. Undated. *The Art Archive/Gift of the Coe Foundation/Buffalo Bill Historical Center, Cody, Wyoming/12.67*

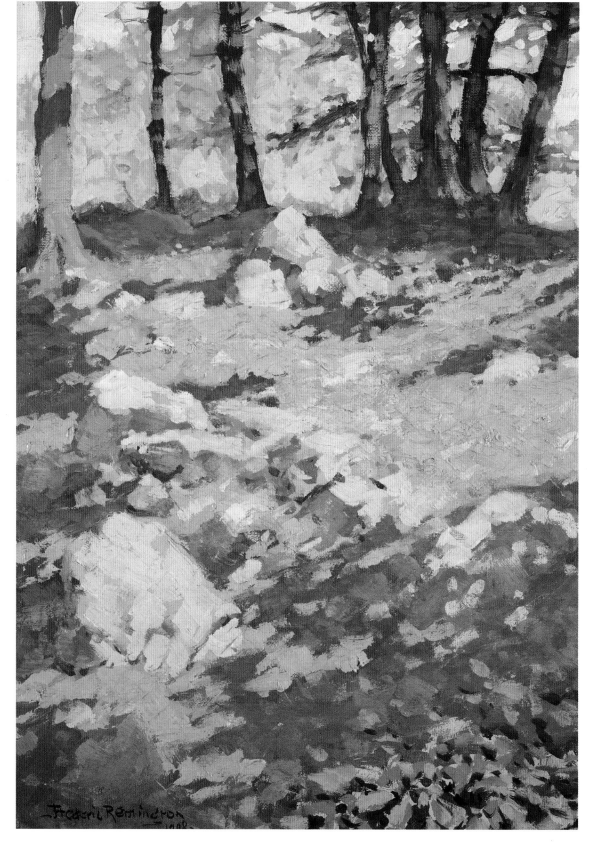

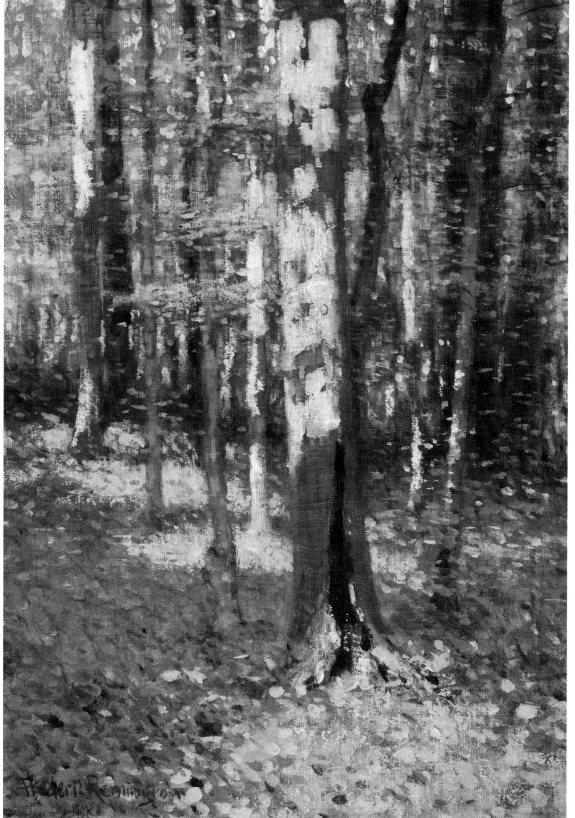

FAR LEFT: Landscape, Fall wood with rocky hillside, 1908. *The Art Archive/ Gift of the Coe Foundation/Buffalo Bill Historical Center, Cody, Wyoming/ 93.67*

LEFT: Landscape, birch wood, 1908. *The Art Archive/Gift of the Coe Foundation/Buffalo Bill Historical Center, Cody, Wyoming/89.67*

RIGHT: Landscape, sunlit birch wood. Undated. *The Art Archive/Gift of the Coe Foundation/Buffalo Bill Historical Center, Cody, Wyoming/87.67*

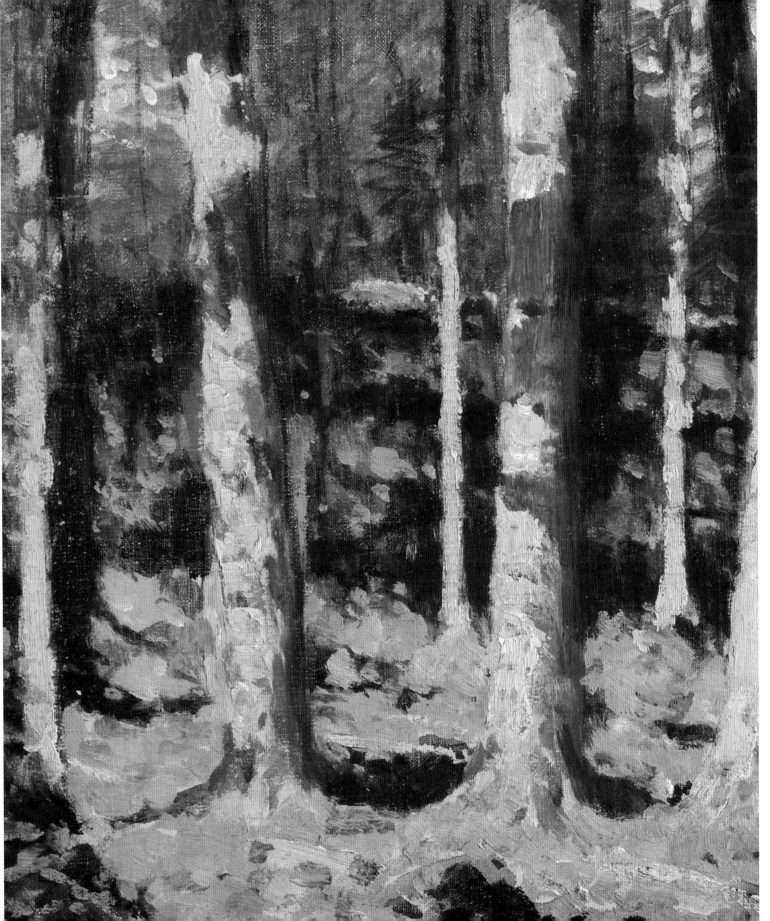

OVER PAGE LEFT: Two trees beside lake – N.Y. Undated. *The Art Archive/Gift of the Coe Foundation/Buffalo Bill Historical Center, Cody, Wyoming/ 7.67*

OVER PAGE RIGHT: Chippewa Bay, c.1907-08. Undated. Remington and Eva bought Ingleneuk, a five-acre island in Chippewa Bay in 1900 and spent every summer there until they sold it in 1908. Remington loved painting the views around the bay and made many sketches of the local scenery. *The Art Archive/Gift of the Coe Foundation/Buffalo Bill Historical Center, Cody, Wyoming/2.67*

217

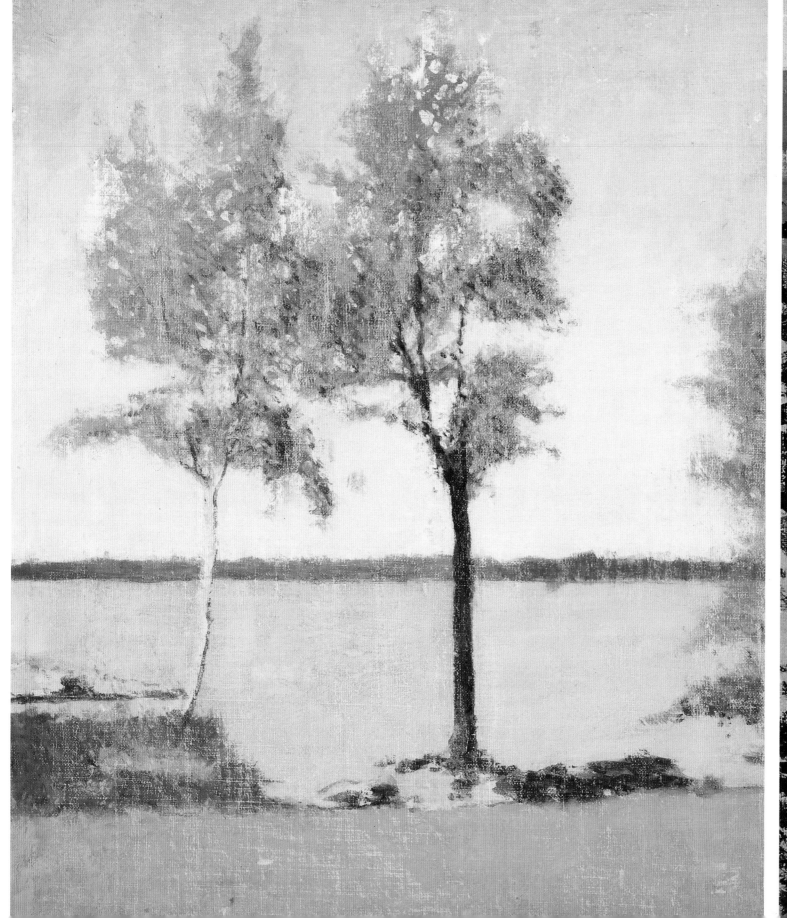

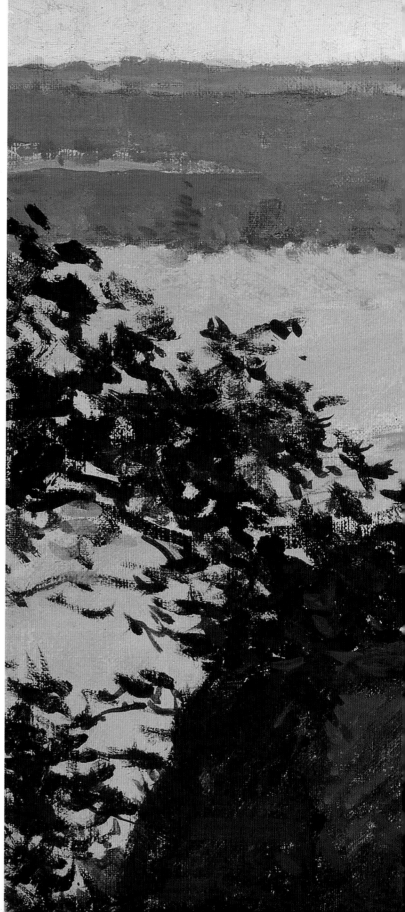

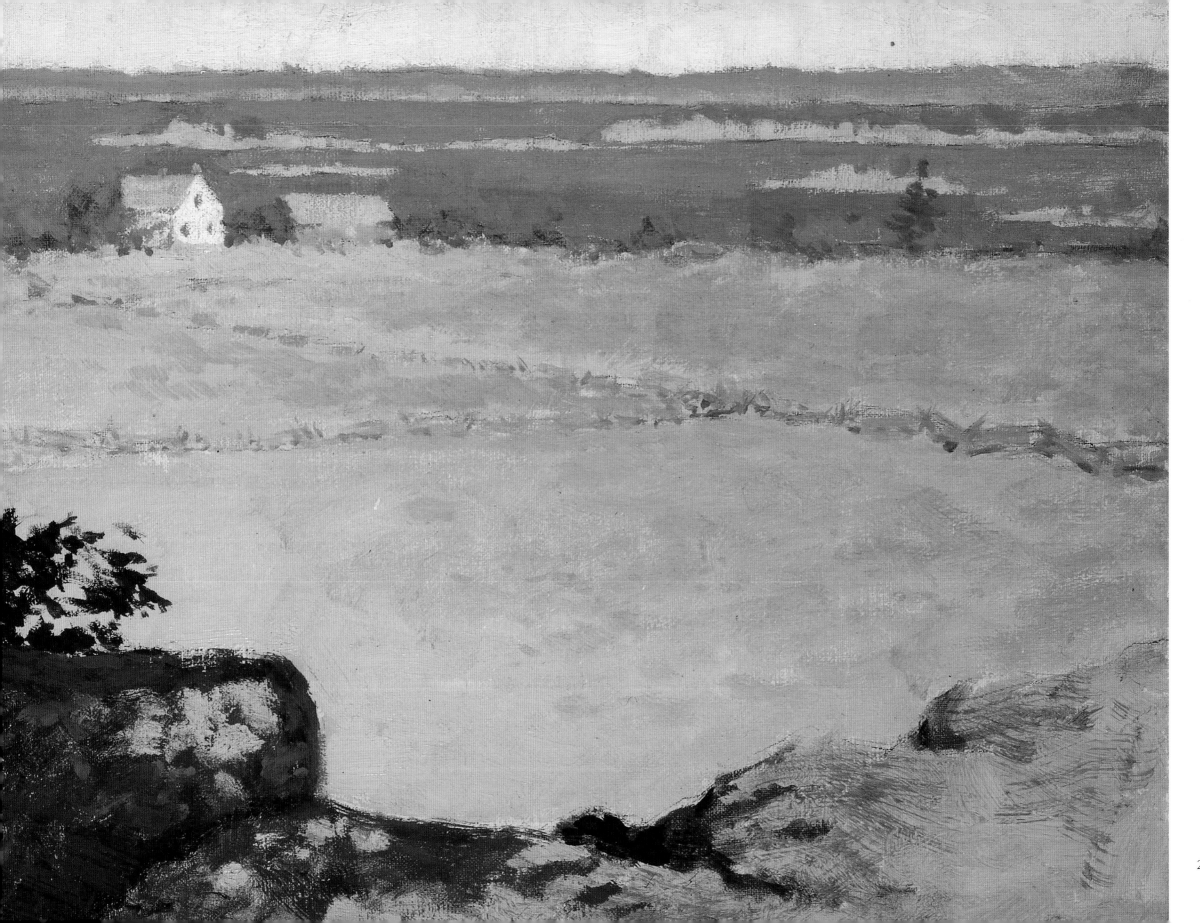

219

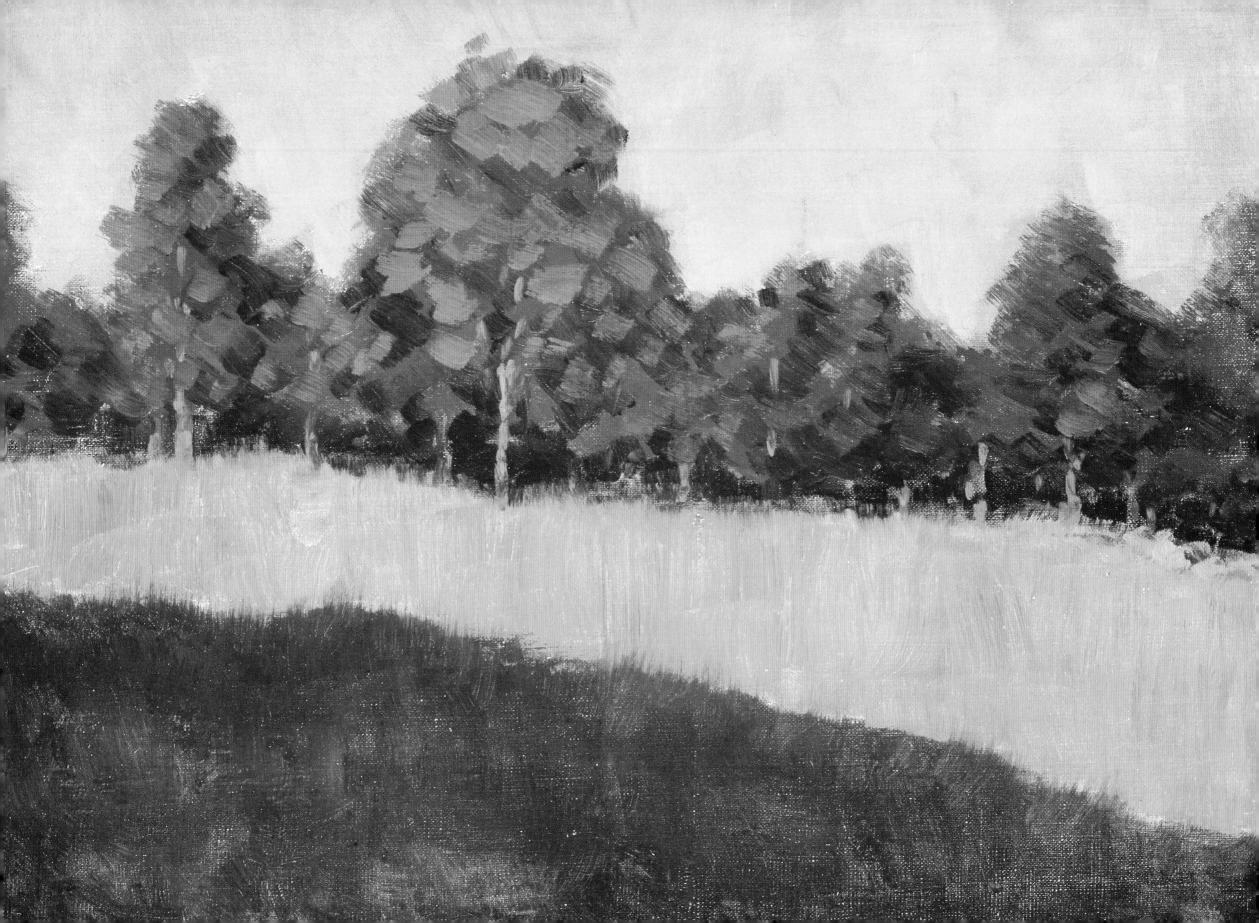

Left: Landscape, night scene in a wood, c. 1908. *The Art Archive/Gift of the Coe Foundation/Buffalo Bill Historical Center, Cody, Wyoming/86.67*

Right: Lake and quaking aspen trees in back. Undated. *The Art Archive/Gift of the Coe Foundation/Buffalo Bill Historical Center, Cody, Wyoming/ 18.67*

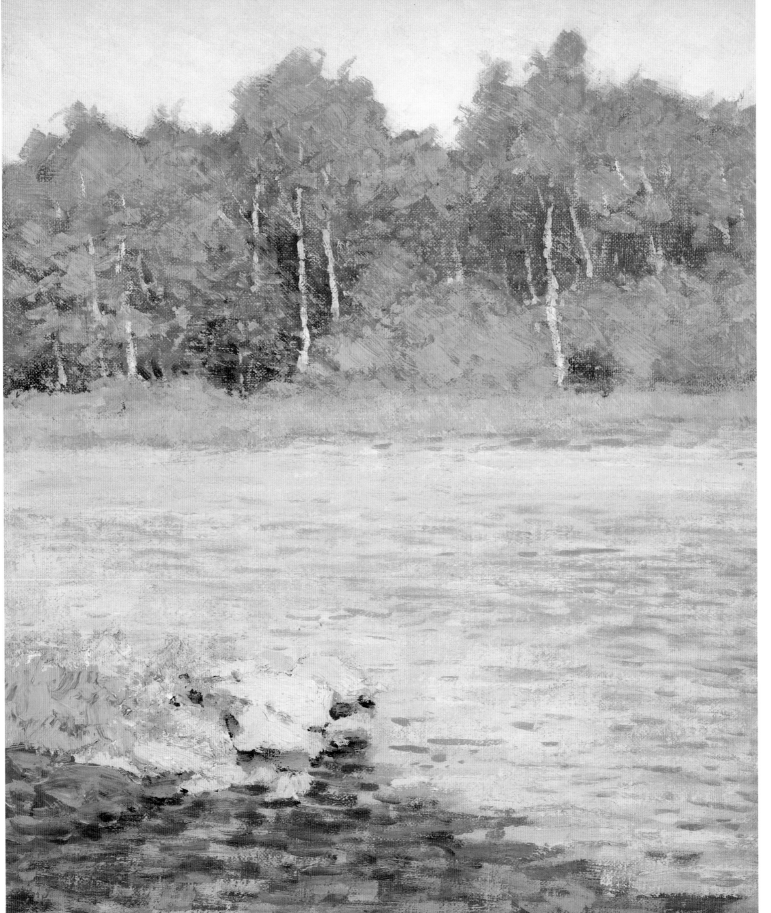

Over page left: Chippewa Bay, c. 1907-08. Remington painted small landscape studies outdoors, in preparation for large easel paintings. Later in life, he came to consider these small paintings as finished works in themselves. *The Art Archive/Gift of the Coe Foundation/ Buffalo Bill Historical Center, Cody, Wyoming/92.67*

Over page right: Untitled, log ranch buildings with wagon, 1908. *The Art Archive/Gift of the Coe Foundation/ Buffalo Bill Historical Center, Cody, Wyoming/59.67*

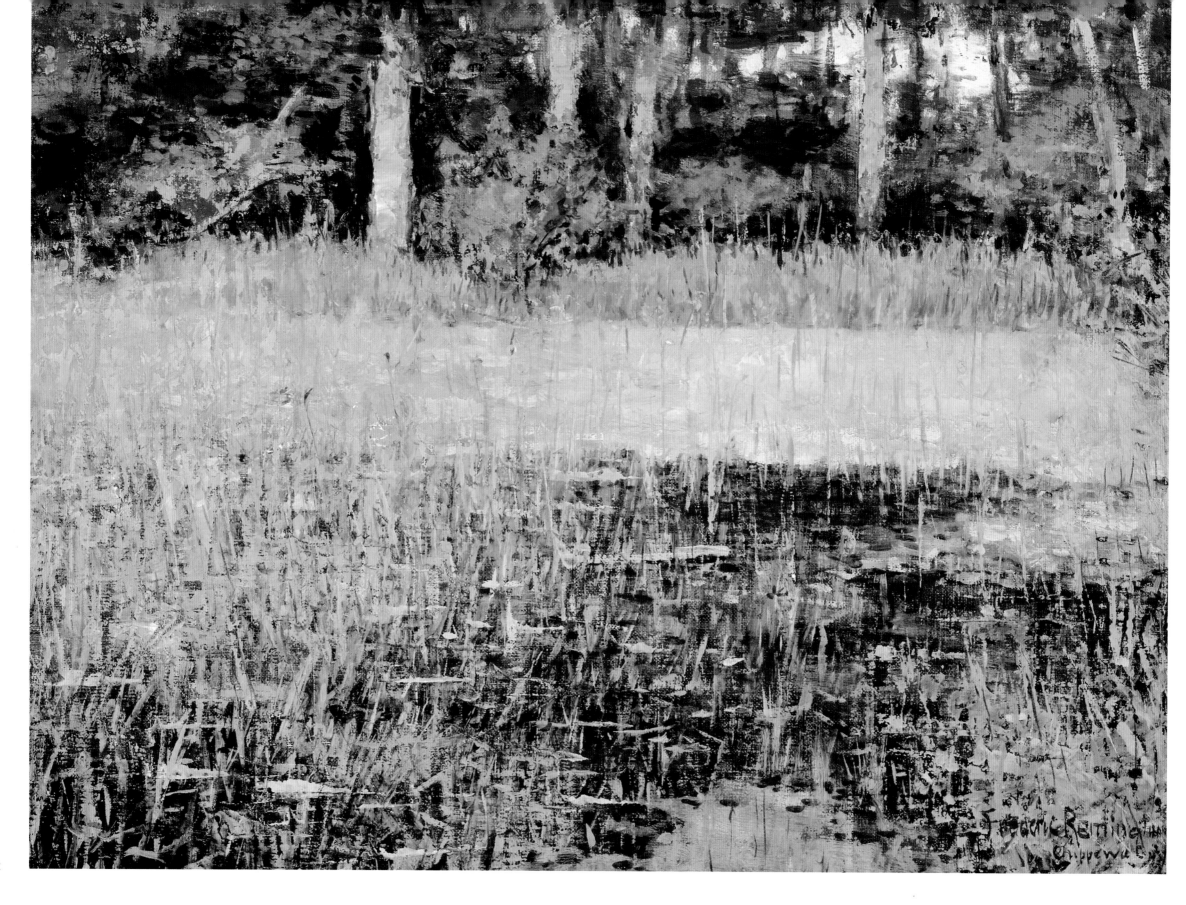